IN AUGUST COMPANY

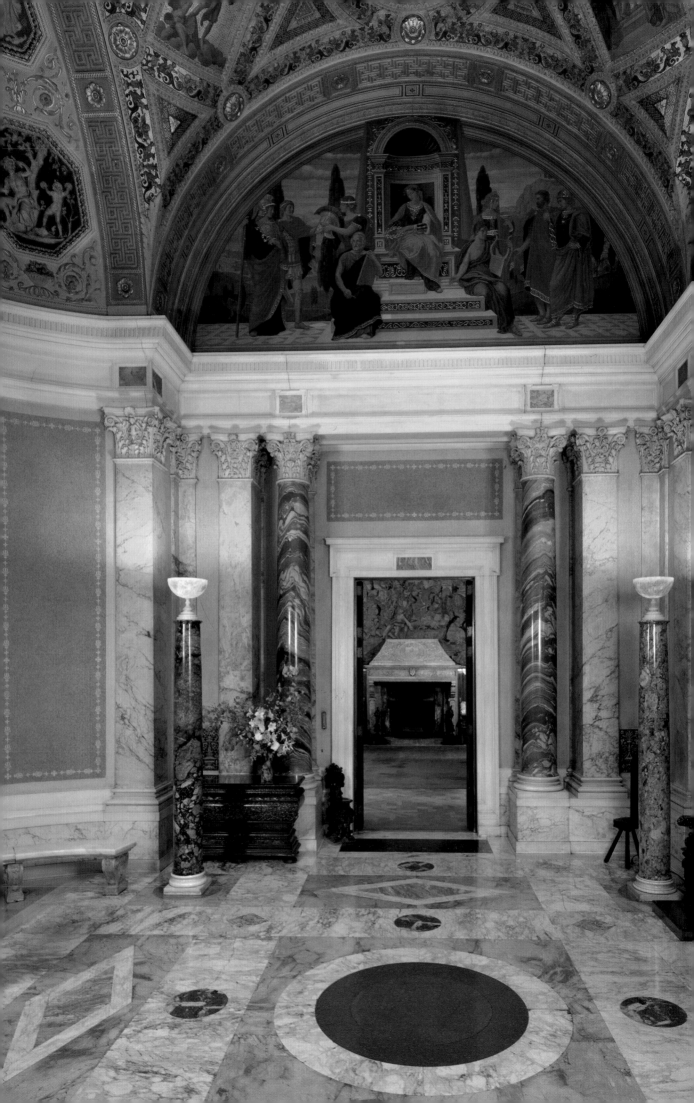

IN
AUGUST COMPANY

The Collections of
The Pierpont Morgan Library

THE PIERPONT MORGAN LIBRARY · NEW YORK

The production of this book
has been made possible by a grant from
THE CARL AND LILY PFORZHEIMER FOUNDATION, INC.

Cover illustration:
Blanche of Castile and King Louis IX of France;
Author Dictating to a Scribe,
Moralized Bible, France, ca. 1230. M 240, f. 8

Frontispiece:
View of the Rotunda

All photography is by David A. Loggie
except pages 6, 12, 15, 67, and 258

The publication of this book
was coordinated by Kathleen Luhrs

Library of Congress Cataloguing in Publication Data
Pierpont Morgan Library,
In august company:
the collections of the Pierpont Morgan Library
p. cm.
Includes bibliographical references.
ISBN 0-87598-093-7
1. Pierpont Morgan Library 2. Rare book libraries—
New York (N.Y.) 3. Research libraries—New York (N.Y.)
4. Library resources—New York (N.Y.) I, title.
2733.P588P53 1992
026.09'09747'1—dc20
91-66326 CIP

ISBN 0-87598-093-7 (paper)
ISBN 0-8109-3863-4 (Abrams: cloth)

Clothbound edition distributed by
Harry N. Abrams, Incorporated, New York
A Times Mirror Company

Printed in the United States of America

CONTENTS

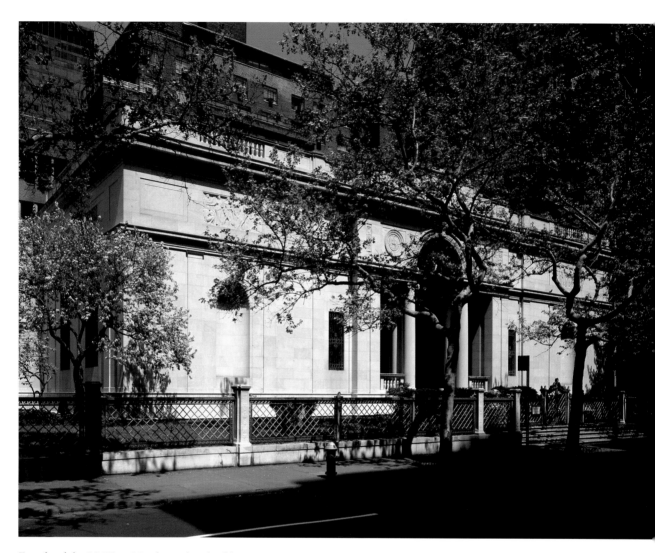

Façade of the McKim, Mead & White building

DIRECTOR'S FOREWORD

THE MORGAN LIBRARY, once the private domain of the financier-collector Pierpont Morgan (1837-1913), is now a public research library, a museum, an architectural landmark, and a historic site. The collections are vast and eclectic, representing the combined and evolving tastes of Pierpont Morgan, his son, J. P. Morgan, Jr., and a succession of other collectors, Library directors, and curators down to the present day.

Chronologically, the sweep extends from the first written civilizations of ancient Mesopotamia to the modern era. For purposes of access, the collections are organized into the following categories: ancient seals and texts, medieval and Renaissance manuscripts, early and later printed books and fine bindings, children's books, autograph manuscripts, music manuscripts, prints and drawings, Gilbert and Sullivan materials, art objects, and the Morgan archives. Accordingly, we have generally followed the same structure in the organization of the present volume. Cutting across these categories, however, is an almost limitless array of different areas of inquiry and study—art, literature, science, mathematics, history, philosophy, religion, law, education, theater, opera, linguistics, music, astrology, paleography, navigation, medicine, witchcraft, gardening, and this list is far from complete.

One quality that nearly all of these diverse materials have in common is their physical fragility, which requires that they be protected from prolonged exposure to the damaging effects of light and the atmosphere. For reasons of conservation more than limitations of physical space, only the merest fraction of the collections can be on public view at any given time. While there are numerous exhibition catalogues, facsimiles, and other publications devoted to specific aspects of the collections, until now there was no single volume that provided a general, well-illustrated overview of the entire holdings. In this book, we have singled out what we consider to be some of the finest and most representative objects from each of the Library's collections. Over two hundred works are reproduced and discussed. The short introductory essays preceding each section are intended to give a general idea of the scope of the collections and how and why they were formed. It is worth noting that many of the objects included were acquired in the last twenty years, an indication of the degree to which, despite ever increasing prices, the Library continues to grow and build upon existing strengths.

This volume also marks an important moment for this institution. In the fall of 1991, the Morgan Library completed the most extensive expansion and renovation program in its history. The project, initiated in 1988 with the purchase of the former house of J. P. Morgan, Jr., involved the restoration of historic spaces and the creation of new ones. To celebrate this event, we presented "Masterpieces of the Morgan Library," the largest exhibition of the collections ever shown. For three months, from October 1 through January 5, visitors had the rare opportunity to see over 275 objects from each of the fields in which we collect. As Michael Kimmelman, chief art critic of the *New York Times*, observed in his review, "Never has the word masterpieces been more a matter of fact and less a matter of hype." With only one or two exceptions, each of the works illustrated and

discussed in this book were on display at that time. It follows, of course, that any publication which presents a selection of objects from such wide-ranging fields will be of limited value to the specialist. Rather it has been our aim to provide an introduction to the collections that will be read and enjoyed by all who have an interest in the Library and in the history of art and ideas.

Our choice of the title *In August Company* may at first appear to be somewhat self-congratulatory. It is in fact the phrase that Mark Twain, one of the most acute critics of his age, used to describe the Library's collections almost a century ago in a letter to Pierpont Morgan. I like to think that Twain would be quite pleased to see his remark appropriated in this way.

In August Company represents the collaborative efforts of almost the entire staff of the Morgan Library. John Plummer, curator of Medieval and Renaissance Manuscripts and Research Fellow at the Library, served as general editor. Information on the collections and individual objects was provided by the curatorial staff: Edith Porada, curator of Seals and Tablets; Peter Dreyer, Cara D. Denison, Stephanie L. Wiles, and Evelyn Phimister, in the Department of Drawings and Prints; William M. Voelkle and Roger S. Wieck, in the Department of Medieval and Renaissance Manuscripts; H. George Fletcher, Anna Lou Ashby, Hope Mayo, Eugenia Zazowska, and Eve Cohen Pasternak, in the Department of Printed Books and Bindings; Robert Parks and Christine Nelson, in the Department of Autograph Manuscripts; J. Rigbie Turner, in the Department of Music Manuscripts and Books; Fredric Woodbridge Wilson, curator of the Gilbert and Sullivan Collection; and D.W. Wright, in the Office of the Registrar and Archivist.

Kathleen Luhrs, the Library's publications coordinator, oversaw all phases of editing, design, and production. She was assisted by Elizabeth Gemming, Mimi Hollanda, Sandy Opatow, Carol Wenzel-Rideout, and Elizabeth Wilson. Unless otherwise indicated, all photographs are by David A. Loggie, with the assistance of Edward J. Sowinski. Nancy Schmugge and Marilyn Palmeri in Photographic Services were constantly helpful. In addition, we are grateful for the cooperation and support of the Library's Reading Room, cataloguing, conservation, bindery, development, and public affairs staffs.

Special thanks are due to Klaus Gemming, the designer of the catalogue, who guided the book's production. We also wish to thank William Schlicht at Finn Typographic Service, where the type was set, and Tony Lalli at Van Dyck/Columbia Printing.

We feel fortunate indeed that John Russell, formerly chief art critic of the *New York Times*, has provided the delightful foreword to this book. We are also grateful to Harry N. Abrams, Publishers, and in particular Mark Greenberg, for patience and support in this undertaking.

And finally, on behalf of the entire staff and Trustees of the Library, I should like to express my deepest thanks to The Carl and Lily Pforzheimer Foundation, Inc., and especially Carl H. Pforzheimer, Jr., for the generous financial assistance for this project.

Charles E. Pierce, Jr., Director

FOREWORD

WHEN FAR FROM HOME, I often dream of a way station on the slopes of Murray Hill in New York City. Its name is the Pierpont Morgan Library, and it stands on Madison Avenue at 36th and 37th streets. Fundamental to my dream is the idea that a second life might one day be granted to me.

In that life, I would haunt the Morgan Library, day by day and year after year, without interruption. By the end, I would be privy to every one of its secrets.

Of the 1,157 ancient Near Eastern cylinder seals that were assembled for Pierpont Morgan between 1885 and 1908, every single one would be as familiar to me as the key to my own front door. If someone were to refer in conversation to Etana, the Mesopotamian shepherd king, I could say "Why, of course! Etana, who flew to Heaven on an eagle to procure the plant of easy birth for his wife." And all present would roll on the ground in amazement.

If in Carnegie Hall one of the French horns were to fluff an entry in Arnold Schoenberg's *Gurrelieder,* I would spot it at once, even though "Gurrelieder" is a colossal score and one not heard every day. Thanks to the manuscript in the Morgan Library, not a note on the specially made forty-eight-stave paper that Schoenberg used would be unfamiliar to me.

If an uppity child were to misbehave at table, I could whip out a line or two from the fifteenth-century French treatise on table manners for children that can be perused in the Morgan Library. (The treatise is in verse, by the way, and I would have had myself coached by a *sociétaire* of the Comédie-Française.)

In the matter of bookbindings, I was inspired in first youth by G. D. Hobson, the ranking English authority in such matters. Since then I have learned much from my contemporary and lifelong friend, his son A. R. A. Hobson, who is the current president of the International Association of Bibliophiles.

From the Hobsons I have learned that Pierpont Morgan did a very good day's work when in 1899 he bought what was called "the library of leather and literature" of a London bookseller called James Toovey. This initial foray into the field of fine bindings resulted eventually in the arrival of a whole hoard of books in which text and binding are memorably connected.

As is said elsewhere in this book, we are here talking not of the hideous and trumpery glued bindings of the 1990s, but of "books made of real animal skins, prepared by hand, or of real paper, made by hand, one sheet at a time, written by hand, one stroke at a time, or printed from real type, cast and set by hand, one character at a time."

Though not quite extinct, this most humane of activities is by now very rare. Blessed, therefore, is the Morgan Library, in which so large a role has always been allotted to books in which—again I quote from a later page—"hands gathered the sheets and folded them; fingers pushed needles and thread to gather the pages together; hands pared boards, shaved leather, hammered metal, and stamped and painted, or on occasion embroidered, the outer surfaces."

If any one reader could go through the Morgan Library, book by book, reading and

re-reading the text and noting the congruence (or lack of it) of the distinguished binding, he might well claim the title, so much coveted in the sixteenth century of "humanissimus vir." (Happy are our own times, in which women may claim the title at least as often as men!)

In physical terms, even with its current enlargement, the Morgan will never be—nor wish to be—a mammoth among libraries. Nor will it have delusions of being all things to all people. In some areas, it has dug deep and, to this day, digs even deeper. Others it leaves untouched and untapped.

It is a private and a personal place, though one to which we all of us can ask access. It bears the stamp (above all in the East and West Rooms) of the redoubtable human being whose name it bears. (I dare to add that Pierpont Morgan had the misfortune to sit for one of the least gifted of all English portrait painters, Frank Holl.)

It could also be said that initially the collections were made in the image of Pierpont Morgan himself and included those kinds of things that were most to the fore in his lifetime. If he often bought in bulk, it was because that was the way buying was done.

The Morgan Library has never lacked for scholars on its staff nor has it lacked, since 1949, for Fellows who bring their own enthusiasms—and bring them at white heat, as often as not. Oftentimes, individual unaffiliated collectors have also decided that, all things considered, the Morgan Library was where they would most like their possessions to be.

Thus it is that Kenneth Clark left some of the finest of his books to the Morgan Library. Thus it is that the Library has acquired major holdings of Charles Dickens and Charlotte and Emily Brontë among novelists, of Samuel Taylor Coleridge among poets, of John Ruskin among aestheticians, and of Edouard Manet among painters.

Common to all the collectors in question was the passion to have, and to hold, and eventually to pass on to others, that animated so many Americans at the start of our century. One of them was Harry Elkins Widener, a twenty-seven-year-old Harvard graduate who in 1912 picked up in London a copy of Francis Bacon's *Essays*, printed in 1598.

"I think I'll take that with me," he said to Quaritch, the great London bookseller. "If I'm shipwrecked, it will go down with me." Quaritch doubtless took it as a young man's joke, but Widener was booked on the *Titanic*, and Bacon's "Essays" did go down with him, just as he had said.

Solace and quiet are fundamental to the Morgan Library, but it is of course by no means the only library of which that can be said. What is special to the Morgan Library is the omnipresent sense that this is a place in which the truth is everywhere at home.

In its every domain it will be found to have pushed a little harder and reached a little further than many a larger and more talked-of institution. There are great individual works of art in the Morgan Library—illuminated manuscripts, paintings, and old master drawings, above all—but minor art can also engender a special tenderness, and I for one shall never forget the Arthur Sullivan exhibition in 1975. Nor shall I forget the P. G. Wodehouse and Beatrix Potter celebrations of more recent date. There, too, truth resided.

When we climb higher, the Morgan Library will not let us down. Are we keen to consult the Rubens drawing of a seated youth, the only existing manuscript text of Book I of Milton's *Paradise Lost,* or the manuscript of Schubert's *Winterreise?* Do we wish to lay hands (in white gloves, of course) on every imaginable edition of *Alice's Adventures in*

Wonderland, on the manuscript of Thoreau's diary for the years from 1837 to 1861 (complete with the original pine box in which it was stored), or on the "aesthetic teapot," made in Worcester in 1882 and ornamented with key figures from Gilbert and Sullivan's *Patience?* In every case, it is in the Morgan Library that these rarities are niched.

When in the national library in Vienna, I have occasionally wished to lay hands on the magical glass acquired by the Emperor Rudolf II that empowers us "to see Apparitions and converse with Spirits." But I have never felt the lack of that glass when in the Morgan Library. How could I, in a place where both apparitions and spirits greet the visitor on every hand?

Hospitality and trust are fundamental to the Morgan Library, and we cannot imagine that Willibald Pirckheimer, the boot-faced friend of Albrecht Dürer, would ever be turned away at the door, as he once was at the library in Bamberg.

Nor do ancient and peremptory loyalties dictate the Morgan's arrangements, as they do in the library at the Escorial, near Madrid, in which every book stands with its fore-edge outwards, in deference to the wishes of its founder, Philip II.

Such is the relative youth of the Morgan Library that it cannot be said of it, as it was of Lord Spencer's library at Althorp, that in May 1763 the author of *The Decline and Fall of the Roman Empire* had knocked himself out in a single morning by going through seventy-eight incunable editions of Cicero. But we can relive that kind of experience in domain upon domain at the Morgan Library.

As will be clear from the entries in this publication that relate to illuminated manuscripts, the Morgan's collections are catalogued with an exemplary care. But it cannot quite rival in that regard the Herzog August Bibliothek in Wolfenbüttel, where the author catalogue was set out in alphabetical order by the foremost European intellectual of his day, Gottfried Wilhelm Leibnitz, when he was in charge of it from 1690 to 1716. (His catalogue is still in use, by the way.)

As the buildings that I so often dream of had their beginnings in 1906, they cannot whisk us way, way back in time. Though unfeignedly grand, they are grand in the style of Pierpont Morgan's own day. In the Louvre in Paris, panels of Irish bog-timber and brass window-grilles were set up in the fourteenth century to protect books from decay, rain, rats, mice, and the intrusion of big-beaked birds. Within the Morgan Library, no such tales can be told.

But the difference is that, unlike some of its counterparts in other countries, the Morgan Library has never been more alive and will become even more so now with its scenic enlargement. In particular, its permanent collections are more accessible, on a rotation basis, to the casual visitor.

Walking from house to house, with an ingenious garden niched between the two, we have time to sit, to breathe, and to dream. We are able to rack up our impressions, one by one. We can feel apart from the world, but not excluded from it. The blessings of daylight and skylight are not withheld from us, and we can also count on one of the most seductive museum shops in the United States.

It is a magical prospect. Even if a second life is not ours for the asking, the first one is looking better by the hour.

<div style="text-align: right">John Russell</div>

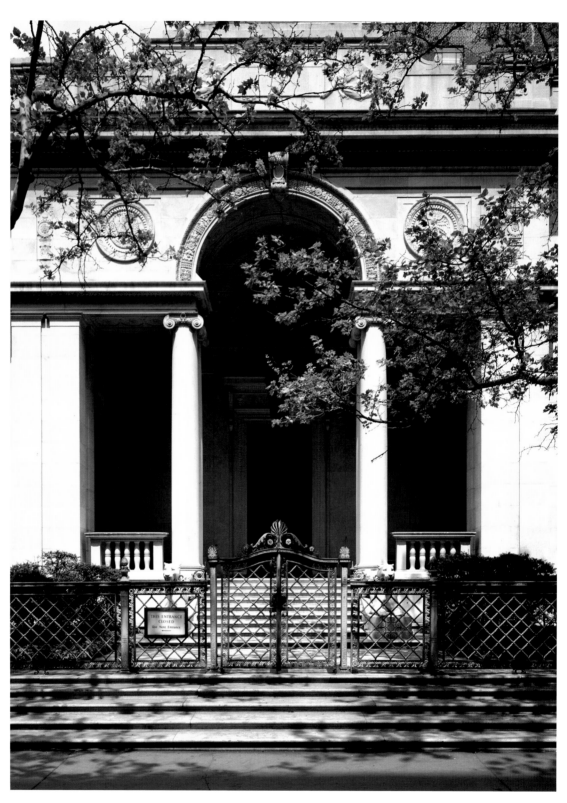

Entrance to the McKim, Mead & White building

INTRODUCTION

I N 1910, Pierpont Morgan received a letter from Mark Twain, responding to his request for the author's manuscript of *Pudd'nhead Wilson*. "One of my high ideals is gratified," replied Twain, "which was to have something of mine placed elbow to elbow with that august company which you have gathered together to remain indestructible in a perishable world." The "august company" to which Twain referred was the group of books, manuscripts, and drawings which Morgan had begun to assemble in the 1890s and which he kept in his white marble library building on East 36th Street in New York. At that time, it was called simply Mr. Morgan's Library and was generally regarded as one of the finest private libraries in the world.

In the creation of this collection, Morgan had been inspired by the European model of a "gentleman's library," acquiring medieval and Renaissance illuminated manuscripts, early and rare printed books, fine bindings, literary and historical autographs, and old master drawings. While the focus was primarily on Western European materials, room was also made for important American authors and historical figures. Twain's *Pudd'nhead Wilson*, for example, joined autograph manuscripts by Cooper, Hawthorne, and Thoreau as well as letters from Washington and Hamilton.

When Morgan died in 1913, the Library and its contents passed to his only son, J. P. Morgan, Jr., who in 1924 established the library as a public institution in memory of "my father's love of rare books and his belief in the educational value of the collection." Since then, The Pierpont Morgan Library has operated as an independent research library and museum devoted to the arts and the humanities. While the collections have increased several times over, the basic categories and chronological limits established by Pierpont Morgan have been largely maintained. The Library's physical space has almost tripled in size, but the elegant library designed for Morgan by McKim, Mead & White has been carefully preserved and remains the heart of the institution.

Pierpont Morgan, Financier and Collector

WHEN PIERPONT MORGAN began to collect, he was already in his fifties and internationally regarded as one of the leading bankers and financiers of his day. He was born in Hartford, Connecticut, on April 17, 1837, into an old and distinguished New England family. Young Morgan, known as "Pip" to his childhood friends, was raised in an atmosphere of wealth, privilege, and refinement. When he was seventeen, the family moved to London, where his father, Junius Spencer Morgan, became a partner in the American-owned investment house of George Peabody & Co. (later to become J. S. Morgan & Co.). Pierpont was sent to boarding school in Switzerland and attended the prestigious University of Göttingen in Germany. Holidays were spent sightseeing in England and on the Continent. A family visit to the Duke of Devonshire's renowned library at Chatsworth may have sown the seed for its counterpart a half century later on

36th Street. In any event, during his formative years Morgan was exposed to an array of cultural experiences unusual for an American boy of his day.

Morgan returned to New York in 1857 and began his business career; four years later he became the American agent for his father's firm, securing and protecting overseas investments in the burgeoning railroad, coal, and steel industries. During the turbulent "boom" years following the Civil War, the house of Morgan gained a reputation for stability and integrity, and Pierpont Morgan emerged as a powerful and respected businessman in his own right. Between 1893 and 1895 he reorganized six of the nation's railroads and maintained a controlling interest in all. In 1895, he halted an impending gold crisis by forming a syndicate to exchange bonds for gold. In 1901, he bought out Andrew Carnegie and launched the U.S. Steel Corporation, the largest corporate enterprise the world had ever known. During the Panic of 1907, he raised $25 million in one afternoon to halt a run on the banks. As one biographer succinctly put it, Morgan essentially operated as a "one-man federal reserve bank."

Of Morgan's private life and personal thoughts regarding his business or collecting ambitions, we know very little. He assiduously shunned publicity and was portrayed by colleagues as brusque, somewhat distant, and often abrupt. One of the few surviving portraits of Morgan is the well-known photograph of 1903 by Edward Steichen, who later likened encountering Morgan's gaze to watching the oncoming headlights of an express train. With friends and family, however, he was relaxed and convivial, entertaining frequently and on a lavish scale. Morgan's first marriage, to Amelia Sturges, ended when she died of tuberculosis four months after their wedding. Three years later, in 1865, he married Frances Louisa Tracy, the daughter of a prominent New York lawyer. They had three daughters, Louisa, Juliet, and Anne, and a son, also named John Pierpont Morgan.

Morgan's life-style was suitably grand and comfortable, but notably unostentatious. In 1880, he changed his New York residence, moving to a large but undistinguished brownstone at 219 Madison Avenue on the corner of 36th Street. He spent several months of each year abroad and was frequently at his father's London town house at Princes Gate and at Dover House, the family estate at Roehampton. He was equally at home in London, Rome, and New York. He seemed to enjoy traveling and on several occasions organized boating parties up the Nile for his American friends.

During his years as a rising young businessman, Morgan exhibited an occasional interest in books and manuscripts and acquired a small group of historical and literary autographs. It was the death of his father in 1890, however, that signaled the beginning of his collecting in earnest. Some biographers have suggested he may have put off collecting out of deference to his father, who was himself a collector of autographs and rare books. More importantly, however, it was only upon his father's death that Pierpont Morgan had the financial resources to build a collection on a truly grand scale. Junius Morgan's estate was valued at roughly $12.4 million, and, in addition, the son assumed leadership of his father's highly profitable London banking house. That Pierpont Morgan should have used a portion of this wealth to collect was not entirely surprising. The rapid economic growth of the country during the 1870s and 1880s had been followed by a keen awareness of the need to enrich the cultural and intellectual lives of the American people as well. Increasingly, it was regarded as the duty of leading Americans to contribute to the creation of a

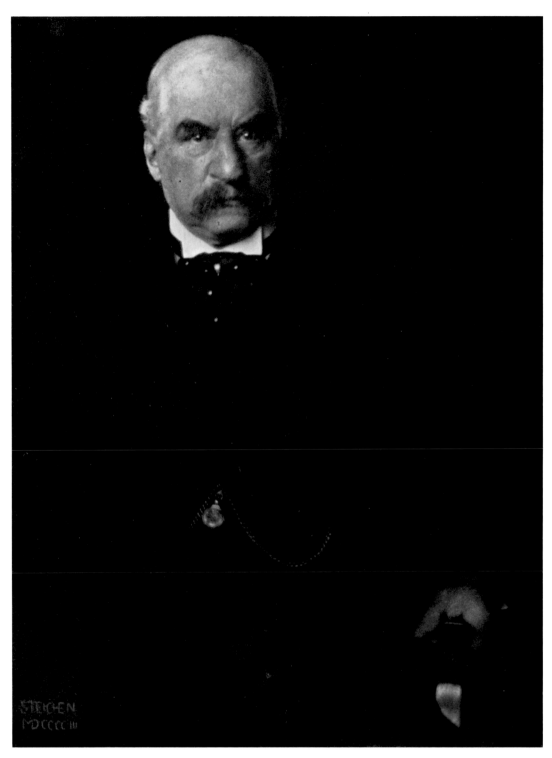

J. Pierpont Morgan, photograph by Edward Steichen
Courtesy of Joanna T. Steichen and George Eastman House

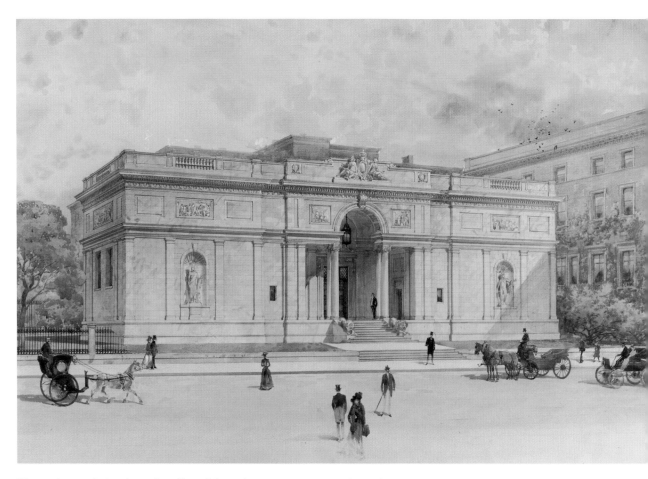

Watercolor rendering from the office of the architects McKim, Mead & White, ca. 1902

great republic which could compete culturally with Europe. At this period, art collecting was perceived not merely as a pastime but as a matter of national pride, and many of the great private collections of European old master paintings and sculpture – such as those of Isabella Stewart Gardner, Henry Walters, and Joseph P. Widener – were formed. In March of 1880, ten years after its founding, New York's Metropolitan Museum of Art was finally established in permanent quarters in Central Park. Morgan was elected a trustee of the museum in 1888, and from 1904 until his death he served as its president. Under his leadership, the museum embarked upon an ambitious program of acquisitions. He was also a major benefactor of the Wadsworth Atheneum in his native Hartford, for which he built the Morgan Memorial building, dedicated in 1910 to the memory of his father.

Morgan's rare books, manuscripts, and autographs – his so-called literary collections – were but one aspect of his collecting interests. He acquired on a vast scale both in quantity and scope. Art objects numbering in the thousands ranged from ancient Egyptian tomb sculpture and Chinese bronzes to Meissen porcelain and paintings by Raphael, Vermeer, and Fragonard. "No price," he was once reported to have said, "is too high for an object of unquestioned beauty and known authenticity."

Mr. Morgan's Library

As he set about the formation of his library, Morgan concentrated primarily on the growth of his autograph collection, which he had begun, albeit modestly, when he was a boy in Hartford. Here as elsewhere he followed a pattern of buying individual items as well as entire collections. In the former category were such prizes as the manuscript of Keats's *Endymion* and Dickens's *A Christmas Carol*. Major purchases of collections included Sir James Fenn's English historical autographs and Stephen Wakeman's over two hundred and fifty American literary autographs, which contained Hawthorne's notebooks and Thoreau's journals.

Morgan was encouraged to collect in the areas of early printed books and illuminated manuscripts by his scholarly nephew Junius Morgan. Here again, there were notable individual purchases, such as the splendid Lindau Gospels, Morgan's first major medieval manuscript acquisition, and the very rare Mainz Psalter of 1459, for which he paid $50,000, at that time the highest price on record for a book. Breadth, however, was achieved through a succession of several astute purchases of entire collections—the James Toovey collection of rare books and bindings; the library of books and manuscripts formed by the American collector Theodore Irwin; and, above all, the Richard Bennett collection, which Morgan acquired in 1902. This group of over seven hundred volumes, including about one hundred illuminated manuscripts and no fewer than thirty-two Caxton imprints, is considered the nucleus of the Morgan Library's printed book and illuminated manuscript collections. Morgan became a serious collector of drawings only toward the end of his life, when he purchased the Charles Fairfax Murray collection. It comprised roughly fifteen hundred works dating from the Renaissance to the eighteenth century and is generally regarded as the first "classic" collection of old master drawings in the United States. As with the Bennett collection, that of Fairfax Murray formed the core of the Library's holdings in this field.

Generally speaking, Morgan's collecting followed accepted patterns of the day, which favored the older historical periods and schools of Western Europe. At times, however, he ventured into areas where few collectors on either side of the Atlantic had gone. In 1911, for example, he purchased most of the group of some sixty Coptic manuscripts that had been discovered the year before in the ruins of a monastic library near the Egyptian village of Hamouli in the Fayum. Another unconventional interest was represented by his impressive collection of ancient Near Eastern cylinder seals, which at his death numbered upwards of twelve hundred items. Given the size of the collections and the speed with which they were formed, the number of "mistakes" Morgan made was remarkably low. Wisely, he sought out the advice of some of the most eminent experts of his day—Sir Hercules Read, Wilhelm von Bode, Sydney Cockerell, Montague Rhodes James, and Bernard Quaritch, to name but a few. And, although Morgan was neither a scholar nor a connoisseur in the strict sense of the word, he seems to have had an intuitive eye for quality. Evidently he was not one to be meddled with in these matters. As George Hellman, a dealer who sold Morgan a number of books and autographs, explained, "The abruptness of Morgan's query and the piercing quality of his dark eyes did not tempt one to circumvention."

Beginning in 1905, Morgan had the able assistance and advice of Belle da Costa Greene

as his librarian and general aide de camp. Barely twenty when Morgan hired her, Miss Greene had little training other than a brief apprenticeship at the Princeton University Library. Nevertheless, she soon demonstrated intelligence, enthusiasm, and energy and became capable of the same swift and single-minded tactics in making acquisitions as her employer. To cite but one example, on a buying trip to London in 1907 she swept up Lord Amherst's Caxtons in private negotiations the night before they were to be sold at auction, thereby adding seventeen Caxtons to Morgan's already outstanding holdings.

A Masterpiece by McKim

THE SHEER QUANTITY of Morgan's collections posed considerable logistical and organizational problems. As a general practice, he kept his art collections in England. Most of these objects had been bought abroad, and, until 1909, there was a daunting tax of twenty percent on art and antiques imported into the United States. The London town house at Princes Gate he had inherited from his father was enlarged and became a showcase for many of his finest paintings, sculpture, and decorative arts. Some of the collections were also kept at Dover House, and a substantial number of objects were on loan to the South Kensington (later to become the Victoria and Albert) Museum.

Initially, Morgan's books and manuscripts were divided between his residences in England and his Madison Avenue brownstone in New York. In time, a storage room in the cellar of the brownstone had to be commandeered for his burgeoning literary collections as well. Still more books were kept in storage at the Lenox Library on Fifth Avenue and 70th Street.

By 1900 Morgan was formulating plans to build a separate structure on the property he had acquired to the east of his house, along 36th Street. At first he considered erecting a small museum or picture gallery on this site. But ultimately he decided on a building that would be more or less exclusively devoted to his literary collections. The extraordinary time, care, and expense that he lavished on this project went far beyond the practical considerations of safe and proper storage. Morgan was forming a great library, and he apparently felt that it demanded a building that bespoke the importance and value of the objects it would house.

Morgan chose as architects for his library McKim, Mead & White, one of the nation's most prestigious firms and the acknowledged leaders of the American Renaissance movement. The epoch-making Villard Houses in New York (1882-86) had been their first major statement of this new aesthetic, which sought to revive the ennobling spirit of Renaissance art and humanism on American soil. Since then the firm had continued to create buildings, monuments, and public spaces that adapted Italian Renaissance prototypes to American purposes. Morgan's singling out of Charles F. McKim (1847-1909) as principal architect for the project was logical. His reputation as a scholar-architect and his grave and serious-minded demeanor appealed to Morgan. The two men knew and respected each other. Morgan's support had helped McKim to establish the American Academy in Rome, where American students could study first hand the great works of the Renaissance and classical antiquity.

Following a meeting in April 1902, McKim submitted two designs for Morgan's

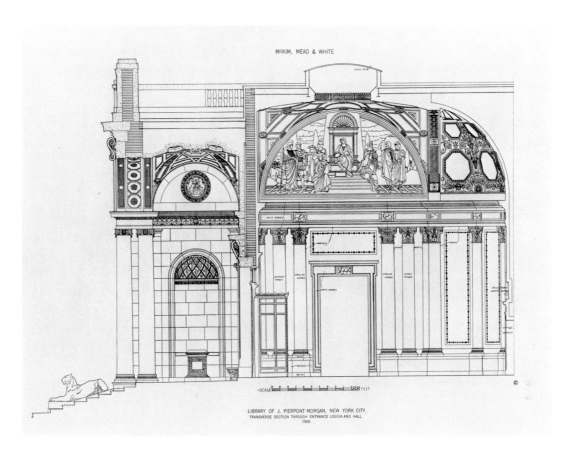

LIBRARY OF J. PIERPONT MORGAN, NEW YORK CITY.
TRANSVERSE SECTION THROUGH ENTRANCE LOGGIA AND HALL
1906

Transverse section showing the entrance loggia, from volume III of
Monograph of the Work of McKim, Mead and White (New York, 1915)

consideration: one was derived from Palladian villas, with a wide, projecting porch surmounted by a pediment; the other combined features of Italian Renaissance garden casinos and urban palazzi. The latter design was accepted with minor alterations and construction got under way in the fall of 1902. In Morgan, McKim had a client who was not only sympathetic to his designs but also willing and able to pay for the finest craftsmen and materials to realize them. As the work was about to begin, he shared with Morgan his dream of one day building a structure in the manner of the classical Greeks—with each block fitted to the next by means of carved grooves instead of mortar. McKim recounted how, during a visit to the Erechtheum in Athens, he had found the carving and craftsmanship so precise that he had been unable to insert a knife blade between the stones. Admitting that the results would not be apparent to the eye and that it would be extremely costly, he nevertheless asked if he might use such a technique for the Library. Intrigued, Morgan inquired about the additional cost. Fifty thousand dollars, was the reply. Morgan's response was a terse but affirmative, "Go ahead." In the end, a small amount of mortar and lead sheeting had to be used along the interlocking grooves, but the construction is essentially faithful to the classical dry-joint method. Completed in 1906, at a cost of approximately $1.2 million, the Morgan Library ranks among the most successful and fully realized examples of American Renaissance architecture and interior design.

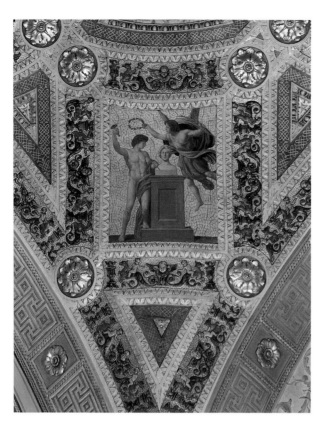

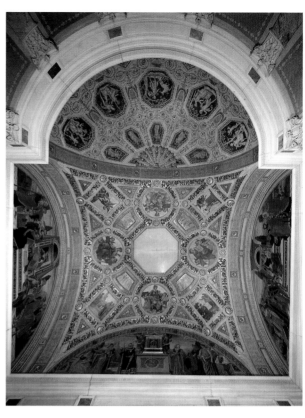

Detail from the Rotunda ceiling (north portion) by H. Siddons Mowbray shows Art crowned

Rotunda ceiling. The central portion was inspired by Raphael's ceiling decorations for the Stanza della Segnatura in the Vatican

McKim concerned himself with virtually every aspect of the project, including the planning and supervision of the interior decorations. The Library would be an expression of the Renaissance philosophy of the unity of all the arts, combining architecture, painting, and sculpture into a harmonious whole. And if McKim cast himself in the role of a great Renaissance architect at work on his magnum opus, then Morgan undertook the role of a great Renaissance patron with equal seriousness. "I am in no way committed to any drawings," read a memorandum to McKim, "nor do I wish anything done until I have definitely decided upon same." The decorative program of the Library is notable not only for its learned use of distinguished Italian Renaissance models, but for the ingenious manner in which they have been adapted to refer to Morgan, his library, and his collections.

The Library was constructed of the finest pinkish-white Tennessee marble. McKim's design, essentially a rectangle with a recessed portico, is of classic simplicity. Doric pilasters decorate the façade, and pairs of double Ionic columns frame the entrance. The design of the arched portico combines two sixteenth-century Italian sources: the garden loggia of the Villa Giulia, designed by Bartolommeo Ammanati, and the entrance of the Villa Medici, designed by Annibale Lippi. For the exterior decoration McKim assembled a distinguished group of craftsmen and sculptors. Andrew O'Connor (1874-1941), later commissioned to create the doors of St. Bartholomew's Church, executed the lunette above the Library's entrance doors that depicts two putti bearing a wreath with the emblem of the great Italian Renaissance printer Aldus Manutius. (Morgan's recent

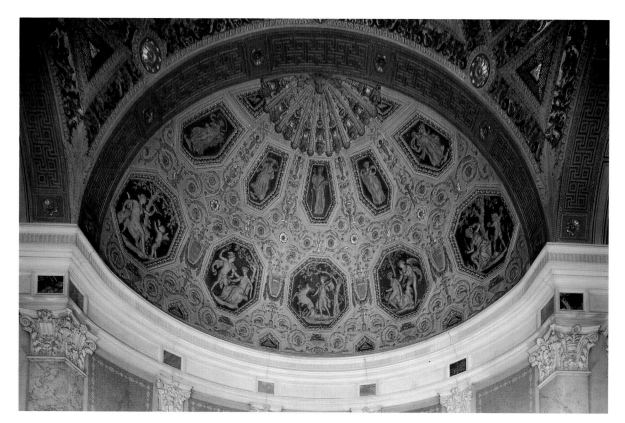

The apse of the Rotunda is decorated with stucco reliefs modeled after Raphael's designs (done in collaboration with Peruzzi) for the Villa Madama

acquisition of a large number of Aldine imprints from the Bennett collection no doubt inspired the creation of this design.) Adolph Weinman (1870-1952), a protégé of the well-known sculptor Augustus Saint-Gaudens, carried out the rectangular panels on either side of the entrance, with allegorical figures relating to learning and the arts. The sleek lionesses guarding the entrance are the work of Edward Clark Potter (1857-1923), who was then working in the studio of Daniel Chester French. Later Potter would create the majestic pair of maned lions for the steps of the New York Public Library.

In dazzling contrast to the serenity of the exterior, the interior decoration is richly colored and ornamented. Nevertheless, the entire program is carefully orchestrated to give the impression of harmony and balance, in conformity with McKim's oft-quoted credo that the interior of a library should "whisper and not shout." His plan for the interior consisted of three rooms leading off the east, north, and west sides of a domed entrance foyer. The largest of the three, the East Room, was designed for book storage and displays. The West Room was Morgan's private study. The North Room, the smallest of the rooms, was the librarian's office. (It remains in use today as the director's office.)

Of all the rooms, the vaulted entrance foyer of the Library, known as the Rotunda, is the most monumental in design and feeling. Pilasters of Skyros marble decorate the walls, and free-standing columns of green-veined Cippolino marble flank the doorways leading to the East and West Rooms. The marble floor, with a large red porphyry disc embedded in the center, is modeled after the floor of the Villa Pia in the Vatican gardens. For the painted and stucco decorations, McKim retained a kindred spirit, the artist H. Siddons

Mowbray (1858-1928), who from 1903 to 1904 had served as director of the American Academy in Rome. When construction began on the Morgan Library, he was completing a series of decorations for another McKim, Mead & White project in New York, the library of the University Club. There his decorations were based on Pinturicchio's paintings for the Borgia apartments in the Vatican. For both McKim and Mowbray, the two Renaissance artists deemed most worthy of emulation were Raphael and his fellow Umbrian, Pinturicchio. Accordingly, both figure prominently as sources for the decorations of the Morgan Library's Rotunda and East Room.

The impressive East Room is by far the largest and grandest of the rooms. The walls, reaching to a height of thirty feet, are lined floor to ceiling with triple tiers of bookcases made of inlaid Circassian walnut. (A staircase concealed behind one of the floor-level bookcases provides access to the upper levels.) Morgan purchased the large Brussels tapestry over the fireplace in 1906. Designed by the sixteenth-century Flemish artist Pieter Coecke van Aelst, it depicts (some would say, ironically) the triumph of avarice. The ceiling paintings, with their classical imagery and lofty references to great cultural luminaries of the past, were intended to awe and inspire scholars at work. They were also intended to create the illusion that they and the room were indeed part of the past. Not only is there the expected reliance on fifteenth- and sixteenth-century Italian prototypes, but in a letter Mowbray explained that "the color used will be very much suppressed, so that the work, when completed, may have the softened harmony and patina of an old room...gold used throughout will be given as nearly as possible the tonal qualities of an old Florentine frame." Here Mowbray's attitude exemplifies that distinctive blend of scholarship and romantic sentiment which characterized so much of the American Renaissance movement.

The West Room, which served as Morgan's private study, is the most sumptuous and yet personal of the Library's rooms. Ranged along the bookshelves are sculpture, porcelain, and other objets d'art from Morgan's collections, and the walls are hung with Renaissance paintings. Perhaps the most extravagant feature of the room is the antique wooden ceiling, which was purchased in Florence and reconstructed under McKim's supervision. During Morgan's day the room served as a meeting place for leaders and notables from the various worlds in which he moved. Here, surrounded by favorite objects from his collections, he received scholars, dealers, and statesmen, as well as business colleagues and friends. Morgan also spent long quiet hours here, sitting by the fire, smoking his cigar, and playing his favorite game of solitaire. As Herbert Satterlee, Morgan's son-in-law and first biographer, later recalled, "No one could really know Mr. Morgan at all unless he had seen him in the West Room. This was because the room expressed his conception of beauty and color in varied and wonderful forms."

The final years of Morgan's life were in many ways trying ones. The U. S. Steel Corporation, which Morgan had founded, was sued under the new antitrust laws, and he himself was summoned to Washington in 1912 to testify before the Pujo Committee regarding money-trust allegations. These events took their toll, and, in January of 1913, when he sailed to Egypt, Morgan was in failing health. From Luxor, he proceeded to Rome, where he died on March 31, 1913, a few weeks before his seventy-sixth birthday. His body was returned to the United States and interred in the family plot in Hartford.

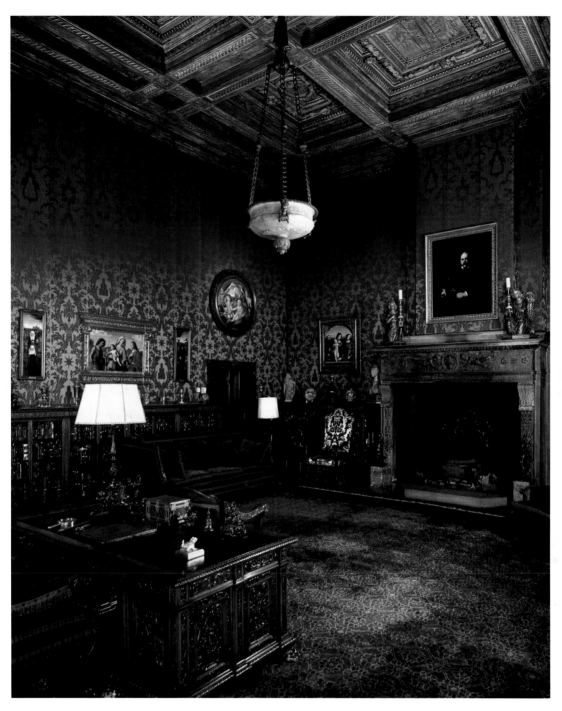

The West Room, which was Pierpont Morgan's study, still contains
many of his favorite paintings and art objects

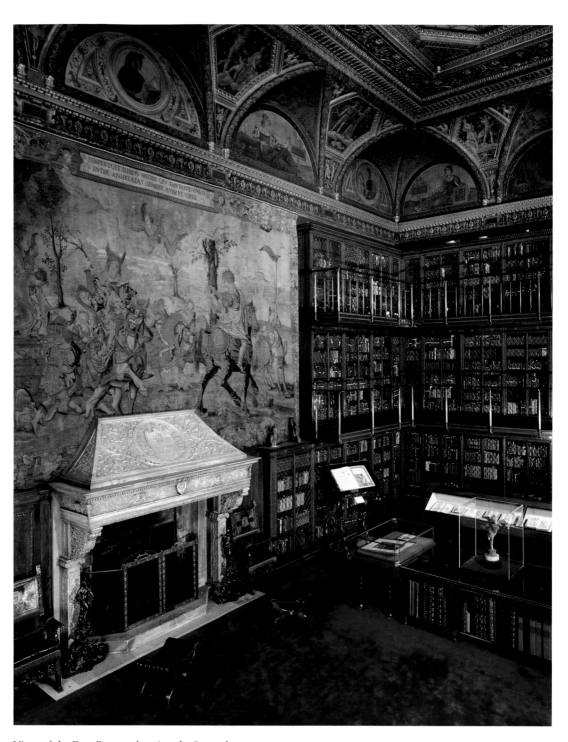

View of the East Room, showing the Brussels tapestry
designed by Pieter Coecke van Aelst

J. P. Morgan, Jr.

MORGAN'S ESTATE was valued at about $128 million, roughly $60 million of which was represented by his art and book collections. He left virtually everything to his only son, J. P. Morgan, Jr., expressing in his will the hope that there would be some disposition of the collections "which would render them permanently available for the instruction and pleasure of the American people." Precisely how this was to be done was left entirely to his son.

By the time of Pierpont Morgan's death nearly all of the paintings, sculpture, and decorative arts that he had kept in England were in New York in a basement storeroom at the Metropolitan Museum. In 1909 the U.S. import duty on art had been abolished (owing in large measure to Morgan's influence), and the same year England had substantially increased death duties. These two circumstances seem to have been the primary incentive for his decision to set in motion the complicated process of transporting his vast collections to New York. The packing and shipping went on continuously for an entire year, beginning in February of 1912. In all there were some 351 cases.

Understandably, the Metropolitan, to which he had been so generous during his life, hoped to receive the entire collection. J. P. Morgan, however, was obliged to sell a number of his father's art objects to pay taxes and maintain the liquidity of the estate. Among these were the beautiful Fragonard *Progress of Love* panels and Rembrandt's portrait of Nicholas Rut, now in New York's Frick Collection. A large group of Chinese porcelains was sold to John D. Rockefeller, Jr. But about forty percent of the collection—between a staggering six to eight thousand objects—was eventually given to the Metropolitan Museum. This gift included Egyptian artifacts, early medieval and Gallo-Roman objects, and a number of Renaissance and baroque paintings, among them Raphael's *Colonna Madonna*. The Wadsworth Atheneum received slightly more than a thousand objects, consisting largely of ancient bronzes, majolica, and French and German porcelain. Some of the art objects that Morgan kept in his Library were also sold. But the collections of books, manuscripts, and drawings remained intact. The decision to maintain the Library and its collections was no doubt forcefully urged by Belle Greene, whose devotion to the Library—and powers of persuasion—rivaled those of Pierpont Morgan himself. But it is also true that J. P. Morgan had always had a special regard for the Library and appreciated it more than any other of his father's collections. Like his father, he was well educated with a thorough grounding in literature, including Greek and Latin classics. Also, since 1904, J. P. Morgan had resided in the brownstone on the corner of 37th Street and Madison Avenue within a few steps of his father's house.

In the years immediately following his father's death, the Library temporarily assumed a secondary role to the more pressing concerns of settling the estate and then arranging financial assistance for the Allies in the early years of World War I. In 1915, however, Belle Greene was able to write to the London book dealer Quaritch: "I am glad to tell you that he [has] a strong interest in the Library and promised that I may go on collecting books and manuscripts when the war is over." The following year Morgan purchased the beautiful thirteenth-century French Old Testament Miniatures, thereby initiating the second great period of growth of the Library's collections. In all, the younger Morgan added 206 illuminated manuscripts to the Library, roughly a third as many as his father.

J. P. Morgan, Jr. (1867-1943), charcoal study for
an oil portrait by Frank O. Salisbury, 1928

In the area of printed books, he added half as many incunables, including an indulgence printed by Gutenberg, bringing the total to about two thousand. Among the notable autographs he acquired were Thackeray's delightful *The Rose and the Ring* and Balzac's *Eugénie Grandet*, as well as a group of some 173 letters from Thomas Jefferson to his daughter Martha. Additions to the collection of old master drawings were modest but included fine drawings by such artists as Reynolds and Ingres.

From Private Library to Public Institution

THE MOST far-reaching consequence of J. P. Morgan's stewardship was his decision to establish the Library as a public institution. When Pierpont Morgan had first formed his library, there were only a handful of scholars, most of them in Europe, who specialized in rare books, manuscripts, and drawings. Now American as well as European scholars in ever growing numbers were pursuing research in these fields. The Library's collections were often central to these studies, and requests to consult them had steadily increased. On February 15, 1924, Morgan transferred ownership of the Library to a board of trustees along with an endowment of $1.5 million to provide for its maintenance. The indenture of trust provided for the use of the collections for research, the establishment of a "gallery of art," and other such activities as the trustees deemed appropriate and desirable. Shortly thereafter, the Library was established as a public reference library by a special act of the legislature of the State of New York.

Belle Greene was named the first director of the Library, and it was primarily she who effected the transition from private collection to public institution. Almost immediately,

and with an energy that awed and occasionally exasperated her colleagues, Miss Greene took on the myriad tasks involved in properly realizing the institution's new role: organizing graduate studies, lectures, exhibitions, and loan procedures. Under her twenty-four-year directorship forty-six exhibitions were mounted, including a comprehensive display of the collections on the occasion of the New York World's Fair in 1939. But Miss Greene's principal allegiance was to the scholars and to the Library's role as a place of research. She began to build a more comprehensive reference collection; saw to it that slides and photographs could be made for those unable to visit the Library; and produced a series of catalogues, facsimiles, monographs, and other publications devoted to the collections.

Within a few years of the Library's incorporation, it became clear that the new, more public role of the institution could not be properly carried out within the confines of McKim's structure. Not only were there scholars conducting research to be accommodated, but there were also a growing number of the merely curious who came to see the sanctum sanctorum of the legendary Pierpont Morgan. Thus Pierpont Morgan's neighboring brownstone was demolished, and on the site a new wing (the "Annex") was constructed that virtually doubled the size of the Library. Completed in 1928, the addition consisted of a large entrance foyer, a reading room for scholars, and an exhibition hall. The new structure was joined to the original library by means of a connecting gallery called the cloister. The architect retained for the project was Benjamin Wistar Morris, who some twenty years before had designed the Morgan Memorial for the Wadsworth Atheneum. (McKim had died in 1909.) Morris's additions were similar in layout and materials to the original Library and were designed to integrate the two buildings as closely as possible. H. Siddons Mowbray was recalled to provide the ceiling paintings for the Annex.

Belle da Costa Greene (1883-1950),
black, red, and white chalk portrait
by Paul-César Helleu, 1912

Entry foyer of the restored Morgan house, built ca. 1853,
looking toward the Book Shop

The Last Half Century

SINCE BELLE GREENE'S retirement in 1948, there have been three directors of the Morgan Library: Frederick B. Adams, Jr. (1948-1969), Charles Ryskamp (1969-1987), and Charles E. Pierce, Jr. (1987-present). Over this period, the Library's activities have increased and become more varied, as the institution pursues its parallel activities as a research library and museum on an ever-widening scale. In addition to its traditional practice of presenting exhibitions of materials from its own holdings, the Library has become an important American venue for major loan exhibitions from many other great institutional and private collections.

In 1949, the Association of Fellows was established "to provide funds for exceptional acquisitions and to encourage the use of the collections." A large percentage of all acquisitions made since then has been in the form of gifts, bequests, or purchases from funds provided by this group of collectors, scholars, and philanthropists. By far the most significant area of growth has occurred in the field of old master drawings. Major gifts in other fields include the superb group of medieval manuscripts assembled by William S. Glazier and Mrs. Landon K. Thorne's extensive collection of William Blake. In several instances the Library has received gifts which established entirely new fields of collecting and study. In 1949, Reginald Allen placed his extensive Gilbert and Sullivan opera collection on deposit; it was formally given in annual installments until his death in 1988. In 1965, the gift of Miss Elisabeth Ball's collection of several thousand early children's books at once established the Library as an important resource in this field. In 1968 the Library became virtually overnight a major repository of music manuscripts when Mary Flagler Cary's extraordinary collection was donated. In each case, these collections have taken root and flourished.

The growth in the Library's collections and services would not have been possible without the series of building projects undertaken in the last several decades. Between 1959 and 1962, the ceiling of the Annex was lowered to permit the construction of the Print Room and additional curatorial offices; at the same time, a large meeting room for concerts and lectures was built as an added story atop the cloister gallery. The architect was Alexander P. Morgan, the son of Pierpont Morgan's nephew and art advisor, Junius. In 1977, there were further additions to the rear of the Annex designed by Platt, Wyckoff and Coles. In both cases, all construction was confined to the Library's Annex and carried out unobtrusively, little changing the basic design of the building.

The most recent expansion is in truth more an act of reclamation than of construction. It was initiated in 1988, when the Library purchased the neighboring brownstone that had been the residence of J. P. Morgan, Jr., from 1904 until his death in 1943. Built about 1853, it was the virtual twin of his father's house on the corner of 36th Street and Madison Avenue. Since 1944, the forty-five-room town house had served as the headquarters of the Lutheran Church in America. The ballroom and adjoining parlors of the ground floor, decorated in the elegant eighteenth-century French and English styles favored by Mrs. Morgan, have been restored and converted to lecture and seminar rooms. The Library book shop has been relocated to what had been the dining room. Several staff offices and the conservation laboratory were moved to the upper floors. A glass-enclosed conservatory, constructed to link the Morgan house with the Library Annex, serves as a year-round

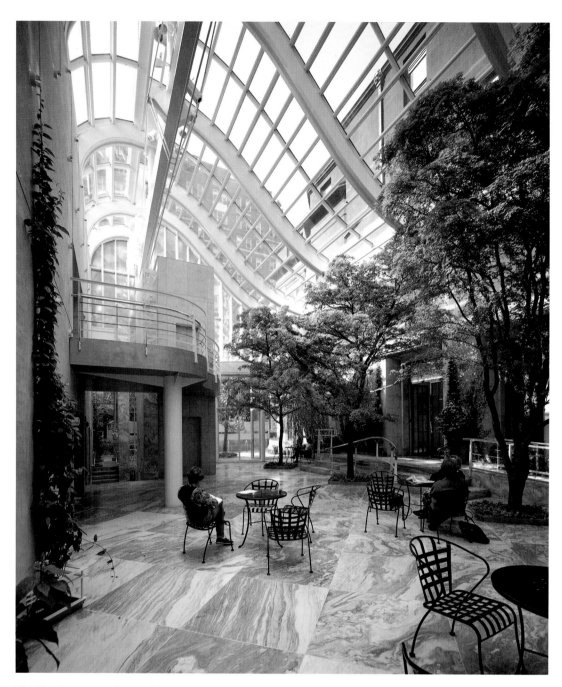

The Garden Court, designed by Voorsanger & Associates, opened in 1991

public garden. Architects for the project were Voorsanger & Associates, who earlier had carried out the restoration of McKim, Mead & White's Villard Houses in New York.

Once again, the Morgan Library has doubled in size and now occupies almost half a city block. By conscious design, however, the new spaces, whether modern or restored, function on a human scale. The Morgan Library continues to be a place in which the great achievements of the past seem not only clearly at home but a vital part of the present.

30 Introduction

The Collections of
The Pierpont Morgan Library

1 PAINTINGS AND ART OBJECTS

THE PAINTINGS AND ART OBJECTS that remain in the Library, of which a sampling follows, were with a few exceptions acquired by its founder, Pierpont Morgan. Quantitatively this collection represents the merest fraction of his original holdings, most of which were sold or given away following his death in 1913. The largest group, chiefly consisting of several thousand ancient and medieval objects, was given to the Metropolitan Museum of Art in 1917. The Wadsworth Atheneum in his native city, Hartford, was another important beneficiary. Nevertheless, some pieces, many of them Morgan's favorite objects, have remained in the Library to the present day. The value of the collection lies not only in the importance and beauty of so many of these works, but in the degree to which they represent the art Morgan so prodigiously acquired in the last twenty years of his life. The chronological span is impressive, ranging from early Mesopotamian and Egyptian culture through Graeco-Roman, the Middle Ages, the Renaissance, and beyond. Art of the ancient world is represented by Near Eastern figurines, Egyptian statuettes, a Roman bronze statue of Eros, a pair of silver cups from the time of the Emperor Augustus, and a vividly engraved Etruscan cista. The collection even includes two objects from the Far East, a Chinese bronze vessel and the oxblood vase known as the Morgan Ruby, the only remaining example in the Library of Morgan's once extensive collection of Ching porcelain.

Impressive as some of the ancient antiquities are, the core of the collection is a small but precious hoard of medieval pieces, reflecting Morgan's immense interest in art of this period. That taste is, of course, evident in the Library's great collection of illuminated manuscripts, and it is only appropriate that such incomparable Romanesque metalwork as the Stavelot Triptych and Malmesbury Ciborium and such exquisite Gothic treasures as the Basin Reliquary and Lichtenthal Casket have remained at the Library.

Morgan also greatly admired Renaissance and baroque art. Although he collected some very fine old master paintings, represented here with examples by Memling, Perugino, and Cima, he seems to have focused on the plastic arts and had a strong affinity for fine small objects. There is, for example, a pair of rare Saint-Porchaire ceramics, Cranach's roundel portraits of Martin Luther and his wife, as well as a few remaining examples of Morgan's collection of miniatures on ivory. The bas relief of the Virgin and Child, a particularly important example of the work of the fifteenth-century Florentine sculptor Antonio Rossellino (1, 9), is typical of his taste.

Detail from Perugino [9]

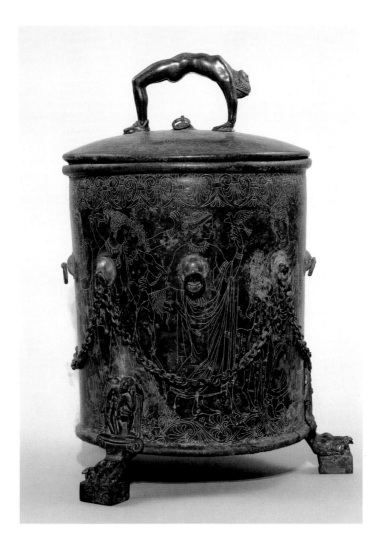

1 Cista with cover

1 ༂

CISTA WITH COVER

Etruscan, ca. B.C. 200. Bronze. Height (from foot to top of the handle of the lid): 14¼ in. (362 mm) diameter (at top of cylinder): 8¹¹/₁₆ in. (221 mm) and (at base of cylinder): 8⅛ in. (206 mm). Purchased by Pierpont Morgan, 1907.

According to Morgan's sale document, the cist was found at Palestrina, the site in the Apennines southeast of Rome known in ancient times as Praeneste. Cylindrical boxes such as this seem to have been popular during the final, Hellenistic period of Etruscan art between the fourth and first centuries B.C. A variety of engraved objects including vases, urns, sarcophagi, and mirrors are especially interesting for what they reveal about Etruscan life and art. Here, however, the scenes depict figures, some of which are identified by engraved names suggesting a connection with the events of the Trojan War. The most likely date for the Morgan cist is the end of the third century, or about 200 B.C.

Boxes like these were probably made to contain women's toilet articles and jewels. Included in the decoration of the cylinder itself are what appear to be triumphal figures, some in a chariot being greeted by a woman carrying a dove. The handle of the cover is in the form of a naked female acrobat. There is something curiously "modern" about the forms evoked by the simple line engraving. Artists like Picasso sometimes took their inspiration from the art of earlier times, including objects from the Graeco-Roman world, notably vase painting and possibly even engravings like these.

2 ❧

Two Double Cups

Roman, ca. first century A.D. Silver. Height:
4⅛ in. (105 mm); diameter: 3½ in. (89 mm).
Purchased by J. P. Morgan, Jr., before 1913.

These two graceful silver cups date from the
time of the Emperor Augustus. Each cup con-
sists of an inner and outer part: the inner is the
liner to which the rim is attached while the
outer serves as the ground on which the orna-
ment is worked. There can be no question that
they were conceived as a pair: the scenes of
cranes feeding among wheat and poppies are
complementary and the construction and di-
mensions of both cups are identical. Their con-
dition is extremely good, but we must still
imagine how they would have originally ap-
peared; handles would have been affixed on
either side (the solder marks are still visible),
possibly in the form of rings attached to the
rim, which would have nicely complemented
the graceful curving lines of the cup and its
decoration; the cups also would have been

decorated in silver gilt which is now largely
worn away.

The cups were found in Rome, but there is
good reason to assume that they are the work
of a Greek craftsman. The guide marks indicat-
ing the placement of the handles are in Greek
letters. Moreover, it is well known that much
of the best silver owned by Romans during this
period was made in Italy by Greek artisans.
Indeed, Pliny the Elder, writing in the 1st cen-
tury A.D., comments at some length on the
great vogue among Roman patricians for silver
of Greek make, which included tableware as
well as cups and other vessels and utensils.

The decoration is of the highest quality and
is carried out in repoussé (in which the design
is hammered from the inside out). The motif of
birds feeding was a popular one of the day. The
poses of the cranes feeding are carefully de-
signed as mirror images of one another. In each
scene the artist has arranged the plant forms to
continue or repeat the elegant line of the birds'
necks. In the cup on the left, for example, the
distended neck of the crane eating a snake or
lizard is echoed in the drooping stalk of wheat.

2 Two double cups

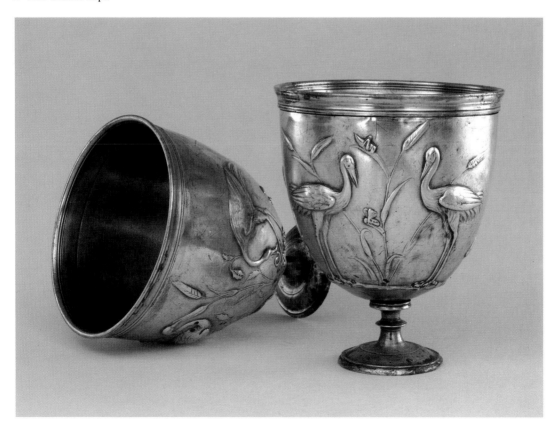

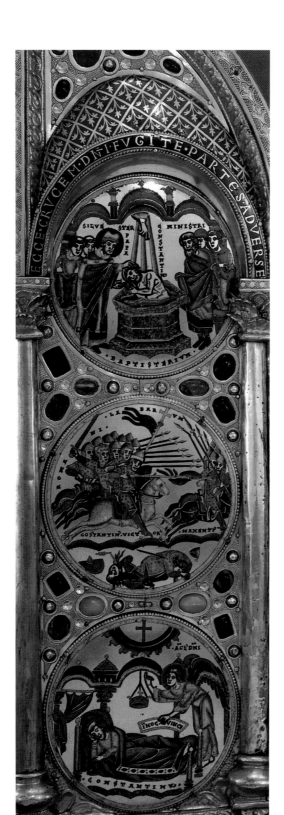

Wing with the story of Constantine's conversion

STAVELOT TRIPTYCH

Belgium, 1150s. Copper and silver gilt, cloisonné and champlevé enamel. Open, 19¹/₁₆ x 26 in. (484 x 660 mm). Purchased by Pierpont Morgan, 1910.

Even in an age which excelled in the use of precious and costly materials, the Stavelot Triptych, the most important art object in the Library, must have appeared as a work of astonishing richness. Its sumptuousness is no doubt a reflection of its important function as a reliquary of the True Cross, perhaps the most sacred of all Christian relics. These wooden fragments are visible in the very center of the main panel, arranged in the shape of a cross and held in place by two pearl-headed pins. Appropriately, the six roundels on the outer wings narrate the Legend of the True Cross. Originally, the triptych was probably more dazzling, for there is evidence that the portions of the central area now covered in velvet were once gold and also studded with gems and semiprecious stones.

The Stavelot Triptych actually comprises three triptychs. The two small ones in the center are Byzantine and date from the late eleventh or early twelfth century. The larger triptych which houses the Byzantine works is Mosan and dated in the 1150s. The term Mosan refers to the art produced along the Meuse or Maas River, especially within the ancient diocese of Liège. Mosan art of this period decisively influenced styles in Germany, France, and even England (see I, 4). The roundels on the wings of the Stavelot Triptych are among the finest and best preserved of all twelfth-century Mosan enamels.

The Stavelot Triptych takes its name from the great imperial Benedictine Abbey of Stavelot, in present-day Belgium. Although there is no early documentation linking this work directly with Stavelot, it is known that the triptych was in the possession of the abbey's last prince-abbot when he fled during the French Revolution in 1792. Moreover, the style and technique of the triptych suggest that it came from the same workshop responsible for two other works most assuredly made for Stavelot, the Pope Alexander Head Reliquary (now in Brussels) and the Remaclus Retable of 1145 (destroyed in the eighteenth century). Both of these objects were commissioned by Abbot Wibald, the famous ecclesiast and art patron who headed the abbey from 1130 to 1158. It is possi-

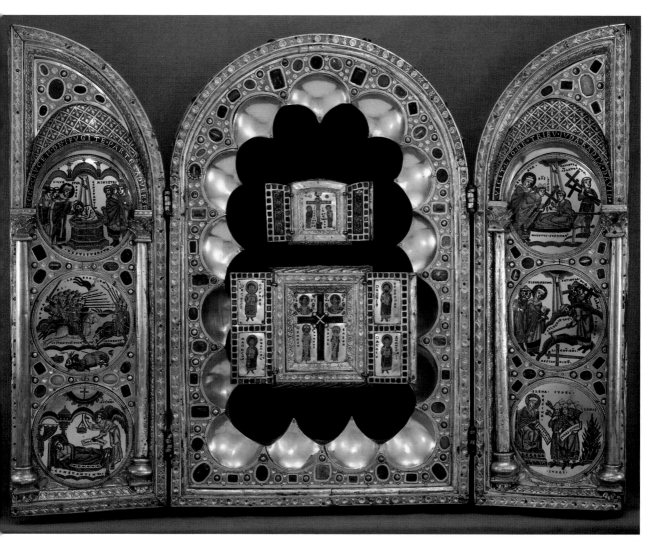

Stavelot Triptych

ble that the Stavelot Triptych was made for
Wibald as well. He acted as adviser and agent
for three successive Holy Roman Emperors and
made several visits on their behalf to Constanti-
nople. He may have received the two Byzantine
triptychs as gifts on one of these visits. Upon
his return, Wibald could have commissioned
this magnificent gold and jeweled reliquary to
display and preserve them.

In the smaller Byzantine triptych, Mary and
John are shown beside the Crucifixion. In the
larger triptych below, the four standard mili-
tary saints of Byzantium appear on the inner
wings: George and Procopius on the left, Theo-
dore and Demetrius on the right. In the center,
beneath busts of the Archangels Gabriel and
Michael and flanking the cross composed of

the relic itself, are the Emperor Constantine
and his mother, Empress Helena. It was not
until Constantine's conversion that Chris-
tianity became the official religion and the
cross became the public symbol of the Chris-
tian faith. According to legend Helena dis-
covered the True Cross and brought back a
part of it to her son. The placement of the
figures of Constantine and Helena clearly dic-
tated the arrangement of the narrative roundels
on the wings of the reliquary.

The three on the left, reading from bottom
to top, narrate the story of Constantine's con-
version. At the bottom is the Dream of Con-
stantine, in which the flaming cross appeared
with the legend "By this conquer"; above is his
defeat of Maxentius; and at the top his legen-

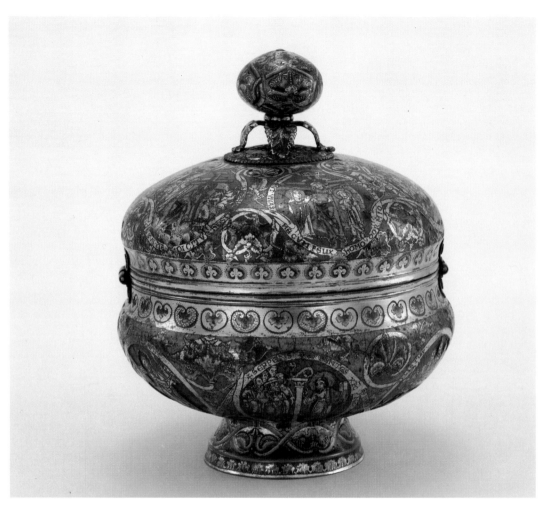

4 Malmesbury or Morgan Ciborium

dary baptism by Pope Silvester. The scenes on the right are devoted to Helena. In the first roundel, she is told by one of a group of Jews threatened with fire that a certain Judas knows the location of the True Cross; in the second, Judas digs up three crosses; in the third, Bishop Macarius identifies the True Cross following its miraculous restoration of a dead man to life. The power of the Cross, as well as the triptych's liturgical function, is affirmed by the inscriptions above the roundels: "Behold the Cross of the Lord. Flee, you hostile powers. The Lion of the Tribe of Judah, the Root of David has conquered." These are taken from an antiphon of the Divine Office sung on the feast days of the Discovery (May 3) and Exaltation (September 14) of the True Cross.

The enamels of the Byzantine triptychs are all of the cloisonné type, in which the design is formed by narrow gold strips, called cloisons, joined together to form compartments for the enamel. The result is a flat and linear design of strong, pure color. The enamels of the Mosan roundels are champlevé, which differs from cloisonné in that the enamel is contained in cavities hollowed out of a thick copper plate. In these, as in most Mosan enamels, two or more colors, usually including white, were often mingled in the same cavity to modulate the color and suggest modeling. This is used to good effect in the enthroned figure of Helena in the first roundel on the right. In his striving for an even greater sense of realism, the artist has placed bits of metallic foil beneath the enameling for the flames in this scene to suggest a flickering fire.

The various elements of the Stavelot triptych, including the classical gems set into the frame, provide a meeting ground for East and West. The Eastern symbolic representation of Con-

Two Double Cups

Roman, ca. first century A.D. Silver. Height:
4⅛ in. (105 mm); diameter: 3½ in. (89 mm).
Purchased by J. P. Morgan, Jr., before 1913.

These two graceful silver cups date from the
time of the Emperor Augustus. Each cup con-
sists of an inner and outer part: the inner is the
liner to which the rim is attached while the
outer serves as the ground on which the orna-
ment is worked. There can be no question that
they were conceived as a pair: the scenes of
cranes feeding among wheat and poppies are
complementary and the construction and di-
mensions of both cups are identical. Their con-
dition is extremely good, but we must still
imagine how they would have originally ap-
peared; handles would have been affixed on
either side (the solder marks are still visible),
possibly in the form of rings attached to the
rim, which would have nicely complemented
the graceful curving lines of the cup and its
decoration; the cups also would have been

decorated in silver gilt which is now largely
worn away.

The cups were found in Rome, but there is
good reason to assume that they are the work
of a Greek craftsman. The guide marks indicat-
ing the placement of the handles are in Greek
letters. Moreover, it is well known that much
of the best silver owned by Romans during this
period was made in Italy by Greek artisans.
Indeed, Pliny the Elder, writing in the 1st cen-
tury A.D., comments at some length on the
great vogue among Roman patricians for silver
of Greek make, which included tableware as
well as cups and other vessels and utensils.

The decoration is of the highest quality and
is carried out in repoussé (in which the design
is hammered from the inside out). The motif of
birds feeding was a popular one of the day. The
poses of the cranes feeding are carefully de-
signed as mirror images of one another. In each
scene the artist has arranged the plant forms to
continue or repeat the elegant line of the birds'
necks. In the cup on the left, for example, the
distended neck of the crane eating a snake or
lizard is echoed in the drooping stalk of wheat.

2 Two double cups

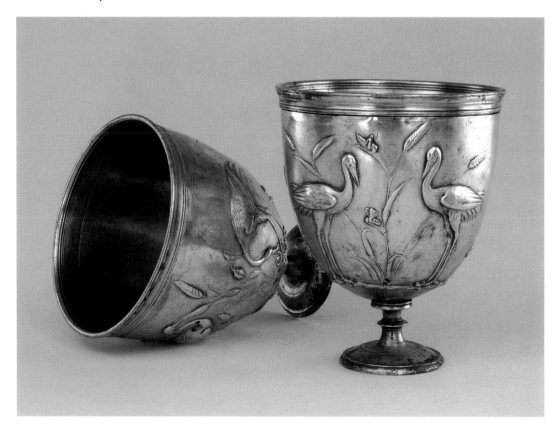

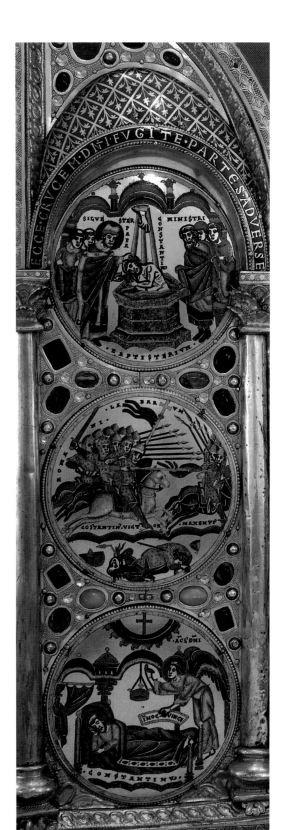

Wing with the story of Constantine's conversion

3 ❧

STAVELOT TRIPTYCH

Belgium, 1150s. Copper and silver gilt, cloisonné and champlevé enamel. Open, 19¹⁄₁₆ x 26 in. (484 x 660 mm). Purchased by Pierpont Morgan, 1910.

Even in an age which excelled in the use of precious and costly materials, the Stavelot Triptych, the most important art object in the Library, must have appeared as a work of astonishing richness. Its sumptuousness is no doubt a reflection of its important function as a reliquary of the True Cross, perhaps the most sacred of all Christian relics. These wooden fragments are visible in the very center of the main panel, arranged in the shape of a cross and held in place by two pearl-headed pins. Appropriately, the six roundels on the outer wings narrate the Legend of the True Cross. Originally, the triptych was probably more dazzling, for there is evidence that the portions of the central area now covered in velvet were once gold and also studded with gems and semiprecious stones.

The Stavelot Triptych actually comprises three triptychs. The two small ones in the center are Byzantine and date from the late eleventh or early twelfth century. The larger triptych which houses the Byzantine works is Mosan and dated in the 1150s. The term Mosan refers to the art produced along the Meuse or Maas River, especially within the ancient diocese of Liège. Mosan art of this period decisively influenced styles in Germany, France, and even England (see I, 4). The roundels on the wings of the Stavelot Triptych are among the finest and best preserved of all twelfth-century Mosan enamels.

The Stavelot Triptych takes its name from the great imperial Benedictine Abbey of Stavelot, in present-day Belgium. Although there is no early documentation linking this work directly with Stavelot, it is known that the triptych was in the possession of the abbey's last prince-abbot when he fled during the French Revolution in 1792. Moreover, the style and technique of the triptych suggest that it came from the same workshop responsible for two other works most assuredly made for Stavelot, the Pope Alexander Head Reliquary (now in Brussels) and the Remaclus Retable of 1145 (destroyed in the eighteenth century). Both of these objects were commissioned by Abbot Wibald, the famous ecclesiast and art patron who headed the abbey from 1130 to 1158. It is possi-

stantine and Helena is juxtaposed to the Western narrative mode, and Byzantine liturgy and hagiography (where Constantine is a saint) are contrasted with their Western counterparts. The triptych, the earliest True Cross reliquary decorated with scenes from the Legend of the True Cross, is a key monument of the Renaissance of the twelfth century.

4 ❧

MALMESBURY OR MORGAN CIBORIUM

England, ca. 1160-70. Copper gilt and champlevé enamel. 7¾ x 5⅞ in. (200 x 155 mm). Purchased by Pierpont Morgan, 1911.

A ciborium is a vessel made to contain consecrated eucharistic wafers and therefore would have been made with the finest available material and workmanship. This ciborium is no exception and is believed to have come from the great Romanesque abbey at Malmesbury in Wiltshire, England. It is closely related in style, date, technique, and iconography to the Balfour and Warwick ciboria, both now in the Victoria and Albert Museum in London. All three show direct influences from a Mosan workshop in the diocese of Liège, providing yet another example of the enormous influence which Mosan art had on the rest of Europe during the twelfth and thirteenth centuries. Although some scholars thought that the ciboria were actually produced in Liège, their English origin is confirmed by the Latin verses on the works. These are verses identical to a twelfth-century poem, copied from murals of that period, that once adorned the chapter house at Worcester, fifty miles north of Malmesbury.

On the inside cover is a scene of Christ Blessing and on the interior of the bowl, where the Hosts would have rested, is a bleeding Lamb of God. Adorning the exterior of the bowl are six Old Testament scenes paired with the six New Testament events on the cover that they were believed to have mystically prefigured. It was a commonplace of medieval thought and scriptural exegesis that the coming of Christ was the fulfillment of the old covenant and hidden within it. Visible in this photograph is the flowering of Aaron's rod, which is juxtaposed to the Nativity; the sacrifice of Cain and Abel is paired with Christ's Presentation in the Temple; the Circumcision of Isaac to Christ's Baptism; Isaac's carrying wood to sacrifice to Christ's Bearing the Cross; Moses and the Brazen Serpent to the Crucifixion; and Samson's

escape from Gaza to the Three Marys at the Tomb.

5 ❧

BASIN PORTABLE SHRINE

France, Paris, ca. 1320-40. Silver gilt, translucent enamels, and gems. Open: 10 x 4⅞ in. (254 x 124 mm). Purchased by Pierpont Morgan, 1911.

The gently swaying gilt Madonna and the delicate shrine in which she is housed embody the courtly elegance of fourteenth-century Parisian sculpture. She is enclosed by walls of transparent enamel which enfold and protect her like the stained-glass windows of a miniature Gothic chapel. When closed, the exterior wings of the shrine form a Last Judgment; when

Backview of the Basin Portable Shrine

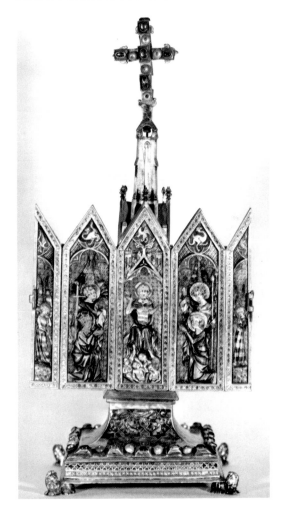

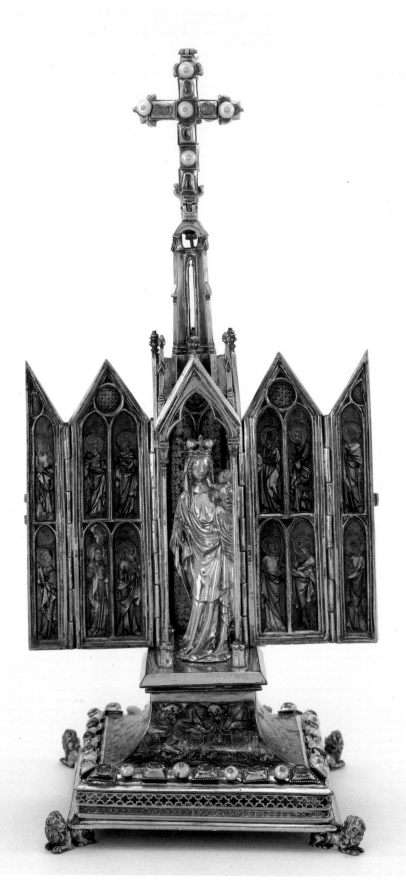

5 Basin Portable Shrine from the front

open, they display the Apostles, some with attributes.

Only a handful of shrines similar to this one survive, most having been destroyed for their precious materials. There must have been many like the present example, for the cult of the Virgin was particularly strong in France, and all the great French churches from about 1200 onward were dedicated to her. Also, Paris in the fourteenth century was one of the most important centers for enameling and goldsmith's work (the names of no less than 273 Parisian goldsmiths are known). The Basin shrine makes extensive use of the so-called *basse-taille* (literally "low relief") enameling technique developed in Italy earlier in the century. The enamel is applied into shallow depressions of an engraved silver plaque so the engraved design can show through.

The shrine takes its name from the inscription on the base which indicates that it was the "gift of Thomas Basin, archbishop of Caesarea, who died on 30 December 1491." Basin could

not have commissioned the work, which was executed at least a century and a half earlier, but his association with it is of historical interest. He was bishop of Lisieux and employed in the service of Charles VII, at whose request he reopened the trial records of Joan of Arc, vindicating her in a *Mémoire* of 1453. The shrine was in the church of St. John of Utrecht, where Basin is buried, until it was sold in 1610.

6 ❧

LICHTENTHAL ALTAR TABERNACLE

Germany, Middle-Rhine, probably Speyer, 1330s. Silver gilt and translucent enamel. 7⅜ x 6⅛ x 5¾ in. (187 x 156 x 146 mm). Purchased by Pierpont Morgan, 1908.

This elaborately decorated box was made to hold the eucharistic wafers on the altar. The distinctive shape and name are derived from this sacred function: tabernaculum literally

6 Lichtenthal Altar Tabernacle

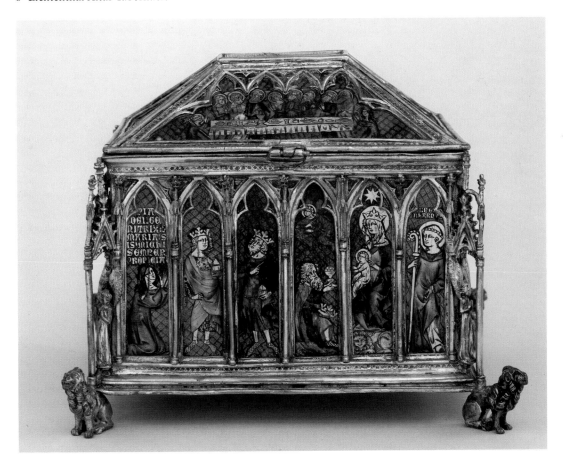

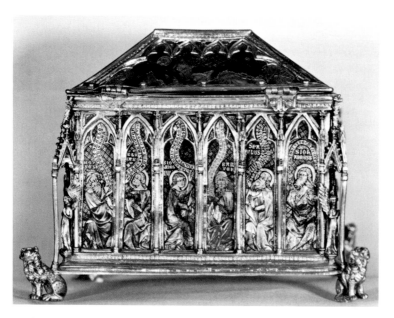

Backview of the Lichtenthal Altar Tabernacle

means a small hut or tent, referring to the Holy of Holies erected by Moses in the wilderness. The inscription in Latin on the cover reads: "This tabernacle was paid for by Sister Greda [Margaret] Pfrumbon of Speyer in honor of the Lord Jesus Christ." Undoubtedly, she gave the tabernacle to the Cistercian convent at Lichtenthal where she was a nun.

The scenes and inscriptions appropriately relate to the Eucharist and Christ. On the front is the Adoration of the Magi, flanked by the donor, Sister Margaret, and the Cistercian patron, St. Bernard of Clairvaux. On the left side is the Annunciation with David and Isaiah; on the right, the Presentation in the Temple with the prophet Malachias. On the back is a series of six standing figures: Moses, Luke, John the Evangelist, Baruch, Paul, and John the Baptist. On the front of the pyramidal cover is the Last Supper, with St. Bernard and Sister Margaret. The cover's three other scenes are all Old Testament prefigurations of the Eucharist: Passover, the Angel Bringing Food to Elijah, and Abraham and Melchisadech.

For centuries, the Rhineland had been one of the leading artistic centers of northern Europe, noted especially for the high quality of its metalwork and enameling. The translucent enamel work on this box is considered to be some of the finest and most important created in the Middle Rhine area during the 1300s. The enamels are executed in basse-taille technique, as are those on the French Basin shrine (1, 5),

which is roughly contemporary in date. Basse-taille enamels have the appearance of stained glass but exhibit great realism because they lack the harder lines that separate colors in the cloisonné and champlevé techniques.

7 ❧

ANTONIO ROSSELLINO

Madonna and Child with Cherubim. Florence, 1460s. Marble bas-relief. 31½ x 22⅛ in. (800 x 562 mm). Purchased by Pierpont Morgan, 1913.

Trained by his brothers in their family workshop, Antonio Rossellino (1427-78) was one of the most talented sculptors active in Florence in the 1460s and 1470s.

This very fine marble relief of the Virgin and Child accompanied by cherubim shows Rossellino at the height of his powers. It is executed in the technique known as *rilievo schiacciato,* literally "flattened relief." Forms and textures are defined through subtle modulations. Donatello, who was an early master of this most painterly of sculptural techniques, employed it in his relief of St. George and the Dragon at Orsanmichele (Florence, 1417). Desiderio da Settignano carried the technique yet further, using it to achieve soft, atmospheric effects. Rossellino's marble relief is notable for its grace, refinement, and its elegance of form.

The curvilinear style and highly pictorial conception pay homage to works by Fra Filippo Lippi painted some twenty to thirty years before. In very fine line and shallow relief Rossellino replicates Lippi's style of figures and drapery.

The Library's relief is very closely related to another piece by Rossellino, the so-called Altman Madonna in the Metropolitan Museum of Art, purchased by Benjamin Altman in 1909. Pierpont Morgan acquired this relief from Sydney Cockerell in 1913. Both works—discussed at some length by Sir John Pope-Hennessy in the 1970 *Metropolitan Museum of Art Journal*—appear to have been produced at approximately the same moment and from the same type of marble. While there are slight differences in composition and size, both are treated in a similar manner. The Morgan work, rendered in somewhat lower relief, is, according to Pope-Hennessy, probably the earlier of the two.

Although there is no documentation to support the dating, the relief must have been sculpted in the 1460s because of the close stylistic connection to Rossellino's Tomb of the Cardinal of Portugal at San Miniato al Monte in Florence. This project, which occupied the sculptor from 1461 to 1466, is regarded as one of the masterpieces of his career and of quattrocento sculpture in general. Rossellino was never again as good as he was in this period and soon after seems to have lost his creative impetus.

7 Bas-relief by Antonio Rossellino

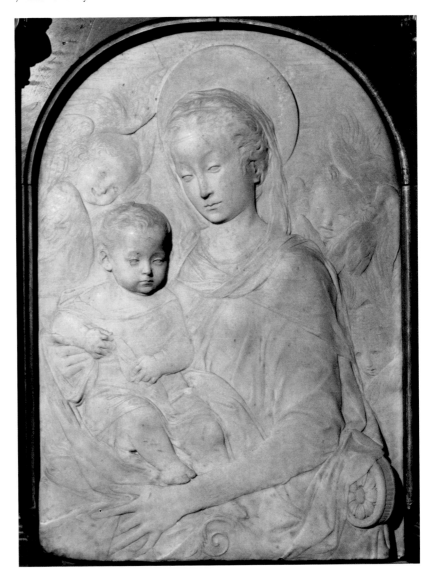

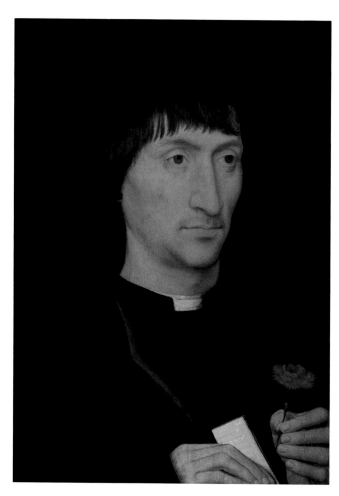

8 Portrait by Hans Memling

8 ❧

HANS MEMLING

The Man with a Pink. Bruges, ca. 1475.
Oil on panel. 10¾ x 15 in. (273 x 381 mm).
Purchased by Pierpont Morgan, before 1913.

Few dates are assigned to Memling (active 1465-94) without argument. While considered to be a Flemish artist, he was born in Seligenstadt, near Frankfurt-am-Main, but the year is uncertain. He became a citizen of Bruges in 1465 and died there in 1494. He must have been in Bruges before 1464, for his style shows him to have been a pupil of Rogier van der Weyden, who died in Brussels in 1464. All that can be said for certain is that he achieved a degree of economic success in Bruges, owning two houses and becoming a master of a large and productive shop. He was particularly well known as a portraitist and a number of his sitters were members of the Italian merchant colony living in Bruges at that time.

This portrait by Memling is one of the finest paintings in the Morgan collection. It can be dated on the basis of style to about 1475, by which time Memling was at the height of his powers and the leading painter of Bruges. The identity of the sitter is not known. The pink, or carnation, in the young man's hand may be a symbol of betrothal (originating from a Netherlandish marriage custom), and hence the work might be one of a pair of wedding portraits. It is a fine example of Memling's mature style in which meticulously observed details combine to suggest an intensely concrete reality. *The Man with a Pink* is a dispassionate and technically brilliant rendering of the natural world, with face, hands, and flower all executed with the same degree of precision.

The Man with a Pink is one of three paintings by Memling in the Morgan Library; the others are a pair of donor portraits which have been identified as the left and right panels from a Crucifixion now in the Museo Civico, Vicenza. All were once in the collection of Rodolphe Kann in Paris when Morgan purchased them early in this century.

9 ❧

PIETRO VANNUCCI, CALLED PERUGINO

Madonna and Saints Adoring the Child. Perugia, ca. 1500. Tempera on wood. 34½ x 28⅜ in. (876 x 721 mm). Purchased by Pierpont Morgan, 1911.

This painting exhibits the grace and tranquility that are the hallmarks of the style of Perugino (1450-1523), the leading painter of Perugia in the late fifteenth and early sixteenth century. His famous student Raphael, whose early work, according to Vasari, could not be distinguished from that of his master, was responsible for spreading his influence.

The painting can be dated around 1500, about the time Raphael's association with Perugino began. Typical of Perugino's devotional paintings, the principal figures dominate the foreground plane and are set against a vast landscape that recedes behind them. Isolated in their own space and spiritual reverie, the figures are united in a rhythmic, linear pattern defined by gesture and drapery. The Madonna is quintessentially Peruginesque, with her oval face, distinctive mouth, and hair and veil looped gracefully at the neck. The identity of the two other saints is uncertain. When the painting was purchased by Pierpont Morgan from the Sitwell Collection, it came with the

traditional title of *The Three Marys*, but this is surely incorrect. The figure on the left is a young man and may be St. John the Evangelist. The female saint on the right may have been taken for Mary Magdalene, but the letters PRON still partially visible on her halo may identify her as St. Sophronia. An anchorite, St. Sophronia is said to have been buried by birds when she died. The frame bears the Latin inscription "Thou art fairer than the Children of men; grace is poured into thy lips; therefore God hath blessed thee forever" (Psalm 45: 2). The frame is not likely original, but its message is certainly appropriate to the sense of piety that the painting was clearly intended to evoke.

9 Painting by Pietro Vannucci, called Perugino

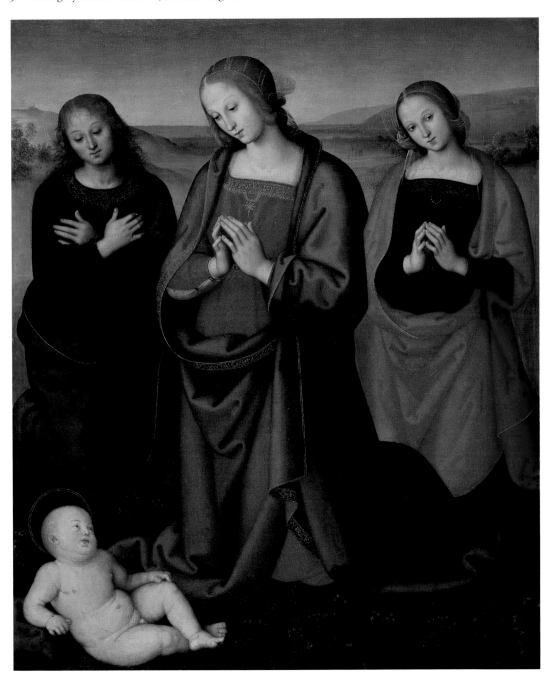

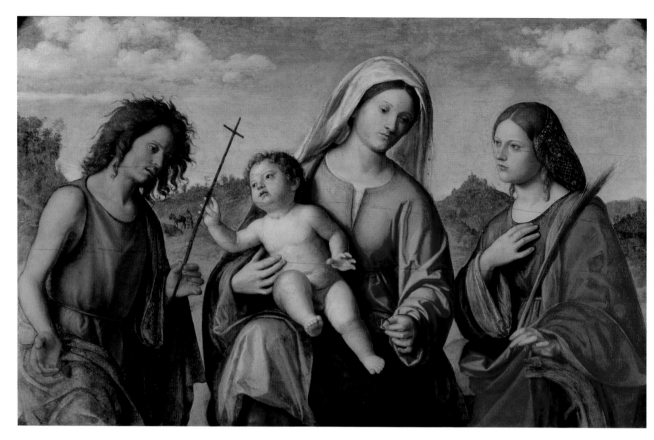

10 Painting by Cima da Conegliano

10 🐌

CIMA DA CONEGLIANO

Virgin and Child with St. Catherine and St. John the Baptist. Venice, ca. 1515. Oil on panel, 37¹¹⁄₁₆ x 24⁹⁄₁₆ inches (957 x 624 mm). Purchased by Pierpont Morgan, 1911.

The paintings of Cima da Conegliano (1460–1517-18) exhibit the serene Venetian feeling so characteristic of the paintings of Giovanni Bellini. It is not certain where or from whom Cima, essentially a conservative painter, received his early training, but in addition to Bellini, his paintings show that he studied the work of Antonello da Messina, whose affinity for sculptural forms and jewel-like surfaces was important for the early development of Bellini as well. Cima's later paintings show the influence of Giorgione.

This painting is of the devotional type known as the *sacra conversazione*, in which the Virgin and Child are shown in the company of saints, with whom they appear to be conversing or in silent communion. Here, the young Madonna holds the Infant Christ who offers a reed cross to a youthful John the Baptist. The lovely female saint on the right rests her hand on a wheel, identifying her as St. Catherine of Alexandria, who was tortured on a spiked wheel for refusing to renounce her faith and marry the Emperor Maxentius. The Virgin presents a ring to Catherine, presumably a reference to the legend of the Mystic Marriage of St. Catherine, in which the saint was borne aloft to heaven and betrothed to Christ.

The Library's *sacra conversazione* is remarkably direct, with the figures very close to the picture plane, separated from the viewer by a marbleized ledge. (The piece of paper with the artist's signature affixed to the ledge was a favorite trompe l'oeil device of the time.) A sense of stillness emanates from the figures, and the distant landscape view adds a poetic quality to the painting. The composition and format are close to Bellini's *Virgin and Child with St. John the Baptist and St. Catherine* (ca. 1500, Accademia, Venice).

Cima's works are often difficult to date. The art historian Bernard Berenson, noting the similarities between Catherine's headwear and that worn in Bellini's *Woman at Her Toilet* of 1515, now in Vienna, suggested that the Library's painting was probably executed a few years later. Cima's late paintings (he died about 1517 or 1518) show an interest not only in light and atmosphere, which he tended to emphasize in mid-career, but in a rich full-bodied coloring. The painting was purchased by Pierpont Morgan from the Charles Fairfax Murray collection, the source of approximately 1500 old master drawings that established the core of the Library's collection of drawings and prints.

11 ⅋

HANS DAUCHER

The Meeting of Emperor Charles V and His Brother Ferdinand I, King of Bohemia. Augsburg, 1527, honestone bas-relief. 6 ¹⁵/₁₆ x 8¾ in. (173 x 219 mm). Purchased by Pierpont Morgan, 1906.

The relief depicts the Roman Emperor Charles V and his brother Ferdinand, king of Bohemia and Hungary, who would later succeed his brother as emperor. Charles, on the left, is identified by his imperial eagle, and Ferdinand, on the right, is identified by the Bohemian lion on his horse's armor. The composition is based on a section of Albrecht Dürer's 1515 woodcut *The Triumphal Arch of the Emperor Maximilian.* Maximilian was Charles's grandfather and predecessor. The section of the scene that Daucher based his relief on represents the meeting between Maximilian and Henry VIII of England. Daucher's relief was thought to represent a meeting between the two brothers on the Brenner Pass in 1530, when they were on their way to the Diet of Augsburg. The date 1527, which is scratched on the plaque, was thought to be a later addition. Recently Thomas Eser, a Daucher scholar, authenticated the date, pointing out that the forms of the numbers are consistent with those on other reliefs by the sculptor. Thus the occasion for the plaque is open to interpretation.

Daucher, who is documented as a sculptor working in Augsburg from 1514, was particularly skilled at small-scale relief carving. Under the influence of Dürer and Italian art he developed a style of subtle delicacy. Most of his plaques are meticulously worked and finely finished. This relief is cut from fine-grained honestone, a medium ideally suited to the carving of delicate and intricate detail.

11 Bas-relief by Hans Daucher

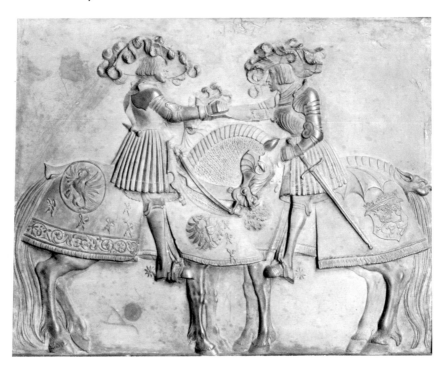

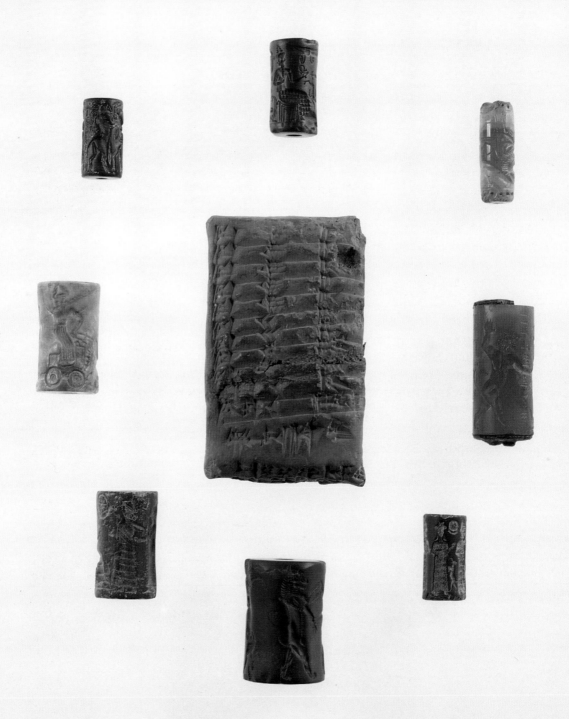

Contest frieze [2]

Libation [4]

Worshiper led before a god

Animals slain in the hunt [13]

Multiplication tablet [18]

Confronted pairs [3]

A centaur and a lion [12]

A winged hero [11]

Presentation scene [8]

11 ANCIENT NEAR EASTERN SEALS AND TABLETS

S EALS, that is stones incised with a design that leaves an impression on plastic material, like damp clay, were produced more or less continuously for a period of about 5,000 years in the region the ancient Greeks called Mesopotamia–"the land between two rivers." The area, drained by the Tigris and Euphrates and their tributaries, roughly corresponds to most of Iraq, and borders on Iran, Syria, and Turkey. It is a land of geographic and climatic extremes, lacking mineral resources. Nevertheless, the peoples of ancient Mesopotamia succeeded in creating the first great civilization in western Asia. The earliest settlements date from the sixth millennium B.C. By about 3400 B.C. an urban culture had evolved in the south of which the most important feature for posterity was the invention of writing.

Each decade brings to light new archaeological finds, and research increasingly affirms the extraordinary intelligence, inventiveness, and artistic sensibilities of these peoples. And yet, particularly in the case of both architecture and sculpture, many periods remain poorly documented or not represented at all. Engraved seals, however, constitute the only type of work for which we have enough examples to reconstruct the history sequence from the end of the fifth millennium B.C. to the time of the Persian empire in the fifth century B.C.

The American collector William Hayes Ward (1835-1916) was among the first to recognize the importance of seals for a knowledge of ancient Near Eastern art and culture. Between about 1885 and 1908, he assembled, probably on Pierpont Morgan's behalf, the great collection of 1,157 seals which forms the core of the Morgan Library's collection. Two major gifts have subsequently been received: 74 cylinder seals and 70 stamp seals collected by Robert F. Kelley and given by his sister in 1977, and a study collection of 480 cylinder and 230 stamp seals given by Jonathan P. Rosen in 1986. The Morgan Library's seal collection is today one of the most important in the world. It covers the significant styles of Mesopotamian engraving from the Chalcolithic to the classic Greek as well as the styles of the other countries of the ancient Near East. Pierpont Morgan also acquired fine ancient cuneiform tablets. Most of these are now in the Babylonian collection at Yale, but a small number was retained at the Morgan Library and includes accounts of various myths and legends, religious and administrative practices, and even personal correspondence (see 11, 18).

The seals discussed below have been selected to give some idea of the quality and scope of the Library's holdings. Although they span a period of several thousand years, it is possible to identify certain consistent or recurring features regarding their functions, techniques, materials, styles, themes, and subjects. The seal design was made by engraving in reverse on a small stone using metal tools and simple bow drills. The function of seals was both practical, as a means of identification, and amuletic, that is the engraved design was intended to protect or benefit the owner in some way. Most seals are quite small, measuring only an inch or so in height. As objects in and of themselves, they are often unimpressive looking, but when one sees the positive impression of the engraved design, it is readily apparent that seal carvers were frequently craftsmen of extraordinary techni-

xamples from the collection

cal facility who had innate artistic gifts. Indeed, the images produced from seals often appear so vivid that the world of the ancients seems tantalizingly close and within our grasp.

In the earliest periods, comparatively soft stones, such as serpentine or marble, were used; while harder materials, such as hematite, prevailed in the first part of the second millennium, followed by jasper, chalcedony, and the like. The choice of materials was not only governed by the technical abilities of the engraver, but by the magical quality considered inherent in the various stones. For example, we learn from an Assyrian text that "If someone carries a seal of lapis lazuli, he will have protection and his god will rejoice in him," and "if someone carries a seal of serpentine, it shall be granted him to live surrounded by devoted obedience."

The first seals were in the form of stamps and were produced in an area that stretched from Turkey to Iran. These stamp seals were impressed on clay lumps slapped over strings that secured the cover of a jar or on the clay placed on the door of a storeroom. Some of the stamps had figural shapes that must have had a beneficial meaning, for example the abbreviated female body of a seal amulet in the Rosen gift, dated about 5000 to 4500 B.C. During the middle of the fourth millennium, when the transformation from village to urban civilization was beginning at some sites, seals in cylindrical form appear, probably

Seal amulet, Gift of Jonathan P. Rosen, 1986-87

first at Uruk, the major site of southern Mesopotamia, or at Susa, in southwest Iran. When a cylinder is rolled out, it covers more surface than a stamp, and this surely was one reason for the adoption of this new form. Officials used their seals to authenticate tablets recording the movement of foodstuffs and goods needed for the growing economy of urban institutions, palaces, and temples. We do not know whether these first cylinder seals were also used as the personal seals of individuals, but this certainly became a part of their function by about 2600 B.C., when inscriptions naming the seal owner were occasionally

carved on the cylinder. At certain times every person of consequence in the Mesopotamian settlements had a cylinder seal. As a rule, they were perforated lengthwise, so that a wire or string could be passed through the hole and then fastened to the necklace or bracelet on which the seal was usually worn. Frequently the cylinders were set between caps of gold, silver, or copper. Beginning in the third millennium it became a common practice to bury seals with their owners; thus each generation had to have cylinders made, and the designs naturally reflect the regional style and period of carving. There are probably more than 30,000 known today.

At first, seal designs were abstract ornamentation, then came animals, and finally humans, gods, and demons. Most of the inscriptions on cylinder seals identify the owner, usually giving his name and perhaps his title or occupation. But it is rare for the inscriptions to have any direct connection with the seal design. Many of the images were intended to influence nature in an almost magical way. The artist drew that which he wanted to become real, for example, the overpowering of dangerous beasts, a flourishing herd of animals, or the desired consequence of an action, such as a sacrifice or prayer offered to a god. As a general rule, there was no attempt at foreshortening or rendering figures in perspective. The artist did not try to make a naturalistic rendering of a particular figure at a particular moment; rather he sought to cast the idea represented by a figure into a permanent form. It is this struggle to find the appropriate permanent form that we can follow through the millennia of Mesopotamian art; at times it was sought using representational forms, at others the lines and shapes almost create abstractions. Human beings are characteristically shown in profile view, but with the shoulders and thorax seen from the front, as for example in Egyptian art. The repertory of gestures is small and the figures are rather stocky and clad in heavy garments from which head and limbs protrude as from a tube. Gods are distinguished from mortals only by their clothing, such as a miter with one or more pairs of bulls' horns. The representation of deities reflects the way in which gods were thought of: they were believed to have eternal life, but otherwise resembled earthly rulers. Even divine bakers and barbers are mentioned in Mesopotamian texts.

There is somewhat more freedom and variety in the representation of animals. The frontal-profile convention is occasionally broken, and postures vary considerably. They are often used to express unleashed fury or pitiful suffering—in contrast with the emotionless faces and rigid bodies of human beings. Monsters can be part human, part animal, or a combination of several beasts, such as lions, eagles, and bulls, embodying the forces of all. Figures like the griffin, which combines a bird of prey and a lion, are astonishingly convincing. Such creatures made a deep impression on later cultures, surviving in art and imagination to the present day.

The scenes represented on seals may be gathered into three broad categories: ritual, mythological, and contest. Toward the end of the third millennium and earlier part of the second, ritual scenes usually show the worship of gods and vary from the bearing of offerings to the mere gestures of prayer in their presence. They illustrate the religious life of the Mesopotamians, which was expressed in continuous appeasement of the gods and frequent efforts to obtain their goodwill. In such scenes the owner probably believed that he had placed himself for all time before the gods in worship or sacrifice. Mythological themes were probably intended to glorify the gods and are most common in the period of the Semitic dynasty of Akkade (about 2340-2150 B.C.).

Contests are a predominant subject on seals during the so-called Early Dynastic period, the time of the Sumerian city states (about 2900-2400 B.C.) and during the Dynasty of Akkade. Typically, they show a human, or superhuman, hero competing against or overpowering an animal or monster. Such scenes may reflect the eternal conflict in which the Mesopotamians saw themselves as the defenders of order and civilized life against the chaotic forces of nature that surrounded them. Rather than conceiving of this conflict in abstract, philosophical terms, they seem to have thought of each force separately and in concrete terms. Thus the lion, as a menace to human life and livestock, was a very real opponent. The various monsters represent fearsome dangers equivalent to those posed by natural predators. The lion griffin, for example, probably represented the destructive aspects of weather, such as lightning or ravaging storms. The protagonists were often heroes, the most important of which was shown as a muscular man with symmetrical curls and a full beard; another protective figure is a man whose lower body is that of a bull and who has magnificent horns rising above his long curls. Precise identifications of such hero types are only gradually being discovered by scholars, but their appearance in scenes of violent combat was surely meant to protect the seal owner in a supernatural way.

It is important to bear in mind that these scenes were not meant to be understood in one glance as a single pictorial entity. Instead, they were to be read element by element, and each had a fixed meaning. The primary aim of the carver was not aesthetic; nevertheless he had a sense of form and space, of balance and rhythm, so he articulated the figures on the cylinders in friezes, using only the band of the cylinder mantle as the surface on which to draw his design. The compositional principle of the frieze was not limited to seals, of course. Bands, in which figures follow each other in rhythmic succession or are assembled according to other schemes, again rhythmically organized, are found throughout the art of the region. Probably the most significant of the schemes is called "heraldic." It consists of a central element, which may be a bird or a hero, dividing a symmetrical pair of figures, often horned animals. These compositions create a feeling of permanence: nothing can alter the symmetrical balance without destroying the composition. Long after the civilizations of the ancient Near East ceased to exist, friezes and heraldic schemes were used in which animal forms were rigidly subjected to laws of composition. They are Mesopotamia's greatest artistic achievement, and, in their influence on the later art of Europe, its most important aesthetic legacy.

Engraved cylinder seals are not only a valuable record of Mesopotamian artistic precepts and practices of the time; they can reveal something about the life, costumes, and furnishings of the period as well. Many of the images symbolize human qualities and intellectual concepts that passed into the literature and art of the Middle Ages and beyond. In the past decades well-documented archaeological material from the ancient Near East has substantially increased, and the study of seals now seems only at the beginning.

1 ?

SCENE IN A LEATHER WORKSHOP (?)

Uruk period (ca. 3300 B.C.). Greenish black serpentine, h. 29.5 mm, d. 25 mm. Cylinder No. 1.

Ancient Uruk, notable for its great ziggurat, was the site of one of the earliest Sumerian city-states. Few cylinder seals from the Uruk period have been recovered, although a large number of seal impressions on clay tablets has survived and attests to the rapid and widespread adoption of this "new" type of seal. The style of the engraving on this rare example of about 3300 B.C. is lively and naturalistic. Two nude craftsmen appear to be active with tools in two rooms of what may have been a workshop. A boot is visible in one of the rooms, and for this reason it has been suggested that the men are leather workers. The rooms are framed by delicately carved feline figures with entwined serpents' necks. These composite beings, combining the powers of two dangerous beasts, were probably thought of as being protective of the building and warding off evil forces. Thus, the scene may have had some ritual significance.

The serpent-necked monsters are related to similar creatures in contemporary Egyptian representations on the so-called hunting pallettes and remind us that relationships with Egypt at the dawn of civilization must have been closer than once thought.

2 ?

CONTEST FRIEZE

Early Dynastic period (ca. 2450 B.C.). Lapis lazuli, h. 24 mm, d. 12 mm. Cylinder No. 80.

This seal shows a nude bearded hero with a dagger and curved weapon attacking a leopard, who in turn menaces one of two horned animals protected by a second hero with upright curls. It was created about 2450 B.C. during the Early Dynastic period, so called because for the first time there are inscriptions giving the names of kings then ruling over Uruk, Ur, and other small city states in southern Mesopotamia. This seal is inscribed for a man, possibly a prince, called Lugal-la (?)me(?) from Uruk. It is made of lapis lazuli, which came only from

1 Scene in a leather workshop (?)

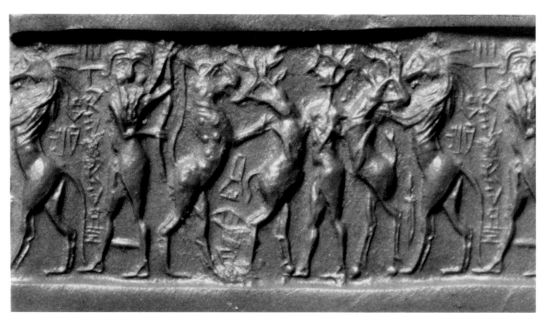

2 Contest frieze

northern Afghanistan and was probably the most precious stone of the time.

During the Early Dynastic period, the protection of flocks and herds, artistically expressed in friezes of animal contests such as these, was a predominant subject for seal engravers. The hero on the right exemplifies the comparatively schematic approach to the human body and face found in Early Dynastic seals, with the pupil of the eye represented by a small drilling set in a hollow surrounded by an oval or rhombic rim. Also characteristic of the period is the convention of portraying animals standing upright on their hind legs. In the case of lions or other feline creatures, it makes them appear semi-human and doubly dangerous. Horned animals, like sheep and goats, also stand on their hind legs, which gives an otherworldly atmosphere to these contests.

3 &

CONFRONTED PAIRS:
A NUDE HERO AND A BULL-MAN
WRESTLING WITH ANIMALS

Akkade period (ca. 2240 B.C.). Black serpentine (damaged), h. 36 mm, d. 25-24 mm. Cylinder No. 159.

During the years ascribed to the reign of the Akkadian king Sargon and his successors, a fundamental change took place in Mesopotamian art. The dream-like designs of the Early Dynastic period were succeeded by dynamic, realistic works which seem to reflect the tremendous energy and power that drove the Akkadians to their conquests.

In this seal of the fully developed Akkadian style, we can observe the continuation of the animal-contest theme of the Early Dynastic period, now transformed according to the new modes of representation. There is a heightened feeling for the musculature and structure of both human and animal forms; in the face of the hero shown in profile on the right, the eye is now properly sunk between the lids and cheekbone. On the left, a nude bearded hero grapples with a water buffalo, a newcomer to the repertory of animals shown on seals (the head has been damaged). The bull man on the right grasps the forepaws of a powerfully built, open-jawed lion.

The format, in which the pairs of figures are presented in heraldic fashion on either side of a central element, is also characteristic of Akkadian seal designs. In some cases the central axis is taken up with an inscription; here, the artist places a tree on a mountain, possibly meant to suggest the gigantic scale in which the figures should be imagined. Earlier writers once identified the nude bearded figure and bull man of Mesopotamian seals with the epic heroes Gilgamesh and his companion, Enkidu, who lived

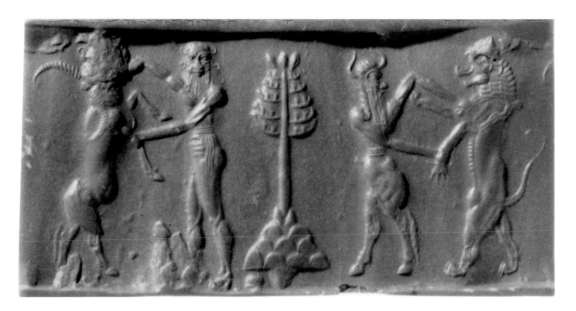

3 Confronted pairs: A nude hero and a bull-man wrestling with animals

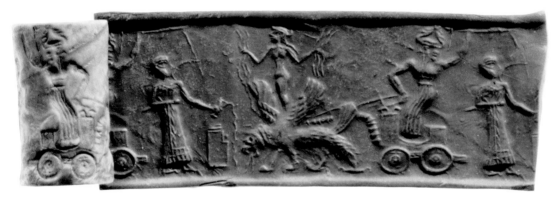

4 Libation before the storm god and rain goddess

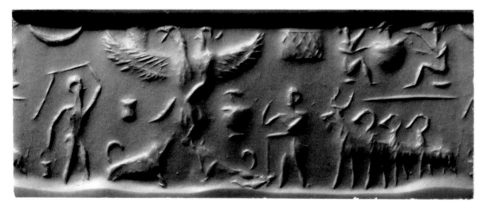

5 Etana's flight to heaven on the back of an eagle; shepherds with flocks

with the beasts of the field. This does not, however, agree with the preserved texts of the Gilgamesh epic, and at present the nude hero is linked with a group of figures associated with the water god.

During the Akkadian period, Mesopotamian art reached a height rarely if ever attained in its subsequent development. This seal and the following two seals are particularly fine examples of this great age of seal engraving.

4 🌰

Libation before the Storm God and Rain Goddess

Dynasty of Akkade (ca. 2240 B.C.). Shell, h. 24.5 mm, d. 16 mm. Cylinder No. 220.

In this splendid seal from the dynasty of Akkade, the storm god rides in a chariot drawn by a fire-spitting lion griffin. In one hand the storm god holds the reins that guide the monster; in the other a whip. His consort, the rain goddess, stands between the wings of the lion griffin, holding bundles of rain. As if to honor these deities, a worshiper on the left pours a libation over the altar.

This seal is but one of various representations of Akkadian weather gods. Such scenes on Akkadian cylinders are important sources for the knowledge of Mesopotamian mythology.

5 🌰

Etana's Flight to Heaven on the Back of an Eagle; Shepherds with Flocks

Dynasty of Akkade (2340-2150 B.C.). Black serpentine, h. 36.5 mm, d. 28-26 mm. Cylinder No. 236.

A myth represented on several Akkadian cylinders is the story of Etana, the shepherd king, shown here flying to heaven on the back of a giant eagle to get the plant of easy birth for his wife. By placing the scene of the shepherds and their flocks on the ground, the artist has made the flight of Etana and the eagle to the upper sphere appear credible. This is one of the few instances in which we can find parallels for subjects on seals in ancient Mesopotamian texts. Indeed, a clay tablet in the Library's collection contains the beginning of the Epic of Etana. This story must have had some propitious meaning to explain its presence on a cylinder seal.

Use has worn away some of the sharpness of the impression, but the cylinder does not appear to have been very carefully engraved in the first place.

6 🌰

A Lion-headed Eagle between Two Mountain Goats

Post-Akkadian period (after 2150 B.C.). Gray steatite, h. 30 mm, d. 17 mm. Cylinder No. 267.

Despite the downfall of the Akkadian dynasty in about the middle of the twenty-second century B.C., some of the southern centers of culture continued to preserve the high standards of Akkadian art. In this unique cylinder of a heraldic composition, a lion-headed eagle has two kneeling mountain goats in his grasp. The modeling follows the best tradition of Akkadian plastic art, though the figures are even more delicately worked—probably through the use of finer instruments. The composition is notable for the beautiful balance achieved between the design and the inscription, which informs us that the seal was created for a minor priestly official, the scribe of a purification priest of the goddess Shara. The seal was probably carved at Lagash, where Shara was considered the consort of the chief god Ningirsu and the lion-headed eagle was a favored image.

7 🌰

Worshiper Led before a Deified King

Third Dynasty of Ur (2038-2004 B.C.). Black steatite, h. 25 mm, d. 13.5 mm. Cylinder No. 292.

The introduction of deified kings in worshiping scenes was an innovation of the so-called Third Dynasty of Ur, which assumed rule of Mesopotamia about 2112 B.C. Like Naram-Sin, a famous king of the Akkade Dynasty, the kings of Ur were deified during their lifetime. In this seal created for Ursakkud, an official of Ibi-Sin, the last king of Ur, a goddess introduces the worshiper to the seated personage. That he is a king rather than a god is shown by his attire. Instead of the horned miter and flounced robe of a god, he wears a round cap with an upturned brim and a bordered mantle. Further-

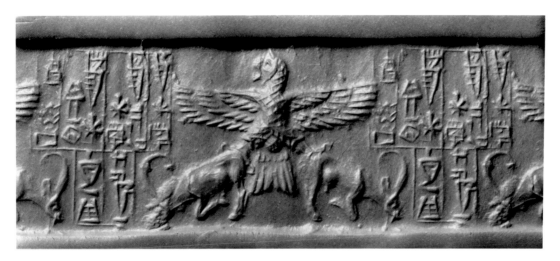

6 A lion-headed eagle between two mountain goats

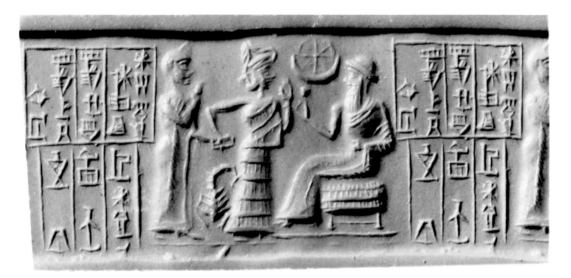

7 Worshiper led before a deified king

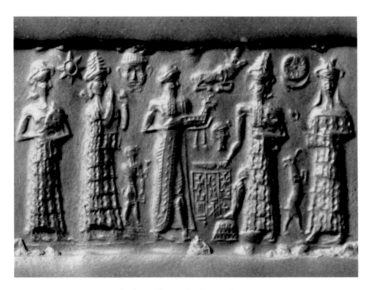

8 Presentation scene before the god Shamash

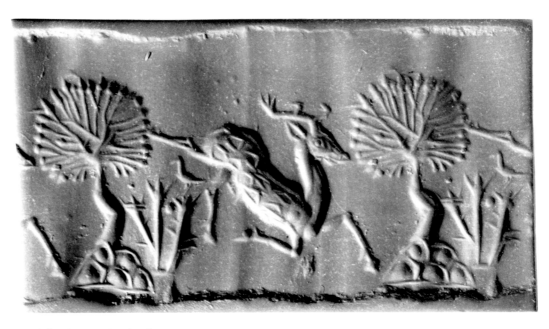

9 A leaping stag in a landscape

more, he is seated on an upholstered chair instead of a throne carved like the facade of a temple. It seems likely that such scenes of worship follow the pattern of the ceremony performed at court when a petitioner came to see the king and was introduced by a court official.

8 ᔔ

PRESENTATION SCENE BEFORE THE GOD SHAMASH

First Dynasty of Babylon (1894-1595 B.C.). Hematite, h. 25 mm, d. 13.5 mm. Cylinder No. 399.

The independence of the Mesopotamian city states was brought to an end by Hammurabi of Babylon, known for his law code. During his reign, Babylon became the political and cultural center of Mesopotamia, supplanting the town of Ur. In the early phase of the so-called Old Babylonian period, some of the gods that had been portrayed in the Akkade period reappeared, for example, on this seal of about 1800 B.C., in which a king brings a sacrificial animal to the sun-god Shamash. The god, poised for ascent, is recognizable by his emblem, a saw with which he cut decisions as a divine judge. Hammurabi saw himself as "the favorite shepherd" of Shamash, whose mission it was "to cause justice to prevail in the land." This seal belongs to the extraordinarily fine

school of engraving that developed during this time in the town of Sippar. Note in particular the precise manner in which the garment designs are indicated.

9 ᔔ

A LEAPING STAG IN A LANDSCAPE

Middle Assyrian (1250-1200 B.C.). Milky chalcedony, h. 30 mm, d. 10 mm. Cylinder No. 601.

A dark age followed upon the destruction of Babylon in 1595 B.C., but soon a period of cultural flowering and exchange emerged during the fourteenth and thirteenth centuries B.C. The designs of seals of the so-called Middle Assyrian period, beginning about 1400 B.C., exhibit a new naturalism and vivacity that is surely a reflection of the general trend toward realism that prevailed both in Egypt and the Aegean during this truly international age. The Library's Middle Assyrian cylinders are the finest of any collection, as exemplified in the present example and 10 (below).

This scene of a stag leaping in a landscape belongs to a series of animal representations whose significance is unknown. The stag is suspended in motion, descending from a hill, one hind leg still held horizontally after the initial spring downwards. The tree with its crooked stem and large, leafy crown could be an olive

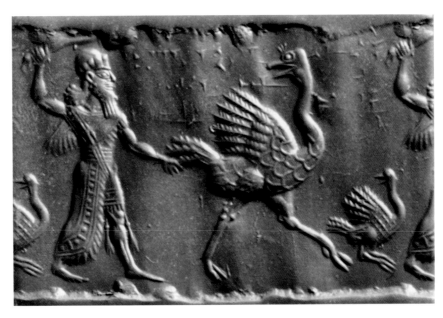

10 A winged genius pursuing two ostriches

tree. It is placed on the little hill with flowers growing beside it, and a bird is perched on one of the stems. The artist who carved this stag, with its antlered head proudly held high and forelegs delicately poised to land, must have been familiar with the extraordinary grace and dignity of this animal whose name, *lulimu*, could also mean "ruler" or "prince." Such naturalistic landscape scenes in which exact symmetry is avoided may be specifically Assyrian of the thirteenth century B.C.

10 🐚

A Winged Genius Pursuing Two Ostriches

Middle Assyrian (1250-1150 B.C.). Gray marble, h. 31 mm, d. 14 mm. Cylinder No. 606.

One of the most striking of the Library's Assyrian seals is this design, probably from the twelfth century B.C.: a winged figure pursues an ostrich, possibly representing the earthly equivalent of the griffin, thought to be the conveyor of death. In the winged hero we have the forerunner of the typical Assyrian of the monumental reliefs of the Neo-Assyrian empire. His powerful body, with its strongly muscled arms and legs, does not seem in the least unnatural, because the awkward transition from the frontal shoulder to the profile hips is concealed by a heavy mantle. (The small drillings in the bor-

ders of the robe probably represent the gold plaquettes that the cuneiform texts describe as being sewn on the garments of deities.) He also wears a diadem and a necklace. His hair reaches to his shoulders and is brushed into small curls at the ends, and his long square beard is divided into several rows of curls. A dagger is stuck in his belt, and with his raised right hand he swings a sword. In one of the ostriches, the artist has achieved even greater expressiveness. The fleeing bird, with its head turned back in fear and fury on the attacker, ranks with the greatest figures of animals in Mesopotamian art.

To appreciate this scene fully, however, we should have to take into consideration the horizontal inscription (erased in ancient times) which originally formed a decorative band across the top of the composition and which would have given additional impact to the flight of the ostrich and the violent pursuit of the winged figure.

11 🐚

A Winged Hero Contesting with a Lion for a Bull

Neo-Babylonian (800-650 B.C.). Carnelian (copper setting preserved at both ends), h. 38.5 mm, d. 18 mm. Cylinder No. 747.

Among the finest of the cylinders of the Assyro-

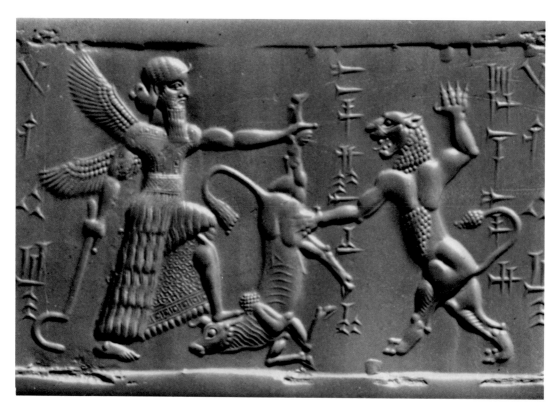

11 A winged hero contesting with a lion for a bull

Babylonian art of the ninth to seventh century B.C., is this Neo-Babylonian seal stone inscribed with the name of the seal owner. In the small space of the cylinder surface, the artist has created a contest of monumental proportions: a demonic lion faces a winged superhuman hero. The lion's threatening gestures and the tension in the span of his sharp claws suggest his evil power. But the hero will be the victor; taller than the lion he acts with a calm force, and the bull, the victim of this contest, remains in his power. As the hero extends his step the smooth muscular forms of the human figure are set off by the carefully detailed flounced garment which opens to reveal its fine inside ornamentation. Motion in the lion's body is indicated by a similar contrast in patterning. Despite the violence of the action the figures seem frozen in time, a result of the symmetry. The elegance and refined execution of this seal are characteristic of the Neo-Babylonian style of this period. Also typically Neo-Babylonian are the pointed diadem worn by the hero and the position he takes with one foot on the victim's head.

12 𝄞

A CENTAUR AND A LION

Neo-Babylonian (ca. 800-650 B.C.). Banded agate, h. 30 mm, d. 9-11 mm. Cylinder No. 749.

This cylinder of the eighth to seventh century B.C. shows a centaur with bow and arrow aiming at a fleeing lion. The centaur probably represents the constellation we know by its Latin name, Sagittarius. With modifications this image was handed down to the Greeks, in turn to the Romans, and on to the present day. Images of constellations may have been produced earlier in Syria. The representation of a nude bearded hero with two stars over his shoulder in another seal in the Library's collection might be interpreted as the equivalent of the constellation we know as Aquarius.

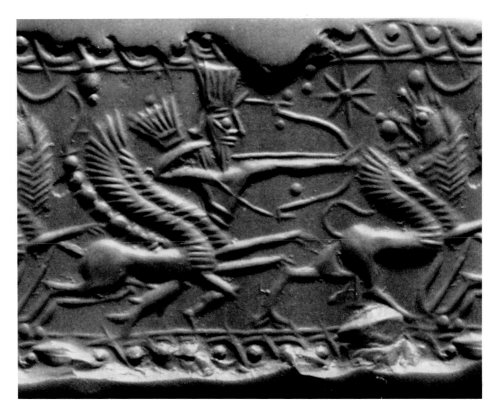

12 A centaur and a lion

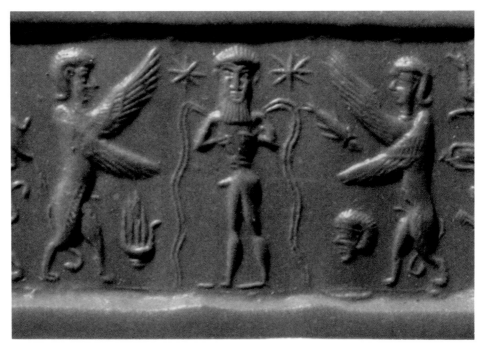

A nude bearded hero from a seal similar to 12

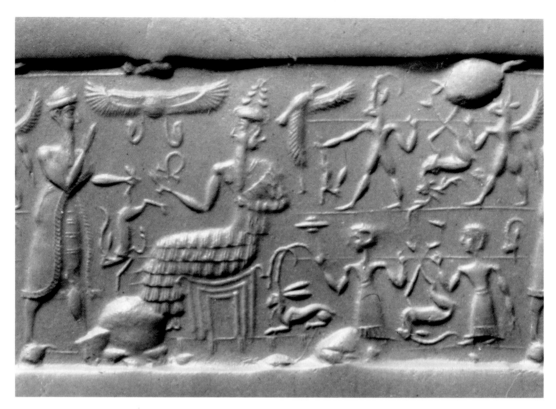

13 Animals slain in the hunt offered to a god

13 ଛ

ANIMALS SLAIN IN THE HUNT
OFFERED TO A GOD

Syrian (ca. 1800 B.C.). Hematite, h. 29.5 mm,
d. 15 mm. Cylinder No. 910.

During the nineteenth and eighteenth centuries
B.C. beautifully carved cylinder seals reflect in-
tensive contact between Babylonia and Syria,
which is understandable in view of the rela-
tively close geographical proximity of these
countries and their political connections. The
presence of Egyptian elements in these same
cylinder seals, however, demands an explana-
tion for which historical texts are lacking and
scholars are still searching.

In this seal, for example, the scene of a king
making an offering to a god is derived from the
glyptic art of the First Dynasty of Babylon, as
are the attire and the throne of the god. But the
fact that the seal belongs to the Syrian sphere is
indicated by the figure of the king. His costume
is Syrian—the mantle with decorative border
and rounded edges worn over a tight-fitting
undergarment and the cap with the brim curv-

ing slightly upward in front and back. Further-
more, the animal he offers to the god is not a
domesticated goat, such as an urban Meso-
potamian would have given, but a wild ante-
lope. That it was probably slain in a hunt is
shown by the fact that the rest of the kill, which
includes a variety of game from stag to hare, is
being brought before the deity by demons and
human attendants in a subsidiary scene. Added
to these Mesopotamian and Syrian elements
are several Egyptian ones: the life-sign held by
the god, the winged sun-disk with twin snakes,
and the vulture, here perched on the pole car-
ried by demons.

14 ଛ

A GOD AND GODDESS BANQUETING

Syrian (ca. 1900 B.C.). Hematite, h. 19.5 mm,
d. 11 mm. Cylinder No. 46KC.

This cylinder of the Old Syrian style has a
disproportionately large string hole, indicating
that an earlier design was effaced and replaced
by the present one. The motif is unusual. A god

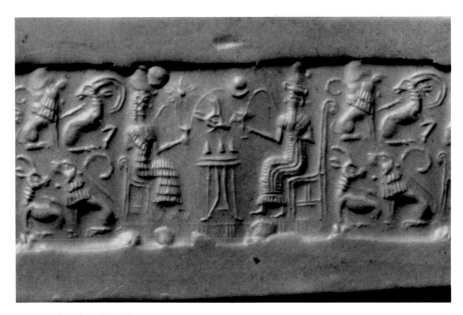

14 A god and goddess banqueting

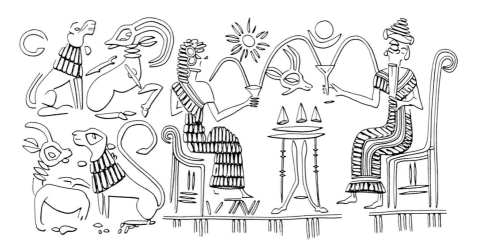

Rendering of the above seal by Elizabeth Simmons

and goddess are enthroned on either side of a table laden with breads and the head of a gazelle. Jets of water spring in an arc from each deity's shoulder. A third arc of liquid rises from the cup of one deity to descend into the cup of another, probably expressing their union. There is no specific explanation available for this motif, nor for the secondary one, which is quite common, showing two pairs of animals, one above the other, with a lion menacing a horned animal in each pair.

This and the following seal are from the large and important collection of seals formed by Robert Kelley and donated in 1977.

15 ❧

A NUDE GODDESS AND WEATHER GOD BEING APPROACHED BY A WORSHIPER

Hittite (ca. 1800-1700 B.C.). Soft black stone, h. 26.5 mm, d. 15 mm. Cylinder No. 72KC.

This rare old Hittite cylinder seal shows a nude goddess in an enclosure and a weather god standing outside. Both face a worshiper carrying a sacrificial animal before whom dances a small man.

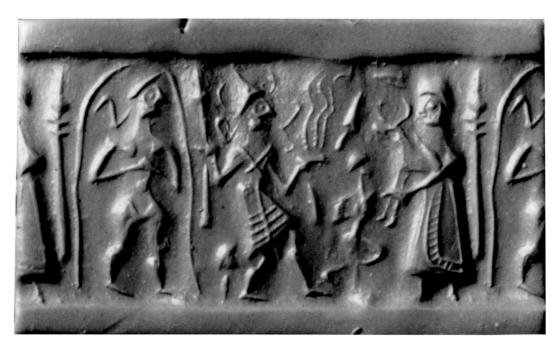

15 A nude goddess and weather god being approached by a worshiper

16 ❧

Two Stamp Seals from Nineveh (or Nimrud)

Nineveh or Nimrud (7th century B.C.). Seal A: brown and white agate, l. 21 mm, w. 15.4 mm. Seal B: blue chalcedony, l. 15.8 mm, w. 9.4 mm (not illustrated). Gift of Mrs. Paul G. Pennoyer.

Shown here is one of two seals "presented to Mr. Kellogg by A. H. Layard, Esq." according to the note which accompanied them. That would have been either between 1845 and 1847 when Sir Austen Henry Layard excavated at Nimrud Kalah, which he originally took to be Nineveh, or between 1849 and 1850, when he actually did excavate the ruins of Nineveh at the modern site of Kuyunjik.

Both seal stones are octagonal with a slightly convex base; they originally would have been pyramidal with a slightly rounded top, the common shape for Neo-Assyrian and Neo-Babylonian stamp seals. Both stones, however, were chipped down almost to the size of ring stones. This may have been done after the Assyro-Babylonian period. The carving on the base of the agate seal seen here was done with much use of a mechanical drill. A worshiper is shown before the symbols of the gods Marduk and Nabu on a platform which rests on the back of a recumbent snake dragon. There is a moon crescent in the sky. The carving on the base of the chalcedony seal is delicately modeled. There the worshiper, in Babylonian dress, appears before the symbols of Marduk and Nabu on an altar.

16 Stamp seal A

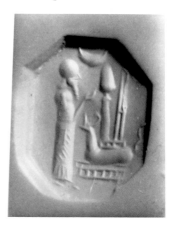

17 ❧

INSCRIBED LAPIS DISK

Akkade Dynasty (ca. 2070 B.C.). Lapis lazuli, 26 mm diam., h. 8 mm, inner diam. 25.2 mm, string hole 4 mm. Promised gift of Mr. and Mrs. Jonathan P. Rosen, 1991.

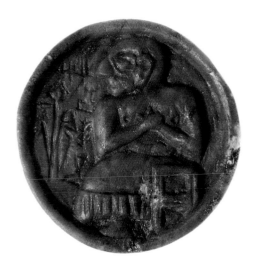

The lapis lazuli disk with relief carving on both sides is an object that has been tentatively located as coming from the southeastern part of Iran. In antiquity lapis lazuli was very valuable because of its blue color and supposed magic qualities. Lapis lazuli mines are located in the mountains of northeast Afghanistan, ancient Bactria.

Written in cuneiform signs on one side of the disk is the name Rimush. He was the second king of the Akkade Dynasty which established the first historically known empire in Asia. Rimush reigned from about 2278 to 2270 B.C. and doubtless acquired the disk in the course of his recorded military campaign in Iran. The style of the engraving is about two hundred years older than the date of Rimush. The same patina covers the entire disk indicating that the inscription is ancient, not modern.

On the side of the disk bearing the inscription is a seated figure in the style of Mesopotamian reliefs of about 2450 B.C. The figure probably represents a king because only figures of major importance, such as rulers, were represented seated. On the other side is a man-headed eagle grasping two horned animals, probably a symbolic representation of victory. This is a recent acquisition, the promised gift of Mr. and Mrs. Jonathan P. Rosen for the opening of the Library's new building in 1991.

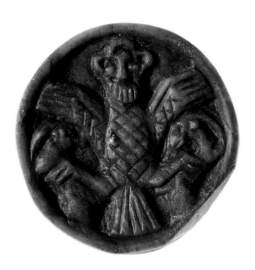

18 ❧

TWO CLAY TABLETS

Texts on clay tablets are an invaluable source of information on the economic and political institutions as well as beliefs and practices of the Mesopotamian people. The Library's collection includes portions of the myth of Adapa, a wise man who failed to gain immortality when he refused to eat the bread of life, and of the shepherd king Etana. The collection also includes the second tablet of the "Deluge Story," which corresponds to a second chapter and prefigures the Noah motif. In addition, there is "An Exorcists Almanach," the name given by modern scholars to a collection of texts to be followed by the exorcist throughout

the year. The Almanach also provided astronomical data for each specified day. Another tablet contains a "Ritual for an Eclipse of the Moon" and shows that the eclipse was considered the "death" of the moon, nature, and man. It details the ritual necessary to ensure revivification.

Commerce was an extremely important part of Mesopotamian life. An "Old Babylonian Mathematical Table" of reciprocals of the number 60, which is shown here, and an "Old Babylonian Multiplication Table" were probably similar to aids that accountants have used throughout history. After about 1800 B.C. most commercial deals had to be recorded and sealed before witnesses, thus a "Sealed Tablet with a Record of Sale of a Field" is one of the thousands of documents which modern scholars have used to attempt to reconstruct the economy of the end of the Old Babylonian period. Other relics of the carefully regulated economic system are a "Promissory Note" and a "Receipt for Interest." Marriage and inheritance were regulated with similar precision as is shown opposite by a "Marriage Contract" from Hana in the Middle Euphrates region.

The Babylonians believed that some deities, on the proper form of request, were willing to communicate with mortal priests through the medium of the body of a specially slaughtered animal. Future events could be discerned in the designs of the livers of sheep and these are discussed in "A List Of Liver Omens" of about 214 B.C.

18 Two sides of mathematical tablet

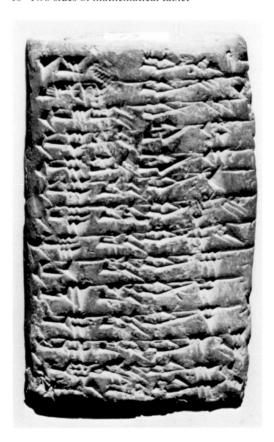 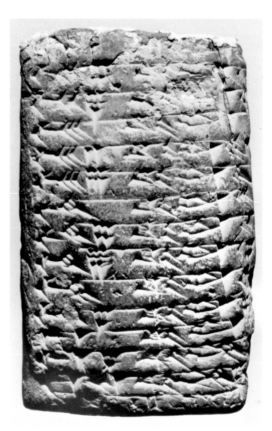

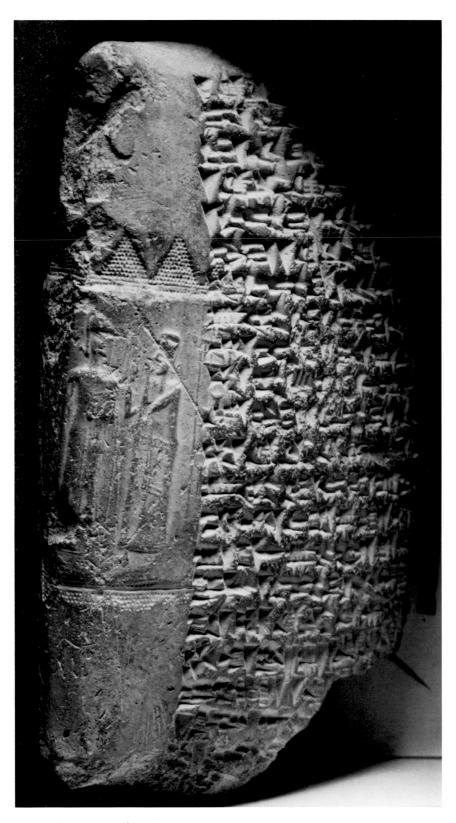

18 Marriage contract from Hana

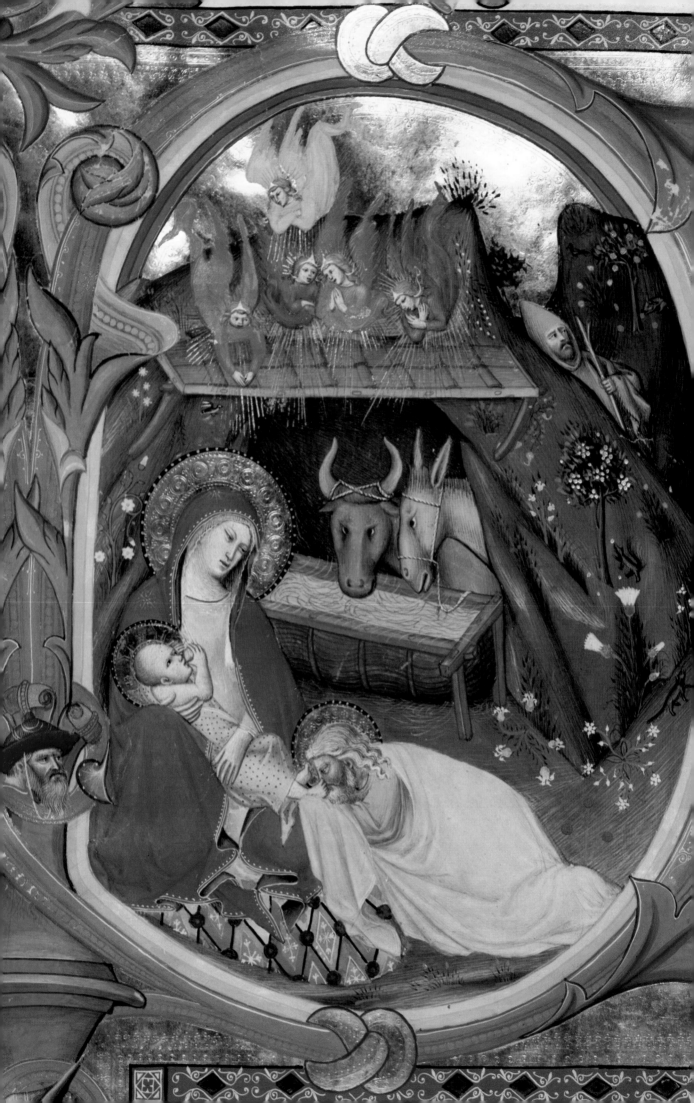

III MEDIEVAL AND RENAISSANCE MANUSCRIPTS

WHEN PIERPONT MORGAN acquired his first medieval manuscripts in the last
year of the last century, he laid the foundation for a collection that would contribute
substantially to their study and appreciation. It became the finest private collection of
manuscripts in the world, numbering about six hundred volumes at the time of his death
in 1913. It was inherited by his son, J. P. Morgan, who had added about two hundred
manuscripts by 1937, when the eminent bibliographer Seymour de Ricci described the
collection as the "most extensive and beautifully selected series of manuscripts existing on
the American continent, and...superior in general quality to all but three or four of the
greatest national libraries of the Old World." About the same time Charles Rufus Morey,
the noted scholar of medieval illumination, observed that "there is scarcely a phase of the
art...which can be fully illustrated and understood at present without reference to
the Morgan manuscripts. The importance of this collection lies not only in its extent, but
in the first-rate quality of its specimens." Now, with nearly 1,250 manuscripts, not
counting its important Egyptian, Greek, and Coptic papyri, the Library is even richer and
more extensive than when de Ricci and Morey wrote over fifty years ago. Written by hand
and often sumptuously painted or illuminated, manuscripts are our best surviving link
with the religious, intellectual, and artistic life of Europe before and for some time after
the development of printing. For a period of more than a thousand years they served as
the principal carriers of the ideas and images that were essential to the development of
Western civilization. Only a small number can be introduced here, and their selection has
been limited to the especially fine and more elaborately illuminated ones. Often commis-
sioned by leaders of church and state, these works were frequently made of rare and
precious materials and required the combined skills of parchment maker, scribe, editor,
illuminator, and binder, sometimes taking many years to complete.

But it should be kept in mind that the collection also includes many significant
unilluminated manuscripts. Most of ancient literature has survived only through medieval
copies, as is the case with Pliny's *Natural History*. The Library's copy of this famous
encyclopedia was written at Lorsch, near Worms, about 830 or 840, and is one of the
earliest known copies of the text. Equally important are the many examples of early
vernacular literature, such as Chaucer's *Canterbury Tales* and Dante's *Divine Comedy*, to
mention only two of the best known texts. While primarily made up of Western manu-
scripts, the collection also has significant examples of Armenian, Syriac, Coptic, Ethio-
pian, Arabic, Persian, Turkish, and Sanskrit manuscripts, as well as a large number of
Indian miniatures.

Of all the tangible artistic expressions of this age—sculpture, architecture, metal work,
enamels, ivories, panel paintings, and tapestries—the illuminated manuscripts are the
most numerous and usually the best preserved. Closed up and protected by sturdy
bindings, many manuscripts have been spared the damaging effects of exposure to light
and air and the altering hands of restorers. Often their intricate decorations and exquisite
miniatures, painted in vivid colors and brightened by burnished gold, appear little

Nativity in an initial *P* [20]

changed by the centuries. Indeed, many seem as fresh as the day they were made. The Library's collection is notable not only for the generally excellent preservation of its holdings but also for the large proportion of books that are intact or nearly intact. Thus, they make it possible to examine the full sequence of images in relation to their proper texts, as their creators intended and as is fundamental to much current research.

Leaving aside the earlier papyri, the collection dates from ancient codices of the fifth century to lavishly illustrated books produced during the Renaissance. From them much can be learned about how people lived, what they read and thought, and how they used and contributed to knowledge. One can also see, often in spectacular examples, the different ways in which books were written, decorated, illustrated, and bound over those centuries. For the earlier periods, many of the most important monastic centers are represented, such as those at Reims, Tours, Lorsch, Corvey, St. Bertin, Canterbury, St. Albans, Bury St. Edmunds, Salzburg, and Weingarten.

The majority of these books are of a religious nature, in keeping with the priorities of the society. In addition to Bibles, there are all kinds of service books, such as Sacramentaries, Missals, Lectionaries, Graduals, Ordinals, Breviaries, Antiphonaries, Psalters, and most common of all, private devotional Books of Hours. In addition there are various theological works and commentaries, lives of the saints, and other forms of pietistic literature. Important works of the classical authors are also represented, including ninth-century Carolingian copies as well as medieval literature and humanist manuscripts of the Renaissance. There are scientific manuscripts dealing with astrology, astronomy, medicine, plants, animals, and minerals; and works of a more practical nature telling when and how to plant, how to take care of horses, and how to hunt and fight. There are works relating to history, such as chronicles and biographies, and to law, exploration, and cartography.

Pierpont Morgan's first half-dozen manuscripts were obtained when he purchased James Toovey's collection of bindings and books in London in June 1899. His first major medieval manuscript, however, and the real cornerstone of the collection, was recommended to him a month later by his nephew Junius Spencer Morgan, who often advised him on purchases. Cabling him in secret code, Junius stated that he could obtain a famous ninth-century Gospels in a jeweled binding, a treasure unequaled in England or France. Morgan wisely took his nephew's advice and bought the manuscript known as the Lindau Gospels (see VI, 2-3).

The largest and most important of his five en bloc purchases was made in 1902, when he acquired the impressive collection of 110 illuminated manuscripts assembled by Richard Bennett of Manchester. Twenty-nine of these had belonged to William Morris, the Victorian author, artist, and printer. The last large purchase was concluded in 1911, when Morgan acquired fifty of the Coptic manuscripts that had been found a year earlier at Hamouli, in the Fayum, Egypt. These ninth- and tenth-century manuscripts, many of textual importance and sometimes decorated with frontispieces, form the oldest, largest, and most important group of Sahidic manuscripts with a single provenance, the Monastery of St. Michael at Sôpehes (III, 2).

A turning point for the collection came in 1905, when Pierpont Morgan hired Belle da Costa Greene as his librarian. Her role in shaping and developing the collection over a period of fifty-some years cannot be overestimated. Through her recommendations and

the active interest of J. P. Morgan until his death in 1943, valuable additions continued to be made, based on their artistic merit or their scholarly or textual importance. Miss Greene's interests were not limited to the growth of the collection; she oversaw its cataloguing, arranged lectures, encouraged the research of serious students and scholars, supported publications, and inaugurated a number of memorable exhibitions. The Association of Fellows, established in 1948, has continued to make the acquisition of exceptional manuscripts possible. Increasingly too, manuscripts and purchase funds have been given or bequeathed by other benefactors as well. One of the most notable recent gifts is the William S. Glazier Collection of seventy-four medieval and Renaissance manuscripts. The Morgan Library's collection has clearly played a major role in the rise and development of manuscript studies in the United States. Today, through exhibitions, facsimiles, and other publications, public and scholar alike are aware of the importance of the hand-produced books of the Middle Ages and Renaissance.

1 ❧

WEIGHING OF THE HEART

Book of the Dead. Amherst Egyptian Papyrus 35.3 (460 x 600 mm). Egypt, probably Thebes, third century B.C. Purchased, 1912.

The Book of the Dead is mainly a collection of prayers, hymns, charms, and similar texts that are an important source for our knowledge of ancient Egyptian religion, funerary practices, and thoughts about death and afterlife. It exists in different versions or recensions and varies considerably from copy to copy. Many of its components are much older than the Book of the Dead itself, which in its most common version was not established until the XXVI Dynasty (663-525 B.C.). The present copy, the second half of a papyrus roll measuring sixteen feet in length, was written in hieratic script during the early Ptolemaic period for Hornedjitef, a Theban priest of Amen-in-Karnak, and found in his tomb at Thebes. The first half, along with his mummy and coffin, is preserved in the British Museum. The papyrus was part of a collection that belonged to the English collector Lord Amherst of Hackney before Pierpont Morgan acquired it in 1912.

Among the larger illustrations of the book is the judgment of the deceased by the weighing of his heart. At the right Hornedjitef is escorted by the two Maats (Truth) into the Great Judgment Hall where the jackal-headed Anubis, the "weigher of righteousness," assisted by the falcon-headed Horus, weighs the deceased's heart against a feather symbolizing truth. To pass the judgment the two should balance each other. To the left of the scales stands the ibis-headed

Thoth, the "scribe of the company of the gods," recording the judgment. According to the text, the deceased must also recite a declaration of innocence in which he denies having committed forty-two transgressions. This is addressed to the forty-two assessors seated in three rows above. If the judgment is favorable, the deceased enters the Field of the Reeds and rides with Re in the solar barque following the sun from East to West. If unfavorable, he is consumed by the "Devourer of the Dead," the composite beast crouched before the throne of the green-headed Osiris, the mortuary deity. The crouching beast has the head of a crocodile, the body of a lion, and the rear part of a hippopotamus. Standing on the lotus before Osiris are the four sons of Horus: Imseti with the head of a man, Hapi with the head of a baboon, Duamutef with the head of a jackal, and Qebehsenuef with that of a falcon. They hold the rudders of the four heavens and are described as the four pillars supporting the sky. As lords of the four quarters of the world, they were associated with the cardinal points of the compass.

Many of these elements have survived in other religions. The weighing of the heart contributed to the Christian weighing of the soul by St. Michael at the Last Judgment, while the forty-two transgressions include many proscriptions of the Ten Commandments. The Devourer recalls the medieval Hell Mouth, which has been linked with the monster called Leviathan, from a Hebrew word which also denoted a crocodile. Like the lords of the four quarters of the world, the evangelists became linked to four human- and animal-headed symbols (based on the cherubim in Ezechiel's vi-

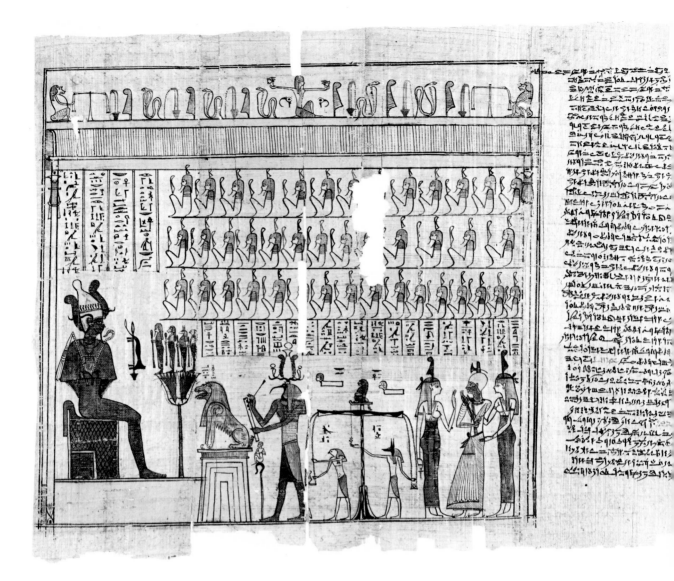

1 Weighing of the Heart

sion) by Irenaeus at the end of the second century and were regarded by him as the four pillars of the Church. The evangelists' symbols were also associated with the four heavenly zones and, by later writers, with the quarters of the world and the cardinal points.

2 ❧

VIRGO LACTANS

Book of the Holy Hermeniae, with hymns and other liturgical texts. M.574, f.1v (280 x 220 mm). Egypt, Toutôn in the Fayum, dated 897/898. Purchased, 1911.

This and fifty-three other Coptic manuscripts in the Morgan Library were found by villagers

in 1910 in a cistern near a place in the Fayum known as Hamouli. Since they were discovered on the site of the destroyed Monastery of the Archangel Michael of the Desert at Sôpehes, it is assumed that the monks must have buried their library for safekeeping, probably during the tenth century. These volumes, written in the Sahidic dialect of Upper Egypt and most with colophons ranging in date from 823 to 914, form the oldest, largest, and most important group of Sahidic manuscripts from a single provenance. Because they come from one library, they provide a valuable source for understanding the reading, devotions, and liturgical rites in the Christian or Coptic monasteries of Upper Egypt, as well as for the history of bookmaking. Because the Coptic Church was established so early and remained quite distinct, these manuscripts preserve important evidence

for understanding the early centuries of Christianity.

Nearly all the volumes were found in their original bindings, including one that is judged to be the finest surviving Coptic binding in the world (see VI, 1). About twenty have decorative or pictorial frontispieces, usually a large ornamental cross composed of interlace patterns. (The earliest such cross is in a fifth-century Coptic Acts of the Apostles in the William S. Glazier Collection.) More rarely, as in the present example, the frontispiece is a full-page picture. The image of the nursing Virgin ("Virgo lactans"), of which this is one of the earliest surviving examples, recalls ancient Egyptian depictions of the goddess Isis nursing Horus, her savior son. This bold iconic image makes a direct appeal through its immediacy, strength, and simplicity, thereby conveying something of the legendary intensity of Egyptian monasticism. Over the shoulders of the Virgin are the Greek abbreviations for the sacred names, Holy Mary and Jesus Christ. The two angels above hold books lettered, in Greek, alpha and omega. These, the first and last letters of the Greek alphabet, refer to the biblical "I am the Alpha and Omega, the beginning and the ending, saith the Lord" from Revelation 1:8. Although not made in the Monastery of St. Michael at Sôpehes, this manuscript was written, according to its colophon, for John, the archimandrite there, by the deacons Basil and Samuel of Toutôn, some fifteen miles away.

2 Virgo Lactans

3 St. Luke

4 Vision of the Heavenly Jerusalem

3 ❧

St. Luke

Gospels. M.728, f.94v (303 x 258 mm).
France, Reims, ca. 860. Purchased, 1927.

The most distinctive and perhaps the most in-
fluential of all the Carolingian schools of paint-
ing was that of Reims, which produced the
Utrecht Psalter (Utrecht, University Library,
Script. eccl. 484), one of the most famous of all
medieval manuscripts. These schools—others
were at Aachen, Metz, Corbie, Tours, and St.
Gall—flourished from the late eighth to the
middle of the tenth century during the reigns of
Charlemagne and his successors. This copy of
the four Gospels, one of the most important
productions of the Reims school, is the only
one written in gold, and is, in terms of illumina-
tion, the finest of the dozen Carolingian manu-
scripts in the Morgan Library. It was probably
made about 860 at the Abbey of St. Remi in
Reims itself, which was then under the brilliant
political and cultural leadership of Archbishop
Hincmar (845-82), counselor of Charles the
Bald. The manuscript remained at the abbey
until the end of the eighteenth century.

As is usual in Gospel Books with miniatures,
each of the four Gospels is preceded by a por-
trait of the appropriate evangelist. Such author
portraits were derived from models found in
the ancient Latin classics. Indeed, at Reims and
other monastic schools, which were important
centers of learning, classical traditions were
revived and conserved. Thus it is not surprising
to see Luke wearing a Roman toga and to find,
in the basket, numerous scrolls, the standard
book form in antiquity. Luke, of course, is not
an actual portrait, but he can be identified by
his symbol, the ox, and by the text that follows.

4 ❧

Vision of the Heavenly Jerusalem

Maius. Beatus of Liébana, *Commentary on the
Apocalypse*. M.644, f.222v (385 x 200 mm).
Spain, province of León, probably San Sal-
vador de Tábara, middle of the tenth century.
Purchased, 1919.

The Apocalypse, or Book of Revelation, is not
only the last Book of the New Testament but is
also the most difficult, puzzling, and terrifying.
According to the text, it was written on the
island of Patmos by a man named John, who,
from the second century, was traditionally

identified with the "beloved" apostle of Christ
and the author of the fourth Gospel.

Beatus was a monk at the Liébanese monas-
tery San Martín de Turieno in northern Spain.
He completed his twelve-book *Commentary
on the Apocalypse* about 776. The long cycles
of pictures accompanying this commentary, of
which about twenty illustrated copies survive,
constitute the greatest achievement of medieval
Spanish illumination. The present manuscript
is the earliest substantially complete copy, dat-
ing about 950. The colophon states that it was
written and illuminated by an artist-scribe
named Maius at the request of Abbot Victor
for a monastery of St. Michael. This is probably
the monastery at Escalada, consecrated in 913.
Maius, however, apparently worked in the
scriptorium of San Salvador de Tábara, where
he died in 968 and was buried. Although he
based his copy on a now lost model, Maius also
made important contributions of his own, such
as the prefatory evangelists' portraits, genea-
logical tables, and especially the frames and
colored backgrounds. He was regarded by his
student as "archipictor," master painter. The
manuscript contains 110 miniatures, including
some illustrating Jerome's *Commentary on
Daniel*, a second text frequently attached to
the Beatus commentary. This text can also be
found in the Library's later Beatus, dated 1220.

Following the ominous and threatening de-
pictions of the end of the world comes this
representation of the Heavenly Jerusalem as a
medieval city, complete with turrets and crene-
lations. In its twelve gates, topped by horseshoe
arches derived from Islamic architecture, apos-
tles stand beneath disks representing the gems
that are cited in the biblical text. Within the
walls of the city itself are the Lamb of God, the
author John holding a book, and the angel
measuring the city with a golden reed.

5 ❧

St. Mark

Gospel Lectionary. M.639, f.218 (332 x 255
mm). Constantinople, end of the eleventh
century. Purchased, 1919.

This Lectionary, which contains the Gospel
readings for the Mass arranged according to
the liturgical year, contains the finest illumina-
tion of the dozen or so Byzantine manuscripts
in the Morgan Library. Five large miniatures
act as highly finished headpieces, marking the

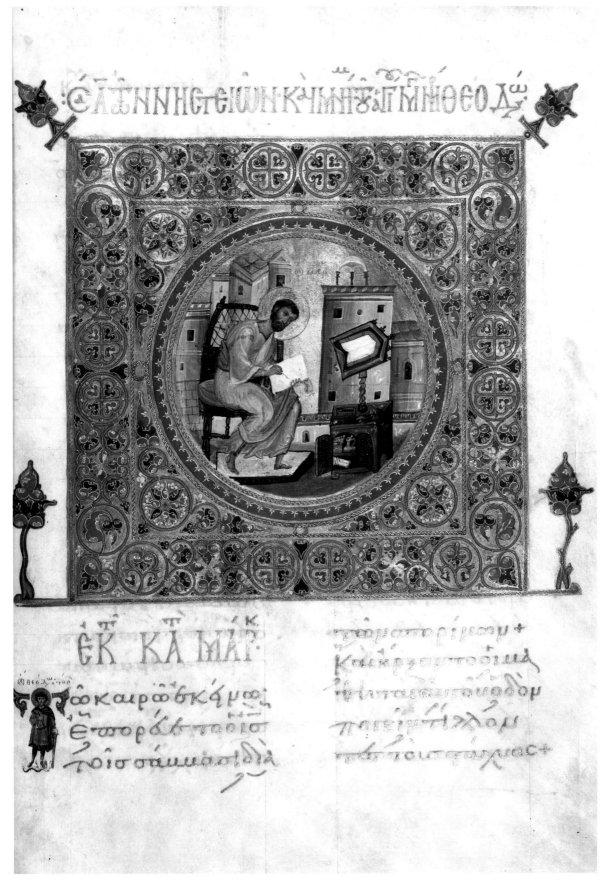

5 St. Mark

major sections of the Lectionary. Four of these miniatures contain portraits of the evangelists from whose Gospel the majority of the subsequent readings of each division are taken (the opening miniature pairs John's portrait with the Harrowing of Hell). The fifth picture precedes the Menologium readings (for saints' feasts) and pairs Christ's Returning the Book of Isaiah in the Temple with the Death of Simeon Stylites.

Illustrated here is the portrait of Mark, which introduces the lessons for Lent and Holy Week. According to established Byzantine conventions, each of the four evangelists conformed to a specific physical type. Mark, as here, was always painted as a dark-haired, bearded, and swarthy young man. Hunched over in the act of writing, Mark assumes a pose whose origins can be traced back to classical antiquity. The elongated figure, however, with its schematized drapery and the two-dimensional backdrop are characteristic of Byzantine illumination in the second half of the eleventh century. Characteristic, too, is the wide gold and foliate frame surrounding this and the four other large miniatures. The style of this illumination is a development of the tenth-century revival of classical forms, the so-called Macedonian Renaissance.

6 ❧

PRESENTATION OF THE VIRGIN IN THE TEMPLE

Gospel Lectionary. G.44, f.2 (267 x 210 mm). Austria, Salzburg, Abbey of St. Peter, ca. 1050. William S. Glazier Collection; deposited in 1963, given in 1984.

Of the many centers of illumination that flourished during the reigns of the Saxon Ottos in the tenth and eleventh centuries—Cologne, Hildesheim, Regensburg, Trier, Fulda, Echternach, Reichenau, Salzburg—none is better represented in the Library than the last. Because of its location, Salzburg both absorbed and transmitted influences between Italy and northern Europe. It was closely allied with Regensburg and receptive to Byzantine style and iconography. This Lectionary, which contains the Gospel readings for the church year, is one of a group of manuscripts, all Gospels or Gospel Lectionaries, produced in Salzburg in the eleventh century. Of these, two others are also in the Morgan Library. The present manuscript

directly anticipates the later Romanesque style in Austria.

This Presentation of the Virgin in the Temple is an early example of the introduction of an apocryphal subject into a Western liturgical book. Its appearance here was undoubtedly due to Byzantine influence, where it occurred earlier. The subject is based on the mid-second-century *Protoevangelium,* an apocryphal Infancy Gospel ascribed to James, a brother of Christ. Of special interest are the two thorn-extractors on the columns flanking the Virgin; these recall the ancient Roman statue of the Spinario, which was also mounted on a column and could still be seen in Rome as late as the twelfth century, when it was regarded by at least one writer as an image of Priapus, god of male generative power. The two women embracing the columns may have a sexual implication, for they recall the barren women who embraced the column of Simeon Stylites to become fruitful. In addition to pagan references, the thorns may refer to hymns that described the Virgin as a lily among roses, free from the thorns of sin.

7 ❧

CIRCUMCISION, PRESENTATION, AND CHRIST AMONG THE DOCTORS

Mathilda Gospels. M.492, f.59v (333 x 226 mm). Italy, Abbey of San Benedetto di Polirone, end of the eleventh century. Purchased, 1912.

This Gospel Book was commissioned by Countess Mathilda of Tuscany as a gift to the Abbey of San Benedetto di Polirone (in northern Italy near Mantua). The Benedictine abbey was founded in 1007 by Mathilda's grandfather, the Marquis Tedaldo, and was later enriched by numerous bequests from her father and herself, becoming one of the wealthiest and most prominent monastic establishments in Italy. Mathilda is especially honored in the commemorative text commissioned by Abbot Wilihelmus (flourished 1088-99) and added at the end of the manuscript. It states that this book should remain on the high altar at all times and lists those the abbey wanted to benefit from the services it celebrated.

The decorative program of the manuscript consists of a sequence of Canon Tables, portraits of the four evangelists, and—rather rare in an Italian Gospel Book of this date—an elaborate series of twenty-seven detailed and lively

6 Presentation of the Virgin in the Temple

7 Circumcision, Presentation, and Christ among the Doctors

illustrations from the life of Christ. The minia-
ture here, which includes three of the seven
episodes preceding the Gospel of Luke, depicts
the Circumcision (where the Christ Child re-
treats in fear from the circumcising knife), the
Presentation of Christ in the Temple, and Mary
and Joseph's finding Christ among the Doctors.

Although the Canon Tables, the portrait of
Matthew, and a few of the larger initials were
completed, all the scenes from the life of Christ
remain in the unfinished state illustrated here.
The miniatures were first drawn in brown ink;

gold was applied to halos, hems, and architec-
tural elements, which were then outlined with
red. The final application of color, for reasons
unknown, was not carried out. In spite of its
incomplete state, the quality of the drawings
alone would rank these Gospels among the
masterpieces of Italian Romanesque art. In-
fluenced by Ottonian illumination in Germany,
the style of Mathilda's Gospels, with its ani-
mated figures and their flowing drapery, marks
a break with Byzantium's hold on Italian art.

ST. JOHN

Gospels of Judith of Flanders. M.709, f.122v (293 x 191 mm). England, 1051-64. Purchased, 1926.

This and another luxury Gospels in the Morgan Library (M.708), as well as two others, were made for Judith of Flanders between 1051 and 1064, when she was in England. The daughter of Count Baldwin of Flanders, she was married about 1051 to Tostig, the son of Earl Godwin and brother of King Harold of England. These books, among the finest surviving Anglo-Saxon manuscripts, exhibit the essentially linear drawing style that ultimately derived from the famous Utrecht Psalter (see III, 3). It is difficult to know exactly where the books were made, especially since their scribes and artists may have traveled as part of Judith's entourage. There is no doubt, however, that she owned the two Morgan Gospels, for in 1094 she bequeathed them to Weingarten Abbey, the ancestral monastery of her second husband, Duke Welf IV of Bavaria, and her burial place. (Judith's son, Welf, at age seventeen, married one of the most distinguished and powerful of her female contemporaries, Countess Mathilda of Tuscany; see III, 7.) The Gospels remained at Weingarten Abbey until 1805, and their influence can be seen on a number of manuscripts produced there in the twelfth and early thirteenth centuries, such as the Berthold Sacramentary (III, 13), the masterpiece of Weingarten illumination.

Shown here is the portrait of John, who is writing the first words of his Gospel in gold, "In principio erat verbum" (In the beginning was the word). In his hands he holds a pen and knife, the latter to sharpen his quill and to scrape away errors. In addition to the expected portraits of the three other evangelists, there is a full-page Crucifixion at the beginning of the book. A small figure kneeling at the foot of the cross and embracing it has been identified as Judith herself.

8 St. John

9 ❧

ASCENSION

Sacramentary. M.641, f.75v (286 x 215 mm).
France, Abbey of Mont-Saint-Michel,
ca. 1060. Purchased, 1919.

Mont-Saint-Michel, the island abbey founded off the coast of France in the eighth century, rose in importance during the time of the Norman Conquest. In the eleventh century, when the colossal building campaign on the towering rock was undertaken, manuscript production at this important monastic site reached its highest pinnacle, and the scriptorium became a pioneer in the emerging style of Romanesque book painting. As a pilgrimage site ideally situated between England and the Continent, the abbey absorbed influences from both and was also in a position to disseminate its distinctive style.

The Sacramentary, which contains the texts read by the celebrant during high Mass, is the most lavishly illuminated manuscript to survive from Mont-Saint-Michel. Its primary decoration consists of eleven full- or half-page miniatures and fourteen historiated initials. The Ascension is executed in an essentially graphic style characteristic of the Norman school of early Romanesque illumination, with figures more drawn than painted. The busy drapery and foliage, the emphasis on the play of jagged lines, and the distinctive palette of light green, soft pinks, and pale purples betray the influence of Anglo-Saxon illumination. This English style of painted or drawn decoration from the tenth and early eleventh centuries emphasized a highly animated line. The iconography of this Ascension, where Christ appears to reach heaven by climbing the slope of the Mount of Olives, is typical for its time—so, too, is the inclusion of the Virgin below, though her presence is not mentioned in the Bible.

9 Ascension

10 Thieves Invading the Burial Church of St. Edmund

10 ❧

THIEVES INVADING THE BURIAL
CHURCH OF ST. EDMUND

Alexis Master. *Life, Passion, and Miracles of
St. Edmund*. M.736, f.18v (274 x 187 mm).
England, Abbey of Bury St. Edmunds, ca. 1130.
Purchased, 1927.

This manuscript, one of the earliest biographies of an English saint with illustrations, was
made for the Abbey of Bury St. Edmunds during the abbacy of St. Anselm (1121-48). In addition to texts relating to the life, passion, and
miracles of St. Edmund (martyred 20 November 870), his Mass and Office were also included. Such lavishly illustrated biographies of

the patron of an abbey were testimonials to
saint and monastery alike.

The thirty-two full-page miniatures at the
beginning of the manuscript form the largest
extant Edmund cycle before the fifteenth century. As such it is a landmark for both the
history of hagiography and art. Almost all the
miniatures depict events described in the passion text by Abbo of Fleury (945-1004). The
rest, illustrating posthumous miracles, are
based on an eclectic miracle text ascribed to
Osbert of Clare, who evidently composed it at
the request of Abbot Anselm shortly before
this manuscript was made, about 1130.

The miniatures have been attributed to the
Alexis Master, credited with the founding of
the St. Albans school of painting. This gifted

11 Scenes from the Life of David

artist is named after the St. Alexis cycle he painted in the famous St. Albans Psalter, now in Hildesheim. He skillfully combined Anglo-Saxon, Ottonian, and Byzantine influences to paint, often in long narrative cycles, in what can be called England's earliest Romanesque style. The St. Albans Psalter cycle differs somewhat in color and modeling from the Morgan miniatures, and it has been suggested that the Morgan miniatures were drawn by the Alexis Master but painted by an assistant.

In the miniature eight thieves attempt to break into St. Edmund's burial place, a Romanesque church with round arches. While the thieves were busy at work, a marvelous miracle occurred: through the posthumous intervention of St. Edmund, they were suddenly paralyzed until the following morning so they were all caught red-handed. Arrested and brought before Bishop Theodred, all eight thieves were ordered hanged from a single pole.

11 ❧

SCENES FROM THE LIFE OF DAVID

Master of the Morgan Leaf. Single leaf from a Bible. M.619, verso (580 x 390 mm). England, Winchester, Cathedral Priory of St. Swithin, ca. 1160-80. Purchased, 1912.

This large glorious leaf was probably created for the Winchester Bible, the most ambitious and finest of all English Romanesque Bibles. This giant Bible, originally in two volumes but now in four, was begun around 1155-60. Its elaborate historiated initials, which introduce the Prologues and Books of the Bible, were the work of at least five artists who labored for more than twenty years. Even so, as indicated by many unfinished initials and blank spaces, the illumination was never completed. At some point after production was under way, a number of full-page frontispieces for individual books was added; two of them, for the books of Judith and Maccabees, survive as unpainted drawings in the manuscript.

The present leaf, the frontispiece to 1 Samuel, is painted, and, if ever inserted in the manuscript, was subsequently removed. Beginning on the other side of the leaf, scenes from the life of David continue here with (top) Saul watching David slay Goliath, (middle) Saul hurling a spear at David and Samuel anointing David, and (bottom) Joab killing Absalom caught in the tree and David mourning the death of his son.

Called one of the finest English paintings of the twelfth century, this leaf is the work of an artist nicknamed the Master of the Morgan Leaf. He was one of the principal artists of the Winchester Bible, working in the period of around 1170-85. On this leaf he painted over drawings by another artist, the so-called Master of the Apocrypha Drawings, a painter whose work dates to an earlier campaign, around 1155-60, and who was also responsible for drawing the two other frontispieces. The Morgan Leaf Master respected his predecessor's drawings on the recto of the leaf, but here, on its verso, he reveals his own distinct style that, especially in its interpretation of drapery, has a softness and fluidity that anticipate the Gothic art of the next century. Nowhere else in the Bible does the power and beauty of his art reach this height. Also attributed to this painter are the magnificent but largely destroyed frescoes from the chapter house of the nunnery at Sigena in Spain; they are now in Barcelona.

12 ❧

FLIGHT INTO EGYPT

Miniatures of the Life of Christ. M.44, f.3 (340 x 222 mm). France, ca. 1200. Purchased, 1902.

This manuscript contains a series of thirty large and impressive pictures, but no text. In all probability the illustrations were originally part of a Psalter, for often such manuscripts, used as prayer books by the laity as well as the ordained, had elaborate picture cycles preceding their texts. This series illustrates the life of Christ from the Annunciation to Pentecost, and concludes with a Last Judgment, Christ as Judge, and the Coronation of the Virgin. Here we see the Holy Family fleeing after Herod commanded the slaughter of all children up to two years of age. A worried attendant hurries the ass with a whip while an angel swinging a censer offers guidance.

The deep glowing colors of the miniatures recall those of stained glass and have led some scholars to compare them to the early windows (ca. 1150-60) of Chartres Cathedral. The classicistic drapery, however, has been compared by others to the early thirteenth-century sculpture of that same church. Still others have noted the similarity of the miniatures and their borders to painted and relief enamels produced at the same time in Limoges; and, indeed, the manuscript has been said to come from the Collegiate Abbey of St. Martial at Limoges. What-

ever their origin and source, these miniatures fall into that fascinating period of transition from Romanesque to Gothic. They have a warmth and charm that is rare in religious art of the Middle Ages.

13 ❧

ADORATION OF THE MAGI

Master of the Berthold Sacramentary. Berthold Sacramentary. M.710, f.19v (293 x 204 mm). Germany, Weingarten Abbey, 1200-32. Purchased, 1926.

The Berthold Sacramentary, named after the abbot of Weingarten who commissioned it between 1200 and 1232, is without question the masterpiece of the Weingarten school of painting. A major monument of Romanesque art, it is possibly the finest and most luxurious thirteenth-century manuscript produced in Ger-

many. Indeed, it occupies a position comparable to that of the twelfth-century Gospels of Henry the Lion (Herzog August Bibliothek, Wolfenbüttel), the masterpiece of the Helmarshausen school, another important monastic center. Unlike the latter, however, the Morgan manuscript still has its original jeweled binding (see VI, 4), which includes depictions of the abbot and the patron saints of Weingarten. Although the codex was formerly known as the Berthold Missal, it is in fact a Sacramentary. Unlike the Missal (which has all of the texts recited at Mass), the Sacramentary contains only those for the celebrant of high Mass.

Most of the Sacramentary's twenty-one full-page miniatures are by an exceptionally forceful and expressive artist who has been named the Master of the Berthold Sacramentary, after this book. Although some antecedents have been suggested for his Adoration of the Magi, the miniature transcends them in every way. At the top the Magi, guided by the star, arrive; the

12 Flight into Egypt

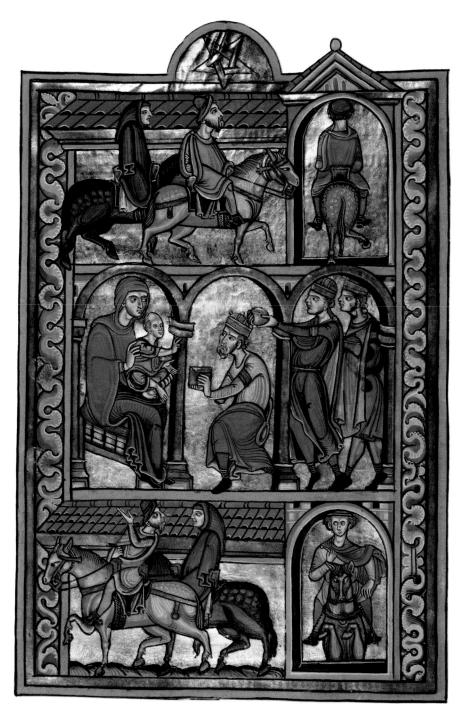

13 Adoration of the Magi

first king is seen turning to ride into the gold background. In the middle the Magi present their gifts to Christ, while at the bottom they emerge from the gold background and discuss what they have seen. Although the makers of the Berthold Sacramentary, in both miniatures and binding, were influenced by the manuscripts in the treasury at Weingarten, such as the two Gospels of Judith of Flanders (see III, 8), they clearly succeeded in creating a monument for Berthold that surpassed them all.

14 ?

CORONATION OF DAVID

Hachette Psalter. G.25, f.4 (225 x 157 mm). England, perhaps London, ca. 1225. William S. Glazier Collection; deposited in 1963, given in 1984.

The decorative program in this majestic Psalter consists of six large pictures that form an impressive pictorial prelude to the whole volume,

a full-page initial *B* introducing Psalm 1, and a series of ornamental and historiated initials marking the liturgical divisions for the psalms. Unlike the customary narrative cycle illustrating the life of Christ (like III, 12), the six pictures are arranged as three diptychs, each devoted to the Virgin, Christ, and King David. In each pair the figure is shown on the left in a scene of humility (the Annunciation, Crucifixion, and David threatened by Saul) and, on the right, of glory (the Virgin and Child Enthroned, Christ in Majesty, and the Coronation of David). Reproduced here is the Coronation of David, as the scroll held by the two angels informs us. Because the two figures crowning David are represented as bishops in contemporaneous ecclesiastic costume, the miniature has been thought by some to reflect a specific coronation or to relate to a historical controversy over the ecclesiastical power of the king.

The style of the attenuated and somewhat angular figures, with their deep drapery folds outlined in black, is characteristic of the early Gothic in England. It can be compared with the earlier English Romanesque style of the Morgan leaf with scenes from the life of David (III, 11) and with that of the Gothic Apocalypse, executed about a generation later (III, 17).

15 ❧

BLANCHE OF CASTILE AND
KING LOUIS IX OF FRANCE and
AUTHOR DICTATING TO A SCRIBE

Moralized Bible. M.240, f.8 (375 x 262 mm). France, probably Paris, ca. 1230. Purchased, 1906.

The present manuscript, containing only eight leaves, was originally the final portion of a monumental three-volume Moralized Bible, today in the library of Toledo Cathedral in Spain. Developed in the early thirteenth century during the reign of Philip Augustus of

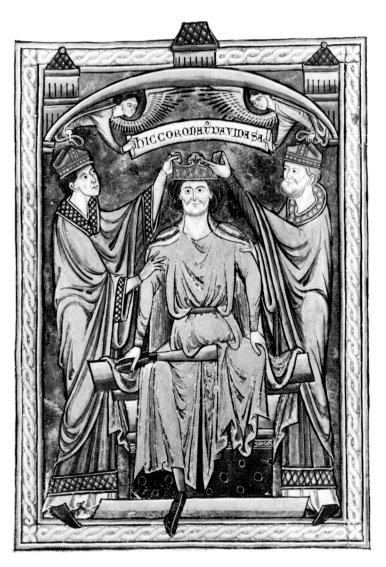

14 Coronation of David

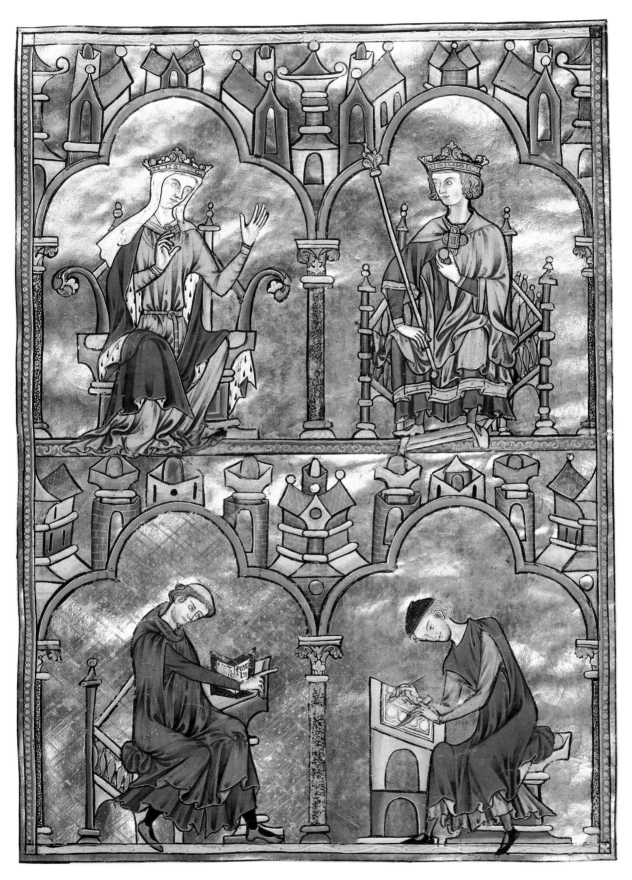

15 Blanche of Castile and King Louis IX *and* Author Dictating to a Scribe

France, the Moralized Bible illustrates the biblical text in great detail, each picture and its biblical passage being accompanied by a second, interpretive or moralizing scene with its textual commentary. For the Toledo volumes with the Morgan fragment, the result is a grand total of some five thousand pictures arranged in medallions.

This large full-page miniature, which occurs at the end of the manuscript, functions as a pictorial colophon for the volumes. At the top are Blanche of Castile (Philip's daughter-in-law) and her son, King Louis IX of France, later canonized as St. Louis. Below her is an ecclesiastic, the editor or "iconographer" of the enterprise who selected the texts and moralizations for this copy and directed the artists. He dictates to a scribe who busily writes in the narrow columns allotted for the text. The leaf on which the scribe works shows the layout of a typical page in the book, consisting of two columns of medallions resembling stained glass and accompanied by narrow columns of text. The picture not only offers portraits of its editor and scribe but also suggests that Blanche, as patron, commissioned the book for her son.

Since Louis ascended the throne of France in 1226 at the tender age of eleven and Blanche was regent until 1234, the manuscript has been dated to the early years of Louis's reign. The queen regent is shown raising her hands toward her son, depicted as a young man, in gestures of instruction and admonition. These edifying gestures parallel those of the author below her. The instructional motif that infuses both registers of the miniature is appropriate for the didactic function of the Moralized Bible. The book would have offered many hours of instruction to the young ruler.

16 ❧

SCENES FROM THE LIFE OF SAUL

Old Testament Miniatures. M.638, f.23v
(390 x 300 mm). France, Paris, 1240s.
Purchased, 1916.

This magnificent leaf shows Saul destroying Nahash and the Ammonites and, below, Saul anointed by Samuel and the sacrifice of peace offerings. It is but one of eighty-six full-page miniatures in the manuscript. In all, nearly three hundred episodes from the Old Testament, from the Creation to the story of David, are represented. The miniatures, among the finest of all thirteenth-century French painting,

are unrivaled in their inventiveness, dramatic narrative, and attention to expressive and realistic detail. The vigorous figures are beautifully drawn, as are the keenly observed costumes, armor, and animals, and the vivid battle scenes are among the finest from the Middle Ages. Although the miniatures may have been planned as part of a luxurious Psalter, it seems more likely that they were made as a lavish Picture Bible.

The manuscript was probably created for Louis IX of France during the 1240s, the same decade in which he was constructing Sainte-Chapelle as a royal preserve for the recently acquired relics of Christ's Passion. The six or seven artists employed in the manuscript may have been mural painters, for the monumentality and breadth of expression of these miniatures—especially the grand battle scenes—relate more to large-scale painting than to manuscript illumination. Scholars have even attributed some murals and stained-glass designs in Sainte-Chapelle to painters of this manuscript.

As a work closely associated with Louis IX, the manuscript can be seen in the context of his ardent crusading interests. The picture cycle emphasizes the battles fought by the Hebrews for the Holy Land, but shows the armies as composed of French knights and infantry. Pictorially, a parallel is suggested between the Hebrews' conquest of the Holy Land and French attempts at its reconquest.

No less extraordinary than the quality of the pictures is the history of the manuscript. It is conjectured that around 1300 the book was taken from Paris to Naples, where the Latin descriptions of the scenes were added. By the early seventeenth century the book, having come north, was in the possession of Cardinal Bernard Maciejowski, bishop of Cracow, duke of Siewierz, and senator of the kingdom of Poland. By 1608, however, the volume was in Persia, having been brought to Isfahan as Maciejowski's gift to the monarch, Shah Abbas the Great, on a mission dispatched by Pope Clement VIII. (The purpose of the mission was to foster the shah's toleration of Christians and to devise military action against the Turks.) The shah had Persian descriptions of the pictures written into the margins. Later in the century, Judeo-Persian transliterations of these descriptions were also added to most leaves. Over two centuries later the book became the property of the noted antiquarian Sir Thomas Phillipps. It was regarded as one of the greatest manuscripts in his collection of some sixty thousand books and manuscripts. Finally, at

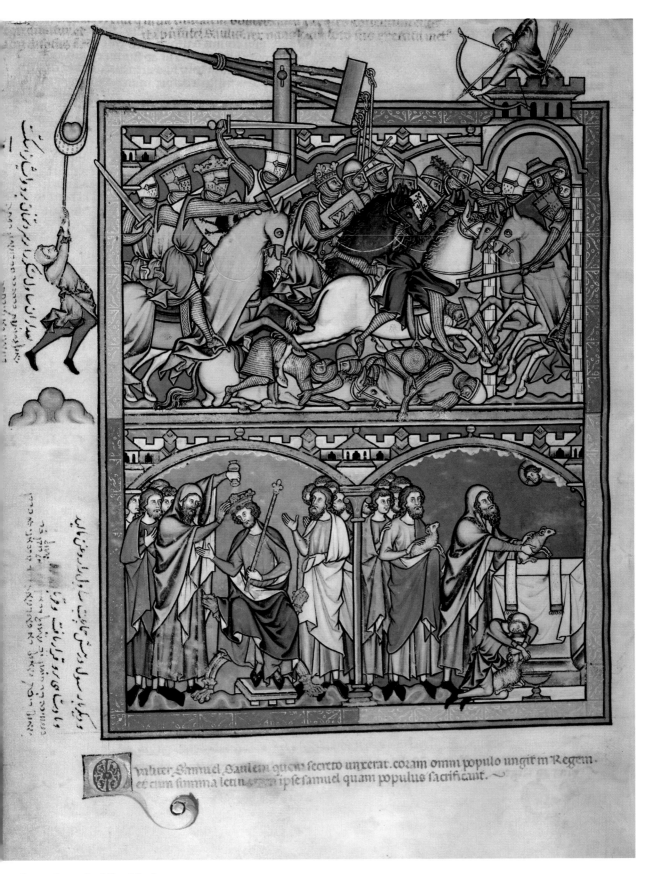

qualiter Samuel Saulem quem secreto unxerat, coram omni populo ungit in Regem. et cum summa letic̃ . . . ipse Samuel quam populus sacrificant. ✦

the great urging of Belle da Costa Greene, it was purchased in 1916 from Phillipps's heirs by J. P. Morgan.

17 ❧

WOMAN CLOTHED WITH THE SUN and ST. MICHAEL BATTLING THE DRAGON

Apocalypse Picture Book. M.524, f.8v (271 x 195 mm). England, London, probably Westminster Abbey, ca. 1255-60. Purchased, 1908.

In the late twelfth century the monk Joachim of Fiore predicted that the world would end in 1260. The circulation of his and similar proph-ecies, as well as the perception of Emperor Frederick II (1194-1250) as the anti-Christ and the threat of the Tartars in eastern Europe, produced an atmosphere that encouraged be-liefs in an approaching final destruction. In this environment, around the middle of the thir-teenth century, a new and consequential cycle of Apocalypse illustration was invented in En-gland. Regarded as that country's most impor-tant pictorial contribution to the late Middle Ages, the series survives in over seventy exam-ples. It continued to influence Apocalypse illus-tration in the fifteenth century, when the cycle was used in the first block book, and into the sixteenth century.

The Morgan Apocalypse is one of the four earliest examples produced in the 1250s. Three

17 Woman Clothed with the Sun *and* St. Michael Battling the Dragon

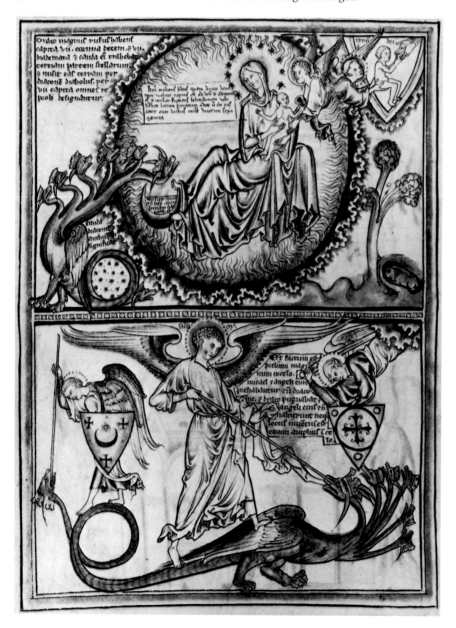

18 First Kiss of Lancelot and Guinevere and Senechal Conversing with the Lady of Malohaut and Laura of Carduel

of these contain cycles of tinted drawings and apparently derive from the same prototype, created shortly before 1250. The Morgan manuscript is thought to be the most accurate reflection of this lost model. The manuscript is in the form of a picture book with double scenes filling each page; biblical quotations or commentaries are inserted into blank spaces in the background or on scrolls. Of the Apocalypses with tinted drawings, the Morgan manuscript is, stylistically, among the most refined and courtly. There is a subtlety of facial expression, pose, and gesture, and the pale washes of the tinting are of remarkable delicacy.

Although the details of the prophecy do not fit exactly, the woman clothed with the sun was identified with the Virgin, the child with Christ, and the dragon with Satan. Representations of the Virgin with the moon under her feet, surrounded by golden rays, and wearing a crown of stars—an iconographic type that would become especially popular in Renaissance and baroque painting—are based on this text.

18 ≈

FIRST KISS OF LANCELOT AND GUINEVERE AND SENECHAL CONVERSING WITH THE LADY OF MALOHAUT AND LAURA OF CARDUEL

Le Roman de Lancelot du Lac. M.805, f.67 detail (346 x 255 mm, leaf size). Northeastern France, early fourteenth century. Purchased on the Lewis Cass Ledyard Fund, 1938.

Between the years 1275 and 1330 Arthurian manuscripts were at the height of popularity, and many illustrated cycles were produced, mostly in lay workshops outside of Paris. The finest and most important depicting the Lancelot legend is this manuscript, which was made in northeastern France, perhaps at Amiens, in the early fourteenth century. The story of Lancelot, one of the most famous knights of King Arthur's Round Table, became especially important when Chrétien de Troyes (about 1170) transformed him into the chivalric lover of Queen Guinevere, the wife of King Arthur.

The present manuscript, with its 39 large miniatures and 107 historiated initials, is a pictorial encyclopedia of medieval chivalry. Not only are there tournaments, battles, kidnappings, and journeys, but also elegant and quieter scenes of banquets and chess playing. The book's best known miniature shows the first kiss of Lancelot and Guinevere, who are accompanied, if not encouraged, by Galehot, the arranger of the meeting. The first kiss was immortalized in Dante's *Divine Comedy* (*Inferno*, Canto V, 127-38), where Francesca da Rimini tells Dante how Paolo, her adulterous lover, was so moved during their reading of the episode that he was compelled to kiss her. They read no more that day, a fact lamented by Dante; otherwise they would have learned of the tragic end of Lancelot and Guinevere and perhaps their own unfortunate demise might have been avoided. (Dante consequently called *Lancelot du Lac* and he who wrote it a *galeotto,* a pimp.)

ارائه بزبای ایستاده تاجون بزین انداستخوان انرشکسته شود وبلرزانشهوت اندل باسدجون
آدروی کشوکند بومینها شرقی والیخون ردوکه غرازی ادرکه کالفاح بسبازماسد وبوی می کود می

وی خودزد تا شهوت زبادت کردد وماده بااوباشد وازدحاسود وجوزکش آمدریامی زبازنیاددکد

19 Two Elephants

The narrative quality of the miniatures, which strictly adhere to the text, is supported by their frieze-like compositions. In the right-hand section of the miniature, against a differently colored background, Senechal converses with the Lady of Malohaut and Laura of Carduel.

19 ❧

Two Elephants

Abu Sa'id 'Ubayd-Allah ibn Ibrahim, known as Ibn Bakhtishu, *Manafi al-Hayawan [Uses of*

Animals], in Persian. M.500, f.13 (335 x 250 mm). Persia, Maragha, dated 1294, 1297, or 1299. Purchased, 1912.

Although Pierpont Morgan was primarily a collector of medieval Christian manuscripts, he acquired several Islamic manuscripts and albums. Of these, this manuscript of the *Manafi al-Hayawan*, which was painted in the city of Maragha in northwest Persia in the last decade of the thirteenth century, is the best known and the most important. It has been ranked among the ten greatest of all Persian manuscripts.

This *Manafi-al-Hayawan*, or Bestiary, is the earliest dated manuscript of the Mongol period. The illustrations were executed during the reign of the Mongol ruler Ghazan Khan (1295-1304), who ordered the text translated from Arabic into Persian. The text and miniatures deal with various animals, birds, reptiles, fish, and insects, as well as some human figures. Like the Western medieval Bestiary, the animals begin with the lion. The text, however, is free from Christian moralizations and deals only with the nature of the animals and their medicinal properties.

The Mongol invasion of Persia and Mesopotamia, which culminated in 1258 with the conquest of Baghdad, was of great importance in the development of Islamic painting. The Mongols brought a new Chinese style, with more naturalistic depictions of animals, plants, and receding landscapes, which was added to the pre-existing Persian conventions in which stylized figures moved in shallow planes. The Morgan codex is of great importance because it shows the first confrontation with and assimilation of these new Eastern ideas on Persian soil. The manuscript and two others with the same characteristics and probably by the same artists can be attributed to the Maragha school.

The two interlocking and rather affectionate elephants shown here make up one of the finest of the forty-four large illustrations in the book. They are royal elephants, as seen from their caps and the bells on their feet. According to the text the tongue of the elephant is upside down, for if it were not, the animal could speak. Among the medicinal derivatives are suggestions that elephant broth is good for colds and asthma and that elephant droppings could be used to prevent conception.

20

NATIVITY

Silvestro dei Gherarducci and workshop.
Single leaf from a Gradual. M.653, f.i
(590 x 400 mm). Italy, Florence, Monastery of Santa Maria degli Angeli, last third of the fourteenth century. Purchased, 1909.

This leaf, four others, and eighteen historiated initials in the Library were cut from choir books illuminated at the Camaldolese Monastery of Santa Maria degli Angeli in Florence. Under the leadership of Silvestro dei Gherarducci (died 1399), that monastery's school of illumination assumed a position of importance

during the second half of the fourteenth century. The creations of Silvestro and the scribe Jacopo are praised by Vasari in his *Lives of the Painters* (1st ed. 1550), where he writes, "I, who have seen them many times, am lost in astonishment that they should have been executed with such good design and with such diligence at that time, when all arts of design were little better than lost.... It is reported that when Pope Leo X came to Florence he wished to see and closely examine these books, since he remembered having heard them highly praised by the Magnificent Lorenzo de' Medici, his father. After he had attentively looked through them and admired them, ... he said, 'If they were in accordance with the rules of the Roman church and not the Camaldolese we should like some specimens for St. Peter's at Rome, for which we would pay the monks a just price.' There were, and perhaps still are, two very fine ones [illuminations] at St. Peter's by the same monks." Although we cannot be sure that this account refers to the Morgan cuttings, Vasari's praise is a fitting tribute to what must have been one of the most glorious choir books of its time. Vasari also states that the monastery preserved Silvestro's right hand in a tabernacle; it is, alas, not preserved (the relic in question may actually have been that of a different Silvester who died in 1348 and who was cook for the monastery).

This leaf was once part of a Gradual, the choir book containing the music for the Mass. Here a large historiated *P* begins the introit for the third (and major) Mass of Christmas: "Puer natus est nobis...." (A child is born to us...). The giant letter encloses a Nativity in which the kneeling Joseph reverently kisses the Savior's foot. Heads peer from the foliage of the stem of the letter, and shepherds, to whom angels announce Christ's birth, appear in the lower margin.

21

VIRGIN WITH THE WRITING CHRIST CHILD

Circle of Jacquemart de Hesdin, Boxwood Sketchbook. M.346, f.1v (129 x 70 mm). France, probably Paris, late fourteenth century. Purchased, 1906.

Medieval sketchbooks are exceedingly rare, and those executed on boxwood are even rarer. In fact only two such examples are known, this one of the late fourteenth century and an early

21 Virgin with the Writing Christ Child

fifteenth-century sketchbook executed by the Flemish artist Jacques Daliwe (Berlin, Deutsche Staatsbibliothek, A 74). The Morgan sketchbook consists of six panels: four thin "leaves" and two thicker covers. It contains the Virgin and Child illustrated here, a jousting scene, courtly figures, numerous heads (of which two have been tentatively identified as Charles VI of France and his wife, Isabeau of Bavaria), and some half-length figures, some of which are thought to depict the "wild men" costumes worn by courtiers at a celebrated masked ball in 1393. Another drawing of a Virgin and Child on a single piece of boxwood, also in the Morgan Library, has recently been identified as also coming from the sketchbook.

The delicacy and high quality of the Virgin with the Writing Christ Child and other draw-

ings in the sketchbook have led to their attribution to Jacquemart de Hesdin, who was active from 1384 to 1413 and who worked for Jean, duc de Berry, the uncle of Charles VI. The Virgin and Child drawing is certainly similar to a miniature of the same subject—including the rare motif of the writing Christ—in the duc de Berry's *Très Belles Heures* of the late fourteenth century (Brussels, Bibliothèque Royale, Mss. 11060-61). But while documents connect that Book of Hours with Jacquemart, its miniature of the Madonna, which is dated about 1385, was inserted into the slightly later manuscript and is not by him. Certain drawings in the sketchbook, on the other hand, resemble the work of André Beauneveu, a sculptor active in the second half of the fourteenth century and employed by the duc de Berry as an illuminator. Precise attributions are made difficult by the fact that more than one hand was involved; also ultraviolet light reveals that some sketches were erased and others were added on top at slightly later dates.

22 🍂

MAKING SNARES AND FEEDING DOGS

Gaston Phébus, *Livre de la chasse*. M.1044, f.45 (385 x 287 mm). France, Paris, ca. 1410. Bequest of Miss Clara S. Peck, 1983.

Gaston III (1331-91), count of Foix-Béarn, nicknamed Phébus because of his golden hair or handsome appearance, wrote his famous *Book of the Chase*, the most popular and influential medieval treatise on hunting, between 1387 and 1389. The text is divided into four books: 1) On gentle and wild beasts, 2) On the nature of dogs and their care, 3) On the instruction of hunters and hunting with dogs, 4) On hunting with traps, snares, and cross-bow. The unusual emphasis on dogs is striking; it is a subject on which Phébus was expert, for he, according to the famous chronicler Jean Froissart, bred various kinds of hunting dogs and kept kennels for at least 1,600 hounds. The miniature reproduced here (from Book 2) depicts different types of rope snares, but it also includes two men feeding dogs, though they are not mentioned in the accompanying text. The eighty-seven miniatures of this manuscript unfold, like a series of tapestries, to show us the appearances and habits of the numerous animals, the variety of apparatus and maneuvers involved in the hunt, and the costumes of both the aristocratic hunters and their servants.

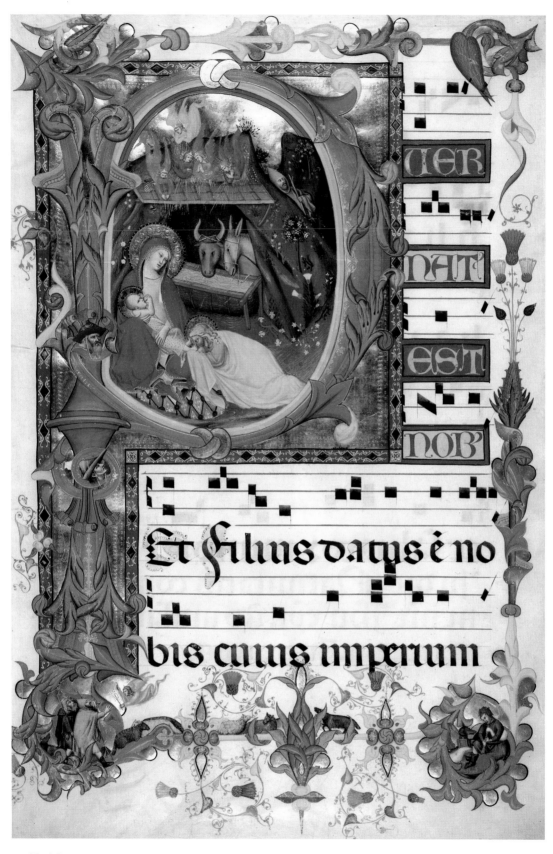

22 Making Snares and Feeding Dogs

The *Livre de la chasse* survives in forty-six manuscripts of which four, including this one, are the oldest and textually the most reliable. Another of the four, a manuscript in the Bibliothèque Nationale in Paris (fr. 616), is a sister manuscript and contains the same number of miniatures (87). Both were painted in the same workshop within a few years of each other and together are regarded as the most beautiful copies of the work.

The manuscript contains the arms of Brittany and may have been made for John the Good, duke of Brittany from 1399 to 1442. It was subsequently owned by Ferdinand and Isabella of Spain, who had a lavish full-page miniature of their coat-of-arms added at the beginning of the book.

23 &

St. Luke Painting the Virgin

Michelino da Besozzo. Prayer Book. M.944, f.75v (170 x 120 mm). Italy, Milan, ca. 1420. Purchased with the generous assistance of Miss Alice Tully in memory of Dr. Edward Graeffe, 1970.

Between the covers of this small prayer book are most of the surviving paintings by Michelino Molinari da Besozzo, a leading Lombard painter of the early fifteenth century. He was highly regarded by his contemporaries, who referred to him as the "supreme painter" and "the most excellent of all the painters in the world." Although Michelino came from nearby

Pavia, he worked most of his life in Milan, where he is mentioned as a master of stained glass and a painter of frescoes in the documents of that city's cathedral between 1398 and 1443. This versatile artist was also an illuminator, a panel painter, and perhaps an architect. He was especially famous for his lifelike renderings of animals. In about 1400 the Milanese humanist and scribe Uberto Decembrio wrote that Michelino made precocious animal studies before he could even speak. Most of Michelino's works, however, no longer survive, and his only signed work, a panel in Siena of the Mystic Marriage of St. Catherine, is the basis of all attributions to him.

Of his few surviving manuscripts, this prayer book is clearly his masterpiece. The twenty-two remaining miniatures betray an assurance and virtuosity that place them among Michelino's mature works, as do the breadth and modeling of the figures. The miniatures and their accompanying prayers are arranged according to the liturgical year, beginning with the Nativity and prayers for Christmas. In the miniature of St. Luke, the evangelist is putting the finishing touches on a small panel of the Virgin and Child. This is one of the earliest Western depictions of St. Luke painting the Virgin, which became especially popular later in the century because Luke was the patron saint of painters and painters' guilds.

23 St. Luke Painting the Virgin

24 Holy Family at Supper

HOLY FAMILY AT SUPPER

Master of Catherine of Cleves. Hours of
Catherine of Cleves. M.917, p.151
(192 x 130 mm). The Netherlands, Utrecht,
ca. 1440. Purchased on the Belle da Costa
Greene Fund and with the assistance of the
Fellows, 1963.

The Master of Catherine of Cleves was, with-
out question, the most gifted and original artist
of the "Golden Age" of Dutch manuscript
painting. This Book of Hours, painted about
1440 for Catherine of Cleves and after which
he is named, is his masterpiece. Because the
thirteen other manuscripts in which he partici-
pated range in date from 1430 to 1460, it is
even possible to follow his stylistic develop-
ment. His early works are draughtsmanlike
and thinly painted, while in his mature phase,
which includes the Cleves Hours, figures and
compositions are more balanced and solidly
painted. In his late works the supple drapery
becomes harder, more angular, and mannered.
The richness of his palette, his extraordinary
powers of observation (in which the most mi-
nute details are captured), the everyday realism
of his biblical scenes, and his complex icon-
ography serve to rank the Cleves Master with
the greatest of all illuminators.

Over a century ago a dealer divided the then
complete manuscript into two parts, each of
which he subsequently sold as complete. Ac-
quired at different times from different sources,
both parts are once again reunited under the
same roof. Their 157 miniatures (a few have
been lost) form numerous cycles, many of
which are not only unusual, but also without
precedent. Their artistic sources are not re-
stricted to earlier Dutch traditions but include
French illumination, Flemish panel painting,
and engravings. The resulting manuscript is
one of the richest of all Books of Hours and is
a key monument in the history of this kind of
manuscript.

Though not a full-page miniature, the repro-
duced Holy Family at Supper is one of the most
intriguing miniatures in the book, for it antici-
pates the genre scenes of the great Golden Age
of Dutch painting by such seventeenth-century
artists as Vermeer. Especially attractive is the
coziness of the little kitchen with its superbly
observed fireplace and the finely painted wisps
of smoke. The Virgin, nursing her Child, sits on
a mat, while Joseph, resting on a chair that he
presumably cut from a barrel, spoons soup.

ST. MATTHEW

Barthélemy van Eyck. Book of Hours. M.358,
f.17 (250 x 180 mm). France, Aix-en-Provence,
ca. 1445. Purchased, 1909.

This St. Matthew and some other miniatures in
this unfinished Book of Hours have recently
been attributed to Barthélemy van Eyck, court
painter and *"varlet de chambre"* to King René
d'Anjou (1409-80). Although his name indi-
cates that he may have come from the same
region as Jan van Eyck, Barthélemy was not a
blood relative of the much more famous Flem-
ish painter. In a way, however, Jan van Eyck
served as Barthélemy's artistic parent, for it is
clear that the latter knew Jan's work and was
indebted to him for aspects of style and, at least
in one case, iconography. Eyckian in this minia-
ture are the minutely observed facial features
of Barthélemy's evangelist and the meticulous
treatment of drapery. The lavish attention Bar-
thélemy bestows on the gilt and painted diaper
background, too, recalls Jan's fascination with
and careful rendering of jewels and metalwork.

Barthélemy was in the service of René d'An-
jou from at least 1447 until his death in 1475/
76. As a high ranking official—and a much
appreciated one—he accompanied René on his
travels from Provence, visiting Naples, Switzer-
land, and Burgundy. As was typical of talented
court artists in the fifteenth century, Barthé-
lemy did not confine his talents to a single
medium. He also painted panels (such as the
famous *Aix Annunciation*, 1443-45, for Pierre
Corpici, René's wealthy cloth merchant), as
well as pictures on cloth, watercolors, cartoons
for murals, and designs for embroidery. Per-
haps the finest of his illuminations is the series
of enchanting, often reproduced, pictures he
painted in the *Coeur d'amour éspris*, a poem
written by René himself (Vienna, Österreich-
ische Nationalbibliothek, Cod. 2597), and after
which the artist was once known as the Master
of the *Coeur d'amour éspris*.

Collaborating with Barthélemy and execut-
ing three miniatures in the Morgan Hours was
the French painter Enguerrand Quarton, best
known for his panel called the *Avignon Pietà*.
Because the manuscript remained unfinished
(on the Matthew page, for example, the figures
in the borders were drawn but never painted),
it provides a fascinating record of illuminators'
working procedures.

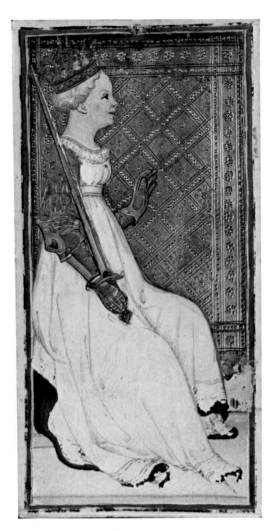

26 Queen of Swords

divided into four fourteen-card suits (cups, staves, coins, and swords). Each suit was made up of ten number cards plus four picture cards (page, knight, queen, and king).

In the Renaissance tarot cards were not the paraphernalia of fortune tellers but were used in a normal card game enjoyed by the nobility. The game, the rules of which have been lost, was invented in northern Italy, probably in Milan or Ferrara, in the second quarter of the fifteenth century. The astrological use of tarot cards derives from scholarly misinformation published by Antoine Court de Gébelin in 1781. He traced their origin to ancient Egypt, identifying them with the Book of Thoth (see III, 1), the scribe of the Egyptian gods.

All three of the earliest decks have been attributed to the Cremonese painter and illuminator Bonifacio Bembo (active 1440-80). More recently, however, the Morgan deck has been given to Francesco Zavattari (active 1417-83), the slightly older illuminator and fresco painter in whose circle Bembo worked. Six cards in a different style, which are apparently replacements, were painted by Antonio Cicognara at the end of the fifteenth century.

This deck may have been made for Bianca Maria Visconti and Francesco Sforza, whose betrothal (1432) and marriage (1441) united the two families. In any case the emblems of both families, intermingled on the cards, reveal that they were made for some member of the Visconti-Sforza family.

26 ∂∙

QUEEN OF SWORDS

Bonifacio Bembo or Francesco Zavattari. Visconti-Sforza Tarot Cards. M.630, no. 23 (173 x 87 mm). Italy, Milan, ca. 1450. Purchased, 1911.

Fifteenth-century painted tarot cards of Italian origin are exceedingly rare, and no complete deck has survived. The thirty-five cards in the Morgan Library, twenty-six in the Accademia Carrara in Bergamo, and thirteen owned by the Colleoni family of Bergamo form the most complete and one of the most important sets known. A complete pack consisted of seventy-eight cards: twenty-one trump (tarot) cards, one wild card (the Fool), and fifty-six cards

27 ∂∙

ANNUNCIATION

Jean Fouquet. Book of Hours. M.834, f.29 (108 x 80 mm). France, Tours, ca. 1460. Purchased with the assistance of the Fellows, 1950.

The greatest French painter of the fifteenth century was unquestionably Jean Fouquet of Tours. Although he painted important portraits of Charles VII and others, most of his painting is to be found in manuscripts. The most impressive of these was the Book of Hours in Chantilly (Musée Condé) made for Etienne Chevalier (ca. 1410-74), treasurer of France from 1452. Aside from the Chevalier Hours, which was probably executed between 1452 and 1456, the Morgan manuscript and a recently discovered fragment now in the J. Paul Getty Museum (MS 7) are the only other Books

25 St. Matthew

27 Annunciation

surrounding vellum has been painted to suggest a black marble wall.

FRONTISPIECE WITH ST. JEROME, KING CORVINUS OF HUNGARY, AND QUEEN BEATRICE OF ARAGON

Monte di Giovanni del Fora. Didymus Alexandrinus, *De spiritu sancto,* and other texts. M.496, f.2 (345 x 230 mm). Italy, Florence, dated 1488. Purchased, 1912.

Humanism entered Hungary under the great bibliophilic King Matthias Corvinus (1443?-90). His large library at Buda was thought to have contained several thousand manuscripts, and his goal, as related by his Italian librarian, Bartholomaeus Fontius, was to outshine every other monarch with his collection. To date, alas, only 216 codices, mostly manuscripts, have survived from the Bibliotheca Corviniana. The Morgan Library owns two splendid manuscripts from that library, a humanist copy of the works of Cicero that Corvinus acquired second hand, and this volume, which was made for him and is by far the more important of the two. Dated 4 December 1488, it was written and signed by Sigismundus de Sigismundis in Florence; it was illuminated by Monte di Giovanni del Fora. A total of five surviving codices, all dated 1488, were illuminated by Monte and his brother Gherardo for Corvinus.

The opening text, Jerome's preface to the Didymus text, is embellished by a grand trompe-l'oeil architectural frame decorated with gilt classical trophies, antique reliefs and medallions, and festooned with garlands. At the center, depicted as a humanist scholar, Jerome sits, peering out at the viewer as if through a circular window. Behind him rises a view of Florence, including the cathedral and its baptistery. Above and below the window, and simulating carved inscriptions, are the title and opening words of the preface written in gold against purple. Above the top panel hovers an illusionistically rendered dove, symbol of the Holy Spirit and subject of the Didymus text. Behind the left column kneel Matthias Corvinus and, behind him, his son with his tutor, Taddeo Ugoleto, who was the king's librarian before Fontius. At the right kneels Corvinus's queen, Beatrice of Aragon, and two members of her family.

of Hours to which we know Fouquet contributed miniatures.

This book was left unfinished by Fouquet and his assistants about 1460, being completed about 1470 by Jean Colombe for its second owner, Jean Robertet. The initials *AR* and motto "S'il avient" (Behold, he arrives) occur on the Annunciation and point to the original owner as possibly Antoine Raguier, who died in 1468. In this Annunciation, the finest of the eight miniatures attributed to Fouquet himself, the event no longer takes place in the interior of a Gothic chapel, as in the Chevalier Hours, but in a Renaissance passageway. Architecture, stone inscriptions, classical putti, and perspective betray the influence of Italian art. Fouquet had firsthand knowledge of that art, for between 1443 and 1447 he visited Rome, where Pope Eugenius IV commissioned a portrait from him. The Annunciation marks the beginning of Matins, the first of the Hours of the Virgin; the opening words, "Domine labia mea aperies" (Lord, Thou shalt open my lips), are carved in relief on the architectural base. The

28 Frontispiece with St. Jerome, King Corvinus of Hungary, and Queen Beatrice of Aragon

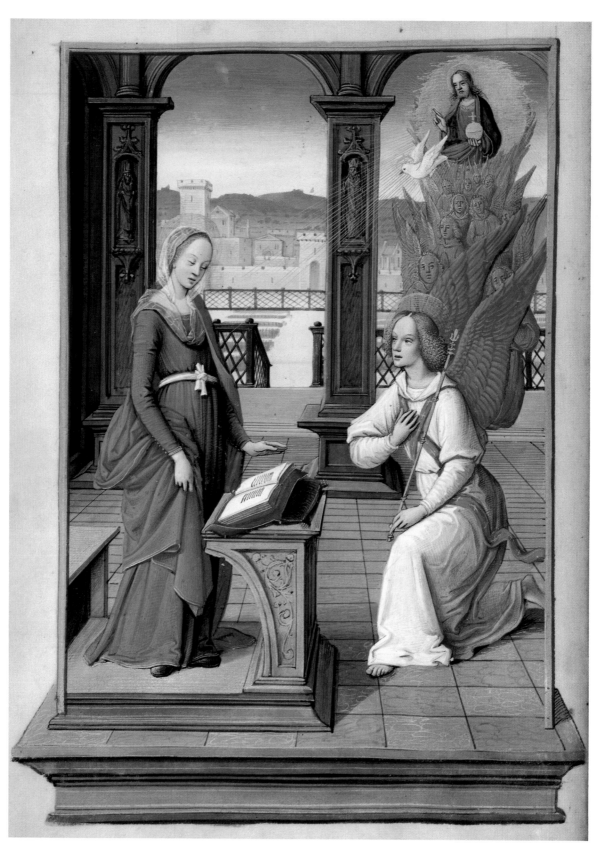

29 Annunciation

ANNUNCIATION

Jean Poyet. Book of Hours. H.8, f.30v (256 x 180 mm). France, Tours, ca. 1500. Dannie and Hettie Heineman Collection; deposited in 1962, given in 1977.

Until just a few years ago any French illumination of high quality from around 1500 (including this manuscript) was attributed to Jean Bourdichon, an artist working in Tours and known for the fine books he painted for the French court (see III, 30). Working in Tours at the same time and often for the same patrons was another artist, Jean Poyet, who was as famous in his own day as Bourdichon but later fell into obscurity. Poyet's patrons included Charles VIII, Anne de Bretagne (queen to two kings of France, Charles VIII and Louis XII), and the Lallemant family of Bourges, discriminating patrons of illumination. Although the evidence for attributing these works to Poyet is circumstantial, his fame, gleaned from contemporaneous documents, matches in time and place the large body of consistently high-quality illumination that has grown up around his name in the last ten years.

This Book of Hours, perhaps Poyet's masterpiece, contains a rich cycle of fifty-four miniatures, many of which are accompanied by marginal scenes painted in monochromes of blue, purple, red, or brown, highlighted with gold. The Annunciation, shown here, is typical of Poyet's novel treatment of a traditional subject. The illuminator places the moment of Christ's Incarnation within an open portico; our gaze is gently led from the foreground, by means of the orthogonals formed by the gold tiles, through the tall arches, and on to the carefully depicted plots of vegetation in the garden (Poyet was famous for his mastery of perspective). Our eye examines the pale walls of the distant city before continuing on to the even more distant mountains, whose blue echoes that of the Virgin's mantle and Gabriel's wings and stole. This royal blue, plus plum, pale pink, and dusty gold are typical colors from Poyet's palette. Also characteristic are the restrained intensity in the faces of Mary and Gabriel and the quiet grandeur of the setting.

According to a tradition that goes back to the eighteenth century, this book was given to Henry VIII of England by Emperor Charles V. The metal clasps of its eighteenth-century binding bear the name, arms, and motto of that English king.

NATIVITY

Jean Bourdichon. Book of Hours. M.732, f.31v (302 x 200 mm). France, Tours, ca. 1515. Purchased, 1927.

The masterpiece of Jean Bourdichon and one of the most famous manuscripts of the Renaissance is the *Grandes Heures* of Anne de Bretagne in Paris (Bibliothèque Nationale, lat. 9474). Anne, queen to two kings of France (Charles VIII and Louis XII), paid Bourdichon the sum of 1,050 *livres tournois* or 600 *écus* of gold in 1508, a staggering amount at that time for a book. On the basis of Bourdichon's documented connection with Anne's manuscript, a large number of other works have been attributed to him, although these often include works from his prolific shop, followers, or various contemporaries. Among the surest attributions to Bourdichon is the present fragmentary Book of Hours, the surviving portions of which closely resemble the *Grandes Heures* itself. If, like that work, it also had forty-nine full-page miniatures (only eight remain), it too must have been made for an equally high ranking patron.

As in the *Grandes Heures,* the miniatures are conceived as close-up icon-like images in which the narrative element has been largely eliminated. In the Nativity, for example, the devotional character of the miniatures is further enhanced by their strongly projecting Renaissance frames, which do not occur in the *Grandes Heures.* The white porcelain-like face of the Virgin is a hallmark of Bourdichon's style, as is his interest in differing light sources. Here, for example, the scene is bathed in light from the star, the lantern held by Joseph, and the rays emanating from the Christ Child.

Although it has been suggested that this book was made shortly before and as preparation for the *Grandes Heures,* it was more likely made afterwards. Frames comparable to those here, for example, are found in two other Books of Hours by Bourdichon that are regarded as late works. The artist lived until at least 1520, when he contributed decorations for the famous meeting of Francis I of France and Henry VIII of England at the Field of the Cloth of Gold, but by 29 July 1521 he was dead.

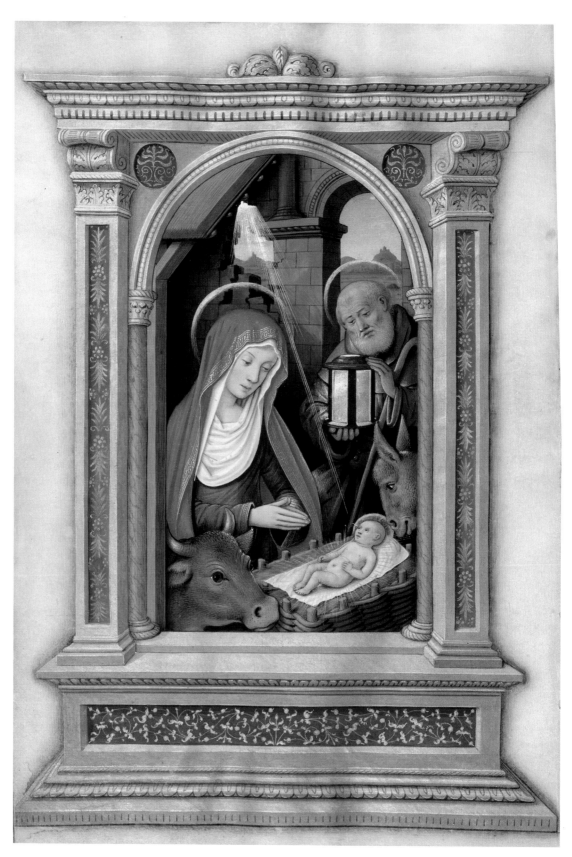

30 Nativity

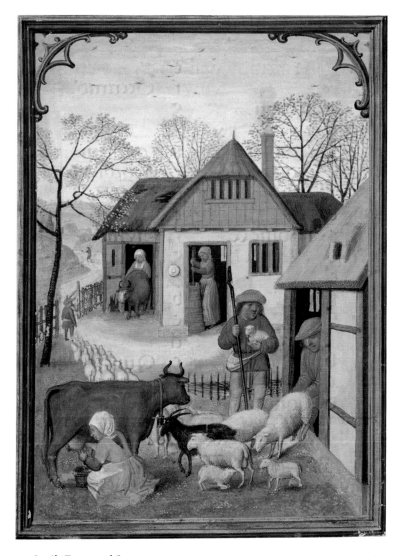

31 April: Farmyard Scene

31 ⧚

APRIL: FARMYARD SCENE

Simon Bening. Da Costa Hours. M.399, f.5v
(172 x 125 mm). Belgium, Bruges, ca. 1515.
Purchased, 1910.

Calendars in Books of Hours, beginning even
with the earliest examples in the late thirteenth
century, were sometimes illustrated by vi-
gnettes depicting the "labors of the months."
These were the seasonal activities, usually rural
and performed by peasants, that took place
throughout the course of each year: shearing
sheep in June, mowing hay in July, reaping
wheat in August, for example. Throughout the

fourteenth and most of the fifteenth century,
calendrical illustrations were usually small, but
by the end of the fifteenth and early sixteenth
centuries, these secular subjects received great-
er artistic attention, especially from Simon
Bening.

A Flemish illuminator working in Bruges in
the early sixteenth century, Simon Bening was
both the son of, and a father to, an illuminator.
His father, Alexander, was one of the leading
illuminators in Flanders of the late fifteenth
century, and his daughter, Lavinia, was to take
her skills as a portrait miniaturist to the court
of Henry VIII of England in the mid-sixteenth
century. Of this family of painters, however,
Simon's fame is the most enduring. Having

died in Bruges before 1561, he is usually regarded as the last great Flemish illuminator. His works were highly sought after, not only in Belgium, but also in Italy, Portugal, and Germany. The present Hours, for example, was made for a member of the Portuguese Sá family, from whom it passed to King Manuel's armorer, Alvaro da Costa, after whom the manuscript takes its name.

Bening was especially known for the sensitively rendered landscapes in his cycles of full-page calendar illustrations. Such cycles had not occurred in manuscripts since their initial and singular appearance, almost exactly a hundred years earlier, in the *Très Riches Heures* of the duc de Berry. That celebrated manuscript, which was then in the library of Margaret of Austria in Malines, provided the stimulus to Bening for these cycles, of which this example is the earliest. Bening, however, also added to their complexity and scope. April, for example, is full of activity: men taking their sheep to pasture, a woman milking, a second woman leading a cow to graze, and a third one churning. The winding road, delicately flowering trees, and pale blue, atmospheric sky make the painterly and poetic achievements of this miniature akin to those of a large-scale landscape.

32 &

ADORATION OF THE MAGI and SOLOMON ADORED BY THE QUEEN OF SHEBA

Giulio Clovio. Farnese Hours. M.69, ff. 38v-39 (each folio 173 x 110 mm). Italy, Rome, dated 1546. Purchased, 1903.

"There has never been, nor perhaps will there ever be for many centuries, a more rare or more excellent miniaturist, or we would rather say, painter of little things, than Don Giulio Clovio." With this sentence Giorgio Vasari begins his account of the artist's life in the second edition of *Lives of the Painters* (1568). Vasari, a contemporary of Clovio (1498-1578), held the Farnese Hours—the artist's undisputed masterpiece—in such high esteem that he felt obliged to describe it in considerable detail, arguing that in this way such a private treasure might be shared with everyone. Clovio, though born in Croatia, made his career as an illuminator in Italy, mostly in Rome. The colophon states that he completed this monument *("Monumenta Haec")* in 1546 for his patron Cardinal Alessandro Farnese. Vasari tells us the work was finished after nine years and "required such study and labor that it would never be possible to pay for it... all is executed with such beauty and grace of manner that it seems impossible that it could have been fashioned by the hand of man. Thus we may say that Don Giulio has surpassed in this field both the ancients and the moderns, and that he has been in our times a new, if smaller, Michelangelo."

The Farnese Hours, justly regarded as the last great Italian manuscript, is also a superb mirror of Mannerist art: here one can see, for example, the *figura serpintinata* of Michelangelo and the elongated and sinuous forms of Pontormo. Mannerist, too, are the seemingly indefatigable love of surprise, the novelty, ingenuity, virtuosity, rampant complexity, scintillating color, and spatial effects, all of which appealed to connoisseurs of the day.

Most of the twenty-six full-page miniatures are grouped typologically, pairing a New Testament event with its Old Testament antecedent. Here, for example, the Magi's visiting Christ has been paired with the queen of Sheba's visit to Solomon. The latter scene contains two portraits, those of Cardinal Farnese (as Solomon) and the unidentified dwarf who, wearing painter's clothes, becomes a kind of pun, for he is actually a "miniature" painter. Solomon's Temple is shown with the twisted columns that, according to legend, were subsequently used in Old St. Peter's.

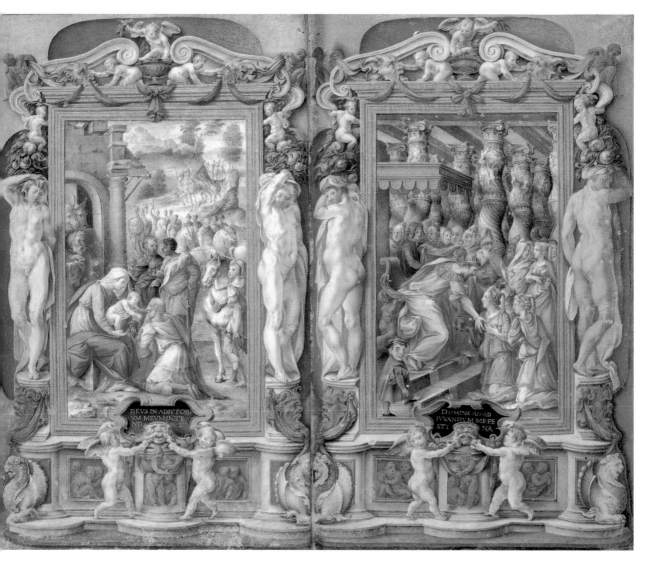

2 Adoration of the Magi *and* Solomon Adored by the Queen of Sheba

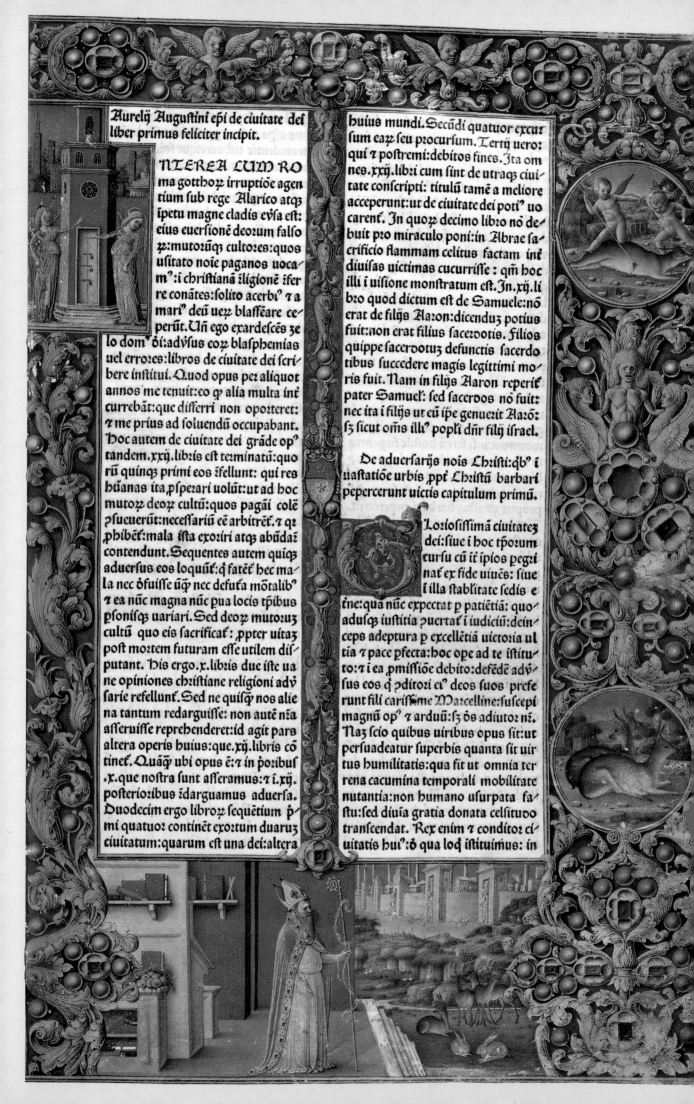

NTEREA CUM RO ma gottho2 irruptióe agen tium sub rege Alarico atq3 ipetu magne cladis evsa est: eius euersione deo2um falso 2: muto2uq3 culto2es: quos usitato noie paganos uoca m9: i christianá 2ligioné 2fer re conátes: solito acerbi9 7 a mari9 deú ue2 blasseare ce perút. Uh ego exardesces ze lo dom9 oi: adv9us co2 blasphemias uel erro2es: libros de ciuitate dei scri bere institui. Quod opus pe2 aliquot annos me tenuit: eo q7 alia multa int currebát: que differri non opo2teret: 7 me prius ad soluendú occupabant. Hoc autem de ciuitate dei grade op9 tandem. xxij. lib2is est te2minatú: quo rú quinq3 primi eos 2fellunt: qui res húanas ita p2spe2ari uolút: ut ad hoc muto2 deo2 cultú: quos pagái colé p2ucuerút: necessariú eé arbitrét. 7 q7 p2hibét: mala ista exo2iri atq3 abúdaz contendunt. Sequentes autem quiq3 aduersus eos loquút: q7 fatét hec ma la nec ófuisse úq7 nec defuta mótalib9 7 ea núc magna núc pua locis t2ibus p2onisq3 uariari. Sed deo2 muto2uz cultú quo eis sacrificat: p2pter uitaz post mo2tem futuram esse utilem dis putant. His ergo. x. lib2is due iste ua ne opiniones christiane religioni adv9 sarie refellunt. Sed ne quisq3 nos alie na tantum redarguisse: non auté n2a asseruisse reprehenderet: id agit pars altera operis huius: que. xij. lib2is có tinet. Quáq3 ubi opus é: 7 in po2ibus .x. que nostra sunt asseramus: 7 i. xij. posterio2ibus idarguamus aduersa. Duodecim ergo libro2 sequétium p2 mi quatuo2 continét exo2tum duaruz ciuitatum: quarum est una dei: altera

huius mundi. Secúdi quatuor excu2 sum ea2 seu p2ocursum. Te2tij uero: qui 7 postremi: debitos fines. Ita om nes. xxij. lib2i cum sint de utraq3 ciui tate conscripti: titulú tamé a meliore accepe2unt: ut de ciuitate dei poti9 uo carent. In quo2 decimo lib2o nó de buit p2o miraculo poni: in Ab2ae sa crificio flammam celitus factam int diuisas uictimas cucurrisse: qm hoc illi i uisione monstratum est. In. xij. li b2o quod dictum est de Samuele: nó erat de filijs Aa2on: dicenduz potius fuit: non erat filius sace2dotis. Filios quippe sace2dotuz defunctis sace2do tibus succedere magis legittimi mo ris fuit. Nam in filijs Aaron repe2it pater Samuel: sed sace2dos nó fuit: nec ita i filijs ut eú ípe genue2it Aa2ó: s3 sicut oms illi9 popli dñr filij israel.

De aduersarȷ̈s nois Lh2isti: qb9 i uastatióe urbis p2pt Lh2istú barbari pepercerunt uictis capitulum p2imú.

Lo2iosissimá ciuitatez dei: siue i hoc tpo2um cursu cú it ipios peg2i nat ex fide uiués: siue i illa stablitate sedis e tne: qua núc expectat p patiétiá: quo adusq3 iustitia p2ue2tat i iudiciú: dein ceps adeptura p excéllétiá uicto2ia ul tia 7 pace pfecta: hoc ope ad te istitu to: 7 i ea p2missióe debito: defédé adv9 sus eos q7 pdito2 ci9 deos suos p2efe runt fili carissme Marcelline: suscepi magnú op9 7 arduú: s3 ós adiuto2 n2. Na2 scio quibus uiribus opus sit: ut persuadeatur superbis quanta sit uir tus humilitatis: qua fit ut omnia ter rena cacumina temporali mobilitate nutantia: non humano usurpata fa stu: sed diuia gratia donata celsituo transcendat. Rex enim 7 condito2 ci uitatis hui9: ó qua loq2 istituimus: in

IV PRINTED BOOKS

THE MORGAN LIBRARY'S collection of printed books may justly be characterized as choice and diverse. It has always been a relatively modest collection in size, but it is noteworthy in the large number of high points in the history of printing, often the only surviving copy or a copy that is perfect in every way. Apart from some of the more recent books in our holdings, we are considering here books made of real animal skins, prepared by hand, or of real paper, made by hand, one sheet at a time, written by hand, one stroke at a time, or printed from real type, cast and set by hand, one character at a time. Volumes that are added to the Library are scrutinized on their individual merits first and then on the particular way in which they enhance the collection. For example, we hold three copies of the first printed book, the Gutenberg Bible, but each copy has particular elements that make it different from the other two, so the assemblage permits scholarly research at one time and place, which in this instance no other institution in the world can provide.

The Library's collection of incunables—books printed in the cradle days of the art, from the 1450s to 1501—is very important, in terms not of numbers of books but of superior or unique copies that represent the work of individual printers and locales prominent or obscure. Some are printed in the major early centers, such as Mainz, Strassburg, Paris, Lyons, and Venice; some are from the relative typographic backwaters of Oudenaarde, Châlons-sur-Marne, Besançon, Albi, and even Constantinople. It is particularly striking that many of these books were made in places that, even today in the midst of instantaneous worldwide electronic communication, are inconsequential locales. But it is precisely these locales that are important for us as indicators of the need for the new craft and the rapid spread of the new technology.

This new technology was the perfection of printing from movable type, enabling one printer to produce in a day what a scribe had heretofore taken a year to accomplish. The achievement was the triumph of a Mainz goldsmith named Johann Gensfleisch, who is known by the name of his family house, the Hof zum Gutenberg. From the 1430s to the 1450s he spent vast sums of other people's money to develop the method to reproduce the same letters countless times over, so that they might be used in endless variations, their shapes transferred in ink to paper and animal skins. He based his work on earlier principles that were well enough known, if to the select few: the cutting of letters in metal, the transfer of images from raised surfaces by means of a press common to such as bookbinders and vintners, and the making of paper or the preparation of animal skins as writing surfaces. The intervening and precision stage was the realm of the skilled goldsmith, accustomed to producing very fine and accurate results in metals. This consisted in moving from the hard steel punch, on which the letter was carved in reverse, to softer copper, into which the punch was struck, to produce an incised, now right-reading form of the letter. This was the matrix, and the goal was much closer. Into the cavity in the matrix would be poured a liquid amalgam based in large part on lead, which would be the actual printing surface. The crucial item was the type mold, holding the copper matrix, into which molten lead was poured and out of which raised letters, again in reverse, were

ugustine's *City of God*, frontispiece
y Girolamo da Cremona [see 5]

extracted, to go into the type case, to be combined into words, and placed in the printing press, to print books quickly.

A particular feature of Gutenberg's genius was how he developed the mold to adjust to the relative size of the particular letter or even group of characters: the mold could cast an i and then be quickly changed to fit an *m*, then perhaps to an *l* or a *t*, and possibly even to *ffl*. One feature of equal importance to the revolutionary method was the result: a potentially limitless number of copies of the same text, so that readers anywhere would have exactly the same wording to see and, if they wished, to dispute. The invention of printing from movable type in the West produced widespread literacy, expanded the human mind, and changed the world forever.

The Library uses the term "printed books collection" as a portmanteau word, since our holdings comprise many individual collections of considerable importance and scope. We have the third largest collection in the world of the works of William Caxton, England's first printer, and the largest outside Britain itself. Pierpont Morgan's purchases of the libraries of such earlier collectors as James Toovey, Theodore Irwin, and Richard Bennett brought in many of the earliest printed books, the books of the Aldine Press, the private library of William Morris, important bindings, and many examples of the best work of the finest printers during these past five centuries. In addition the Library continues to expand its renowned collection of children's books (see v). The Dannie and Hettie Heineman Collection is a treasure house of highlights on the intellectual and scientific history of Europe, with particular strengths in French and German works. The Paul Mellon gift is a distinguished collection of European books. It is particularly rich in illustrated books on architecture and ornament, artists' manuals, costume, travel, and topography. The Gordon N. Ray bequest recently and instantaneously made the Library an important source for the history of eighteenth- and nineteenth-century literature, particularly as reflected in illustrated books of the period. Certain of the Library's author collections are particularly strong: Francis Bacon, Molière, Racine, John Bunyan, Rousseau, Blake, Sir Walter Scott, the English romantic poets, and the major Victorian writers.

The Library's printed book collections enable scholars, not only of early printing, but of the development of thought, literature, the arts, and history, to do productive research in one place, by consulting originals that answer their questions and permit them to advance knowledge. We are also able, through the judicious exhibition of selected books, to show significant works representative of the human intellect to a wider public.

The printed book has gone through good and bad times over the years, and regular cycles can be charted. The Morgan Library safeguards representatives of the best of the book arts down the years. If our strengths are generally and rightly perceived to lie in the earlier centuries of printed books, additional strengths will soon be apparent to the careful reader of these pages.

I ❧

GUTENBERG BIBLE

Biblia Latina. [Mainz: Johann Gutenberg &
Johann Fust, ca. 1455]. F°. PML 818. Purchased
by Pierpont Morgan in 1897.

The Gutenberg Bible is the first book printed
from movable type. Popularly named for
Johann Gutenberg (d. 1468), the Mainz gold-
smith who invented the mechanical process
that made printing possible, it is also called the
42-line Bible, from the average number of lines
of type on a page. The copy at the Bibliothèque
Nationale in Paris, once owned by Cardinal
Mazarin, carries a rubricator's date of August
1456, which helps to date the completion of
printing. Gutenberg and his colleagues proba-
bly printed the book between 1453 and 1455,
in two massive volumes of 324 and 318 leaves,
respectively. Certainly printing was under way
by the autumn of 1454, when an Italian
humanist in Germany, Aeneas Sylvius Piccolo-
mini (the future Pope Pius II), saw sample
leaves and reported enthusiastically on them
to a friend in Rome. He was the first of a long
line of viewers to be overwhelmed by the ele-
gance and beauty that printing could achieve.
Intact and fragmentary copies still existing im-
ply that some one hundred and eighty Bibles
were completed, of which forty-eight survive,
in varying degrees of completeness. This Bible
mirrors the style of Rhenish liturgical manu-
scripts of the period, which made it acceptable
in the marketplace and suitable for its intended
audience.

Illustrated here is Jerome's preface to Luke
and the opening of the Gospel according to
Luke in the second volume of the Gutenberg
Bible. This vellum copy is illuminated in a style
that has been attributed to Bruges. The Guten-
berg Bible is both a typographic masterpiece
and the harbinger of what has become the
greatest revolution in the history of the West
and arguably in the history of mankind: the
wide dissemination of knowledge through
printing. In its day, moreover, the Gutenberg
Bible represented the culmination of perhaps
twenty years of experimentation in perfecting
the design and production of movable type,
and it cost a prodigious amount of money.
Indeed, it bankrupted Gutenberg, who saw his
enterprise foreclosed and taken over by his
business partner and principal financial backer,
Johann Fust. Clearly the cornerstone in the
history of printing and of any collection of
printed books, the Gutenberg Bible has for cen-

turies been a treasure of legendary rarity and
value. The Morgan Library is unique in posses-
sing three copies, one on vellum and two on
paper. Each copy possesses important features
of decoration, and of variants in printing, lack-
ing from the other two. It is significant for
scholarly research that all three are variants
and do not replicate one another, and our vel-
lum copy is one of only eleven to survive com-
plete.

2 ❧

THE BENEDICTINE OR MAINZ PSALTER

Psalterium Benedictinum (Bursfeld Congrega-
tion). Mainz: Johann Fust & Peter Schoeffer,
29 August 1459. F°. PML 14. Purchased by
Pierpont Morgan, ca. 1900.

A splendid two-color initial opens the first line
of text of Psalm 1 in the Benedictine Psalter
printed at Mainz in 1459. Also known as the
Mainz Psalter or the Latin Psalter, it is a direct
descendant of the Gutenberg Bible. The Psalter
represents an immediate technical advance,
being set in two sizes of type (whereas the 42-
line Bible was set in a single font), and a great
technological leap, as the first instance of three-
color printing. There are two editions or print-
ings of the Psalter, from 1457 and 1459, and
they constitute the first and second printed
books issued with a date. Both are of extreme
rarity, and the Morgan Library possesses the
only copy of the 1459 edition in the United
States. This book was produced by Gutenberg's
former partner Fust and the printer Peter
Schoeffer, who had been Gutenberg's foreman
and who continued the Western world's first
printing firm for many years.

A psalter is a liturgical service book con-
taining the Psalms. The large format of this
copy indicates that it was intended for use by
more than one reader simultaneously and from
something of a distance, as in congregational
choral readings. In the beginning of Psalm 1,
note the opening bars of plainchant, with the
neumes or notes added by hand, that set the
tone for the singers in this Gregorian chant.
Note also that nothing is perfect in life: on line
eight, the proper reading *erit* appears as the
typographical error *eit;* moreover, and what is
probably worse, it was correctly set in the 1457
edition, from which this version was set.

This psalter was printed for Benedictine
monks of the Bursfeld Observance. It is distin-
guished for its handsome typography, and par-

Lucas sirus·natoe anthi
ocensis·arte medic9·disci
pulus apostoloꝝ·postea
paulū secut9 usꝗ ad con-
fessionē ei9 seruiens dño sine crimine:
nam neꝗ vxorem vnꝗ habuit neꝗ fi-
lios:septuaginta et quatuoz annoꝝ
obijt in bithinia·plen9 spiritu sancto.
Qui cū iam scripta essent euāgelia·ꝑ
matheū quidē in iudea·ꝑ marcū aūt
in italia:sancto instigante spiritu in
achaie partibꝫ hoc scripsit euangeliū:
significans etiā ipe in principio ante
suū alia esse descripta·Cui extra ea ꝙ
ordo euāgelice dispositionis exposcit
ea maxime necessitas laboris fuit:ut
primū grecis fidelibꝫ omni ꝓphetati-
one venturi in carnē dei cristi manife-
stata humanitate ne iudaicis fabulis
attenti:in solo legis desiderio teneren-
tur:vel ne hereticis fabulis et stultis
solicitationibꝫ seducti excideret a ve-
ritate elaboraret:dehinc·ut in princi-
pio euangelij iohānis natiuitate pre-
sumpta·cui euangelium scriberet et in
quo elect9 scriberet indicaret:contestās i
se cōpleta esse·ꝗ essent ab alijs inchoa-
ta·Cui ideo post baptismū filij dei a
ꝑfectione generatōnis i cristo implere
regrende a principio natiuitatis huma-
ne potestas ꝑmissa ē:ut requirentibꝫ
demoustraret in quo apprehendes e-
rat ꝑer nathan filiū dauid introitu re-
currentis i deū generatiōnis admisso-
indisparabilis dei ꝓdicās in homini-
bus cristū suū·ꝑfecti opus hois redire
in se ꝑ filiū faceret:qui per dauid patrē
venientibus iter ꝓbebat in cristo·Cui
luce non immerito etiā scribēdorum
actuū apostoloꝝ potestas i ministerio
datur:ut deo in deū pleno et filio ꝓdi-
tionis extincto·oratione ab apostolis

facta·sorte domini electionis numer9
compleretur:sicꝗ paulus cōsumma-
tione apostolicis actibꝫ daret·quē diu
cōtra stimulū recalcitrante dūs elegis-
set·Quod et legentibꝫ ac requirentibꝫ
deū·et si per singula expediri a nobis
vtile fuerat:sciens tamē ꝙ operātem
agricolā oporteat de suis fructibus e-
dere·vitauim9 publicā curiositatem:
ne nō tā volentibꝫ deū demōstrare vide-
remur·quā fastidientibus prodidisse.

Explicit ꝓhemiū Incipit euangelium
secundum lucam ꝓhemium ipsi-
us beati luce in euangelium suum

Quoniā quidē multi cō-
nati sūt ordinare nar-
ratiōes ꝗ i nobis com-
plete sūt reꝝ·sicut tradi-
derūt nobis ꝗ ab inicio
ipi viderūt·et ministri
fuerūt ꝓmonis:visū ē et michi assecuto
oīa a principio diligēter ex ordine tibi
scribere optime theophile:ut cognoscas
eoꝝ verboꝝ de ꝗbꝫ eruditus es veritatē.

Fuit in diebus herodis re-
gis iudee sacerdos quidam
nomine zacharias de vi-
ce abia·et vxor illi de filia-
bus aaron:et nomen eius elizabeth.
Erant autem iusti ambo ante deum:
incedentes in omnibus mandatis et
iustificationibus domini sine quere-
la·Et non erat illis filius·eo ꝙ es-
set elizabeth sterilis:et ambo proces-
sissent i diebꝫ suis·Factū est aūt cū sa-
cerdotio fungeretur zacharias in ordi-
ne vicis sue ante deū:secdm cōsuetudi-
nem sacerdotij sorte exijt ut incensum
poneret ingressus in templū domini.
Et omnis multitudo ipli erat orās fo-
ris hora incensi·Apparuit autem illi
angelus dñi:stans a dextris altaris

Beatus[♪]

vir ã Seruíte dño·Euouae· qui nõ abíjt in cõsilio im= pioꝝ·⁊ in via pᵉccatoꝝ nõ stetit: et in cathedra pᵉstilẽ= tie nõ sedit, Sed in lege dñi volũtas eius: ⁊ in lege ei⁹ meditabiꞇ die ac nocte, Et eit tanꝗ lignũ qð plantatũ est secus decursus aꝗrũ: qð fructũ suũ dabit in tᵖe suo, Et foliũ ei⁹ nõ dᵉfluet:⁊ oĩa quecũꝗ faciet ꝓspᵉrabunꞇ, Non sic impij nõ sic: sed tanꝗ puluis quẽ proíciꞇ ventus a facie terre, Ideo nõ resurgũt impij in iudicio: neꝗ pᵉccõ= res in cõsilio iustoꝝ, Qm nouit dñs via iu= storũ: et iter impioꝝ ꝑibit, Glia p̃ꞇ, Ofdd

Vare fremuerũt gẽtes:⁊ ppłi meditati sũt inania, Astiterũt reges tᵉre et prin= cipᵉs ꝓueneᶜꞇ in vnũ: adũsus dñm ⁊ adũsus xpm ei⁹, Dirũpam⁹ vincła eoꝝ:⁊ piciam⁹ a nobis iugũ ipoꝝ, Qui habitat in celis irri= debit eos: et dñs subsannabit eos, Tũc lo= queꞇ ad eos in ira sua: et in furoꝛe suo cõtur= babit eos, Ego aũt cõstitutus sũ reꞃ ab eo

2 The Benedictine or Mainz Psalter

ticularly for its ornamented initials. These very large initials are printed from two-component metal type, including the decorative elements. Irregularities in their positioning in different copies have suggested that these initials and decorations were printed separately from stencils after the text type was printed. Scholars who have been involved in modern attempts to re-create the process (for example, at the Gutenberg Museum in Mainz) are convinced that this represents the first—and very successful—instance of multicolored printing. According to this interpretation, all three colors were printed in one pass through the press after the elements carrying color were separately inked by hand and then inserted back in the form.

3 ❧

BLOCKBOOK

Canticum canticorum. [Blockbook; Netherlands, ca. 1465]. F°. PML 21990. Purchased by J. P. Morgan, 1923.

The Morgan Library has a very fine collection of blockbooks, and the *Canticum canticorum* is widely held to be the most beautiful of the genre. It portrays, in word and image, a graceful allegory in thirty-two scenes of Solomon's Song of Songs that depicts the wedding of the Virgin with the Church. The quality of the art is particularly accomplished in its graceful delineation. At the other end of the aesthetic spectrum, the banderolles, as the long furled scrolls of paper with their snippets of biblical dialogue are called, are the distant ancestors of the so-called speech balloons of comic strips with which we are so familiar.

Blockbooks constitute a somewhat strange form of printing, having more to do with graphics than typography. They are not, in fact, printed from movable type, or indeed from movable anything. Nor are they produced on a printing press. Both text and illustration are carved in relief on a wood block and then transferred, through friction, by the process of rubbing the blank side of the paper placed on the inked block. Thus both text and image, lacking the pressure of the printing press, tend to be slightly fuzzy and imprecise. The ink, which is a sort of dye rather than the paint derivative of printer's ink, tends to verge upon the brownish, when compared to the brilliant black of contemporary printed books.

This somewhat crude appearance led bib-

3 *Canticum canticorum*, folio 3v-4r

4 *Missale speciale,* folio 1r

liographers of an earlier day to conclude that blockbooks were the forerunners of the earliest printed books, representing a developmental stage in the process of perfecting movable type. Scholarly investigations over the past quarter-century, however, have shown that the paper on which the blockbooks were printed was manufactured about 1465, a full decade after Gutenberg turned his invention into successful practice. Scholarly investigations have also been able to fix the place of manufacture of the paper in the blockbooks to the general region of northeast France and the production of the books themselves to Flanders, specifically to the Brussels-Louvain area. Speculation (but nothing stronger) inclines toward an attribution of the *Canticum canticorum* to a design by Hans Memling at the start of his career, and the atelier of Rogier van der Weyden.

Illustrated is the top half of folios 3v-4r, in which appear the daughters of Jerusalem, Christ, and the Virgin, with the vine as symbol of fruitfulness, in the allegory of the Song of Songs as the betrothal of Christ with the Church.

4 ಎ

MISSALE SPECIALE

Missale speciale. [Basel?, ca. 1473]. F°. PML 45545. Purchased with the assistance of the Fellows, 1954.

The *Missale speciale* contains liturgies of the Mass once believed to have been composed especially for the diocese of Constance, and it was thereby popularly but fallaciously known as the Constance Missal. In fact, these are Masses on Special Occasions, although "specific" might be a more accurate adjective to describe in English what the liturgical compiler had in mind with his use of *Missae speciales*. Illustrated here is the Introit of the first Mass at Dawn on Christmas, which is the first page of the book of Masses on Special Occasions printed at Basel about 1473. The book has been the focal point of much controversy for the past century, but it has also been the catalyst for a good deal of recent advance in the scholarship of fifteenth-century books.

Late in the nineteenth century a German scholar, Otto Hupp, determined that the type used in the Missal was one of two used to print the 1457 Benedictine Psalter; moreover, he deemed it the earlier of the fonts. It was also much cruder in appearance and use than either

the Gutenberg Bible or the Psalter. Thus he concluded that the so-called Constance Missal was the first printed book to survive, and that it was Gutenberg's work.

More recent scholarship, especially the detective work of Allan Stevenson, has shown that the *Missale speciale* is printed on paper stocks that are found in about a dozen other printed books all dated from 1472 to 1474 and 1478. The same paper has also been found in written documents prepared between 1472 and 1479, so the terminal dates seem reasonably sure. The paper may be attributed solely to Basel. No use of the paper prior to 1472 has been found, and thus it seems inescapable that the book cannot have been printed before about 1473, which is the approximate date currently assigned to it. Neither is there any inherent difficulty in reconciling the use of a typeface cast about 1473 from brass matrices made in the mid-1450s, for it is a matter of record that matrices have survived and on occasion have been reused over the passage of many years and even centuries.

Although this Missal, being perhaps a score of years younger than the Gutenberg Bible, is no longer described as the first printed book, it remains the first printed Missal, and is extremely rare. Four copies are known to survive, as well as a single copy of a variant comprising only 72 leaves, in contrast to the 192 leaves of the complete form. The Morgan Library copy is the only one in the United States.

5 ಎ

PLUTARCH

Vitae illustrium virorum (vol. II only). Venice: Nicolaus Jenson, 2 January 1478. F°. PML 77565. Purchased as the gift of Mr. and Mrs. Alexandre P. Rosenberg and of the Edwin H. Herzog Fund, 1982.

For sheer visual splendor, this copy of the Latin edition of Plutarch's *Lives*, printed by Nicolaus Jenson (1420-80) at Venice in January 1478, is hard to praise highly enough. Jenson, an émigré French goldsmith turned printer, cut a roman type that has always been regarded as particularly elegant. Tradition identifies Jenson with a royal French emissary sent to Mainz in the 1450s to meet Gutenberg and inquire into rumors of a marvelous new invention. The Morgan Library already owned a copy of Jenson's Plutarch on paper when the opportunity

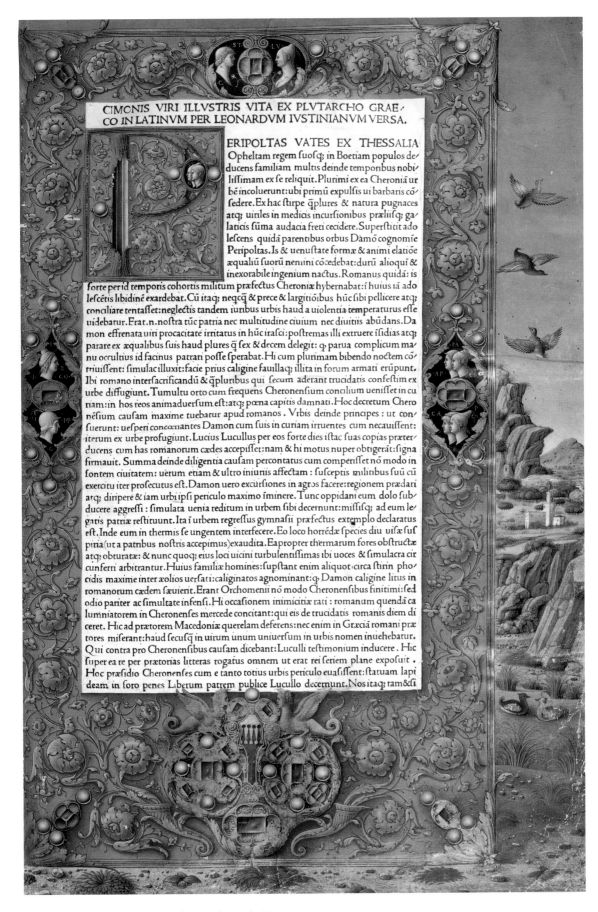

CIMONIS VIRI ILLVSTRIS VITA EX PLVTARCHO GRAE⸗
CO IN LATINVM PER LEONARDVM IVSTINIANVM VERSA.

ERIPOLTAS VATES EX THESSALIA
Opheltam regem fuofᶇ in Boetiam populos de⸗
ducens familiam multis deinde temporibus nobi⸗
liffimam ex fe reliquit. Plurimi ex ea Cheroniã ur
bē incoluerunt: ubi primũ expulfis ui barbaris cõ⸗
federe. Ex hac ftirpe q̃plures & natura pugnaces
atᶇ uiriles in medicis incurfionibus præliifᶇ ga⸗
laticis fũma audacia freti cecidere. Superftitit ado
lefcens quidã parentibus orbus Dàmõ cognomie
Peripoltas. Is & uenuftate formæ & animi elatiõe
æqualiũ fuorũ nemini cõcedebat: durũ alioqui &
inexorabile ingenium nactus. Romanus quidã: is
forte per id temporis cohortis militum præfectus Cheroniæ hybernabat: ĩ huius tã ado
lefcētis libidinē exardebat. Cũ itaᶇ neqcq̃ & prece & largitiõibus hũc fibi pellicere atᶇ
conciliare tentaffet: neglectis tandem iuribus urbis haud a uiolentia temperaturus effe
uidebatur. Erat. n. noftra tũc patria nec multitudine ciuium nec diuitiis abũdans. Da
mon effrenata uiri procacitate irritatus in hũc irafci: poftremas illi extruere ĩfidias atᶇ
parare ex æqualibus fuis haud plures q̃ fex & decem delegit: q̃ parua complicum ma
nu occultius id facinus patrari poffe fperabat. Hi cum plurimam bibendo noctem cõ⸗
triuiffent: fimulac illuxit: facie prius caligine fauillaᶇ illita in forum armati erũpunt.
Ibi romano inter facrificandũ & q̃pluribus qui fecum aderant trucidatis confeftim ex
urbe diffugiunt. Tumultu orto cum frequens Cheronenfium concilium ueniffet in cu
riam: in hos reos animaduerfum eft: atᶇ pœna capitis damnati. Hoc decretum Chero
nēfium caufam maxime tuebatur apud romanos. Vrbis deinde principes: ut cõ⸗
fuerunt: uefperi concœnantes Damon cum fuis in curiam irruentes cum necauiffent:
iterum ex urbe profugiunt. Lucius Lucullus per eos forte dies iftac fuas copias præter⸗
ducens cum has romanorum cædes accepiffet: nam & hi motus nuper obrigerãt: figna
firmauit. Summa deinde diligentia caufam percontatus cum comperiffet nõ modo in
fontem ciuitatem: uerum etiam & ultro iniuriis affectam: fufceptis militibus fuũ cũ
exercitu iter profecutus eft. Damon uero excurfiones in agros facere: regionem prædari
atᶇ diripere & iam urbi ipfi periculo maximo iminere. Tunc oppidani eum dolo fub⸗
ducere aggreffi: fimulata uenia reditum in urbem fibi decernunt: miffifᶇ ad eum le⸗
gatis patriæ reftituunt. Ita ĩ urbem regreffus gymnafii præfectus extemplo declaratus
eft. Inde eum in thermis fe ungentem interfecere. Eo loco horrédæ fpecies diu uifæ fuf
piria (ut a patribus noftris accepimus) exaudita. Eapropter thermarum fores obftructæ
atᶇ obturatæ: & nunc quoᶇ eius loci uicini turbulentiffimas ibi uoces & fimulacra cir
cunferri arbitrantur. Huius familiæ homines: fupftant enim aliquot circa ftirin pho⸗
cidis maxime inter æolios uerfati: caliginatos agnominant: q̃ Damon caligine litus in
romanorum cædem fæuierit. Erant Orchomenii nõ modo Cheronenfibus finitimi: fed
odio pariter ac fimultate infenfi. Hi occafionem inimicitiæ rati: romanum quendã ca
lumniatorem in Cheronenfes mercede concitant: qui eis de trucidatis romanis diem di
ceret. Hic ad prætorem Macedoniæ querelam deferens: nec enim in Græcià romani præ
tores miferant: haud fecuq̃ ĩ uirum unum uniuerfum in urbis nomen inuehebatur.
Qui contra pro Cheronenfibus caufam dicebant: Luculli teftimonium inducere. Hic
fuper ea re per prætorias litteras rogatus omnem ut erat rei feriem plane expofuit.
Hoc præfidio Cheronenfes cum e tanto totius urbis periculo euafiffent: ftatuam lapi
deam in foro penes Liberum patrem publice Lucullo decernunt. Nos itaᶇ tam & fi

5 Plutarch's *Lives*, frontispiece by Girolamo da Cremona

Cre begynneth the volume intituled and named the recuyell of the histozyes of Troye/ composed and drawen out of dyuerce bookes of latyn in to frenssh by the ryght venemble persone and woz/ shipfull man. Raoul le ffeure. prest and chapelayn vnto the ryght noble glozyous and myghty prynce in his tyme Phelyp duc of Bourgoyne of Brabant 2c Jn the pere of the Jncarnacion of our lozd god/ a thou/ sand foure hondexd/ sixty and foure / And translated and drawen out of frensshe in to englisshe by William Carton mercer of p cyte of London / at the comaundemet of the right hye myghty and vertuouse Prynccsse hys redoubtyd lady . Margarete by the grace of god/ . Du/ chesse of Bourgoyne of Lothyk of Brabant 2c / Which sayd translacion and werke was begonne in Brugis in the Countre of Flaundres the fyrst day of marche the pere of the Jncarnacion of our sayd lozd god/ a thousand/ foure hondexd/ sixty and eyghte / And ended and fynysshid in the holy cyte of Colen the . xix . day of septembre the pere of our sayd lozd god/ a thousand/ foure hondexd/ sixty and enleuen 2c .

And on that other syde of this leef folowith the prologe

6 Caxton, *Recuyell*, folio 2r

arose to purchase this gorgeous copy on vellum. It is volume two; the companion first volume is in the Bibliothèque Nationale in Paris. Both of them contain the arms of the Agostini family of Venice, found in at least eight other luxurious, specially illuminated Venetian incunables from the 1470s and in one Milanese incunable of 1475. The Agostini were involved in the paper trade, and, given the high cost of paper at the time, they became very wealthy and may well have invested their excess capital in these special luxury copies as a commercial enterprise.

The Library's volume has a magnificent illuminated frontispiece that has been convincingly identified as by Girolamo da Cremona (active in the second half of the fifteenth century), whose work was influenced by his sometime colleague Andrea Mantegna, and whose last years were spent in Venice. Girolamo also painted frontispieces in two other Venetian incunables on vellum in the Morgan Library:

Augustine's *City of God* (1475) and Aristotle's *Works* (1483). The latter was called by an earlier owner, Henry Yates Thompson, "the most magnificent book in the world."

6 &

CAXTON'S *RECUYELL*

Raoul Le Fevre, *Recuyell of the Histories of Troy* (translated by William Caxton). [Bruges: William Caxton, ca. 1474]. F°. PML 771, fol. 2r. Purchased by Pierpont Morgan from Lord Amherst of Hackney, 1908.

The *Recuyell of the Histories of Troy* is both the first printed book in the English language and the first book printed in Bruges. The translator and printer, William Caxton (ca. 1422– ca. 1491), was an English merchant long resident in Bruges. He spent much of 1471 and 1472 in Cologne, in exile from Flanders, and it must have been while he was in Cologne that he came in contact with the still new invention of printing from movable type. He returned eventually to Bruges, where he set up a printing shop. He was back in his native London in 1476, and settled in Westminster. When he opened a printing establishment, At the Sign of the Red Pale, within the confines of Westminster Abbey, he became England's first printer. In the illustration here William Caxton explains how Raoul Le Fevre wrote the *Recuyell of the Histories of Troy*, and how he, a "mercer of the City of London," came to translate it into English at Bruges and Cologne between 1468 and 1471.

Caxton has remained an engaging figure, though much of our current knowledge of him is now based on scholarly research, rather than on the romantic writing of an earlier day. He was both a man of business and for some time a person of political importance to the English community in the Low Countries. He dedicated his translation of the *Recuyell* to his patroness, the duchess of Burgundy, who was Margaret of York, sister of Edward IV of England. Caxton states that she kept after him to finish it, and he did so over some three years or more, 1468 to 1471, in Bruges, Ghent, and Cologne. The reasons for his travels are most likely found in the bloody struggles between the houses of Lancaster and York, the so-called War of the Roses. Since Caxton had tied his fortunes to those of Margaret of York, upon whom he was dependent for much of his wherewithal, he stayed with her court in these

years of danger as it moved to safer locales. Only after the ensuring of greater political stability in England did he feel it safe enough to return home.

Caxton invented a new and successful career for himself as a translator and printer of popular works, both on the Continent and in England. His typeface reflects the tastes of court life, but this *bâtarde* never took permanent hold because of its relatively fussy fashion. Caxtons themselves, however, have always been among the most keenly collected of rare books. The Morgan Library has an extremely important collection of editions printed by William Caxton, and more extensive gatherings can be found only at the British Library and at the John Rylands University Library in Manchester.

7 ⁊

ULM AESOP

Aesop. *Vitae et fabulae*. Ulm: Johann Zainer, [ca. 1476]. F°. PML 23211. Purchased by J. P. Morgan, 1925.

The raven garbed in peacock's feathers forms the focal point of this woodcut in the Ulm Aesop (fol. 98v). The fables gathered together under the name of Aesop have been a perennial favorite. They readily lend themselves to illustration, and indeed the earliest Greek and Latin fable manuscripts contain pictures (the earliest Greek manuscript is in the Morgan Library). The first printed book to contain illustrations also derives from Aesop: a moralizing collection of fables in verse, printed in 1461 and surviving in a single copy in Germany.

When this method of combining text and illustration was applied to Aesop, the combination in many ways achieved perfection virtually from the beginning. The Latin-German Aesop we see here was undertaken by Heinrich Steinhöwel, an Ulm town physician, who had studied and taught at Padua for several years, and who became one of the most important mediators of Italian and classical literature to the German-speaking peoples. Besides the Aesop, he translated and published Petrarch, Boccaccio, and Apollonius of Tyre, and he compiled a German chronicle and a treatise on the plague. He was a financial patron of Johann Zainer's press, and it is probably a reflection of his taste that most of his translations appeared in illustrated editions. The text of the present book comprises a core of Aesop stories supple-

7 Page of the Ulm Aesop

mented by a large stock of additional fables drawn from late classical, medieval, and Italian Renaissance sources. The woodcut illustrations, filled with character and action, are probably the work of several hands. At least the best of them are possibly the work of Jörg Syrlin the Elder, who carved the choir stalls for the cathedral at Ulm that was completed in 1474.

The Ulm Aesop is arguably the finest and unquestionably the most influential of the fifteenth-century German books illustrated with woodcuts. The fineness of line in the illustrations harmonizes perfectly with the weight of the typography. Before the end of the fifteenth century, more than thirty editions of Aesop were published in a variety of languages, with illustrations using and reusing either the original Ulm woodcuts or copies of them.

The Morgan Library has a fine and extensive collection of Aesops. This is the only copy in this country with the Ulm woodcuts.

GEOFFREY DE LA TOUR-LANDRY

Geoffroy de la Tour-Landry. *Der Ritter vom Turn*. Basel: Michael Furter for Johann Bergmann, 1493. F°. PML 39058. Purchased in 1947.

This is a German version of French moral tales for young ladies composed by an Angevin seigneur, Geoffroy de la Tour-Landry (de la Tour = vom Turn), who had fought in several campaigns of the Hundred Years' War. He wrote the book about 1371 for the edification of his daughters, and his most interesting stories come from his recollections of recent events and society, giving a vivid picture of upper-class manners in late medieval France. This first German edition was translated by Marquart von Stein (ca. 1430–ca. 1496), a German count who in his youth had spent time at the Burgundian court. The book continued to be more popular in Germany than in France, where no edition prior to 1514 is known.

The *Ritter vom Turn* is particularly celebrated for its illustrations and universally acknowledged to be one of the finest books illustrated by woodcuts of northern origin produced in the fifteenth century. There are forty-five cuts, of which one is repeated; competent authority attributes them to the young Albrecht Dürer (1471-1528). Here we see the title page with Dürer's woodcut illustration. This is the first edition; it is also the first book to contain extensive illustration by Dürer, then twenty-two and residing in Basel. The woodcuts, which were copied closely in several editions subsequently published at Strassburg, were perhaps the most graceful and sophisticated to appear in a printed book up to that time. They have a depth of coloring and a strength of line typical of Dürer's work, showing his sure hand even at this early stage in his career. The vigor of the woodcuts required a corollary usage on the title page, as illustrated. To harmonize with the graphic strength of the woodcut, Furter has printed the title zylographically—that is to say, not from movable metal types but in letters carved from a single block of wood and printed directly from the block at the same time as the woodcut illustration.

8 Title page of *Der Ritter vom Turn*

LANGRES MISSAL

Missal, Use of Langres. [Paris: Jean du Pré, ca. 1491]. F°. PML 46713. Purchased as the gift of the Fellows, 1955.

Among the specialties of the Parisian printing shops during the experimental years of the late fifteenth century were finely printed and finely illustrated editions of Missals and other service books, as well as smaller-format Books of Hours for private use. Among the most elegant of these is a small group of liturgical books, including the present Langres Missal, in which Jean du Pré experimented with printing in color. This sumptuous book is another example of a novel attempt that achieved immediate perfection—in this case, the printing of line-cut illustrations in color. The year before, du Pré had ventured a first attempt with the line-cut illustrations in a Book of Hours, and the Langres Missal is only his second try. The first illustration in the volume, reproduced here, is not merely a metal engraving but the first metal cut used in Paris. It is printed in light blue, the decorative border pieces in red, and the text in lustrous black. The delineation is theologically interesting too, since it portrays the doctrine of

9 Page of the Langres Missal

transubstantiation: the change of the bread and wine into the body and blood of Christ at the Consecration of the Mass.

The Morgan Library copy is one of two perfect copies known; two other surviving copies are imperfect. Our copy is of further significance because the other complete copy, specially printed on vellum for presentation to the Bishop of Langres, has the cuts painted over by hand with miniatures, thus concealing the color printing. Illustrated here is the Mass for the first Sunday of Advent depicting transubstantiation during the consecration of the host.

10 &

ABBEVILLE AUGUSTINE *CITY OF GOD*

Augustine. *De la cité de Dieu*. Abbeville: Pierre Gérard & Jean du Pré, 24 November 1486–12 April 1486/87. F°. PML 343. Purchased by Pierpont Morgan with the Bennett Collection, 1902.

This French edition of Augustine's *City of God* represents at least two areas of particular strength in the Morgan Library's collection of incunabula: individual distinction and geo-

Part of the woodcut text reads:

Ce chapitre est par maniere de prolo
gue iusques ou il dist. Ce nest mie chose
conuenable: ou le premier chapitre com/
mence.

Incois que ie dpe de
l'institucion de l'ome
ou il sera demonstre
sa naissance des deux
citez tant come il tou
che et appartient aux
creatures raisonnables mortelles/si com
me ou liure precedent il a este demonstre

te angee/p lesquelles tant come nous
pourone sera prouue: comment aux hô/
mes et aux anges/ compaignie ne soit
mie dicte estre desconuenable ne mal se
ant/a ce que quatre citez/cest adire qua
tre compaignies ne soiet mie dictes estre
ordonnees Cest assauoir deux des an/
ges: et deux des hômes Mais qui plus
est deux:cest assauoir vne aux bone:lau
tre aux mauuais Non mie seulement
aux anges: mais aux hommes.

Declaration de ce liure.

10 Page of Abbeville Augustine, *City of God*

graphical origin outside the typographical mainstream. This large-folio edition can lay strong claim to being the most splendid fifteenth-century French imprint. It is one of only three books printed at Abbeville in the fifteenth century, two of which were extraordinary productions in format and decoration. Illustrated here, within medieval walls, is the creation of Eve in the Garden of Paradise.

Jean du Pré, whose work we have just considered (No. 9), is found in only this one of the three books. He was busy in his own establishment at Paris, where he seems to have been successful enough to venture afield in one way or another. It seems likely that his true presence was in financing Gerard's shop rather than in working there himself. The type used to set the three Abbeville books is du Pré's. Another indicator of the Parisian underpinning of the Abbeville venture may be found in the illustrations. The beautiful woodcuts were almost certainly made in Paris; at least, they show up there in the stock of the printer Antoine Vérard.

The Abbeville Augustine has an additional significance for us. It represents Pierpont Morgan's acquisition of the Bennett Collection, the foundation of the Library's outstanding collection of incunabula. And the Bennett Collection itself has another claim in the history of books and printing because it included much of the library of William Morris, one star item of which was in fact the Abbeville Augustine.

ALDINE ARISTOTLE

Aristotle. [*Works*. (Greek)]. Venice: Aldus
Manutius, 1 November 1495-June 1498. F°.
PML 1126. Purchased by Pierpont Morgan
with the Toovey Collection, 1899.

The central achievement of the Renaissance in
Italy was the reintroduction in the original lan-
guage of the literary and learned works of
Greek antiquity. The works of Aristotle were
the first major prose texts to be printed in the
original Greek, thanks to Aldus Manutius, the
first and the most important of the great hu-
manist scholar-printers. Like Gutenberg, Aldus
spent his earliest years as a publisher doing
purely experimental and developmental work;
in his case it culminated in this first, or Aristotle
font, of four Greek typefaces. The Greek alpha-
bet, with its varied forms, accents, and breath-
ings, presents many more obstacles for de-
velopment into type than the Latin alphabet.
Aldus was successful by 1495, and he set out to
publish all the important Greek classics, begin-
ning with Aristotle.

The Aristotle appeared in five large volumes,
which Aldus issued in two groups. First came
the *Organon*, comprising the six treatises on
logic. Then came the rest of the Aristotelian
corpus, containing the works in pure philos-
ophy, issued in four volumes from 1497 to
1498. Bibliographers tend to describe the entire
series as one group of five volumes, but Aldus,
who, like his fellow scholars, firmly distin-
guished between Aristotelian logic and philos-
ophy, listed his edition as being in one and four
volumes, respectively. The Morgan Library
possesses very fine copies of the entire work.
The illustration seen here is the opening of
chapter two (fol. K4r) of Aristotle's *Prior Ana-
lytics* in the 1495 Aldine edition, decorated in
the Byzantine Hellenistic style. It is taken from
the *Organon*. In the preface to this volume
Aldus wrote to his patron and former pupil
Alberto Pio da Savoia, prince of Carpi, of his
publishing plans: to provide the world with the
entire corpus of ancient Greek learning, despite
the turbulence of times that were more favor-
able to weapons than to books.

This earliest and in many ways most impor-
tant of the Aldine Greek folios heralded the
achievement of the Aldine Press over many de-
cades. The Morgan Library has an extensive
collection of Aldine books.

11 Aldine Aristotle, opening to chapter 2

CONSTANTINOPLE *ARBA'A TURIM*

Jacob ben Asher. *Arba'a Turim* (Hebrew; vol.
III only). Constantinople: David & Samuel ibn
Nachmias, 13 December 1493. F°. PML 77122.
Purchased on the Fellows Fund and the Fellows
Capital Fund, 1981.

This is the only book printed in Constantinople
in the fifteenth century, and it has generated
much argument among scholars. It also shows
the fertile ground awaiting Jewish and non-
Jewish bibliographers working together. The
Arba'a Turim ("Four Pillars" [of Hebrew law])
treats religious law, civil law, marriage and

לא טוב היות האדם לבדו אעשה לו עזר כנגדו א

divorce, and the right conduct of life. This volume, the third of the four that treated one "Pillar" apiece, is on marriage and divorce. On the page we see here (fol. aleph 3v, Hebrew style), Jacob ben Asher, taking as his point of departure God's word that "it is not good for man to be alone" (Genesis 2:18), begins his discussion of marriage; an early reader comments in the margin that he would not have used the author's phraseology.

This fourteenth-century codification of Hebrew law is dated on Friday, the 4th of Tebeth, 5254, which corresponds with 13 December 1493 in the Christian calendar. But no other Constantinople printing can be found before 1505, when the printers of the book began an extensive program of publishing for the needs of the Jewish communities of the East. Since Constantinople is the farthest east and most remote of the incunable printing towns, and its name is absent from all the standard lists and histories of printing, a corrected date of 1504 or 1505 was long suggested. Recent scholarship has shown conclusively, however, that the *Arba'a Turim* is printed on 1490s Venetian paper (which thereafter, for many years, could not be exported to Constantinople because of warfare and trade embargo). It is also partially printed from type available in the Soncino shop in Naples in 1492, which reinforces the 1493 date.

It is likely that the printers David and Samuel ibn Nachmias were Sephardim expelled from Spain following the *Reconquista* of 1492, and that they were in the entourage of the Jewish philosopher-banker Isaac Abravanel. Abravanel's group made its exodus from Valencia to Naples in the summer of 1492, and there met Joshua Solomon Soncino, whose specialty was printing in Hebrew. The two brothers must soon have sailed for the eastern corner of the Mediterranean, where they set up the shop that produced this clean and neat edition of a substantial text.

The Morgan Library has a small but select gathering of Hebrew incunables, including a monument deserving something of the status of a national treasure: the sole American copy of the first complete edition of the Hebrew Bible, printed in 1488. The *Arba'a Turim* enhances this collection by being the first book printed in Constantinople and the only one printed there in the entire incunabular period.

13

COMPLUTENSIAN POLYGLOT

[Biblia Sacra Polyglotta]. *Vetus testamentum multiplici lingua nunc primo impressum…. Nouum testamentum grece et latine in academia complutensi nouiter impressum.* Alcalá de Henares: Arnão Guillén de Brocar, 1514-1517 [1522]. F°. PML 812. Purchased by Pierpont Morgan, 1906.

This monument to the so-called New Learning of ecclesiastical and biblical reform sweeping Europe in the early part of the sixteenth century was produced in six massive volumes in a small university town near Madrid. The town's Latin name is Complutum; hence this quadrilingual Bible is commonly known as the Complutensian Polyglot. It was sponsored by the cardinal primate of Spain, Francisco Ximénez de Císneros, who was also the founder of the university and lived just long enough to see the completion of the printing.

The Bible was not published for some five years after the completion of printing, until papal sanction was given on 15 March 1522 and privilege granted for the issuance of six hundred copies. During the intervening period Erasmus's Greek New Testament was published in 1516, two years after the completion of printing of the Complutensian New Testament but six years before it could be consulted by the learned. As a result, much early Protestant biblical scholarship was based on Erasmus's translation, which was much less sound than the Complutensian. Not until 1550, when Estienne's *textus receptus* of the Greek New Testament, based on the Complutensian's readings rather than those of Erasmus, was published, did the Complutensian properly come into its own. Thereafter it formed the basis of New Testament criticism for the following three hundred years, and with justification, since the Complutensian had been prepared over the course of fifteen years by a group of scholars working from a large variety of manuscripts gathered from a wide number of sources throughout Europe. It has been suggested that Erasmus, aware of the completion of work in Alcalá, rushed his own edition and translation through to win the prize of first publication. It may also be that the exclusive imperial privilege granted Erasmus's New Testament for four years kept the Complutensian unavailable for the years from 1516 to 1520.

The Complutensian is the first of the great polyglot Bibles, furnishing Jerome's Latin Vul-

Pꝛitiua heb.	Ter. Heb.	Trāsla.B.Hiero.	Trāsla.Gre.lxx.cū interp.latina.



אֶל־מֹשֶׁה אֶת־הָאֹהֶל וְאֶת־כָּל־
כֵּלָיו קְרָסָיו קְרָשָׁיו בְּרִיחוֹ וְעַמֻּדָיו
וַאֲדָנָיו׃ וְאֶת־מִכְסֵה עוֹרֹת הָאֵילִם
הַמְאָדָּמִים וְאֶת־מִכְסֵה עֹרֹת הַתְּחָשִׁים וְאֵת פָּרֹכֶת הַמָּסָךְ׃ אֶת־
אֲרֹן הָעֵדֻת וְאֶת־בַּדָּיו וְאֵת
הַכַּפֹּרֶת׃ אֶת־הַשֻּׁלְחָן אֶת־כָּל־כֵּלָיו
וְאֵת לֶחֶם הַפָּנִים׃ אֶת־הַמְּנֹרָה
הַטְּהֹרָה אֶת־נֵרֹתֶיהָ נֵרֹת הַמַּעֲרָכָה
וְאֶת־כָּל־כֵּלֶיהָ וְאֵת שֶׁמֶן הַמָּאוֹר׃
וְאֵת מִזְבַּח הַזָּהָב וְאֵת שֶׁמֶן הַמִּשְׁחָה וְאֵת קְטֹרֶת הַסַּמִּים וְאֵת מָסַךְ
פֶּתַח הָאֹהֶל׃ אֵת מִזְבַּח הַנְּחֹשֶׁת
וְאֶת־מִכְבַּר הַנְּחֹשֶׁת אֲשֶׁר־לוֹ אֶת־
בַּדָּיו וְאֶת־כָּל־כֵּלָיו אֶת־הַכִּיֹּר וְאֶת־
כַּנּוֹ׃ אֵת קַלְעֵי הֶחָצֵר אֶת־עַמֻּדֶיהָ
וְאֶת־אֲדָנֶיהָ וְאֵת הַמָּסָךְ לְשַׁעַר
הֶחָצֵר אֶת־מֵיתָרָיו וִיתֵדֹתֶיהָ וְאֵת
כָּל־כְּלֵי עֲבֹדַת הַמִּשְׁכָּן לְאֹהֶל מוֹעֵד׃
אֶת־בִּגְדֵי הַשְּׂרָד לְשָׁרֵת בַּקֹּדֶשׁ
אֶת־בִּגְדֵי הַקֹּדֶשׁ לְאַהֲרֹן הַכֹּהֵן
וְאֶת־בִּגְדֵי בָנָיו לְכַהֵן׃ כְּכֹל אֲשֶׁר־
צִוָּה יְהוָה אֶת־מֹשֶׁה כֵּן עָשׂוּ בְּנֵי
יִשְׂרָאֵל אֵת כָּל־הָעֲבֹדָה׃ וַיַּרְא
מֹשֶׁה אֶת־כָּל־הַמְּלָאכָה וְהִנֵּה
עָשׂוּ אֹתָהּ כַּאֲשֶׁר צִוָּה יְהוָה כֵּן
עָשׂוּ וַיְבָרֶךְ אֹתָם מֹשֶׁה׃

[Latin — Hieronymus translation:]

&m tectū &° vniuersam supellectilem: anulos tabulas: vectes: columnas: ac bases: opertorium de pellibus arietum rubricatis: & aliud operimentum de hyacinthinis pellibus: velum: arcam: vectes propiciatorium: mensam cum vasis suis: & propositionis panibus: candelabrum: lucernas: & vtensilia earum cum oleo: altare aureum & vnguentum: & thymiama ex aromatibus: & tentorium in introitu tabernaculi: altare eneum: reticulum: vectes: & vasa eius omnia: labrum cum basi sua: tentoria atrii & columnas cum basibus suis: tentorium in introitu atrii: funiculos illius & paxillos. Nihil ex vasis defuit que in ministerio tabernaculi & in tectū federis iussa sūt fieri. Vestes quoq̃ quibus sacerdotes vtuntur in sanctuario: aaro scilicet & filii eius obtulerunt filii israel: sicut preceperat dominus. Que postq̃ moyses cūcta vidit cōpleta: benedixit eis.

[Greek LXX with interlinear Latin — partially legible:]

ad moysen: τ oīa vasa eius: ... anulos eius: et collinas eius: vectes eius: τ paxillos eius: ... bases eius: τ opimēta pelles arietū rubricatas: τ cooptoria pelles hyacinthinas: τ velū: τ arcam testimonij: τ vectes eius: τ propiciatorium: τ mēsam: τ oīa vasa eius: τ panes ppositiōis: τ cādelabrū purū: τ lucernas eius lucernas incēdij: τ oīa vasa eius: et altare aureū: et olcū vnctiōis: et thymiama cōpositiōis: et velū porte tabnaculi: et altare eneū: et craticulā eius eneā: et vectes eius: et oīa vasa eius: et labrū: et basim eius: cortinas atrij: et collinas et bases eius: velum porte atrij: et funiculos eius: et parillos tabernaculi testimonij: et vestes ministratoriū ad ministrandū in eis in sctuario: vestes sctuarij: sūt aaron: et vestes filiorū eius in sacerdotio: fm oēs q̃cūq̃ ꝓcepit dns moysi: sic fecerūt filii israel oēs apparatū. et vidit moyses oīa: et fuerīt faciētes ea queadmodū ꝓcepit dns: sic fecerūt: et bñdixit eis moyses.

[Latin — interpretatio chaldaica:]

ad moysen τ omnia vasa eiusdē tabernaculi: fibulas eius: tabulas eius: vectes eius: τ collinas τ bases eius: opertoriū de pellibus arietum rubricatis: et opertoriū de pellibus hyacinthinis: velū q̃s q̃ extenditur: arcam testimonij τ vectes ei²: τ propiciatorium: mensam τ oīa vasa eius: τ panē propositionis: candelabrū mundissimū: τ lucerrias que ordinantur et omnia vasa eius: τ oleum ad illuminandum: altare aureū τ oleum vnctionis: thymiama aromatū. Tentoriū q̃ quod erat in ostio tabernaculi: altare eneum: et reticulū eius eneū: vectes eius τ oīa vasa eius. Labrum τ basim eius: cortinas atrij cū collinis suis et cum basibus suis: velum quoq̃ ad ostium atrij: funiculos eius τ parillos eius τ omnia vasa ministerij tabernaculi federis iussa ministerij ad ministrandum in sanctuario: vestes sanctas aaron sacerdotis τ vestes filiorū eius τ ministrent. iuxta omnia que precepit dns moysi: ita fecerūt filii israel omne opus. Audītq̃ moyses omne opus τ ecce fecerant illud sicut preceperat dominus ita fecerunt: benedixit q̃ eis moyses. Ca.40.

[Aramaic (Chaldee/Targum) column:]

[Targum Onkelos text — Exodus, in Aramaic script]

Ca.xl.

14 Two French noël title pages and the reverse of another
 (l. to r.) PML 75870, 75869, 75871

gate with texts of the Hebrew Old Testament, the Septuagint translation of the Old Testament into Greek, the original Greek New Testament, and the "Chaldean" or Aramaic version of the Old Testament, along with interlinear or parallel Latin translation of the other languages. It was a staggering technological feat. Here we see a typical text page (from Exodus 39), showing the complex settings of five languages in several sizes of type.

14 ❧

FRENCH NOËLS

Les Noelz Nouueaulx....[Paris: Widow of J. Trepperel, ca. 1515]; Les grans noelz nouueaulx....Paris: A lenseigne de lescu de France [Widow of J. Trepperel, c. 1515]; Les noelz notez....[Paris: Widow of J. Trepperel, ca. 1515]. PML 75870, 75869, 75871. 8°. Purchased on the Cary Fund, 1979.

These three small books are among the earliest printed texts of French colloquial noëls or carols. Each is the only known copy to survive. Although noëls are now associated exclusively with Christmas, the term was originally simply an expression of Christian joy, and noëls were sung on feast days and other occasions. During the Middle Ages local songs and verses were often adapted to Christian themes and incorporated into the Church services, bringing the Christian message closer to the people. Similarly, popular songs were included in the cycles of "mystery plays." Beginning in the late fifteenth century these songs, or noëls, were collected and written down. By the early sixteenth century inexpensive printed collections began to appear, and it was not unusual for French families to sing noëls together in the evenings. By the end of the century, the custom had dwindled to Christmas eve.

The Library's noëls were all printed at the Paris printing shop established by Jean Trepperel, which specialized in pamphlets for popular consumption. Following Trepperel's death in 1511 or 1512, his widow carried on his trade, and it is her imprint that appears on these books. Tiny ephemeral pamphlets such as these preserve the historic regional patois of France; they are also important as unique examples of early French printing and as early musical sources. These books were previously owned by the distinguished Geneva collector Edmée Maus. Her collection of thirty-five unique copies of the earliest French popular farces and plays, also printed by the Trepperels, is now in the Bibliothèque Nationale.

Embleme.

Hereby is meant, as also in the vvhole courſe of this Æglogue, that Poetry is a diuine in
ſtinct and vnnatural rage paſſing the reache of comen reaſon. VVhom Piers an-
ſwereth Epiphonematicõs as admiring the excellencye of the ſkyll vvhereof
in Cuddie hee hadde already hadde a taſte.

Nouember.

Ægloga vndecina.

ARGVMENT.

*IN this xi. Æglogue be bewayleth the death of ſome mayden of greate
bloud, whom he calleth Dido. The perſonage is ſecrete, and to me alto-
gether vnknowne, albe of him ſelſe I often required the ſame. This Æglo-
gue is made in imitation of Marot his ſong, which he made vpon the death
of Loys the french Queene. But farre paſſing his reache, and in myne opi-
nion all other the Eglogues of this booke.*

Thenot.　　Colin.

C *Olin my deare, when ſhall it pleaſe thee ſing,
As thou were wont ſongs of ſome iouiſaunce?
Thy Muſe to long ſlombzeth in ſozrowing,
Lulled aſleepe through loues miſgouernaunce,*

L.4.　　　　　Now

15 Title page from Ronsard's *Amours*　　16 Page from Spenser, *The Shepheardes Calender*

15 略

RONSARD'S *AMOURS*

Pierre de Ronsard. *Les Amours*. Paris: Widow of Maurice de la Porte, 1552. 8°. Heineman 210. Dannie and Hettie Heineman Collection, donated in 1977.

Pierre de Ronsard (1524-85) was the central figure of the Pléiade, the circle of seven poets who revivified and redirected French literature in the mid-sixteenth century under the influence of classical and Italian models. His *Amours* is a collection of love sonnets in the style of the Italian *canzoniere* written to several women, most notably Cassandre Salviati, daughter of a Florentine banker resident in Paris. She is portrayed voluptuously in her twentieth year in an engraving in this elegant little book. She and Ronsard, shown crowned with the poet's laurel in his twenty-seventh year, gaze at each other across the pages. Couplets in Greek by Ronsard's fellow-poet Jean-Antoine de Baïf complement the classical attire of the lovers. (A third member of the Pléiade was Jean Dorat, the brilliant tutor who taught Ronsard Greek.)

Like others of Ronsard's early collections,

this is a striking piece of printing from a time when Parisian book production was the most beautiful in Europe. It was issued by the widow of Maurice de la Porte, a printer who provided books for the University of Paris, which is reflected in the technical achievement of the extensive appendix of musical notation, giving settings by several composers for a number of the sonnets. But this technological accomplishment only enhances the overall feel of elegance that the book epitomizes. With true Gallic bibliophilic verve, the book is contemporaneously ruled throughout in red borders on every page, including the blanks.

The book is of great rarity: we know of no other copy in the United States. This copy itself was formerly owned by Prosper Blanchemain, the nineteenth-century scholar who brought Ronsard's work back to the prominence it now holds after several centuries of neglect.

16 略

SPENSER, *SHEPHERD'S CALENDAR*

Edmund Spenser. *The Shepheardes Calender Contayning Twelue Aeglogues Proportionable to the Twelue Monethes*. London: Hugh

Singleton, 1579. 4°. PML 127066. Purchased on the Gordon N. Ray Fund, 1990.

Edmund Spenser (1552-99) was the most important English poet after Chaucer. In *The Shepheardes Calender* he set the tone for other poets of his time, which they might ignore only at their peril. His pastoral theme of love debated by shepherds is based upon Virgil's *Eclogues*, but his models were varied. In the illustrated November eclogue, for instance, he says that he used Clément Marot's lament for a dead queen of France, but his moral is that death has no sting. In the leafless month of November, we see a funeral procession symbolic of the dying year winding its way to church, behind a shepherd crowning his friend who plays the pipes (fol. L4r).

This is the first edition of Spenser's first major work, which he dedicated to Sir Philip Sidney, the author of *Arcadia*. This is one of only seven known copies of the first edition. It was previously owned by the important American bibliophile Henry Bradley Martin. The first folio edition of Spenser's collected poetry appeared in 1611, and before that time five editions of *The Shepheardes Calender* had been published in quarto, all of which are in the Morgan Library. The Morgan Library has strong collections of Spenser and of English literature in first and significant later editions.

17 ð

BIBLE

The Holy Bible…Newly Translated out of the Originall Tongues. London: Robert Barker, 1611. F° PML 5460. Purchased by Pierpont Morgan, date unknown.

This is the first edition of the Bible in English, known alternatively as the Authorized Version or the King James Bible. From the time of its publication in 1611 to the late nineteenth century, it remained the only English translation of the Bible used in the service of the Anglican Church. It is still today the form of the scriptural text most familiar to the English-speaking world, cherished equally for its spiritual and literary qualities. In the words of the English historian Thomas Macaulay, it is "a book which if everything else in our language should perish, would alone suffice to show the extent of its beauty and power."

The motivation for the creation of this Bible was part of an effort by James I to achieve a compromise between the High Church and the Puritans. Almost immediately after his accession to the throne in March 1603, he was presented with a petition by a thousand dissenting Puritan ministers. Well aware that they were a strong group in Parliament, James called a conference of Puritan and Anglican divines which met under his personal chairmanship at Hampton Court in January 1604. On balance, the Puritans were dissatisfied with the results of the conference, which led many to emigrate to Holland and ultimately to America. One point of agreement, however, was the decision to prepare a new version of the English Bible. For this purpose a team of forty-seven revisers, drawn almost equally from both parties, was created. The aim of the revisers was to produce a text that could be understood by all, scholar and plowboy alike, and still be authoritative and accurate.

17 Title page from the King James Bible

Selection of the team and rules for revision alone took five months. The revisers worked in six groups, each of which was allocated a certain portion of the biblical text to work on, and then drafts were circulated among them all. A wide array of important editions of the Bible in English and other languages was consulted. The initial work was completed in two years; the final text was hammered out by a committee of six who sat in London every day for nine months. To protect the theological compromises made by both sides, almost no records of the enterprise or the discussions were kept. The result of their efforts was, according to the *Oxford History of English Literature*, "the noblest monument of English prose." The vocabulary is relatively small, but great use is made of rhythm and cadence. It is certainly the only literary masterpiece ever produced by a committee.

18 &

SIR FRANCIS BACON

*[Novum organum]. Francisci de Verulamio,...
Instauratio magna.* London: B. Norton and
J. Bill, 1620. F° PML 42969. Purchased as
the gift of Roland L. Redmond, 1952.

This is the first edition of *Novum organum*, the "new organum or instrument" in which Francis Bacon (1561-1626) sets forth his theory of scientific method designed to impart "true directions concerning the interpretation of nature." The engraved frontispiece shows a ship in full sail passing through the Pillars of Hercules from the old world to the new. It is an emblem of the ambitions of the author, who wished to achieve nothing less than *Instauratio magna*, a "great instauration or establishment," that would be "the total reconstruction of the sciences, arts and human knowledge." This large philosophical work was intended to be in five parts, only three of which were completed. The *Novum organum* is the first. The Library also owns copies of Bacon's *The Advancement of Learning* (1605), in which he first addressed the classification of knowledge. Bacon's work set a model for many later attempts at classification; in the eighteenth century it was the foundation on which the French philosophes constructed the *Encyclopédie*.

Francis Bacon contended that it was impossible to continue to accept that all knowledge had been discovered by Aristotle or could logically be deduced from his writings. Instead, he proposed that knowledge be based on direct observation of perceived facts, regardless of whether this contradicted the authority of the ancients. His emphasis on direct observation from available evidence had a profound influence in grounding the next generation of English scientists, or natural philosophers as they were then called, in the experimental method.

Bacon was born into the highest ranks of Tudor civil service; his father was lord keeper and his uncle was Elizabeth I's chief minister. He trained as a lawyer and had an unparalleled belief in his considerable abilities. Bacon's great political opportunities came in the reign of James I. He was appointed attorney general in 1613, and his contemporaries were often shocked by his fierce prosecution of cases. He rose to the lord chancellorship in 1618, by which time he had made many enemies. His public life came to an abrupt end in 1621 when he was convicted of taking bribes. The remaining five years of his life were devoted to writing. He died in 1626, the result of a chill caught while stuffing a chicken with snow to observe the effects of cold on the preservation of the flesh. It is telling of Bacon's character that he describes his method of experiment thus: "Nature, like a witness, when put to the torture would reveal her secrets."

He is seen to best advantage as a writer and student of human nature in his essays, which appeared between 1597 and 1625 and set the English pattern for short prose pieces. The Library's extensive holdings of Bacon were built on the foundation of the gift in 1942 of Roland L. Redmond's important collection. The Library owns copies of all the essays issued during Bacon's lifetime from the third edition and many other works including his *History of Henry VII*, notable for being an early history rather than a simple chronicle.

19 &

FIRST FOLIO

William Shakespeare. *Mr. William Shakespeares Comedies, Histories, & Tragedies.*
London: Isaac Jaggard & Edmund Blount,
1623. F°. PML 5122. Purchased by Pierpont
Morgan with the Toovey Collection, 1899.

Across the centuries, Shakespeare stares at us in Droeshout's famed portrait on the title page of the First Folio, and yet, as Ben Jonson wrote,

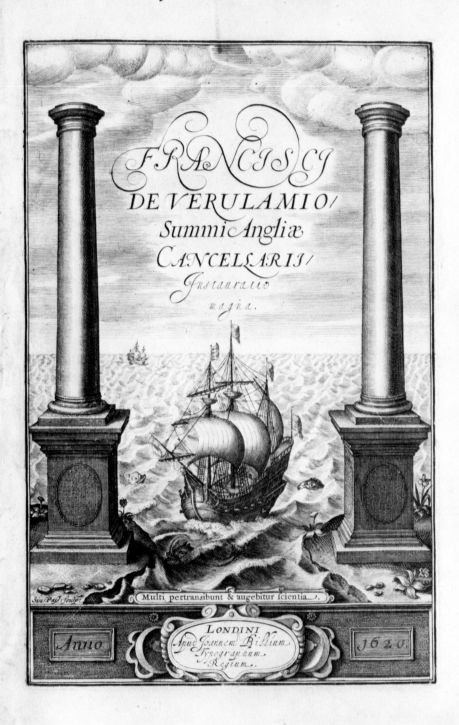

FRANCISCI
DE VERULAMIO,
Summi Angliæ
CANCELLARII,
Instauratio
magna.

Multi pertransibunt & augebitur scientia.

LONDINI
Apud Joannem Billium
Typographum
Regium.

Anno 1620.

18 Title page from Bacon's *Novum organum*

Mr. WILLIAM
SHAKESPEARES
COMEDIES,
HISTORIES, &
TRAGEDIES.

Publiſhed according to the True Originall Copies.

LONDON
Printed by Iſaac Iaggard, and Ed. Blount. 1623.

19 Title page of the First Folio

Thou art a Moniment, without a tombe
And art still alive, while thy Booke doth live.

This monument more lasting than bronze has been fundamental in keeping alive Shakespeare's genius, from the day it was published some seven years after his death. One of the great landmarks in English literature, it is likewise a monument in the history of the English language as we have spoken, written, and developed it over the past four centuries. The great moments and characters in Shakespeare's plays are more real to us than the history books.

This first collected edition of Shakespeare's plays is universally known from its format as the First Folio. Three more would follow over the years, and *Pericles* would not appear in print until the Third Folio, of 1664. About half the plays had been issued before 1623 in single, small quarto editions, selling for about six-

pence apiece. Not all of them, however, were based upon authoritative texts. The texts for the First Folio, for all their faults, established standards and were supplied by Shakespeare's old acting company, which drew on a mixture of sources: various of the quarto editions, occasionally with manuscript revisions; manuscript prompt books; even Shakespeare's final drafts. The First Folio may fairly be described as the single greatest printed book in the English language. This volume is one of the very few survivors of the first printing, without *Troilus and Cressida*.

20 ❧

THE ELIOT INDIAN BIBLE

*Mamusse wunneetupanatamwe up-biblum god....*Ne quoshkinnumuk nashpe Wuttinneumoh Christ nob asoowesit John Eliot. *The Holy Bible: containing the Old Testament and the New*. Translated into the Indian Language....Cambridge: Printed by Samuel Green and Marmaduke Johnson, 1663 [& 1661]. 4°. PML 5440. Purchased by Pierpont Morgan with Theodore Irwin's library, 1900.

The first Bible produced in North America was printed in the Massachusetts Bay Colony not in the language of the English colonists but in the Massachuset language, an Algonquin Indian dialect. This copy of the first edition of 1663 is inscribed: Thomas Shepard's Book 2.6.1666 ye gift of ye Revd. Translator. The "Revd. Translator" was John Eliot (1604-90), a Puritan minister living in Roxbury, Massachusetts, who began to learn the Indian language in about 1643 and by 1648 was preaching to the Indians in their native tongue.

Eliot, who had been educated at Cambridge, arrived in Boston in 1631 on the same ship with the wife and children of John Winthrop, the governor of Massachusetts Bay Colony. The following year he was appointed teacher in the Roxbury church, a post he held to the end of his life. Almost immediately he began to show concern for the temporal as well as spiritual welfare of the Indians. He encouraged the formation of self-governing settlements and worked to secure clothing, housing, and other necessities for them.

He probably began his translation of the Bible around 1646; it was completed by 1658. The task of setting the translation into type was the most ambitious printing project then undertaken in the English colonies. The first

press in the colonies had arrived from England in late 1638 and was set up in Cambridge, Massachusetts. Its first printer was Stephen Daye. In 1639, Eliot had helped to edit the so-called Bay Psalm Book. In 1649, Samuel Green acquired the press from Daye (or possibly from his son Matthew), and it was he who undertook the monumental task of printing Eliot's Indian Bible. The project was underwritten by the recently formed Corporation for Promoting and Propagating the Gospel of Jesus Christ in New England, the first English missionary society. The corporation sent paper, types, and an assistant printer named Marmaduke Johnson from London in 1660. The Indians played important roles in making the Bible. Eliot was helped with his translation by John Nesutan, a native preacher who had studied at Harvard, and Green and Johnson were assisted in the production by a Nipmuck tribesman named James Printer. By the summer of 1661, 1,500 copies of the New Testament were complete. Five hundred were distributed and the balance held back to be bound with the Old Testament and published in 1663. The Library's copy is a complete first edition with both Old and New Testaments. Most of the copies of the Bible were destroyed during King Philip's War (1675-76), which caused other losses: John Nesutan, who served in the colonial forces against his own people, was killed;

James Printer left his trade to fight the colonists but later returned.

Eliot, often referred to as the Indian apostle, is regarded as one of the most dedicated and compassionate of the colonial missionaries. Just before his death, he donated seventy-five acres of land for the "teaching of Indians and Negroes." Cotton Mather, not noted for the generosity of his judgment, wrote, "He that would write of Eliot must write of charity or say nothing."

21 &

ISAAC NEWTON

Philosophiae naturalis principia mathematica. London: Joseph Streater, for the Royal Society, 1687. 4°. PML 78144. Purchased by the Heineman Foundation for the Dannie and Hettie Heineman Collection, 1984.

The *Principia* has been described as the greatest work in the history of science. In it, Newton (1642-1727) provided for the first time a mathematical description of his law of universal gravitation and demonstrated that all the motions of the universe could be explained by the application of this single principle. The circumstances leading to its publication effectively began with a wager made by Sir Christopher

20 First title page of 1663 Eliot Indian Bible

21 Title page of Newton, *Principia*

Wren that no one could prove the motion and orbits of the planets. Edmund Halley, the astronomer royal, went to Cambridge to consult Isaac Newton in August of 1684. Because Newton was known to be reclusive – difficult but brilliant – Halley came to the point immediately: "What would the curve be described by the planets supposing that gravity diminished as the inverse square of the distance?" "An ellipse," Newton replied, to Halley's amazement, "I have calculated it." The problem was of such insignificance to Newton that he had not bothered to keep the formal proof. Moreover, after the controversy surrounding the publication of his earlier papers on optics, he never intended to make any of his discoveries public. At Halley's urging, Newton rewrote the proof and also prepared lectures on planetary motion. Writing the *Principia* took precisely twenty-one months. Only after great encouragement from Halley, including correcting the printer's proofs and underwriting the cost of printing, were 300 or so copies of the first edition published in 1687. The premises of Newton's theories of the physical universe remained unchallenged until the twentieth century and provided the model for all fields of scientific thought for the next two hundred years and more.

Isaac Newton was born on Christmas day 1642, the premature, posthumous child of an illiterate farmer. He was not expected to live, being, in his own words, "so small that I might have been put in a quart mug." He received some elementary education, but spent more time hiding under hedges with his books and calculations than learning farming. At an uncle's suggestion, he was sent to Cambridge in 1661. In 1665 he returned home because of the plague. Before his return to Cambridge in 1667, Newton devised, in addition to numerous mathematical discoveries, his "fluxions," which we know as calculus, discovered white light to be a compound of the colors of the spectrum, and first conceived his universal law of gravitation. One of the greatest mathematicians of all time, he spent the vast portion of his life involved in the study of alchemy and problems of theology. Idolized by his own country and revered by the world, he died at age eighty-four and was buried in Westminster Abbey.

22 ❧

PHILLIS WHEATLEY

Poems on Various Subjects, Religious and Moral. London: For A. Bell, 1773. 4°. PML 77263. Bequest of Miss Tessie Jones in memory of her father, Herschel V. Jones, 1968.

Phillis Wheatley (ca. 1753-84), the first black American poet, arrived on a slave ship in Boston harbor in 1761, when she was about eight years old. She was purchased by John Wheatley, a prosperous Boston merchant, whose family taught her to read and encouraged her literary ambitions. By the age of about twelve or thirteen, she was writing occasional verse. This is the first edition of her collected poems, published in London in 1773. The Library's copy has the author's signature on the verso of the title page. The frontispiece includes an engraved portrait of the author by Scipio Moorhead, a slave owned by a Boston minister. Phillis's poem, "To S. M.: A Young African Painter, On Seeing His Works," is among the thirty-nine poems in this volume. The Library also has the first American edition of her collected poems, published posthumously *(Phillis Wheatley. Poems on Various Subjects, Religious and Moral.* Philadelphia: Joseph Crukshank, 1786. 12°. PML 127050. Purchased on the Gordon N. Ray Fund, 1990).

Prior to the London publication of her collected works, several of her poems had appeared in print in America and had brought her considerable recognition among Boston intellectuals. Her principal themes, learning, virtue, and redemption through Christ, were influenced by her extensive reading of Alexander Pope. Her efforts to raise subscriptions in

22 Author's signature on flyleaf of *Poems*

Entered at Stationer's Hall.

Phillis Wheatley

22 Frontispiece and title page of Wheatley's *Poems*

America for the publication of a volume of collected works failed, however, to generate sufficient response, and she attempted a British publication. The project was brought to fruition when she was able to travel to London in 1772 with Wheatley's son Nathaniel. The London edition is dedicated to Lady Huntingdon, a prominent English Methodist who was instrumental in obtaining support for the book. *Poems on Various Subjects, Religious and Moral* was finally published in September of 1773, a few months after Phillis's return to America. That same fall she was legally freed.

In 1778 she was married to a free black man, who, according to a contemporary memoir, was "disagreeable and unable to give Phillis the care she needed." Always physically frail, she died alone and in poverty in 1784, at the age of about thirty. Her achievements were cited as proof of antislavery arguments that blacks had intellectual capacity and could profit by education, something doubted by many during the eighteenth century.

23 ❧

ENCYCLOPÉDIE

Denis Diderot, editor, *Encyclopédie; ou, Dictionnaire raisonné des sciences, des arts et des métiers, par une société des gens des lettres.* Paris: Chez Briasson, David l'aîné, Le Breton, Durand, 1751-80. F°. PML 78072-78106. Purchased on the H. S. Morgan Fund and the General Book Fund, 1984.

Far from being a neutral compendium of useful knowledge, Diderot's *Encyclopédie* was, at the time of its publication, tantamount to a political manifesto. Its thirty-five folio volumes, published over a period of twenty-nine years, were an attempt on the part of radical French intellectuals to establish their authority—by virtue of their superior reason and intellect—to provide a "systematic account of order and concatenation of human knowledge."

The Tree of Knowledge in volume one, illustrated here, was adapted as a visual metaphor for their revolutionary approach to the world as "natural." The device is derived from Bacon, but with significant variation: Where Bacon had divided human knowledge into Memory, Imagination, and Reason, he also allowed for divine learning to account for revelation. In the hands of the encyclopedists, the largest part of human understanding is defined as the domain of "Philosophy," and they did not allow of any knowledge that was not empirical. This classification held that it was not tradition, church, government, or royal academies that defined the world, but experience and reason. Worse still, church and government were subject to criticism by reason, i.e. the encylopedists.

The project began innocently enough with a

23 Frontispiece to the *Encyclopédie*, engraved by
B. L. Prevost after a design by C. N. Cochin, fils

d'Alembert, who resigned from the project in 1758. In 1759, the seven volumes that had appeared to date were banned by the government and placed on the index by the pope. For the next twenty years Diderot carried on alone, writing countless small articles and many major ones, while dealing with the editorial business and the unremitting attacks of enemies. It is hard to believe that so substantial a work was an "underground publication." Any ordinary man would have been worn out, but Diderot had at least two other simultaneous careers. His salons made him the virtual founder of French art criticism and, though he published almost nothing in his lifetime, he is now considered a major creative writer.

24 🕿

THE DECLARATION OF INDEPENDENCE

"In Congress, July 4, 1776. A Declaration." Philadelphia: Printed by John Dunlap, [1776]. F° broadside. PML 77518. Gift of the Robert Wood Johnson, Jr., Charitable Trust, 1982.

The Declaration of Independence is the formal statement by the Continental Congress announcing the separation of the thirteen colonies from Great Britain and the birth of the United States. This is one of twenty-five recorded copies of the first printing of this most timeless and eloquent of American historical documents. In June of 1776 a Committee of Five was chosen to draft Congress's resolution to break from Great Britain. Thomas Jefferson wrote the rough draft, which was then slightly revised by the other members of the committee in the weeks following Congress's meeting in Philadelphia. The Declaration was approved on July 2, and over the next two days it was again revised before the committee was authorized to print the corrected text. On the evening of July 4, a manuscript copy of the Declaration was taken to the printing shop of John Dunlap, a short walk from the State House in Philadelphia. He spent the night setting type, and printed copies were ready for delivery in the morning. The broadside was sent to "the several Assemblies, Conventions & Committees or Councils of Safety and to the several Commanding Officers of the Continental troops" and soon appeared in newspapers throughout the colonies. Perhaps no piece of American news had been so widely or urgently disseminated.

The Library's copy belonged to Benjamin

proposal to publish a French translation of Chambers's *Cyclopaedia* (London, 1728). The plan changed, however, as the printer Le Breton took in several partners and the brilliant young Denis Diderot (1713-84) as editor. At the time, Diderot was in prison, the consequence of one of several skirmishes with government censors. His release was obtained through the influence of the publishers with the promise that the first volume would be dedicated to the royal director of publications. Diderot proceeded to enlist the aid of the eminent mathematician Jean d'Alembert (1717-83). Together they recruited almost every French intellectual radical of the day, including Voltaire, Montesquieu, and Rousseau. Each volume was a *succès de scandale* throughout Europe. The number of subscribers jumped from one to four thousand. The court, the church, and the judiciary were outraged. The struggle proved too much for

In CONGRESS, July 4, 1776.

A DECLARATION

By the REPRESENTATIVES of the

UNITED STATES OF AMERICA,

In GENERAL CONGRESS ASSEMBLED.

WHEN in the Courſe of human Events, it becomes neceſſary for one People to diſſolve the Political Bands which have connected them with another, and to aſſume among the Powers of the Earth, the ſeparate and equal Station to which the Laws of Nature and of Nature's God entitle them, a decent Reſpect to the Opinions of Mankind requires that they ſhould declare the cauſes which impel them to the Separation.

We hold theſe Truths to be ſelf-evident, that all Men are created equal, that they are endowed by their Creator with certain unalienable Rights, that among theſe are Life, Liberty, and the Purſuit of Happineſs.—That to ſecure theſe Rights, Governments are inſtituted among Men, deriving their juſt Powers from the Conſent of the Governed, that whenever any Form of Government becomes deſtructive of theſe Ends, it is the Right of the People to alter or to aboliſh it, and to inſtitute new Government, laying its Foundation on ſuch Principles, and organizing its Powers in ſuch Form, as to them ſhall ſeem moſt likely to effect their Safety and Happineſs. Prudence, indeed, will dictate that Governments long eſtabliſhed ſhould not be changed for light and tranſient Cauſes; and accordingly all Experience hath ſhewn, that Mankind are more diſpoſed to ſuffer, while Evils are ſufferable, than to right themſelves by aboliſhing the Forms to which they are accuſtomed. But when a long Train of Abuſes and Uſurpations, purſuing invariably the ſame Object, evinces a Deſign to reduce them under abſolute Deſpotiſm, it is their Right, it is their Duty, to throw off ſuch Government, and to provide new Guards for their future Security. Such has been the patient Sufferance of theſe Colonies; and ſuch is now the Neceſſity which conſtrains them to alter their former Syſtems of Government. The Hiſtory of the preſent King of Great-Britain is a Hiſtory of repeated Injuries and Uſurpations, all having in direct Object the Eſtabliſhment of an abſolute Tyranny over theſe States. To prove this, let Facts be ſubmitted to a candid World.

He has refuſed his Aſſent to Laws, the moſt wholeſome and neceſſary for the public Good.

He has forbidden his Governors to paſs Laws of immediate and preſſing Importance, unleſs ſuſpended in their Operation till his Aſſent ſhould be obtained; and when ſo ſuſpended, he has utterly neglected to attend to them.

He has refuſed to paſs other Laws for the Accommodation of large Diſtricts of People, unleſs thoſe People would relinquiſh the Right of Repreſentation in the Legiſlature, a Right ineſtimable to them, and formidable to Tyrants only.

He has called together Legiſlative Bodies at Places unuſual, uncomfortable, and diſtant from the Depoſitory of their public Records, for the ſole Purpoſe of fatiguing them into Compliance with his Meaſures.

He has diſſolved Repreſentative Houſes repeatedly, for oppoſing with manly Firmneſs his Invaſions on the Rights of the People.

He has refuſed for a long Time, after ſuch Diſſolutions, to cauſe others to be elected; whereby the Legiſlative Powers, incapable of Annihilation, have returned to the People at large for their exerciſe; the State remaining in the mean time expoſed to all the Dangers of Invaſion from without, and Convulſions within.

He has endeavoured to prevent the Population of theſe States; for that Purpoſe obſtructing the Laws for Naturalization of Foreigners; refuſing to paſs others to encourage their Migrations hither, and raiſing the Conditions of new Appropriations of Lands.

He has obſtructed the Adminiſtration of Juſtice, by refuſing his Aſſent to Laws for eſtabliſhing Judiciary Powers.

He has made Judges dependent on his Will alone, for the Tenure of their Offices, and the Amount and Payment of their Salaries.

He has erected a Multitude of new Offices, and ſent hither Swarms of Officers to harraſs our People, and eat out their Subſtance.

He has kept among us, in Times of Peace, Standing Armies, without the conſent of our Legiſlatures.

He has affected to render the Military independent of and ſuperior to the Civil Power.

He has combined with others to ſubject us to a Juriſdiction foreign to our Conſtitution, and unacknowledged by our Laws; giving his Aſſent to their Acts of pretended Legiſlation:

For quartering large Bodies of Armed Troops among us:

For protecting them, by a mock Trial, from Puniſhment for any Murders which they ſhould commit on the Inhabitants of theſe States:

For cutting off our Trade with all Parts of the World:

For impoſing Taxes on us without our Conſent:

For depriving us, in many Caſes, of the Benefits of Trial by Jury:

For tranſporting us beyond Seas to be tried for pretended Offences:

For aboliſhing the free Syſtem of Engliſh Laws in a neighbouring Province, eſtabliſhing therein an arbitrary Government, and enlarging its Boundaries, ſo as to render it at once an Example and fit Inſtrument for introducing the ſame abſolute Rule into theſe Colonies:

For taking away our Charters, aboliſhing our moſt valuable Laws, and altering fundamentally the Forms of our Governments:

For ſuſpending our own Legiſlatures, and declaring themſelves inveſted with Power to legiſlate for us in all Caſes whatſoever.

He has abdicated Government here, by declaring us out of his Protection and waging War againſt us.

He has plundered our Seas, ravaged our Coaſts, burnt our Towns, and deſtroyed the Lives of our People.

He is, at this Time, tranſporting large Armies of foreign Mercenaries to compleat the Works of Death, Deſolation, and Tyranny, already begun with circumſtances of Cruelty and Perfidy, ſcarcely paralleled in the moſt barbarous Ages, and totally unworthy the Head of a civilized Nation.

He has conſtrained our fellow Citizens taken Captive on the high Seas to bear Arms againſt their Country, to become the Executioners of their Friends and Brethren, or to fall themſelves by their Hands.

He has excited domeſtic Inſurrections amongſt us, and has endeavoured to bring on the Inhabitants of our Frontiers, the mercileſs Indian Savages, whoſe known Rule of Warfare, is an undiſtinguiſhed Deſtruction, of all Ages, Sexes and Conditions.

In every ſtage of theſe Oppreſſions we have Petitioned for Redreſs in the moſt humble Terms: Our repeated Petitions have been anſwered only by repeated Injury. A Prince, whoſe Character is thus marked by every act which may define a Tyrant, is unfit to be the Ruler of a free People.

Nor have we been wanting in Attentions to our Britiſh Brethren. We have warned them from Time to Time of Attempts by their Legiſlature to extend an unwarrantable Juriſdiction over us. We have reminded them of the Circumſtances of our Emigration and Settlement here. We have appealed to their native Juſtice and Magnanimity, and we have conjured them by the Ties of our common Kindred to diſavow theſe Uſurpations, which, would inevitably interrupt our Connections and Correſpondence. They too have been deaf to the Voice of Juſtice and of Conſanguinity. We muſt, therefore, acquieſce in the Neceſſity, which denounces our Separation, and hold them, as we hold the reſt of Mankind, Enemies in War, in Peace, Friends.

We, therefore, the Repreſentatives of the UNITED STATES OF AMERICA, in GENERAL CONGRESS, Aſſembled, appealing to the Supreme Judge of the World for the Rectitude of our Intentions, do, in the Name, and by Authority of the good People of theſe Colonies, ſolemnly Publiſh and Declare, That theſe United Colonies are, and of Right ought to be, FREE AND INDEPENDENT STATES; that they are abſolved from all Allegiance to the Britiſh Crown, and that all political Connection between them and the State of Great-Britain, is and ought to be totally diſſolved; and that as FREE AND INDEPENDENT STATES, they have full Power to levy War, conclude Peace, contract Alliances, eſtabliſh Commerce, and to do all other Acts and Things which INDEPENDENT STATES may of right do. And for the ſupport of this Declaration, with a firm Reliance on the Protection of divine Providence, we mutually pledge to each other our Lives, our Fortunes, and our ſacred Honor.

Signed by ORDER and in BEHALF of the CONGRESS,

JOHN HANCOCK, President.

ATTEST.
CHARLES THOMSON, Secretary.

PHILADELPHIA: PRINTED BY JOHN DUNLAP.

Chew (1722-1810), chief justice of Pennsylvania. Folded neatly and filed among his private papers, it was preserved–clean and fresh as the day it was printed–until it was auctioned in New York in 1982. Ironically, perhaps, Chew did not show a conspicuous enthusiasm for the patriot cause. Despite his friendship with Washington, he was relieved of his public posts and remained for some while under house arrest.

25 🍂

WILLIAM BLAKE

Songs of Innocence. The Author & Printer W. Blake, 1789. [Relief etching with added watercolor, etched 1789, printed about 1794.] Copy D. PML 58636. Bequest of Miss Tessie Jones in memory of her father, Herschel V. Jones, 1968.

For all the scholarly disagreement over the poet and mystic William Blake (1757-1827), he remains a highly important figure in the development of the book arts. "The Lamb" is among the best known of Blake's group of poems,

25 From Blake's *Songs of Innocence*

which appeared as *Songs of Innocence* (1789) and *Songs of Innocence and of Experience* (1794). It expresses his mystical faith in the unseen and the unknowable. As a youth, he apprenticed under the engraver James Basire and for about thirty years was best known as the engraver of other artists' work. In 1789, however, Blake broke new ground with *Songs of Innocence,* the first of his illuminated books. These were produced using a new etching technique, which he believed had been communicated to him by his deceased younger brother in a dream. Blake drew the text and design on the surface of the plate and then etched away the surrounding areas, leaving the printing surface in relief. After printing the plates, he and his wife added color and gold by hand. Each printed volume is therefore a unique copy, with variations in ink and coloring. To make books in this way took great amounts of time, and copies of these texts were assembled as required by patrons. They were not published in the usual sense.

This copy of *Songs of Innocence* is among the earliest issued by Blake. It was owned by Ann Flaxman, wife of the painter John Flaxman, one of Blake's few close friends and supporters. She and her husband financed his first and only typographically conventional book of poetry, *Poetical Sketches,* published in 1783. The Library's collection of Blake, which was already major, became even more renowned in 1972 with the addition of Mrs. Landon K. Thorne's collection. The holdings include original drawings and manuscripts as well as multiple copies of various illuminated books.

26 🍂

JOHANN WOLFGANG VON GOETHE

Zur Farbenlehre. Tübingen: J. G. Cotta, 1810. 8°. 2 v. + 2 v. plates. Heineman 663. Dannie and Hettie Heineman Collection, donated in 1977.

For many, Goethe (1749-1832) is best known as a literary figure, the author of *Faust* and *The Sorrows of Young Werther.* He possessed a great intellectual energy and curiosity, however, and wrote extensively on art theory and criticism, geology, archaeology, botany, and physics. During the course of his long life he produced fourteen volumes of scientific writing. *Zur Farbenlehre (On the Theory of Colors)* is his fierce and in many ways misguided attack on Newton's discovery, pub-

26 Plate I from Goethe, *Zur Farbenlehre*

lished more than a century earlier, that white light is a composite of various colors that can be separated through a prism. Before Newton, scientists had considered white light to be pure. Goethe held to the older idea, asserting that colors result from the mixing of light and darkness and that all things are sufficiently turbid to create color. Nevertheless, his theory is not without merit as a study of the psychology of color perception: Goethe identified the three primary colors—yellow, blue, and red—as the most pure color sensations. His idea that the human brain responds to color as emotion and will generate compensatory sensations to balance the effect of color was to be remarkably influential in subsequent German philosophy and psychology.

Goethe's interest in the natural sciences was stimulated when as a young man he became a minister of state to the duke of Weimar. In the execution of his duties he instructed himself in agriculture, horticulture, and mining, all of which were of paramount importance to the economy of the duchy. His discovery in 1785 of formations in the human jawbone analogous to those in apes prefigured the insights of Darwin. In 1791, he published his studies in plant morphology which were even more important for the development of the science of botany. All the time he was working on his novel *Wilhelm Meister Lehrjahre* (1795-96) and completing the first part of *Faust* (1808), generally regarded as one of the classics of world literature.

Zur Farbenlehre is among the number of important printed books and manuscripts collected by Dannie and Hettie Heineman. Dannie Heineman was especially interested in Goethe, and the collection contains a number of early editions (including four presentation copies) as well as manuscript portions of *Faust*, Part II, and "Die wandelnde Glocke." Other strengths of the Heineman collection are science and philosophy, ranging from works by Galileo to Einstein, French and German literature of the eighteenth and nineteenth centuries, and music manuscripts.

27 ｓ

PIERRE-JOSEPH REDOUTÉ

Les Roses, par P. J. Redouté, peintre de fleurs....Avec le texte par Cl. Ant. Thory.... Paris: Firmin Didot, 1817-24. PML 45395-45397. Estate of Mrs. J. P. Morgan; gift of Junius S. Morgan and Henry S. Morgan, 1953.

Les Roses is the most celebrated and reproduced of all flower books. It was produced following the surge in natural history studies of the eighteenth century, when the creation of lavishly illustrated plant and animal books was greatly in vogue. Redouté's work represents a pinnacle of excellence in the specialized field of flower illustration. The 169 engraved plates of *Les Roses* comprise virtually all the important varieties then known.

Reproduced here is the *Rosa centifolia bullata,* engraved by Langlois, one of the most famous in the series and a superb example of Redouté's art and of stipple engraving, which he fostered. This painstaking technique, which he may have learned in England, produces images of unrivaled delicacy and precision. It was achieved by puncturing the plate using either indented tools, individual points of a needle, or etched dots to create an infinity of small recesses of varying sizes and depths, each of which would hold a minute quantity of ink. This allowed the engraver to reproduce the slightest nuance of tone in the original drawings. The printing in colors was usually done from a single plate; the colors were applied individually with a rag ball and the plate re-inked before each impression. The Library's copy of *Les Roses* is one of a few with the plates printed on large paper and in both colored and uncolored states. The color printed set has been finished with additional hand-coloring, which may be by Redouté himself. In addition, the Library has two signed watercolors on vellum from which the engravings were made.

Pierre-Joseph Redouté (1759-1840), born in Luxembourg, spent most of his life in France. In Paris he trained with the great Dutch flower painter Gerard van Spaendonck, under whose supervision he painted over six thousand watercolors for the collection of the Muséum National d'Histoire Naturelle. His career was greatly assisted by his ability to attract influential patrons. Just prior to the Revolution, he was appointed draughtsman to the cabinet of Marie-Antoinette (while imprisoned in the Temple she reportedly sent for him to paint a cactus which had particularly taken her fancy). As the "official painter" to the Empress Josephine, Redouté was commissioned to commemorate the species of lilies and other flowers in her garden at Malmaison. The Library also has *Les Liliacées* (1802-16), a sumptuous production of 503 plates. With the end of imperial patronage, following Napoleon's defeat at Waterloo, Redouté began to publish

Rosa centifolia Bullata.
Rosier à feuilles de Laitue.

P. J. Redouté pinx. Imprimerie de Rémond Langlois sculp.

27 *Rosa centifolia bullata*, engraving after Redouté from *Les Roses*

Les Roses, in parts, each containing six plates. In this way he capitalized on his reputation and continued to live the lavish way of life to which he had become accustomed. Redouté was prodigal with money, however, and despite his fame and skill, he died in poverty.

The Library owns all of Redouté's major works. *Les Roses* was among the large and important group of garden and horticultural books formed by Mrs. J. P. Morgan.

28 ❧

ANTHONY TROLLOPE

The Small House at Allington. London: Smith, Elder and Co., 1864. 2v. 8°. GNR 2175. Bequest of Gordon N. Ray, 1987.

Anthony Trollope (1815-82), whose many novels deal with life in the Victorian era, is credited with having created the English multi-novel series. *The Small House at Allington* (1864) is set in the cathedral town of Barchester. Many of the same characters weave in

28 Wood engraving after J. E. Millais, from Trollope, *The Small House at Allington*

"HE IS OF THAT SORT THAT THEY MAKE THE ANGELS OF," SAID THE VERGER.

and out of four other novels, which were later issued as a collected edition – the Chronicles of Barsetshire. Besides some half a dozen books from the library of Trollope's son Henry, the Morgan Library has the autograph manuscripts of two of Trollope's works as well as some letters. Among the letters are several from the correspondence of the artist John Everett Millais, the illustrator of this edition of *The Small House at Allington.* Here we see an example of Millais's effective style of characterization. Between September 1862 and April 1864, the book was serialized in the *Cornhill Magazine,* where Millais also included historiated initials that do not appear in the book.

The Morgan Library has a strong collection of Victorian literature, including books in parts, the form in which many of the novels of the period were first issued, autograph manuscripts, and presentation copies. Among the popular authors particularly well represented are Dickens, Thackeray, Ruskin, and Trollope. This volume has a bright green embossed and gilt publisher's binding.

29 ❧

EDGAR ALLAN POE

Le Corbeau. The Raven. Poëme par Edgar Poe, traduction française de Stéphane Mallarmé, avec illustrations par Edouard Manet. Paris: Richard Lesclide, Éditeur, 1875. GNR Fr. 277. Bequest of Gordon N. Ray, 1987.

Edouard Manet and Stephen Mallarmé met in Paris in the latter part of 1873 and were constant companions until the poet's death in 1883. *Le Corbeau,* Mallarmé's translation of Poe's *The Raven,* with lithographs by Manet, appeared in 1875 and was completely unlike anything that had been conceived before. It is the first collaboration of writer and painter to produce a book that was consciously developed as a total work of art. As such, *Le Corbeau* stands at the head of the tradition of the *livre de peintre,* one of France's most distinctive contributions to the history of the book.

In his rendering of the poem, Mallarmé did not attempt to produce a literal translation of the original. Rather he has used Poe's verse as a vehicle for his own allusive mode of expression: "To paint not the thing," as he once explained, "but the effect it produces." That he should have turned to the work of Poe for inspiration is not surprising. His great mentor was the French symbolist poet Baudelaire, whose own

29 Illustration by Manet for the
 French edition of *The Raven*

translations of Poe formed half of his collected works. Manet's lithographs, while realistic in form and faithful to the content of the text, were intended to elicit the eerie mood and irrational sensations evoked by the words on the page.

Le Corbeau was published in a deluxe format in an announced edition of 240. In fact, many fewer copies were produced. The Library's copy is number 80 and is signed by both Manet and Mallarmé. Two types of paper were used for the publication: chine, a thin, soft, coated paper that receives printing particularly well; and, as in the present case, hollande, a slightly stiffer, laid paper with a yellowish cast. As a commercial venture, *Le Corbeau* was a failure. As a consequence, plans for a second collaboration were abandoned.

The Library's copy was one of some 17,000 volumes received in the bequest of Gordon N. Ray, an eminent scholar and collector of French and English illustrated books. In Ray's estimation *Le Corbeau* ranks as one of the one hundred outstanding illustrated books produced in France before World War I.

GEOFFREY CHAUCER

The Works of Geoffrey Chaucer. Hammersmith: The Kelmscott Press, 20 June 1896. F°. PML 76889 (paper copy; presentation to Sydney Cockerell). The gift of John M. Crawford, Jr., 1975.

The Works of Geoffrey Chaucer is the masterpiece of the Kelmscott Press, the printing establishment founded in 1891 by William Morris and named after his Oxfordshire home, Kelmscott Manor. Rejecting what he perceived to be the "decay" of printing and the increasing shoddiness and mechanization of nineteenth-century book production, Morris advocated a return to fifteenth-century techniques and standards of craftsmanship, quality, and design. The Chaucer, five years in planning and execution, was intended to be the "ideal" book and, in Morris's own words, "essentially a work of art." He designed all the decorations: title, borders, frames, and large initials (sixteen of his original drawings for the Chaucer are in the Morgan Library). Many of these are modeled after examples found in Morris's own important collection of medieval manuscripts and early printed books, some of which are also at the Morgan Library. The pre-Raphaelite artist Edward Burne-Jones, a friend and aesthetic collaborator of Morris since their student days at Oxford, provided the drawings for the eighty-seven woodcut illustrations. Shown here is the first page of the prologue to *The Canterbury Tales*.

That the culmination of Morris's endeavors in the art of the book should be the works of Geoffrey Chaucer came as no surprise to his circle of friends and admirers. Many of Morris's own literary works were patterned after Chaucer, whom he had referred to in print as "my Master." The Kelmscott Chaucer is, moreover, reflective of the contemporary Victorian rediscovery of his works and early English literature in general. Much of the credit for this revival is given to Morris's friend F. J. Furnivall, who founded the Chaucer Society in 1868 "to do honour to Chaucer...and to see how far the best unpublished manuscripts of his works differ from the printed texts." The text and spelling of the Kelmscott Chaucer follows that of Skeat's monumental six-volume edition of Chaucer's works which had appeared in 1894 and was meant to reflect a collation of all authoritative manuscripts.

The Library also has another copy bound in

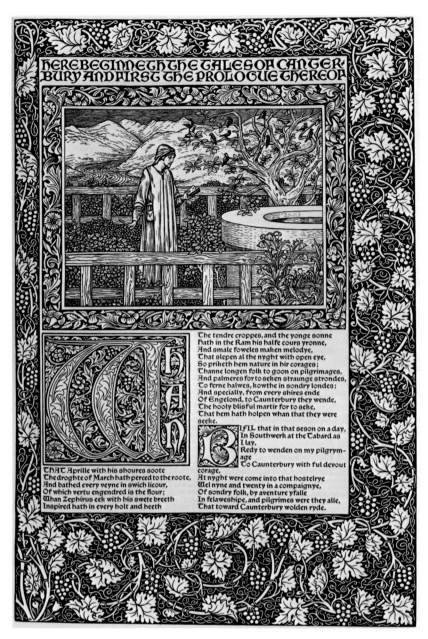

30 Page from the Kelmscott Chaucer

a white pigskin binding designed by Morris and patterned after a fifteenth-century German binding in his collection. The copy pictured here has unique associations, being the one Morris inscribed and gave to Sydney Cockerell, secretary of the press and administrative head of the enterprise. The inscription is dated July 7, 1896, a month after the first bound volumes were delivered. Morris's health had been declining for some time, and he died in October.

With this copy is a wrapper of Morris-designed chintz, which his wife Jane had given to Cockerell. Following Morris's death, Cockerell completed the books in production and organized the gradual closing down of the press. He went on to become the director of the Fitzwilliam Museum at Cambridge, and was a trusted friend and adviser to Belle Greene in the formation of the Morgan Library's book and manuscript collection.

Joris Karl Huysmans

A rebours. Deux-cent-vingt gravures sur bois en couleurs de Auguste Lepère. Paris: Les cent bibliophiles, 1903. GNR Fr 328. Bequest of Gordon N. Ray, 1987.

The novel *A rebours* by Joris Karl Huysmans (1848-1907), generally translated as *Against Nature*, was a sensation when it first appeared in Paris in 1884. It is the strange story of des Esseintes, a wealthy, cultivated man who seeks to escape from the world in which he lives through dreams. Each chapter relates his experiments with a different "specialty"—literature or precious gems, art, or perfumes. None of these experiences, however, saves him from complete boredom and disaffection. *A rebours*

was treated as a guide to the true attitudes of modern French artists and has been called the bible of the late nineteenth-century Symbolists and Decadents. The book was greatly admired by Oscar Wilde, who introduced it into *Dorian Gray* as the yellow book Lord Henry Wotton hands to young Dorian.

The Library's copy is one of 130 specially produced copies which appeared in 1903 with woodcut illustrations by August Lepère (1849-1918). At the time, Lepère was best known for scenes of Paris and the provinces. In this book, however, he was dealing with one of France's most subtle writers. Lepère's designs are allusive rather than literal, and they frequently contain witty references, by way of tribute, to other artists. Where des Esseintes muses on foreign travel, Lepère's designs look like the Japanese prints of Hokusai. Where the refer-

31 Pages from *A rebours*, illustrated by Lepère

ence is to Symbolist art, he refers to Gustav Moreau and Odilon Redon; and in a reference to London, he presents an image strongly influenced by Gustave Doré. The design on many pages reflects the Art Nouveau style, including the image reproduced here from Chapter 1.

The artist worked two years on the book, and it is almost a dictionary of the visual tradition of the time. This copy is in a handsome mosaic morocco binding with doublures by Marius Michel. Its Art Nouveau design of flowers and leaves is related to Lepère's designs for Chapter 4.

32 ⵌ

PHILIPP ANDRÉ

Specimens of Polyautography. London: P. André, April 1803. 13 lithographed plates. Single leaves, sizes vary. PML 76358. Gift of Paul Mellon, 1979.

Specimens of Polyautography (polyautography was an early term for lithography) first appeared in 1803 and was an effort to introduce lithographic printing into England. The process had been invented in the 1790s in Germany by Aloysius Senefelder (1771-1834), who en-

31 Binding of Huysmans, *A rebours*

32 Frontispiece from *Specimens of Polyautography*

trusted Philipp André with the task of organizing the London publication. The plan was to assemble an album of lithographs by prominent English artists created, as the title page proclaimed, "from original drawings made purposely for this work." The Anglo-American artist Benjamin West was among the first whose work was included—an 1801 pen lithograph of the angel at the tomb of the risen Christ. Other artists included Thomas Barker, James Barry, Henry Fuseli, and Thomas Stothard. A publication, in six parts of six sheets each, was planned. The first two were issued by André in 1803. The project was completed in 1806-7 by C. J. Vollweiler.

Lithography, from the Greek words for stone and writing, is the only major process of graphic reproduction to have had a known inventor. Aloysius Senefelder, in Munich, discovered, apparently by accident, that if he wrote in grease on paper, pressed the greasy marking onto smooth limestone, then soaked the stone in water, the printer's ink adhered only to the original grease marks. A sheet of paper pressed against the stone reproduced, in reverse, the original design. There were numerous advantages to the technique. An artist could work directly on the stone, and it could be resurfaced and used again and again. The number of impressions was not limited as it was in printing from soft copper plates.

Commercially lithography was a failure for its first twenty years in England. British aquatint engravers, fearing competition from the new "upstart" process, had a heavy import duty imposed on the Munich stones necessary for fine lithographic printing. Worse still, it was snubbed as a cheap alternative to the "real" process of etching and engraving. As Ruskin, the aesthetic dictator for much of the English-speaking world during the nineteenth century, warned, "Let no lithographic works come into your house if you can help it, nor even look at any." The process was used widely for book illustration from the 1840s onward. The earliest lithographs were not in color, but as the century progressed, chromolithography became a major form of book illustration and was used for packages, posters, and advertising. The technique has since evolved into offset lithography for printing text, leading to the virtual demise of letterpress printing as invented by Gutenberg.

v Children's Books

L ITERATURE for the instruction and diversion of children is a wide and varied field. It is also one in which the survival rate is poor. Passed from hand to hand, often inexpensively produced and treated roughly, these works are ephemeral. Fragile in nature, they are, however, enduring in thought and spirit, the popular ones being reprinted and re-illustrated to inform and delight generation after generation of children. In the world of scholarship, the study of children's books is a comparatively recent development. The production of books designed specifically for children only became widespread in the eighteenth century. Today, scholars and students in increasing numbers are exploring the ways in which the development of children's literature and book publishing intersects with social, economic, literary, and art history. The Morgan Library is fortunate in having been able to participate in this fascinating field of inquiry.

Except for the acquisition of the manuscript of Thackeray's *The Rose and the Ring* (v, 7) and some books and manuscripts for young adults, the collection of children's books at the Library really began with the gift in 1965 of a substantial portion of Elisabeth Ball's English and French children's books. Miss Ball's collection in turn was built on two famous collections acquired by her father in the 1930s: the Gumuchian collection (a French bookseller) and that of the English collector Charles T. Owen. The Library received several thousand volumes from Miss Ball. In the 1970s she endowed a fund that allows for additions to the collection. It provided, for example, for the purchase of the Wilbur Macey Stone-Gillett G. Griffin collection of American children's books in 1970. Miss Ball died in 1982.

While the Library contains several major groups of drawings and exceptional autograph manuscripts in the realm of children's literature, the collection is primarily composed of printed books. The period covered is roughly from the early sixteenth century to the late nineteenth century, with an emphasis on the eighteenth and nineteenth centuries. Recently the nineteenth-century holdings have been expanded by the addition of the Thomas Balston section of the Gordon N. Ray bequest and the Lewis Carroll collection of Arthur A. Houghton, Jr. We have also benefited from the generosity of several Fellows, in particular the English and American collection formed by Mrs. Sherman P. Haight and the acquisitions support of Miss Julia P. Wightman, who in 1991 gave the Library her major collection of children's books, a gift of about 1500 volumes.

The changed attitude toward children that came about in England and much of the rest of Europe in the late seventeenth and early eighteenth centuries resulted in a wealth of books made especially for the young. It is here that the collection is particularly strong, with books by such well-known English printers as Thomas Boreman, the Newberys, Harris, Tabart, Kendrew of York, and Lumsden of Glasgow. Illustrators represented in the collection range from anonymous carvers of crude woodcuts to the very famous and talented, such as Caldecott, Cruikshank, Greenaway, and Potter. American holdings include New England primers, colonial books for children, a large number of books printed by Munro and Francis and the Babcock family, books illustrated by the New York

wood engraver Alexander Anderson, and a small group of books printed by the Sunday School Union.

French holdings constitute one of the most fertile fields for research, for much remains unexplored regarding the practices and patterns of the French trade in children's books. Indeed, the Library's files on genres, printers, authors, and illustrators constitute a valuable resource for such studies. The nineteenth century was important for recording European folktales, and the Brothers Grimm were the most significant of those who gathered this material. The first edition of their work is in the early children's book collection, despite the fact that it was originally intended as an anthropological work. Indeed such names as Robert Browning, William Blake, John Locke, and Lady Gregory are among the many famous authors represented in the children's book collection. Important continental works range from the educational works of Comenius in the sixteenth century to the movable books developed by Meggendorfer and the first appearance in periodical and book form of Carlo Collodi's story of a puppet-come-to-life, *The Adventures of Pinocchio* (1881-83).

The early children's book collection is a logical one for the Morgan Library, affording scholars the opportunity to study the European and American book trade in children's books and providing rich resources for the study of the history of printing trades and practices, education, and book illustration. What follows is only a glimpse of the available resources.

1 ❧

TABLE MANNERS

Les Contenances de la table. [Lyons: Printer of the *Champion des dames* (Jean Du Pré), ca. 1487.] 4°. PML 63681. Purchase: Ball Fund, 1973.

Les Contenances de la table, a rhymed treatise on table manners, is one of the first books ever printed specifically to be read by children. While various printed Latin grammars had already appeared and were obviously used by children, the *Contenances* is distinguished by being written in the vernacular and explicitly addressed to "enfants." It must have been a popular book, for no fewer than seven copies of fifteenth-century editions survive, each, however, only in a single copy. The Morgan copy is thought to be the first edition. It was printed in Lyons in about 1487 by the anonymous "Printer of the Champion des dames," later identified as Jean du Pré, who was active there from 1488 to 1495.

The title shown here features a delightful calligraphic initial L from which sprout two grotesque heads and a fantastic bird that fastens its long beak onto the neck of the uppermost figure. The text is in the form of quatrains, each commencing with the word *enfant.* The

beginning verses, reproduced here, admonish the young reader on such topics as having properly trimmed fingernails and washed hands. The *Contenances* belongs to an important category of children's literature known as courtesy books, intended to teach young people proper behavior. Courtesy books date at least from the fourteenth century and are still flourishing, Gelett Burgess's *Goops and How to Be Them* (1900) being a modern classic of the genre. An early example in the Library's collections is the *Avis aus Roys,* a French manuscript of about 1360, addressed to young princes and designed to prepare them for life as future rulers. The *Contenances,* however, is directed to children of humble as well as noble birth and deals specifically with behavior at the table. Like many medieval texts it has a complex genealogy and wide circle of relations. Treatises on table manners in verse are found in almost all medieval vernaculars. Most of them descend more or less directly from a short twelfth-century poem which is in turn derived from one section of Petrus Alfonsi's *Disciplina clericalis.* The text of *Les Contenances,* whose authorship is unknown, is derived from this earlier tradition. The English printer William Caxton produced two children's books on behavior in the 1470s that are similar in content and format. The Library's copy was successively

Es
contenances & fa tabfe.

1 Title page and text page of *Les Contenances de la table*

owned by the English artist and collector Charles Fairfax Murray and the prominent Swiss collector Edmée Maus.

2 �763

JOHANN AMOS COMENIUS

*Orbis sensualium pictus. Hoc est, omnium fundamentalium in mundo rerum & in vita actionum, pictura & nomenclatura. Die sichtbare Welt....*Nuremberg: Michael Endter, 1658. 8°. PML 83013. Purchase: Miss Julia P. Wightman, 1978.

Comenius's famous *Orbis sensualium pictus,* translated into English as *Visible World* in 1659, is regarded by many as the earliest picture book for children. This is one of three extant perfect copies of the first edition of 1658 and the only one in the United States. Comenius (1592-1670), a Moravian teacher and theorist on education, was a pioneer in popularizing a notion now universally taken for granted—that children learn willingly and rapidly when provided with visual aids.

"Sight," wrote Comenius, "is the chiefest of senses." And so he built a book around pictures. Its purpose was two-fold: to serve as a Latin grammar and, more generally, as an introduction to the world through pictures. The book is, in fact, the first pictorial encyclopedia. "It is a *little Book,* as you see," explains Comenius in his preface, "of no great bulk, yet a brief of the whole world, as a whole language: *full of Pictures, Nomenclatures and Descriptions of things.*" In format, it is a dictionary-like compendium of vocabulary arranged by subject under an illustrative woodcut: the text provides the Latin word and the German equivalent.

To be sure, there were precedents for allying pictures and text in instructional children's books. In 1649 a French doctor, Louis Couvay, produced a handsomely illustrated Latin grammar of which the Library owns a first edition (*Méthode nouvelle et très-exacte...*[Paris, 1649]). Comenius himself had produced three works containing pictures keyed to Latin and vernacular vocabularies, often known by the short-title catch phrases *Vestibulum, Janua,* and *Atrium.* But his *Orbis pictus* was by far the

2 Pages in Latin and German of Comenius,
Orbis sensualium pictus

most ambitious and influential of these early efforts. Only one year after publication of the book, an English translation by Charles Hoole appeared and remained in use by children in the English-speaking world well into the nineteenth century. A copy of the first American edition (New York, 1810) is one of a variety of translations and editions of Comenius's work in the Library available for comparative study.

3 🐦

AESOP

Aesop's Fables with His Life: in English, French & Latin. Illustrated by Francis Barlow. London: William Godbid for Francis Barlow, 1666. F°. PML 64797. Gift: Mrs. G. W. P. Heffelfinger, 1974.

The fables of Aesop are perhaps the most frequently read and illustrated of all books for children. Their enduring appeal undoubtedly derives from the vigor and simplicity of the stories, while the moralizing purpose of the fables has endeared them to parents. It was recognized early on that the familiarity and clarity of the tales also made Aesop a useful text for teaching foreign languages, particularly when accompanied by illustrations. This seventeenth-century polyglot Aesop in English, French, and Latin is notable for the handsome engravings after Barlow, who was regarded in his day as one of the finest English draughtsmen of animal scenes. Indeed, his series of 112 engravings for Aesop inspired, directly or indirectly, English book illustrations of the text for the next two centuries.

"Do not the humble with neglect despise" is the moral for the fable of the lion and mouse illustrated here: the tiny mouse, by methodically gnawing through the ropes, has rescued a lion trapped in a net. The English and Latin versions of the story appear below. Barlow paid for the publication of the book himself, and his introduction specifies that he intended it to help young people learn languages in a congenial way. Thomas Philpot supplied the English text and Robert Codrington provided the French and Latin. This is one of only about a dozen copies of the first edition to survive, most having been destroyed in the great fire of London which swept over the printer's premises in 1666. In 1687 Barlow published a second edition, with a much improved English text by Aphra Behn.

The original texts of the fables of Aesop do

not exist. Indeed, it is unlikely that the famed storyteller, supposedly born in Thrace in the early sixth century B.C., ever wrote his fables down. The earliest reference to a written version of Aesop is a fourth century B.C. prose verse in Greek by one Demetrius of Phalerum. This too has been lost, but served as a source for various other copies of the stories that do survive. Prominent among them is the Library's papyrus fragment from the third or fourth century A.D., which is the earliest surviving Greek text for three of the fables set down by the poet Babrius. Of equal, if not greater, importance is the Library's ninth-century A.D. manuscript, the Codex Pithoaenus, the earliest known collection of Aesop's fables rendered in Latin verse by the Roman poet Phaedrus. The Library also has a copy of the Aesop printed in Ulm about 1476, which is the first printed version known to contain pictures.

3 Polyglot edition of Aesop

The Lyon and Mouse. 47

A Lion was Entangled in a Snare.
Nor could his teeth or paws ye ambush teare
Since his wilde Struglings more engag'd him in
The treacherous foldings of ye ruder Gin.

When a kinde Mouse by gnawing did vntwine
The Snarled Cordage of the raveld line
So did the Lion Life and freedome gett,
Infranchis'd from ye Prison of his Nett.

Doe not ye humble in neglect dispise.

A Mouse a Lion rescu'd from Surprize.

FAB. XXIII. De Leone & Mure.

LEO æstu, cursuq; defessus in umbra quiescebat, Murium autem grege tergum ejus percurrente expergefactus unum è multis comprehendit, Supplicat misellus, clamitans Indignum se esse cui irascatur ; Leo reputans nihil laudis esse in Nece tantillæ bestiolæ captivum dimittit ; Non multo post, Leo dum per segetes currit incidit in plagas, rugire licet , exire non licet, Rugientem Leonem Mus audit, vocem agnoscit, repit in cuniculos, & quæsitos laqueorum nodos invenit, corroditque, quo facto Leo è plagis evadit.

MORALE.

INterdum & ipsi potentes egent ope servorum humilimorum, Vir prudens igitur etiamsi potest, timebit tamen, vel vilissimo homuncioni nocere; Nihil est quod magis commendat Reges quam clementia , & annexa potestati Moderatio. R 2 FAB.

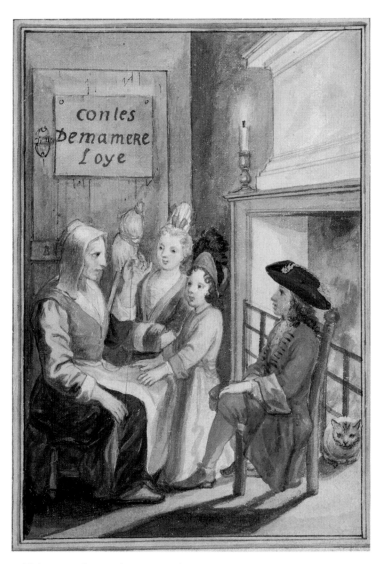

4 Title page of Perrault's *Contes de ma Mere l'Oye*

4 &

CHARLES PERRAULT

Contes de ma Mere l'Oye. Manuscript in a scribal hand. Decorated with seven gouache illustrations, dated 1695. MA 1505. Purchased as a gift of the Fellows, 1953.

This is the original manuscript of the *Tales of Mother Goose*, attributed to Charles Perrault (1628-1702). Dated 1695, it contains the earliest written versions of, and illustrations for, Sleeping Beauty, Little Red Riding Hood, Puss in Boots, Bluebeard, and Diamonds and Toads (Cinderella is absent). The stories as we find them here must be admired more for the artistry with which they are presented than their originality. Each of the tales undoubtedly had

its origins in folklore and was passed down in oral tradition. "Contes de ma mere l'oye" seems to have been a traditional term for such stories in France. This oral tradition is charmingly portrayed in the illustration for the frontispiece, where we see a nurse telling stories to her young charges sitting by the fire. Fairy tales as a literary genre became popular at the court of Louis XIV at Versailles, and this manuscript is in fact dedicated to one of his young nieces, Elisabeth Charlotte d'Orléans. While much of fairytale literature produced during Louis's reign is characterized by elegance of language and courtly embellishments, the text of this manuscript is exceptional in its simple, economical style in which every sentence is important to the development of the story.

The authorship of the manuscript is tradi-

Illustrations to opening sections of Perrault, Puss in Boots and Little Red Riding Hood

tionally ascribed to Charles Perrault, a French academician and poet who once served as secretary to Colbert, Louis XIV's finance minister. The dedicatory inscription, signed "P.P.," however, gives rise to the theory that the author was Perrault's third son Pierre, who later took the surname Darmancour. Moreover, the first authorized printing, which appeared two years later is signed "P. Darmancour." Since the royal privilege for printing was issued in his name and then transferred to Claude Barbin as publisher, Pierre may well have been the true author. He would have been only about sixteen or seventeen at the time the manuscript was written. It was published two years later. Thus far, the reason for the attribution to Charles is lost in history. In any event, this manuscript is the form in which the tales have been known and loved for almost three centuries. The seven anonymous illustrations in the manuscript are executed in gouache. Adapted for numerous subsequent illustrated versions of the stories, they were extremely influential. The Library also has editions of fairy tales by Mme d'Aulnoy and Mlle l'Héritier, among others.

5 ❧

HIEROGLYPHICS

A Curious Hieroglyphick Bible…for the amusement of youth. Worcester, Massachusetts: Isaiah Thomas, 1788. 18°. PML 85500. Gift: Miss Elisabeth Ball, 1964.

Rebuses, or "hieroglyphics," are here used to entice children to read the Bible. Should there be any potential for misconstruing the text, it

appears in full at the foot of the page. This kind of Bible reached a peak of popularity in the eighteenth century. The *Eighteenth-Century Short Title Catalogue* reports a Greek New Testament printed in London in 1703. Also reported is *A Curious Hieroglyphic Bible* printed by and for T. Hodgson in 1783, second edition 1784. This American edition was printed

5 Page of *A Curious Hieroglyphick Bible*

6 Dutch catchpenny print

only four years later by the patriot printer Isaiah Thomas, who moved his press during the American Revolution from Boston and resettled in Worcester, Massachusetts, where he later founded the American Antiquarian Society. This is the first edition of the first hieroglyphic Bible printed in the United States. Only six other copies have been reported.

The Library has recently acquired the German prototype for these Bibles designed for children (*Geistliche Herzens-Einbildungen inn zweihundert fünfzig biblischen Figur-Sprüchen* by Melchior Mattsperger, Augsburg, 1699).

6 🎕

DUTCH CATCHPENNY PRINT

Verscheyde Soorten van Gedierten.
Haarlem: Margareta van Bancken, 1690.
Single sheet, 35.5 x 29 cm. PML 84761.
Purchase: Ball Fund, 1985.

Since the early blockbooks, illustration has been an integral part of popular literature. The earliest examples were created from woodblocks, but changing technology created more sophisticated methods, such as copper plates.

Catchpenny prints—originally a derogatory term—constituted one part of a popular genre that included broadside ballads, slip songs, and chapbooks. These inexpensive, single sheets were sold in toy shops and bookshops, and by hawkers and peddlers as well. They were so popular that at one point toward the end of the nineteenth century, when wood engravings had replaced copper engravings, as many as 250,000 copies of some broadsides were sold.

Catchpenny prints were popular in the Netherlands from the seventeenth century through the nineteenth. In the Low Countries, popular prints continued to be made from woodcuts. The same blocks were often kept, sold from publisher to publisher, and reused, sometimes over centuries. After printing, Dutch woodcuts were frequently colored by hand in a distinctive style, which came to be called "colorier à la manière hollandaise." Patches of blue, red, and yellow were applied at random with a dabber or the thumb, and pink, green, or other colors were sometimes used as well.

From the late seventeenth century, broadsides intended for children were printed in the Netherlands and peddled for small sums or given as prizes in school. The early prints were simple, often merely pictures of objects or creatures with their names as captions, and may have been used for instruction as well as amusement. This sheet of animals printed from twenty-four small woodblocks by or after Dirk de Bray (fl. 1651-78) is one of the earliest dated Dutch prints. From its Haarlem printer, Margareta van Bancken, only two prints are known, each in only two copies.

Dutch books and bindings are of special interest to the Library, and this print is one of several from the Van Veen collection that offer a fascinating array of popular images ranging from animals and street cries to folktales, including versions of the tales of Robinson Crusoe (in which the children's book collection is particularly strong), William Tell, and Red Riding Hood.

7 🎕

HEINRICH HOFFMANN

*[Der Struwwelpeter]. Lustige Geschichte und drollige Bilder....*Frankfurt am Main: Literarische Anstalt (J. Rütten), [1845]. PML 84753.
Gift: Mr. H. P. Kraus, 1984.

Struwwelpeter (shock-headed Peter; or slovenly Peter) occupies roughly the position in German children's literature that Alice does in English: one of the small group of classics immediately recognized by a single name. Both have become immortal. Its author was a Frankfurt doctor who wrote and illustrated a small album of vividly cautionary tales in 1844 as a Christmas present for his young son. He later showed the manuscript to a publisher friend, who insisted that it be printed. This, the first edition, has chromolithographic illustrations that closely follow Hoffmann's original drawings. Not only did Hoffmann insist that his drawings be copied line-for-line, he also insisted that the binding be flimsy—this was *supposed* to be a short-lived book. It was published in an edition of 1500 copies. The book was an immediate and enduring success, and countless editions poured out in the next decades. Its original title, *Lustige Geschichte und drollige Bilder,* which the English translated as "Jolly Tales and Funny Pictures," was not changed to Struwwelpeter until the third edition.

The first edition is of great rarity; this is one of a handful of copies to have survived. Hoffmann's original manuscript is now one of the treasures of the Germanisches Nationalmuseum, Nuremberg, who generously lent it to the Morgan Library's exhibition of children's literature in 1954.

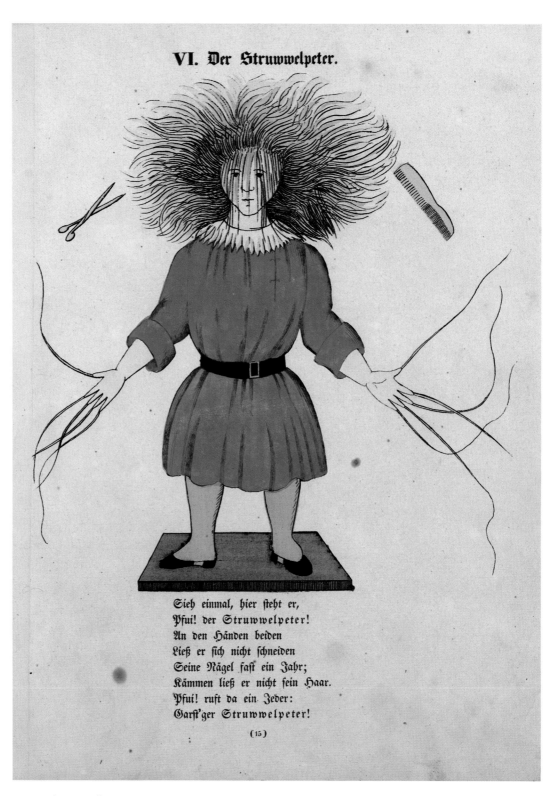

7 Page from Hoffmann, *Der Struwwelpeter*

In addition to this first edition and the third, the Library owns an 1876 edition, several editions of an American version called *Slovenly Peter*, an edition in Hebrew, and an Egyptian *Struwwelpeter* published in London about 1899. The book is only one of the Library's classic German children's books.

8 ᚼ

WILLIAM MAKEPEACE THACKERAY

The Rose and the Ring. Autograph manuscript, with pen and ink sketches, 1853-54. MA 926. Purchased by J. P. Morgan, Jr., 1915.

The manuscript of *The Rose and the Ring* by William Makepeace Thackeray (1811-63), with the author's own delightful illustrations, is one of the great documents of all children's literature. For the first time a major English author had created a full-length story simply for the amusement and joy of children, rather than for their edification.

The story was begun during the Christmas-Epiphany season of 1853-54, when Thackeray and his family were in Rome where he was working on the novel *The Newcombes*. In tra-

8 Thackeray, illustration for *The Rose and the Ring*

ditional English fashion, they celebrated the end of the holiday with a Twelfth-Night party, for which Thackeray had to design the figures because none were available in Italy. Around the figures of King and Queen, Lady and Lover, Captain and Dandy, Thackeray developed a tale set in the kingdoms of Paflagonia and Crim Tartary. An American child, Edith Story, had to miss the party because she was recuperating from malaria. Thackeray continued to develop

8 Thackeray, illustration for *The Rose and the Ring*

the story and read it to her daily. "It is wonderful how easy this folly trickles from the pen," reads an entry in his diary for March 2. He had completed *The Rose and the Ring* in Naples by November, after which his daughters copied the text and he added illustrations. It was published as a Christmas book, dated 1855 for the new year, and has remained in print to this day.

The Library has a strong representation of nineteenth-century English literature and of Thackeray. J. P. Morgan, Jr., acquired this manuscript in 1915 and the printed edition which Thackeray presented to Edith Story. A facsimile edition of the manuscript was published by the Morgan Library in 1947 with an introduction by the Thackeray scholar Gordon N. Ray.

9 🐌

LEWIS CARROLL, PEN NAME OF
CHARLES LUTWIDGE DODGSON

Alice's Adventures in Wonderland. London: Macmillan and Co., 1865. 8°. Bound in full red morocco by The Doves Bindery. Three letters from T. J. Cobden-Sanderson to the previous owner laid in. AAH 36. Gift: Arthur A. Houghton, Jr., 1987.

Alice's Adventures in Wonderland–indisputably one of the two or three greatest children's books ever written–had a somewhat inauspicious beginning. All two thousand copies of the first edition were withdrawn by the author before publication because of bad printing and poor reproductions. Only twenty-three copies of this "suppressed" edition of 1865 are known to survive, all richly prized by collectors. The Library's copy is notable for its handsome red morocco binding tooled with hearts and roses by the prominent English binder T. J. Cobden-Sanderson. A small sheet laid in contains the holograph of Robert Southey's poem "The Old Man and His Comforts," which Carroll parodies in his book as "You Are Old Father William."

Charles Dodgson (1832-98), who wrote under the nom de plume of Lewis Carroll, was an Oxford don and mathematician. The story of *Alice's Adventures Underground*, as it was first called, began as an extemporaneous tale he invented one afternoon to entertain the three daughters of Dean Liddell of Christ Church, Oxford, during a picnic on the river. It was to please one of the girls, Alice, that he wrote the story down. Carroll was a ruthless perfec-

tionist. His instructions to John Tenniel, whom he retained to illustrate the book, required that the artist conform in every detail to the exact vision of the characters and settings in the author's mind. "Lewis Carroll is impossible," Tenniel confided to his friend Harry Furniss. In the event, however, it was Tenniel who considered the reproductions of the first edition unacceptable and urged Carroll to have the work redone. The new improved version, which pleased both author and illustrator, carried the publication date 1866. Many of the rejected copies were sent to Appleton's in New York, where they were issued with a new title page.

This copy was the gift of Arthur A. Houghton, Jr., who built one of the great Alice collections. It contains not only first editions of the Alice books, but also every translation he could find, Dodgson's mathematical treatises and ephemeral publications, his pocket watch, many of his original photographs of children, and related manuscript material. Given to the Library in 1987, this collection added to an already significant group of Lewis Carroll books and related illustrations.

9 From Lewis Carroll's *Alice's Adventures in Wonderland*

" *You are old,*" *said the youth,* " *as I mentioned before,*
 And have grown most uncommonly fat ;
Yet you turned a back-somersault in at the door—
 Pray, what is the reason of that ?"

" *In my youth,*" *said the sage, as he shook his grey locks,*
 " *I kept all my limbs very supple*
By the use of this ointment—one shilling the box—
 Allow me to sell you a couple."

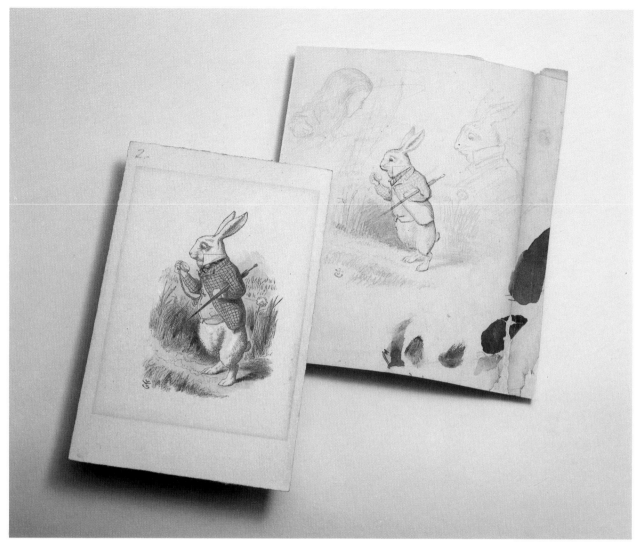

9 Proof of John Tenniel's illustration for the *Nursery Alice* at left (Houghton 590.2)
 and one of his original drawings of the White Rabbit (Gift of Mr. and Mrs. Benjamin Gale, 1982.11:1)

9 Doves Bindery *Alice* and holograph of Southey poem

My rabbit Peter is so lazy, he lies before the fire in a box, with a little rug. His claws grew too long, quite uncomfortable, so I tried to cut them with scissors, but they were so hard that I had to use the big gardens scissors. He sat quite still and allowed me to do his little front paws but when I cut the other hind foot claws

he was tickled, + kicked, very naughty. If he were a wild rabbit digging holes they would be worn down + would not need cutting.

Here are some rabbits throwing snow balls.

10 Beatrix Potter letter to Noël Moore

10 ❧

BEATRIX POTTER

Autograph letter to Noël Moore, 4 February 1895. MA 2009. Gift: Colonel David McC. McKell, 1959.

The tale of Peter Rabbit, along with virtually all the "little books" for children by Beatrix Potter (1866-1943), originated as picture-letters written to the children of her former governess Annie Carter Moore. The most frequent recipient was Noël, who was often ill. The Library owns eleven of her letters to him, written over the period from 1892 to 1900. In this letter of 1895, when Noël was seven, she complains that her pet rabbit, Peter, has become lazy and is given to long naps in his box by the fire, and explains the difficulties of keeping his nails clipped. Peter, christened Peter Piper, was a large Belgian rabbit that Beatrix Potter had acquired "for the exhorbitant sum of 4/6." Young Noël was already well acquainted with Peter's habits and antics. Almost two years before, in September 1893, she had sent him a picture letter which began "My dear Noël, I don't know what to write to you, so I shall tell you a story about four little rabbits whose names were Flopsy, Mopsy, Cottontail and Peter." In the ensuing pages the now-famous story unfolded of Peter's youthful adventures in Mr. McGregor's garden. It was not until seven years later, in 1900, that Beatrix Potter decided to turn the letter—which Noël

10 Bronze figures of Goody and Timmy Tiptoes
and Benjamin Bunny from Potter's stories
(Gift of Miss Elizabeth M. Riley in honor
of Charles Ryskamp on his 10th anniversary
as director, 1979, PML 84981)

had carefully saved along with all his letters
from her—into a book. After being turned
down by at least six publishers, the book was
privately issued in 1901, in a small edition with
black and white illustrations and paid for by
the author herself. The book was such a success
that it attracted the attention of the publisher
Frederick Warne, who had previously rejected
it. *The Tale of Peter Rabbit* was re-issued by

Warne the same year, this time with color illus-
trations. Thereafter, Warne published all of
Beatrix Potter's books.

Her delightful animal figures have been re-
produced in many forms, on pottery and as
stuffed toys; the Library has a set of twelve
miniature enameled bronze figures based on
her book illustrations—they were cast in Vien-
na about 1910.

11 &

KATE GREENAWAY

Eight preparatory designs to illustrate *The Pied
Piper of Hamelin* by Robert Browning (1887).
Pen and black ink, with watercolor. 225 x 201
mm. 1974.13. Anonymous gift. 220 x 193 mm.

The name of Kate Greenaway (1846-1901) is as
recognizable to those who love Victorian chil-
dren's books as Alice is to lovers of fantasy.
These drawings for *The Pied Piper of Hamelin*
capture the spirit of wonder surrounding the
notion that real children could be led away by
the magical melody of a piper.

11 Kate Greenaway, watercolor for *The Pied Piper of Hamelin*

11 Kate Greenaway, watercolor for *The Pied Piper of Hamelin*

The children's book collection contains Greenaway's small almanachs, published from 1883 to 1895, and other books, and the Library's Autograph Letters and Manuscript Department contains almost six hundred letters written to her from the artist and author John Ruskin. In some of these Ruskin advises her on her drawings.

He thought that the Pied Piper was her best work.

12 ❧

ANTOINE DE SAINT-EXUPÉRY

Le Petit Prince. Autograph manuscript with illustrations by the author, ca. 1943. Purchased for the Elisabeth Ball Collection, 1968.

This is the original 176-leaf manuscript, written in pencil and illustrated with the author's sketches, of *Le Petit Prince (The Little Prince)*.

The book is a fantasy about an aviator forced down in the Sahara desert where he is befriended by a young prince who is on a visit to Earth from another planet. Saint-Exupéry (1900-44) was himself an aviator and produced a number of novels based on his experiences as a pilot, such as *Vol de Nuit (Night Flight; 1931)* and *Pilote de Guerre (Flight to Arras; 1942)*.

Although *The Little Prince* may have been written as an allegory for adults, it has been adopted and loved by children everywhere. Indeed it has a very broad appeal and is among the most widely translated books in the world. Not the least of its interest is the fact that in relatively few decades since its composition we Earthlings have come to take astronauts and space travel very much for granted. Perhaps we have mythologized.

The book was written while the French author was in the United States. Most of the manuscript and illustrations were produced during the summer of 1943 when he was living

in a rental cottage on Long Island. The following year he was lost in a reconnaissance mission over the Mediterranean. *The Little Prince* was published in both English and French editions in 1943. The manuscript is of particular interest in that it contains text and several drawings that were not used in the published version. The scene shown here, of the Little Prince floating about the earth, for example, does not appear in the published book.

Saint-Exupéry's other books are represented in the printed books collection, as are those of many other French writers.

12 Saint-Exupéry, illustration for *The Little Prince*, folio 170

VI BINDINGS

WHAT WE KNOW TODAY as conventional twentieth-century binding has more to do with gluing machines than with people. But in the bindings shown here we are talking about the real thing. Hands gathered the sheets and folded them; fingers pushed needles and thread to gather the pages together; hands pared boards, shaved leather, hammered metal, and stamped and painted, or on occasion embroidered, the outer surfaces. Whether the production of one or many, whether the work of a past master or an inspired neophyte, they are the products of human hands, and they speak to us accordingly.

Bindings came into existence with the adoption of the codex, the standard book form, nearly two thousand years ago. Unlike the scroll, which it supplanted, the codex consists of sheets held together by sewing and/or gluing into a book block. The earliest bindings were devised to hold these gathered sheets together in a practical instrument that would last and protect the contents. The oldest surviving examples date from the fourth century of our era. The evidence of these examples suggests that early on, perhaps from the very beginning, bindings were conceived not merely as a protection but as decoration and adornment as well.

The materials used to create the bindings have remained essentially unchanged: thread, boards of wood or other stiff matter, coverings of skin, metal, or fabric. Down through the centuries, many binders have developed a style that has become art of a high order, contributing materially to the decorative arts in a functional way. The bindings that protect books are often a window into the books themselves or the motives of their makers or owners. Modest or forceful, plain or flamboyant, they often mirror their contents. Our interest in bookbinding, however, goes well beyond its status as one of the decorative arts. The history of bookbinding sheds much light on the original ownership and localization of copies, the history of libraries and of book collecting, as well as the marketing of books. These considerations may add considerably to, and often eclipse, the significance of a binding as a decorative object.

The Morgan Library's collection has been formed and added to with the express intention of including historically and artistically significant bindings over a wide range of countries and periods. It is among the finest collection of bookbindings in this hemisphere, equally strong in quantity and quality over the more than fifteen centuries it surveys. We continue to acquire in the areas of our traditional strength, as grounded in the collections of Pierpont Morgan himself—English, French, and Italian bindings of the sixteenth through the early nineteenth century—but we concurrently seek to broaden the collection. It may fairly be said that one of the special qualities of the Morgan Library's collection of bindings, matched by few others, is its diversity.

The collection has grown gradually over nearly a hundred years. The famous Lindau Gospels, purchased by Pierpont Morgan in 1899, was his first truly significant acquisition in the field of medieval manuscripts. But the value of the manuscript itself is rivaled if not surpassed by the jeweled covers that enclose and protect it. They are judged to be the

Central panel from English embroidered binding,
ca. 1640-50 [9]

Library's most important examples of the binder's art. The first major addition to the Library's binding collection that same year came with Morgan's purchase of the "library of leather and literature" of the late London bookseller James Toovey. It included the library of the third earl of Gosford, and the Gosford-Toovey holdings were particularly rich in Aldines and other early printed books, many of them in contemporary bindings. The next largest was the "Rahir Fifty," comprising the bindings sold to Morgan in 1907 by Édouard Rahir. Another notable acquisition was the purchase in 1911 of most of the group of ancient Coptic codices—many still in their original bindings—that had been discovered the year before at Hamouli in the Fayum. Single items were bought steadily by Morgan's librarian and first director, Belle da Costa Greene, and by his son, J. P. Morgan, Jr. Subsequently, in 1926, in the course of developing the Library's collection of medieval manuscripts, the remarkable Weingarten Abbey bindings were purchased from the earl of Leicester. Then, in the early 1950s, the Library's second director, Frederick B. Adams, Jr., began a vigorous program of acquiring bindings that continues to this day. Mr. Adams was in a very real sense the Library's first curator of bindings, enthusiastically devoting much of his energy to this area, in the midst of his overall responsibilities. In more recent years, a trustee of the Library, Miss Julia P. Wightman, has demonstrated particular concern for the enhancement of the bindings collection and has supported its development munificently. She is, in truth if not in actual title, the current honorary curator of bindings.

In the section that follows, you see a sampling of the results of human ingenuity over the course of more than a millennium and a half. Some of the bindings are easily seen to be masterpieces, but not all of them bespeak everyone's taste at all times, and doubtless some of them have languished on occasion. Fortunately, we see the intrinsic beauty of these works, and we strive to keep away the tooth of time.

I ❧

COPTIC TRACERY BINDING

Egypt, the Fayum, seventh or eighth century. Cover of a Gospels, Monastery of Holy Mary Mother of God, Perkethoout, the Fayum, seventh or eighth century. M.569 (385 x 295 mm). Purchased by Pierpont Morgan, 1911.

The Copts were native Egyptians who played an important role in the history of Christianity. Their greatest contribution was the development of monasticism. When, in 1911, Pierpont Morgan purchased most of the sixty Coptic manuscripts found a year earlier in Hamouli (III, No. 2), he acquired the largest, oldest, and most important group of Sahidic manuscripts with a single provenance, the nearby Monastery of St. Michael in the Fayum district of Egypt. Almost all were found with their bindings, and they constitute an essential collection for the study of Coptic bookbinding. Because of the fragile condition of both manuscripts

and bindings, it was necessary to detach and preserve them separately. Unfortunately some information about the methods of sewing was thereby lost.

This cover is regarded as the finest surviving Coptic bookbinding. At its center is a cross surrounded by interlace designs composed of two intertwined squares within a circle. All these were cut from a single piece of red leather and sewn over gilt parchment. In addition, white vellum strips were woven into the borders marking the broad decorative areas and the large circle. Small colored circles, with bright red centers, punctuate the arms of the cross, the perimeter of the large circle, and the bottom border. The use of leather tracery over a gilded ground is earlier than this binding, for the identical technique is found on Coptic shoes usually dated to the sixth and seventh centuries.

The manuscript of the Gospels this cover protected, however, was not made at the Monastery of St. Michael. According to its colophon, the manuscript was originally owned by

1 Coptic tracery binding

the neighboring Church of the Blessed Mary Mother of God at Perkethoout. Later the Monastery of St. Michael added its ex-libris—also made of red leather letters sewn onto gilt parchment on the inside of the front cover.

2 ❧

GILT SILVER, ENAMEL, AND JEWELED BOOKCOVER

South Germany?, late eighth century. Rear cover of Lindau Gospels, Abbey of St. Gall, Switzerland, late ninth century. M.1 (350 x 275 mm). Purchased by Pierpont Morgan, 1899.

This cover was about one hundred years old when the Lindau Gospels was written in the late ninth century, and thus was not made for the manuscript. Whether it was intended to be a bookcover is uncertain, nor is anything known about its history before it was enlarged and restored, probably in 1594, the date stamped on the volume's leather spine.

The design is arranged around a cross of the *pattée* type whose arms broaden at their ends. Extending from the central square are four busts of Christ in champlevé enamel framed by garnets, as are other elements in the cross. Between the arms of the cross are four silver-gilt panels engraved with animal interlace. The cloisonné frames at the top and left of the binding are original, while the borders on the right and bottom are late sixteenth-century replacements. The medallions depicting the

2 Evangelist medallion is a later addition

evangelists, trimmed to fit the corners, were also added in the sixteenth century and were pressed from the same stamp as those in another binding dated 1594—one made in Prague for the twelfth-century Gospels of Henry the Lion.

The date and origin of this cover remain uncertain, mainly because its components point to different times and places. The general design has been compared to Hiberno-Saxon decorative schemes, especially to the carpet pages of the Lindisfarne Gospels of about 700. The two gilt silver medallions in the vertical arms of the cross have stylistic resemblances to Viking animal ornament, the earliest examples of which date about 800. The enamel beast and bird forms on the cross and frame are similar to Merovingian art produced in France in the middle of the eighth century. The garnets and champlevé birds within the cross are closest to those on the lid of the so-called Agate Casket, of uncertain origin, in Oviedo Cathedral.

3 ❧

REPOUSSÉ GOLD AND JEWELED BOOKCOVER

Court School of Charles the Bald, ca. 880. Front cover of Lindau Gospels, Abbey of St. Gall, Switzerland, late ninth century. M.1 (350 x 275 mm). Purchased by Pierpont Morgan, 1899.

Like the back cover (No. 2), the front cover is one of the most important of all medieval jeweled bindings. It is dominated by the large gold repoussé figure of Christ crucified within a jeweled cross. Surrounding Christ are ten repoussé figures in lower relief, all in mourning poses. Above the head of Christ are personifications of the moon and sun. In the upper quadrants are four angels; in the lower quadrants are the Virgin and John above, and below two women, perhaps Mary Magdalene and Mary, wife of Cleophas. The raised arcades of the borders are visible from an angle, and the jeweled bosses resemble towers. These architectural forms may allude to the jeweled city of the Heavenly Jerusalem.

This cover is one of the three contemporary pieces of Carolingian goldsmiths' work ascribed to the so-called court school of the Emperor Charles the Bald, grandson of Charlemagne. Where this workshop was located is uncertain, although some scholars have argued for the Abbey of St. Denis, near Paris, where

2 Gilt silver, enamel, and jeweled bookcover

3 Repoussé gold and jeweled bookcover

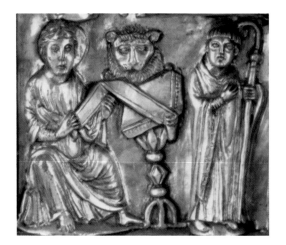 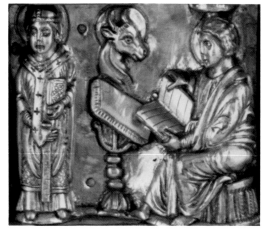

4 Details show St. Mark and Abbot Berthold, St. Nicholas and St. Luke

Charles was secular abbot from 867 until his death in 877.

Although written at the Abbey of St. Gall in the late ninth century, the manuscript has no documented provenance before the seventeenth century, when it belonged to the Convent of Lindau on Lake Constance, where it remained until the convent's secularization in 1803. Although finely written and decorated, the manuscript has no evangelist portraits and seems relatively modest when compared to its binding. Neither cover was originally made for the manuscript, but both were presumably present in 1594, the date stamped on the spine.

4 ❧

GILT SILVER AND JEWELED BOOKCOVER

Weingarten Abbey, about 1215. Cover of the Berthold Sacramentary, Weingarten Abbey, Germany, 1200-32. M.710 (300 x 210 mm). Purchased by J. P. Morgan, 1926.

Like the jeweled covers of the Lindau Gospels, this binding also ranks as one of the finest examples of medieval metalsmiths' work. Indeed, its artistic importance rivals the Sacramentary for which it was made (see III, 13). The cover was commissioned by Abbot Berthold (1200-32), perhaps between 1215, when fire damaged the abbey church, and 1217, when it was rededicated. No dedication feasts, however, are included in the book's calendar. Although likely, there is no firm evidence that the binding was made in the abbey itself.

Embellished with almost one hundred gems and intricate filigree work, the cover is domi- nated by a silver-gilt statuette of the Virgin and Child that is anchored into place by a framed cross. The Virgin's right hand, which originally held a scepter, is missing. Surrounding the Virgin, whose prominence reflects the importance of her cult at Weingarten, are twelve repoussé figures identified by inscriptions. In the four corners are the evangelists with their symbols. Flanking the cross and arranged in pairs from top to bottom are: the Archangels Michael (to whom an altar was dedicated at the abbey) and Gabriel; personifications of Virginity and Humility referring to the Virgin; Saints Oswald and Martin (patrons of the abbey); and Abbot Berthold and St. Nicholas.

This is one of the few medieval bindings that also served as reliquaries. According to the inscription running around the sides of the cover, relics of the Virgin Mary and Saints George, Oswald, Bartholomew, Thomas, Peter, Paul, and James were contained beneath the metalwork.

5 ❧

CUIR-CISELÉ BINDING

Austria, possibly monastery of Göttweig, ca. 1390. Cover of the Gospel of Luke, with the commentary of Nicolaus de Gorran and other texts, Monastery of Göttweig, Austria, ca. 1390. M. 822 (310 x 235 mm). Purchased, 1947.

The great majority of *cuir-ciselé* bindings, that is, bindings of cut-leather, date from the fifteenth century, but this is one of about two dozen that survive from the second half of the

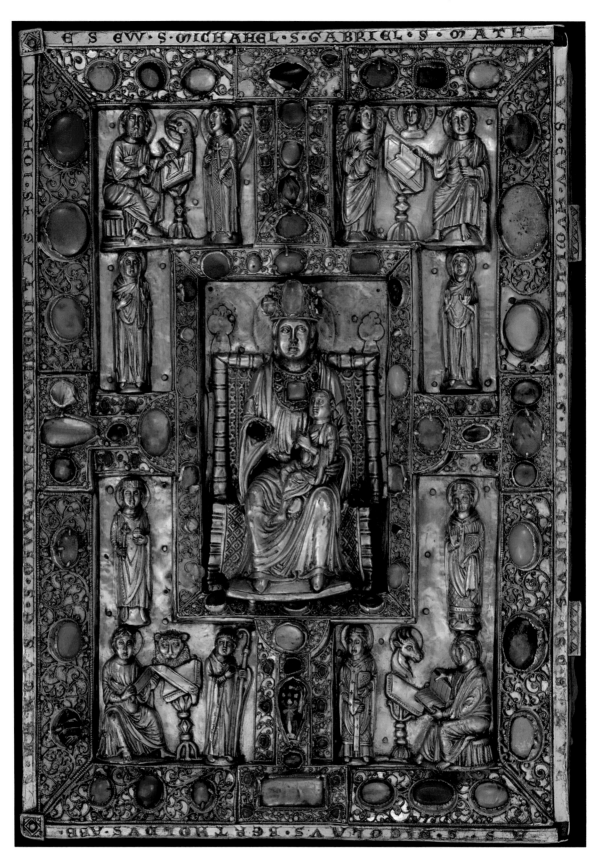

4 Gilt silver and jeweled bookcover

5 Cuir-ciselé binding

fourteenth century, when the technique first became popular. Basically the pattern is inscribed on the leather with a sharp tool, such as a knife. Most of the examples come from Germany, Bohemia, or Austria.

The fourteenth-century examples share many features, and the present binding is characteristic. A central rectangular field is surrounded by a narrow border that, in this case, also contains the Latin title of the manuscript, "ewangelium luce cum glosa gorre." While human figures are rare, the floral and leaf patterns often contain natural or fabulous animals. Here six grotesque wyvern- or dragon-like creatures inhabit the six circles of the rectangular field. Dotted backgrounds make the design easier to read. The binding, which is from the Benedictine monastery of Göttweig, some forty miles west of Vienna, is very similar to one with eight medallions, each with a beast, still preserved there. Both bindings house paper manuscripts of the late fourteenth century.

6 Binding for Jean Grolier

7 Roman binding with Apollo and Pegasus medallion

BINDING FOR JEAN GROLIER

Paris, ca. 1540. On: Valerius Maximus. Venice: Heirs of Aldus, 1534. 8°. PML 75174. Gift of Mrs. Francis Kettaneh in memory of her husband, 1977.

The French royal treasury official Jean Grolier (1479 [1486?]-1565) is the single best-known patron of luxury bookbindings, and his name continues to be synonymous with the love of books. He commissioned most of his fine bindings from a number of Parisian shops between the late 1530s and the mid-1550s. Because of the interlacing nature of the gold tooling on such bindings as the present one, this and similar bindings were assigned to the "Entrelac Binder," working in Paris in the period from 1540 to 1543 and formerly identified with the atelier of Claude de Picques. It is now believed, however, that the binder of this book is Jean Picard, active in Paris for some years at this time before he decamped to avoid his creditors in the early fall of 1547.

The Morgan Library owns sixteen of Grolier's books, thirteen of them in the original bindings he commissioned, which is by far the largest single collection of Grolier bindings in this country. Typically the bindings have an elegant austerity about them: very fine but plain brown morocco leather (imported goatskin, apparently rare in Paris at the time), restrainedly tooled in gold, with a minimum of lettering. This lettering tends to fall into two groups—the work's title in brief, and Grolier's mottos. His ownership mottos usually take the form "Io. Grolierii et amicorum" (Jean Grolier's and his friends') on the upper cover, with a phrase from Psalm 141, "Portio mea Domine sit in terra viventium" (Lord, may my share be in the land of the living), on the lower cover.

Grolier often owned multiple copies of what were long taken to be favorite works. Presumably one copy was to be read, one was to be safeguarded, and one was to lend to friends—this in keeping with his bibliophilic motto. Recent scholarship, however, has argued convincingly that these multiple copies reflect nothing more noble than a commercial venture, linking the contacts of his many years in Italy with a perceived market in his native France. The various well-bound books would show customers copies ready for sale as well as samples from binders awaiting their patronage.

Roman Binding with Apollo and Pegasus Medallion

Rome, ca. 1546. On: Paulus Orosius. *Historie* [Italian]. Trans. Giovanni Guerini. [Toscolano]: Paganinus & Alexander de Paganinis, [ca. 1527-33]. PML 50667. Gift of the Fellows, 1960.

Examples from a group of Roman sixteenth-century gold-tooled bindings decorated with an impressed medallion of Apollo and Pegasus have been prized by connoisseurs for more than a century. Some one hundred and forty-four examples are known, and the Morgan Library possesses five, four in brown morocco, and the present one, in red morocco, with the central device painted in colors rather than stamped entirely in gilt. The presence of the medallion in colors is scarcer by far than in the all-gilded form. Works in Latin were bound in black and dark shades of brown or green, while red was reserved for works in the vernacular. The medallion shows Apollo in a chariot driving the two horses of the sun toward the steep cliff of Mount Parnassus, on whose summit Pegasus stands poised for flight. It is impressed in blind, painted in green and black with gilt highlights, and surrounded by a Greek motto, "Straight and not crooked," in gold.

Decades of inconclusive scholarship were set aside by Anthony Hobson in an elegant study that showed that all the bindings in this group are on a Renaissance "gentleman's library." The books were assembled in Rome between 1545 and 1547 for Giovanni Battista Grimaldi (ca. 1524–ca. 1612), a youthful member of a Genoese patrician family, by the eminent humanist-poet Claudio Tolomei. Tolomei had the books bound in three shops, and Mr. Hobson has assigned our book to Maestro Luigi (Luigi de Gave or de Gradi), who had a long career as a binder to several popes and other important patrons. Tolomei, it seems, also chose the medallion—the ascent to Parnassus through the practice of virtù—as a suitable device for a young man of wealth with an interest in literature. Tolomei, the founder of the Accademia della Virtù, saw Grimaldi as a youthful Apollo.

Roger Bartlett Mosaic Binding

Oxford, 1678. On: The Holy Bible. London: J. Bill, C. Barker, R. T. Newcomb, & H. Hills, 1678. 4°. PML 59412. Purchased as the gift of Miss Julia P. Wightman, 1969.

The Restoration, the period following the return of the English monarchy to the throne in

8 Roger Bartlett mosaic binding

1660, was the grand era of English bookbinding. Perhaps the best-documented binder of that age was Roger Bartlett, who was originally a binder in London. After the Great Fire of 1666, he moved to Oxford, working there until his retirement about 1690. He died in his native Watlington in 1712.

One of the finest of Bartlett's works is this Bible, bound in red with colored leather onlays in black, white, and brown, showing the use of nearly a score of his tools in the gilding. The cottage-roof or split-pediment pattern is characteristic of his bindings. Of particular interest is the fore-edge painting, visible when the leaves are fanned, a medallion portrait of a young woman enwreathed with flowers. Perhaps the subject is the book's first owner, who carefully signed her name on the title page both as Mary Alston and as Mary Clayton, with the date 1678. The change of name in the ownership inscription makes one suspect that this binding was a present for her marriage.

9 ❧

EMBROIDERED BINDING

English, ca. 1640-50. On: The Bible. London: Deputies of Christopher Barker, 1599. 4°. PML 17197. Purchased by Pierpont Morgan, 1910.

There was a considerable fashion in England for embroidered covers on Bibles and small prayer books in the first half of the seventeenth century. Most of them were worked by professional embroiderers, and they were customarily sold from milliners' shops rather than by the stationers who were the licensed booksellers of the time.

The present spectacular example seems to be the product of a very talented and inspired amateur. She identified herself with a rhyming couplet:

> Anne Cornwaleys Wrought me
> now shee is called Anne Leigh.

Anne Cornwallis Leigh (1612-84) was the daughter of Thomas Cornwallis and his wife Anne, the daughter of Samuel Bevercotes of Ordsall; she married Thomas Leigh of Rushall, Staffordshire, about 1650, and the binding is attributed to this period.

It is a particularly superb example of the genre, in an excellent state of preservation, the colors still fresh and bright, the figures rendered in very high relief. The upper cover portrays Adam and Eve flanking the Tree and Serpent in the Garden of Paradise in a central panel, surrounded by all of creation, from a lobster, a fish, a crab, and a mermaid in the sea, through an elephant, an alligator, and a unicorn, to the birds of the air (including some

9 Embroidered binding

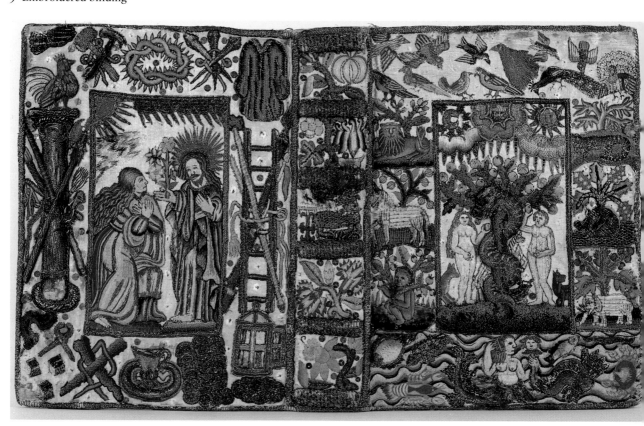

patriotically colored ones in red, white, and blue!). The spine carries flora and the Lamb of God as a symbol of Christ. The lower cover portrays Christ with Mary Magdalene after the Resurrection, in a central panel, surrounded by the symbols of the Passion carried out in great detail.

10 &

BINDING FOR QUEEN CHRISTINA
OF SWEDEN

Paris, 1646. On: Publius Terentius Afer. *Comoediae*. Paris: Typographia Regia, 1642. F°. PML 77230. Purchased as the gift of Miss Julia P. Wightman, 1981.

A handsomely bound volume has always been considered an appropriate token in the quest for royal favor or patronage, and this one was seen as part of the perfect gift for New Year's 1647. Queen Christina of Sweden (1626-89), who had just passed her twentieth birthday, was the object of yet another political quest by Louis XIV's prime minister, Cardinal Mazarin. He had intended at first to compliment her with gifts thought appropriate to her age and sex: some small riding horses, and perfumed lingerie (Mazarin was, after all, both Italian by birth and French by conviction). But his ambassador to the Swedish court, Pierre Chanut, was aware that Christina was devoted to books and learning. He advised that she be given a selection of the imposing publications of the recently founded Imprimerie Royale, finely bound with her arms embossed in gilt on the covers. Mazarin was agreeable; he was, after all, a very learned man and a bibliophile (we have already seen that his copy of the Gutenberg Bible is crucial to dating its completion).

So it was done: a group of books, including the eight-volume Vulgate Bible and the editions of Tasso, Horace, Suetonius, and our Terence, were uniformly bound and sent to Stockholm for Chanut to present to Christina, complete with a fulsome dedicatory inscription in each volume, on 2 January 1647. Christina was delighted with the books, and most of them moved with her and the balance of her huge library to Rome in the next decade. She would be of material assistance later to Mazarin in his plans for the Kingdom of Naples, but that is a story for another time.

10 Binding for Queen Christina of Sweden

11 Portuguese binding for the Marquês de Pombal

11 Detail: arms of the Marquês de Pombal

11 ⁊ᵔᵔ

PORTUGUESE BINDING FOR THE MARQUÊS DE POMBAL

Lisbon, ca. 1776. On: Ferreira da Graça, Francisco. *Estatutos literarios dos religiosos carmelitas calçados da provincia de Portugal.* Lisbon: Regia Officina Typografica, 1776. PML 78284. Purchased as the gift of Miss Julia P. Wightman, 1984.

This Portuguese binding, in red morocco with gilt arms and a dominant border in dentelle or lace style, nonetheless shows a strong French influence in its execution. This influence happens to be appropriate to the person for whom the binding was made, perhaps for presentation to him as a gift. The arms are those of Sebastião de Carvalho, marquês de Pombal (1699-1782), a successful politician and diplomat. The marquês, who spent long periods at foreign courts and returned to Portugal with imported ideas for change, ruled Portugal as virtual sovereign—some say as dictator—from 1750 to 1777. These *Statutes* of the Discalced Carmelites of Portugal constitute their official acts and end with the usual governmental and royal privileges of the time.

12 ⁊ᵔᵔ

BINDINGS BY COBDEN-SANDERSON, 1887-91

Binding dated 1889 on William Morris, *The Story of Sigurd the Volsung and the Fall of the Niblungs.* London: Reeves & Turner, 1887. 4°. PML 2109. Purchased by Pierpont Morgan, probably in 1901. Binding dated 1887 on William Morris, *Love Is Enough.* London: F. S. Ellis, 1873. PML 77075. Gift of John A. Saks, 1981. Binding dated 1891 on Dante Gabriel

Rossetti, *Poems.* London: F. S. Ellis, 1870. 8°. PML 7242. Purchased by Pierpont Morgan, apparently with George B. De Forest's library, ca. 1902. Binding dated 1890 on Matthew Arnold, *Selected Poems.* London: Macmillan & Co. 1878. 8°. PML 2110. Purchased by Pierpont Morgan with Theodore Irwin's library, 1900.

The twentieth-century revival of the book arts that has brought so much pleasure to so many people is in very large part attributable to the inspiration of the skilled circle around William Morris, active in England in the last two decades of the nineteenth century.

A neighbor of William and Jane Morris at Hammersmith in the early 1880s was a barrister named Thomas James Sanderson, who upon his marriage in 1882 to the daughter of the wealthy statesman-industrialist Richard Cobden became T. J. Cobden-Sanderson and retired from the law. At the suggestion of Jane Morris in 1883, he took up bookbinding, first in apprenticeship to the prominent London binder Roger De Coverly, and then as an independent practitioner. He bound with his own hands until 1893, after which he founded a shop with workers, the Doves Bindery, confining himself thereafter to design and supervision.

12 Binding on Morris, *Love Is Enough*

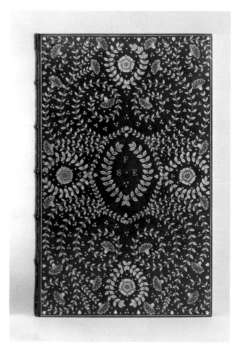

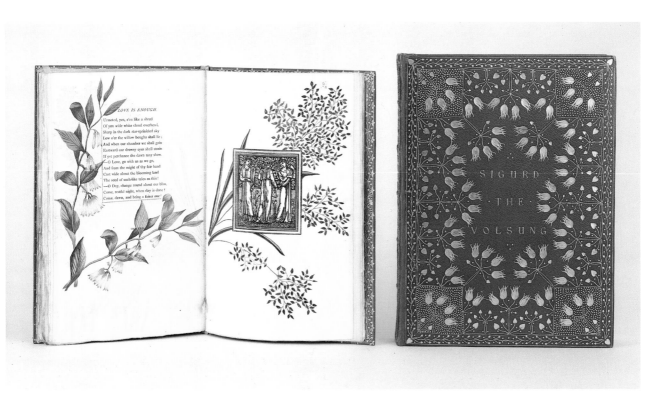

12 Left: Morris, *Love Is Enough* and right: Morris, *The Story of Sigurd*

12 Left: Arnold, *Selected Poems* and right: Rossetti, *Poems*

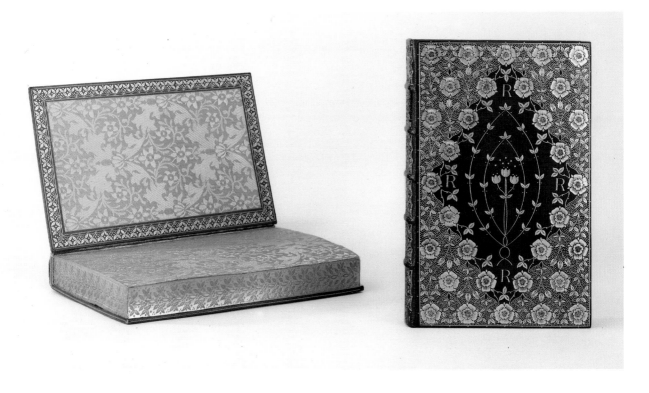

This suite of representative bindings by T. J. Cobden-Sanderson from the years 1887-1891 gives a good picture of his taste in fine leathers, chaste decoration, and precision in tooling, which revolutionized fine bookbinding. Cobden-Sanderson's tools and layouts, which broke decisively with the current fashions for "retrospective" bindings—pseudo-Gothic extravaganzas enjoyed a particular vogue, to cite one extreme example— revolutionized the aesthetic of fine bookbinding. The delicate, small floral tools that he designed himself are related to, yet not copied from, William Morris's own masterful floral decorations in various forms as cloth and type.

The Story of Sigurd the Volsung...is bound in red morocco, gilt, with gilt edges and signed 18 C*S 89 on the lower rear turn-in. The large paper copy, specially decorated with floral borders by Beatrice Pagden, of *Love Is Enough* was bound for Morris's friend and sometime publisher, F. S. Ellis, in tan morocco, and signed 18 C-S 87 on the lower rear turn-in. The original invoice from Cobden-Sanderson to Ellis, dated 5 and 7 January 1888, for 20 guineas is still in the book. Rossetti's *Poems*, bound in blue morocco, gilt, with gilt and gauffered edges, and with endleaves of Morris silk brocade, is signed at foot of spine: 18 C*S 91. The book carries the inscription at the back:

> Rossetti's Poems
> Bound by me at
> Goodyers Hendon 1891
> T. J. Cobden-Sanderson.
> "She had three lilies in her hand,
> And the stars in her hair were seven."

Selected Poems, bound in pale-green morocco, gilt, with gilt and gauffered edges, and with endleaves of Morris silk brocade, is signed on the lower rear turn-in: 18 C S 90. This volume was bound for the London bookseller Bain, who served as a kind of agent for Cobden-Sanderson's work. Bain sent this volume to the New York book firm of Dodd, Mead; the collector Theodore Irwin of Oswego bought it for $160 and exhibited it immediately at the Grolier Club.

13 🙚

BINDING BY PAUL BONET, 1959

On: André Suarès. *Cirque*. (Illustrated by Georges Rouault.) Paris: Ambroise Vollard, 1939 [but unpublished]. F°. PML 76385. Purchased as the gift of Mr. and Mrs. Hans P. Kraus, 1979.

The combination of book and binding makes this the most splendid *livre d'artiste* in the Morgan Library's collections. The term may be taken several ways: the book contains much original work by the artist, in the form of aquatint—that is, producing the effect of a drawing in watercolor or india ink—and woodcut illustrations, but the entire book itself, from its enormous scale to the quality of its paper and presswork, is a work of art in its own right.

Georges Rouault worked on the series of illustrations over many years for Vollard to enhance Suarès's writings. In the end, though, the resultant book was never formally published, and it is likely that most of the few surviving sets of pages of text and illustrations vary in their makeup. The present copy contains a large number of proofs of the illustrations. While working on Suarès's *Cirque*, Rouault wrote his own text, calling it *Cirque de l'étoile filante*, partly using existing illustrations, and partly creating new ones. Vollard published this new work in 1938 in the same format as the abortive *Cirque*.

Paul Bonet, the great innovator in French luxury bindings and the best-known of the twentieth-century French art binders, eventually executed a number of bindings both for *Cirque* and for *Cirque de l'étoile filante*. These bindings were all variants on a single decorative theme, a style that Bonet called "à decor rayonnant," noting that his intention had been to evoke the blaze of radiating circus lights. Our volume, bound in black morocco, with onlays of variously colored calf, and gold-tooled in a sunburst pattern, succeeds brilliantly in achieving his intent.

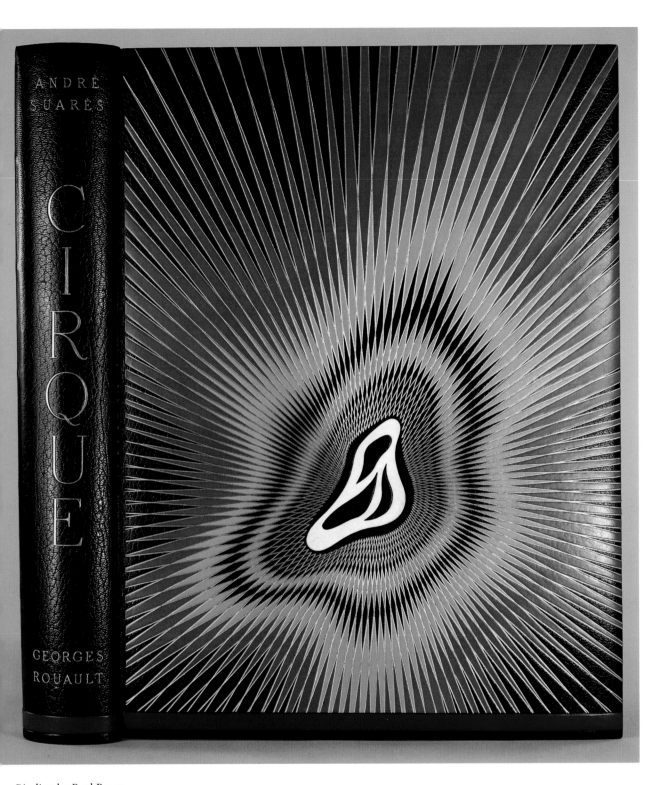

3 Binding by Paul Bonet

Signore

Dalle ultime nuove ricevute dai viaggiatori Dilettanti delle Arti venuti da
codesta Città abbiamo inteso con nostro sommo piacere la grata nuova della sua
ristabilita salute. Bisogna però avvertir bene a conservarla, perche se l'intraprese
viaggio di Sicilia a costato qualche Disgrazio: qualche altra intrapresa non abbia
a costare delli svantaggi alle sue premurose attenzioni, scoperte, ed osservazioni
non solo sulle antichità esistenti e non movibili, ma anche sopra di quelli, che
l'intendente Sig: Townly và acquistando di giorno in giorno per arricchire la sua
Patria. Fra l'altre si dice qui che il nostro gran Dilettante con le sue conoscenze
del disegno abbia acquistato un busto di eccellente maniera, il che ci a molto val
te grati. Napoli, Napoli stà in cervello: perche se tu non apprezzi per tua Disgrazia
v'è chi ti dà il castigo. Più in Roma al presente siamo senza veri conoscitori,
e dilettanti.

Sò bene, che siete nemico dell'adulazione, perche niente volete che si dica di
voi. Ma qualche volta permettete ad un vostro predicante, che dicendo il vero si
sfoghi, altrimenti fà il crepaccio.

Ritorna in Napoli il Sig: Jivaivomo costì già conosciuto per le opere
fin ora pubblicate. La domanda onestissima che mi a fatto fondato sulla fama
che vi siete acquistato di Protettore delle Arti, che io l'accompagnassi con una
lettera, per il desiderio di venire a voi sicuro di rincontrare ne vostri meriti
quella fama che dal publico con stima ed onore di voi si decanta. E siccome
tutti quelli che anno fatta qualche intrapresa giovevole al publico si accarezzate
e l'incoraggite, così questo domanda di esere ammesso frà gl'altri.

VII AUTOGRAPH MANUSCRIPTS

"I THOUGHT, I knew the complete story by heart, but I did not know there was so much in the manuscript which was never printed," remarked J. P. Morgan, Jr., in 1915 when purchasing the autograph manuscript of Thackeray's *The Rose and the Ring* (v, 8). In the ensuing decades, the Library has continued to add materials which contribute to the complete stories of the creation of great literary works, the biographies of notable individuals, and events of historical significance. Among the additions have been letters of artists from the Renaissance through the twentieth century and manuscripts and letters of humanists and rulers of the Italian Renaissance. While the collection has grown to the tens of thousands since the days of Pierpont Morgan and J. P. Morgan, Jr., the emphasis has continued to be on individual works of importance rather than comprehensiveness in any particular field.

The general pattern of the collection was established by Pierpont Morgan, who by his death in 1913 had obtained important autograph representations of the work of most major British and American writers of the eighteenth and nineteenth centuries. Though interested primarily in the authors of generations previous to his own, he did acquire several contemporary literary manuscripts, including that of a controversial novel of his day, Emile Zola's *Nana*. The manuscripts of Mark Twain's *Pudd'nhead Wilson* (vii, 19) and Thomas Hardy's "The Romantic Adventures of a Milkmaid" he purchased directly from the authors. In collecting historical documents, Morgan's focus was on traditional areas such as English rulers and the American founding fathers. As with literary manuscripts, he did, however, acquire a few timely items, including two of Emile Zola's public letters written in defense of Alfred Dreyfus at the turn of the century.

Broad and eclectic, the collection is plentiful in single manuscripts which not only crystallize moments in history and the creative lives of writers but also evince the particular human immediacy of handwritten documents of the past. The witch hysteria in Salem in 1692 becomes very personal to us through the entreaty of one of its victims, Rebecca Eames. Her petition to the governor of Massachusetts describes vividly the duress under which confessions were extracted from those accused. For some documents the compelling dimension is provided by our awareness of what transpired after they were penned. Abraham Lincoln's handwritten notes for a speech in 1858 in which he hopes that "not bloody bullets, but peaceful ballots" will resolve the national conflict over slavery are especially moving in the context of our knowledge of the tragic war which was to come. Similarly, our familiarity with an author's life affects our response to a literary manuscript. Sylvia Plath's childhood notebook of carefree poems about tea parties, playmates, and holidays evokes great poignancy because of what we know of her brief and unhappy adult years.

The collection is rich in authors' drafts and revisions, fascinating for the glimpses they give of "the story-weaver at his loom," to use Charles Dickens's telling phrase. The manuscript of Dickens's own *Our Mutual Friend* makes palpable his method of composition: great rushes of writing, followed by slower, more careful drafting, then sudden

Among many artists' letters in the collection is one from Piranesi to Charles Townley of 1772 showing the famous Warwick Vase excavated in Italy in 1771.

returns to the flurry. While the handwriting in William Makepeace Thackeray's *Vanity Fair* answers questions about the order in which the novel was written and revised, it also raises important questions. The manuscript shows his two distinct styles of handwriting: the original draft of the early chapters in his sloping hand, with later insertions standing out dramatically in his upright hand. The most notable additions are several moralizing passages. Do these interpolations reveal, as some scholars suggest, that as Thackeray wrote he developed a more profound sense of the novelist's responsibility and therefore added specific moral direction for the reader? Or, as others surmise, was he merely filling out the narrative so that each part would be the appropriate length for serial publication? The answers to such questions are rarely definitive, and different scholars examine the same manuscripts to explore and test their own theories. The Library's literary manuscripts thus continue to serve as vital documents for scholarly exploration and debate.

While historical and literary manuscripts inform us about events and artistic works in the realm of public knowledge, autograph letters in the collection give us entrance into private worlds. Correspondence often exemplifies Jane Austen's dictum that the art of letter writing "is to express on paper exactly what one would say to the same person by word of mouth," and thus carries a level of frankness unavailable elsewhere. Also, by enticing us with the opportunity to read something intended not for our eyes but specifically for the eyes of someone else, letters appeal to our natural curiosity about the private thoughts and passions of other human beings. Particularly intriguing are the letters of lovers. Among the most passionate in the Library's collection are those of Napoleon to Josephine. "I draw from your lips, from your heart, a flame which consumes me," he writes at the beginning of their romance. In contrast to Napoleon's intense ardor is the subdued eloquence of Elizabeth Barrett Browning. In a letter posted to her brother George when she eloped to the Continent with Robert Browning, she recounts her initial refusal of Browning's proposal because of her age and ill health, adding: "His answer was—not the common gallantries which come so easily to the lips of men—but simply that *he loved me*—he met argument with fact."

Other letters in the collection derive their interest from the discrepancies which they reveal between creative achievements and private conduct. Artistic geniuses, we regretfully learn, can sometimes be singularly deficient in their human relations. One example is in a note appended by Lord Byron to a plea from his homesick daughter, Allegra, barely five years old. From the convent where she had been placed, she begs in the neat, careful script of a child who has just learned to write, "I should so much like a visit from my Papa.... Will you not please your Allegrina who loves you so?" Forwarding the letter to a friend, Byron dismisses her entreaty as a mere attempt "to get some paternal gingerbread." The poet did not visit his child then, and, indeed, never saw her again, for she died the following year.

The foregoing examples and those that follow are but a sample of the Morgan Library's extensive collection of manuscripts and letters. Under the guidance of Belle da Costa Greene, George K. Boyce, and, most recently, Herbert Cahoon, the autograph holdings have made possible more exact history and more authoritative literary editions, thus contributing to the better understanding of American and European culture.

1 Alberti letter of 1454

1

LEONE BATTISTA ALBERTI

Autograph letter signed, dated Rome, 18 November [1454], to Matteo de' Pasti. MA 1734. Gift of the Fellows, 1956.

Commissioned by Sigismondo Malatesta to transform the medieval church of San Francesco at Rimini into the modern Tempio Malatestiano, Alberti (1404-72) planned a structure that would respect the original building yet conform to his classical ideals. In this angry letter to Matteo de' Pasti, the on-site architect of the project, Alberti dismisses a critic of his design with a characteristic appeal to reason:

"I for my part have more faith in those who built the thermae and the Pantheon and all these noble edifices than in him, and a great deal more in reason than in any man." Countering a criticism of his plans for the façade, he writes, "You can see where the size and proportions of the columns come from: if you alter anything all that harmony is destroyed." In literal references to mathematical ratios and musical intervals, Alberti offers a practical outline of the theory expressed two years earlier in his monumental treatise *De re aedificatoria*.

The Tempio Malatestiano was never completed, and the only extant visual record of Alberti's full design is a medal cast by de' Pasti in 1450. The letter reproduced here—the only

Page from Alberti's *De re aedificatoria* (1452),
annotated by an early reader, PML 44056

record by Alberti himself on the plans for the Tempio—is particularly revealing, since it addresses precisely those features of the church which were never executed. The small but telling drawing, for example, shows a volute intended to decorate the straight sloping walls of the actual structure, contradicting the image of curved elements on de' Pasti's medal. Even in its unfinished state, the Tempio was hailed by Vasari as "one of the foremost temples in Italy" and has since been acclaimed as a superb embodiment of Renaissance architectural theory.

The Morgan Library's fine collection of artists' letters spans the Italian Renaissance to the present and has been substantially augmented over the past twenty years by several important acquisitions. Among them are art historian John Rewald's letters of impressionist and post-impressionist artists, art dealer Paul Rosenberg's collection of some 450 letters and documents of twentieth-century artists, and the Tabarant archive of Edouard Manet papers and photographs, purchased as a Charles W. Engelhard memorial gift.

HISTOIRE NATURELLE DES INDES

Illustrated manuscript, ca. 1586. MA 3900.
Bequest of Miss Clara S. Peck, 1983.

It was not mere zeal for adventure but the promise of enrichment which drove Elizabethan explorers to the Americas. Nevertheless, the encounter with a vast new world of alien cultures and uncharted landscapes offered these early navigators a freshness of experience far beyond the practical. This remarkable manuscript, identified as "Histoire naturelle des Indes" (Natural History of the Indies) on its title page, is a systematic catalogue of some of the earliest European observations of West Indian flora, fauna, and native and colonial customs. The 199 colored drawings are naive but buoyant, and with the accompanying French descriptive text they provide perhaps the most extensive portrait in existence of the late sixteenth-century Caribbean world. The entry reproduced here is entitled "How the Indian Women Suffer Labor Pains":

When the Indian women are in labor, the Indian men gather with their musical instruments and walk around the house, called *la bouhie*, dancing, making as much noise as possible and singing loudly, saying that this way the woman's pain will go away.

If the anonymous author of this natural history was neither a sophisticated botanist nor schooled ethnographer, he was certainly a studious observer, versed in Caribbean lore and attuned to local custom. The manuscript begins with botanical illustrations which document the infinite variety of tropical vegetation, from the sweet onions which the Indians eat "as we eat apples" to the mensenille tree, so poisonous "that if a person looks up at it, he will be blinded for three hours afterwards." The creative husbandry of the natives is noted in descriptions of medicinal remedies and culinary practices. A catalogue of West Indian fauna is followed by over forty entries depicting native life—hunting, healing, cooking, sewing—as well as colonial employment of natives and slaves for mining and smelting. At the conclusion of the manuscript the author presents an engaging narrative of a courtship culminating in a wedding celebration set in lush, tropical abundance.

The work has been informally dubbed the "Drake manuscript" because the English explorer Sir Francis Drake is twice named in the

Come les femmes yndiennes sont en paine
d'enffans

Les yndiennes estant en trauail d'enffans les yndar
s'assemblent auec leurs instrumens et ses bons a l'entour
de la maison qui l'appelle caboucu en danssans faisant le plus
grand bruit qu'ilz peuuent Chantens a haulte boix disans le
par tel moyen la douleur d'laz femmes se passe

2 Folio 107 of Histoire naturelle des Indes

text and the some thirty geographical references match his ports of call. We know that he often employed shipboard artists, and indeed he himself painted as he traveled. Yet aside from a few scattered maps and sketches, this manuscript may be the most substantial surviving visual record of these early explorations. It is the combined work of at least two scribes and two artists. Aside from its obvious visual charm and historical allure, the Drake manuscript offers rich primary source material from the anthropological to the linguistic to the ethnobotanical. Because the manuscript was unknown to scholars until 1867 and in private hands until it was acquired by the Morgan Library in 1983, these possibilities have only begun to be addressed.

3 ❦

JOHN MILTON

Paradise Lost. Manuscript of Book I, ca. 1665. MA 307. Purchased by Pierpont Morgan, 1904.

The centerpiece of the Library's collection of literary manuscripts is, without a doubt, this only surviving manuscript portion of Milton's grand epic poem, transcribed and corrected at his direction. This is the copy of Book I that Milton's printer, Samuel Simmons, used to set the type for the first edition, as the ink smudges and signature marks on its nineteen leaves confirm. Blind since 1651, Milton (1608-74) relied on a number of amanuenses to transcribe the verses he composed during the night, when, as he writes, his "celestial patroness.../dictates to me slumb'ring, or inspires/Easy my unpremeditated verse" (*Paradise Lost*, Book IX). The verses were then read back to him and corrected, in this case by at least five different hands, one of which has been identified as that of his nephew Edward Phillips. Shown here is the opening of the poem, in which Milton invokes his celestial muse.

The verso of the first leaf bears the imprimatur of the licenser, Thomas Thomkyns, chaplain to Gilbert Sheldon, Archbishop of Canterbury, authorizing the printing of the poem. Over twenty years before, in his *Areopagitica*, Milton had argued against "this plot of licensing" books, on the grounds that "it hinders and retards the importation of our richest merchandise, truth," and he issued his early pamphlets on divorce without seeking the requisite license. An early biographer of Milton reports that, in fact, there was some trouble over the licensing of *Paradise Lost*–Thomkyns apparently felt that Milton's Satan shone too brightly in the first book. But Thomkyns signed the imprimatur, and the poem was printed in 1667.

The young scholar Thomas Ellwood, who often read to the blind poet in exchange for Latin lessons, recounts that he visited Milton at Chalfont St. Giles in August of 1665: "After some common Discourses had passed between us, he called for a manuscript of his; which being brought he delivered to me, bidding me take it home with me and read at my leisure." It was not until two years later, after the effects of the great plague had subsided and Milton returned to London, that the manuscript was delivered to his printer. Simmons later sold the copyright (along with the licensed manuscript of Book I) for twenty-five pounds to the London bookseller Brabazon Aylmer, who in turn sold it to another bookseller, Jacob Tonson. The manuscript remained in the hands of Tonson's descendants until it was purchased by Pierpont Morgan in 1904.

Milton at the age of ten, oil on wood, by an unidentified artist

Paradise lost.

Illumine, what is low raise & support;
That to the highth of this great argument
I may assert th' eternal Providence,
And justifie the wayes of God to men.

Say first, for heav'n hides nothing from thy view
Nor the deep tract of hell, say first what cause
Mov'd our grand parents in that happie state,
ffavour'd of heav'n so highly, to fall off
ffrom thir Creator, & transgresse his will
ffor one restraint, Lords of the world besides?
Who first seduc'd them to that fowle revolt?
Th' infernal Serpent; hee it was, whose guile
Stirr'd up with envy & revenge, deceav'd
The Mother of Mankind; what time his pride
Had cast him out from heav'n; with all his host
Of rebell angells, by whose aide aspiring
To set himselfe in glory above his peeres,
Hee trusted to have equall'd the most High,
If he oppos'd; & with ambitious aime
Against the throne & Monarchy of God,
Rais'd impious warr in heav'n & battell proud,
With vaine attempt. Him the Almighty power
Hurld headlong flaming from th' etherial skie
With hideous ruine & combustion downe
To bottomles perdition, there to dwell

3 Opening page of *Paradise Lost*

4 Opening of Locke's *An Essay concerning Humane Understanding*

4 ❧

JOHN LOCKE

An Essay concerning Humane understanding.
Manuscript with autograph corrections, Books
I and II, 1685. MA 998. Purchased 1924.

When Locke (1632-1704) and several friends
were meeting in 1671 to address questions of
moral philosophy, they found their discourse
inconclusive without a firm sense of their own
capacities for knowledge. As Locke described
the impasse, "it came into my Thoughts, that
we took a wrong course; and that, before we
set our selves upon Enquiries of that Nature, it
was necessary to examine our own Abilities,
and see, what Objects our Understandings
were, or were not fitted. to deal with." To ex-
plore the nature of human understanding,
Locke set down "some hasty and undigested
thoughts" on the matter for discussion at the
next meeting. This was the private impetus for
the great seventeenth-century exposition of
empiricism, the *Essay concerning Human Un-
derstanding.*

Having been "begun by chance,...continued

by Intreaty; written by incoherent parcels; and, after long intervals of neglect, resum'd again, as my Humour or Occasions permitted," the *Essay* occupied Locke over the next nineteen years. After one of those "long intervals" Locke took up the *Essay* in 1685, adding the extensive corrections and revisions that appear in this 383-page manuscript of Books I and II. In them, Locke overturns the Cartesian doctrine of innate knowledge and asserts that cognitive inquiry must be rooted in observation and experience. Along with his contemporaries Sir Isaac Newton and Robert Boyle, Locke inaugurated a scientific age of empirical research grounded in the physical world. His modest claim was to serve as an "Under-Labourer in clearing Ground a little, and removing some of the Rubbish, that lies in the way to knowledge."

By 1686, Locke's influential discourse in four books was essentially complete, and the first of the five editions published during his lifetime appeared in 1690. This is the longest and latest of three extant manuscripts of Locke's *Essay*. The others, one at the Bodleian Library, Oxford, and the other in a private collection, were both written in 1671. In addition to the manuscript of the *Essay*, the Morgan Library holds twenty-four Locke autograph letters and the autograph manuscript of his translation of Pierre Nicole's *Essais de Morale*.

5 ❧

SAMUEL JOHNSON

Life of Pope. Manuscript, mostly autograph, 1781. MA 205. Purchased by Pierpont Morgan, 1896.

Himself the subject of the most famous of literary biographies, Johnson (1709-84) profiled the leading poet of his century in the *Life of*

5 Folio 35 [30] of Johnson's *Life of Pope*

Pope. Moving beyond the simple panegyric and overt didacticism which had characterized earlier lives, Johnson combined extensive biographical detail with discerning literary criticism to produce an insightful portrait. Johnson's esteem for the biographical arts was well-known from a 1750 *Rambler* essay in which he argued for honesty uncolored by homage: "If we owe regard to the memory of the dead," he wrote, "there is yet more respect to be paid to knowledge, to virtue, and to truth." The fifty-two essays of his *Lives of the Poets* set a precedent for truth in biography to which even Boswell was indebted.

Johnson was engaged to write the *Lives* by a cartel of leading London booksellers who proposed a multi-volume edition of the works of English poets from 1600. In an attempt to foil a similar plan by a Scottish publisher, the cartel approached him with a proposal that he write what Johnson airily described as "Little Lives, and little Prefaces, to a little edition of the English Poets." He accepted eagerly. While many of the lives remained "little," a few—the "prefaces" for Pope, Swift, Milton, and Dryden, for example—grew into full-scale literary biography, complete with critical evaluation.

In the *Life of Pope*, the longest of the lives and Johnson's last major work, the biographer is unsparing in his description of Pope's acquisitiveness and self-importance, but extravagant in his praise of Pope's literary genius. It was Pope's intellectual diligence which most impressed Johnson, and in the passage shown he does a bit of textual editing to show how Pope carefully refined his translation of the *Iliad*. Like modern textual scholars, Johnson "delights to trace the mind from the rudeness of its first conceptions to the elegance of its last," so much so that the manuscript employs at least twice as many examples of Pope's revisions as the printed *Life*. The heavily revised manuscript of Pope's *Essay on Man*, also in the Morgan Library, reveals how he labored to perfect his verse, with results that Johnson likened to "a velvet lawn, shaven by the scythe, and leveled by the roller."

6 ɜ

GEORGE WASHINGTON

Autograph letter signed, 20 May 1792, to James Madison. MA 505. Purchased by Pierpont Morgan.

Planning to retire at the end of his first term as

Washington life mask by Jean-Antoine Houdon

president, Washington (1732-99) requested James Madison, then a representative from Virginia, to draft for him a "valedictory address...in plain and modest terms." His suggestions for the content included his hope that the new government of the United States "may by wisdom, good disposition and mutual allowances; aided by experience, bring it as near to perfection as any human institution ever ap[p]roximated." Washington was persuaded to stand for another term, and there was no need for a "Farewell Address" until 1796. Alexander Hamilton assisted in the final formulation of that address. The counsel of Madison and Hamilton certainly contributed to the immense success of the "Farewell Address," but, as this letter indicates, the general design and fundamental ideas came directly from Washington. Reprinted in nearly all the nation's newspapers soon after its delivery, the valedictory brought forth emotional tributes from many of Washington's countrymen. John Quincy Adams wrote to the retired president that he prayed the address would "serve as the foundation upon which the whole system of

[the country's] future policy may rise." For John Adams, the speech exemplified Washington's mastery of the theatrics of politics. In a letter to Dr. Benjamin Rush now in the Library, Adams noted a "strain of Shakespearean excellence" appropriate to "dramatical exhibitions" and confided that "if [Washington] was not the greatest President, he was the best actor of Presidency we have ever had."

The first president's life and hopes are further revealed in the Library's over one hundred manuscripts by and relating to Washington. Reflecting the absorbing interest in American history of Junius, Pierpont, and J. P. Morgan, Jr., the Americana collection includes autograph representations of other founding fathers and presidents, as well as substantial documentation of the American Revolution and the early decades of the republic. There are letters concerning Benedict Arnold's treason and John Paul Jones's victory in the *Bon Homme Richard*, letters from Cornwallis asking Washington for terms of surrender and from Burgoyne sending the terms for the surrender at Saratoga, a contemporary manuscript of the Articles of Confederation, Jefferson's letter informing the speaker of the House of Delegates of the "ratification of the Confederation of the thirteen United States of America," and the first printed draft of the Constitution heavily annotated by Abraham Baldwin, one of the more influential members of the Continental Congress.

6 Washington to Madison, 20 May 1792

7 Jane Austen to Martha Lloyd, 16 February 1813

7

JANE AUSTEN

Autograph letter signed, 16 February [1813]
to Martha Lloyd. MA 2911. Bequest of Mrs.
Alberta H. Burke, 1975.

Letter writing was central to the development
of Jane Austen (1775-1817) as an artist. The
epistolary novel was at its height of popularity
during her youth, and she experimented with
the form in two early works: *Elinor and Mari-
anne*, which was extensively revised to become
Sense and Sensibility, and *Lady Susan,* which
was unpublished during her lifetime. As an ar-
tistic form, the novel-in-letters evidently tried
her patience. *Lady Susan* concludes abruptly,
"This Correspondence, by a meeting between
some of the Parties & a separation between the
others, could not, to the great detriment of the
Post office Revenue, be continued longer." In
her own life, nevertheless, she was in accord
with Jane Fairfax in *Emma,* who proclaimed,
"The post-office is a wonderful establishment."

Jane Austen devoted a significant portion of
each day to correspondence, and through her
frequent letters to relatives and friends she re-
fined her craft.

The intelligence, wit, and moral sensibility
of her heroines appear in her own corre-
spondence. The letter shown exhibits the skep-
ticism of authority which informs her novels.
Writing to one of her dearest friends, Martha
Lloyd, she comments on the scandalous affairs
of the prince regent, later George IV, and his
wife, the Princess of Wales, and alludes to a
public letter which the princess had written to
the prince:

I suppose all the World is sitting in Judgement upon
the Princess of Wales' letter. Poor woman, I shall
support her as long as I can, because she IS a woman,
and because I hate her husband—but I can hardly
forgive her for calling herself 'attached and affec-
tionate' to a man whom she must detest...but if
I must give up the Princess, I am resolved at least
always to think that she would have been respect-
able, if the Prince had behaved only tolerably by her
at first.

Sir Walter Scott by Daniel Maclise, 1825, pencil on light gray paper
Gift of Charles Ryskamp in memory of Benjamin Sonnenberg, 1978.31

Of the several thousand letters that Jane Austen must have written, just over one hundred thirty survive. Of these, some fifty reside in the Morgan Library, making it the largest single collection. No complete manuscripts have been located of her six major novels. Of the extant manuscripts, the Morgan Library holdings include *Lady Susan,* the first six leaves of *The Watsons,* and the satirical "Plan of a Novel."

8 ❧

SIR WALTER SCOTT

Ivanhoe. Autograph manuscript of surviving portions of volumes II and III, [1819]. MA 440. Purchased by Pierpont Morgan, 1901.

Sir Walter Scott's imaginative integration of romantic plot and faraway time codified a new genre of fiction—the historical novel. Invitingly adaptable, the model inspired novelists through the remainder of the century, notably Thackeray, Dickens, Pushkin, Tolstoy, Stendhal, and Balzac. In *Ivanhoe,* Scott (1771-1832) wrote for the first time in his career about a time—the fifteenth century—and a place—the heart of England—some distance from the Scottish settings of his earlier successes. Steeped in the history and lore of Scotland, he had applied his erudition first to a series of immensely popular verse romances. Such works as the verse romance *The Lady of the Lake* and the novels *Waverley, Guy Mannering,* and *Rob Roy* entranced his readers with authentic depictions of Scottish rural life and replications of regional speech. With *Ivanhoe,* he left the Scottish scene to create a colorful story of a remote era of battling knights, elaborate tournaments, besieged castles, and captive maidens rescued by their champions. The manuscript reveals that he wrote freely, concentrating on the narrative and showing little concern for the niceties of punctuation and paragraphing. As was customary for his novels, a transcriber attended to these details before the preparation of proofs.

unkindness let us put the Jew to ransom since the Leopard will not change his spot
and a Jew he will continue to be" — "The priest said Clement is not half so confident
of his forced conversion since he received that buffet on the ear" — "Go to know what
prelate them of conversions — what is there no respect — all masters no men — I tell
thee fellow I was somewhat tetchish when I received the good knight's courtesy or
I had kept my ground under it — But as thou prat'st more of it there shall
learn I can give as well as take — " "Peace all said the Captain and thou Jew think
of thy ransom: Man — needest not be told that thy race are held accursed in
all Christian communities and trust me that we cannot endure thy presence
amongst us think therefore of an offer while I examine a prisoner of another
cast — " "were many of Front-de-Boeuf's men taken" demanded the knight "None
of note enough to be put to ransom answered the Captain — a set of hilding
fellows there were whom we dismissed to find them a new master — Enough had
been done for revenge and for profit the rest of them were not worth a carde
: er. The prisoner I speak of is better booty — a jolly priest riding to visit his leman
and I may judge by his horse-gear and wearing apparel — here cometh the wor-
thy prelate as pert as a pyot. And between two yeomen was brought before
the sylvan throne of the Outlaw chief our old friend Prior Aymer of Jorvaulx.

Chapter V

Geminius Flower of warriors
Now set with Titus Lartius
Marcius as with a man busied about decrees
Condemning some to death and some to exile
Ransoming him, or pitying, threatening the other.

The captive Prior's features and manner exhibited a whimsical mix-
ture of offended pride deranged foppery and bodily terrors. "Why how now my masters" said he
with a voice in which all these emotions were blended "what order is this among ye. Be ye Turks
or Christians that handle a churchman. Know ye what it is manus imponere in servos Domini
— ye have plundered my mails torn my cope of curious cut & lace which might have served
a Cardinal. Another in my place would have laid his Excommunicabo vobis But I
am placable and if ye order forth my palfreys release my priests and restore my mails, and
abbey and make your vow to eat no venison until next Pentecost it may be ye shall
hear little more of this mad frolic". — "Holy Father said the Chief Outlaw it grieves me to
think that you have met with such usage from any of my followers as calls for your fatherly
reprehension" — "Usage" echoed the Priest encouraged by the mild tone of the sylvan leader
it were usage for no hound of good race much less for a Christian far less for a priest and
least of all for the Prior of the holy community of Jorvaulx. Here is a profane and drunken
minstrel called Allen a Dale — nebulo quidam — who has menaced me with corporal punish-
ment nay with death itself an I pay not down five hundred crowns of ransom besides
all the treasure of which he hath me — gold chains and gymmal rings to an unknown
value besides what is broken and spoiled among their rude hands as my pounced-box
and silver crisping tongs — " "It is impossible that Allen a Dale can have thus treated a
man of your reverend bearing" replied the Captain "It is true as the gospel of Saint Nicodemus
nevertheless said the Prior he swore with many a cruel North-country oath there he would hang
me up on the highest tree in the greenwood — " "Did he so in very deed Nay then reverend
father I think you were better comply with his demands for Allen a dale is the very man
to abide by his word when he has so pledged it — " "You do but jest with me said the astound-
ed Prior "and I love a good jest at my heart. But ha ha ha when it has lasted the
livelong night it is time to be grave in the morning — " "And I am as grave as a father
confessor" replied the Outlaw "you must pay a round ransom sir Prior or your Convent
is likely to be called to a new election for your place will know you no more — " "Are
ye Christians" said the Prior and hold this language to a Churchman" — "Christians
aye

To emphasize the novelty of *Ivanhoe*, Scott insisted that it be published on finer paper and in a larger format than his previous novels. Known at the time anonymously as "the author of *Waverley*," he sought also to have the work appear under the pseudonym Laurence Templeton. His publisher acceded to the new format but persuaded Scott not to disappoint the avid followers of "the author of *Waverley*." Public response to the novel was enthusiastic, and the first printing of 10,000 was exhausted in two weeks. On the Continent, the astounding success of *Ivanhoe* can be gauged not only by the various translations but also by its frequency as a subject for the lyric stage. Of the seventeen Scott novels that became operas, *Ivanhoe* was one of the most attractive to librettists. Operatic treatments include a pastiche of Rossini's music staged in Paris, Marschner's *Der Templer und die Jüdin*, Nicolai's *Il templario*, as well as works by Giovanni Pacini and Sir Arthur Sullivan which retained the novel's title.

The Morgan Library preserves an unrivaled number of Scott's novels in manuscript, among them *The Antiquary, Guy Mannering, Old Mortality, Peveril of the Peak, St. Ronan's Well*, and *Woodstock*. Of the verse romances, the Library holds the complete manuscripts of *The Lady of the Lake* and *Rokeby* and portions of *The Bridal of Triermain* and *The Lay of the Last Minstrel*.

about its indelicacy. "You shan't make *Canticles* of my Cantos," Byron wrote to Murray, "The poem will please if it is lively—if it is stupid it will fail—but I will have none of your damned cutting and slashing."

Murray was concerned not only about the comically frank portrayal of Juan's exploits, but also about Byron's unabashed ridicule of the poet Robert Southey (the "Sir Laureat" of the first stanza shown here) in his mock dedication to the poem. In the end Byron agreed to the anonymous publication of the first two cantos and suppressed the bold dedication. "I won't attack the dog so fiercely without putting my name," he wrote to Murray. Southey was not the only subject of Byron's satire in the suppressed verses. Wordsworth and the "Lake Poets" were blasted for what Byron saw as their limited perspective, in which poetry indulges private "reveries" rather than engaging its audience: "There is a narrowness in such a notion,/which makes me wish you'd change your lakes for ocean." *Don Juan* was Byron's ambitious answer to this important new poetic school.

The Morgan Library's collection of Byron manuscripts is one of the most extensive. Besides Cantos I-V and XIII of *Don Juan*, it in-

Watercolor on ivory,
miniature portrait of Lord Byron

9 ᷓ

LORD BYRON
GEORGE GORDON NOËL BYRON

Don Juan. Autograph manuscript of Cantos I-V, 1818-20. MA 56-57. Purchased by Pierpont Morgan, 1900.

Byron (1788-1824) detested what he called "sweating poesy"—overworking and revising verse—and his manuscript indeed reveals a fluid hand, often working with little revision to achieve a swift, conversational pace. Autograph stanzas like those pictured here, however, belie the poet's avowed facility of composition. The writing of this sprawling, episodic poem in the complex *ottava rima* stanzaic form was hardly effortless, despite the effect of comic ease which makes *Don Juan* eminently readable. But if textual revision was acceptable to Byron, self-censorship was quite another matter, and he refused to modify his poem when publisher John Murray expressed anxiety

2. 10.

Meantime — Sir Launcelot — I bound to ~~dedicate~~
 dedicate —
In haste simple wrote this song to you —
And if in flattering strains I ~~cannot~~ do not judicate —
'Tis that I still retain my "Buff & blue"

My Politics as yet are all to educate —
 Apostacy's so fashionable too
~~~~~~~~~~~~~~~~~~~~~~~~~~~~~~~~~~~~~~~~~~~~~~~
~~~~~~~~~~~~~~~~~~~~~~~~~~~~~~~~~~~~~~~~~~~~~~~
~~~~~~~~~~~~~~~~~~~~~~~~~~~~~~~~~~~~~~~~~~~~~~~
To keep one's creed is a task grown quite Herculean
Is it not so my Tory Ultra=Julian?

I want a hero — ~~is a common~~ an uncommon want —

     When every Year or Month sends forth a new one
Till after ~~searching~~ ~~solacing the Gazettes with~~ cant
The Age discovers he is not the true one
Of such as these I should not care to vaunt
I'll therefore take our ancient friend Don Juan —
   We all have
~~You've doubtless~~ seen him in the Pantomime
Sent to the Devil — somewhat ere his time.

        2.   VI

Most epic Poets plunge in "Medias res"
Horace commends it as the surest road —

9 Folio from Canto 1 of Byron's *Don Juan*

cludes *Beppo, The Corsair, Manfred, Marino Faliero, Mazeppa,* "Morgante Maggiore," *The Prophecy of Dante, Werner,* numerous short poems, and over seventy letters. Other major poets of the English Romantic period are also represented. In the collection are the Pickering manuscript of William Blake; the Coleorton papers of William and Dorothy Wordsworth; one of the largest collections of Coleridge letters; Southey's *Life of Cowper* and *Life of Bunyan;* and Keats's "Endymion," "Ode to Psyche," and "On First Looking into Chapman's Homer."

10 ❧

CHARLOTTE BRONTË

*The Poetaster.* Autograph manuscript, 1830. MA 2696. The Henry Houston Bonnell Brontë Collection. Bequest of Mrs. Bonnell, 1969.

In her biography of Charlotte Brontë (1816-55), Elizabeth Gaskell writes, "I have had a curious packet confided to me, containing an immense amount of manuscript, in an inconceivably small space; tales, dramas, poems, romances, written principally by Charlotte, in a hand which it is almost impossible to decipher without the aid of a magnifying glass." Gaskell's packet was the Brontë juvenilia, a remarkable assemblage of miniature manuscripts bound by hand as tiny books, chronicling the social and political history of the imaginary African kingdom of Angria. Both Charlotte and her brother Branwell enthusiastically record the day in 1826 when their father brought home a set of twelve toy soldiers, a gift which inspired years of imaginative play and

engendered the Angrian cycle of romance and intrigue. Drawing on the political events and literary figures of the day, Charlotte and Branwell constructed an elaborate saga based in an exotic geography, peopled by a huge cast of characters whose actions were directed by the supernatural Genii—the all-powerful child authors.

The manuscript reproduced here—one of over twenty juvenile compositions in the Library's Brontë collection—measures just 2.5 x 4.5 centimeters. Its sixteen pages of microscopic text constitute the second half of Charlotte's only full-scale play, *The Poetaster.* (The first half is in the Amy Lowell collection of the Harvard College Library.) Written when she was only fourteen, it satirizes the Romantic conception of poetic genius in the character of Henry Rhymer, an airy young poet who insists, "The thoughts should come spontaneously as I write or they're not the inspirations of genius." Like Ben Jonson in his *The Poetaster,* on which her play is based, Charlotte opposes two concepts of poesy in a dramatic dialogue. Rhymer's pomposity is offset by the caution of established poet Captain Tree, whose own method of composition involves careful textual revision: "How most people in general are deceived in their ideas of great authors. Every sentence is by them thought the outpourings of a mind overflowing with the sublime and the beautiful. Alas, did they but know the trouble it often costs me for me to bring some passage neatly to a close, . . . to polish and round the period." The Morgan Library's rich collection of Brontë manuscripts was augmented in 1969 with the addition of the Henry Houston Bonnell Brontë collection.

10 Pages from Brontë, *The Poetaster* (shown actual size)

11 ≈

HENRY DAVID THOREAU

Autograph journal, 1837-61. MA 1302.
Purchased by Pierpont Morgan, 1909.

                    Walden Sat. July 5th-45
Yesterday I came here to live. My house makes me
think of some mountain houses I have seen, which
seemed to have a fresher auroral atmosphere about
them as I fancy of the halls of Olympus.

For readers of *Walden*, this simple entry for 5
July 1845 in Thoreau's journal is charged with
artistic and spiritual promise. If *Walden* charts
a single year of life in the Concord woods, the
journal builds season upon season, year upon
year, offering close to a lifetime of Thoreau's
careful observations of the natural world. From
1837, shortly after his graduation from Har-
vard, until 1861, a few months before his death,
Thoreau (1817-62) kept a journal which was to
become the central literary endeavor of his life.
For the Transcendentalists with whom he was
allied during his early years, journal-keeping
offered a powerful means of self-cultivation. It

was probably Emerson who encouraged Tho-
reau to begin the work, as reported in his very
first entry for 22 October 1837: "'What are
you doing now?' he asked, 'Do you keep a
journal?'—So I make my first entry today." The
bulk of the manuscript—over two million
words in forty volumes—resides in the Morgan
Library, housed in the stout pine box built by
Thoreau to preserve his notebooks.

In his entry for 9 February 1851, Thoreau
writes, "I do not know where to find in any
literature whether ancient or modern—an ade-
quate [ac]count of that Nature with which I am
acquainted. Mythology comes nearest to it of
any." If anyone has come close to providing an
"adequate account" of Nature it is Thoreau,
not only in *Walden* but in his lifelong verbal
rendering of the New England landscape. The
journal did more than provide grist for Tho-
reau's few published works, including *A Week
on the Concord and Merrimack Rivers* and
*Walden*. It is a comprehensive literary medita-
tion in its own right, having little in common
with the daily jottings of most diarists.

The eleven manuscript volumes of Thoreau's

Thoreau's journals and box

11  Entry from Thoreau's journal, 5 July 1845

unpublished "Indian notebooks" (*Extracts from works relating to the Indians*) are also in the Morgan Library, along with a number of poems, essays, and letters. The Thoreau journals came to the Library in 1909 when Pierpont Morgan purchased the Stephen H. Wakeman collection of American authors, with important representations of Emerson, Hawthorne, Poe, Whittier, Lowell, Holmes, Bryant, and Longfellow.

12  &

HONORÉ DE BALZAC

*Eugénie Grandet.* Autograph manuscript and corrected galley proofs, 1833. MA 1036. Purchased 1925.

In the example shown, what appears to the literary scholar as compelling evidence of Balzac's creative exuberance seemed to his printers

12   A galley of Balzac, *Eugénie Grandet*

a frustrating demonstration of carelessness. A tortuous mass of rapid writing, corrections, additions, and forty-one leaves of corrected galley proofs bound in, the manuscript of *Eugénie Grandet* is a typical example of Balzac's method of composition. Customarily, Balzac (1799-1850) would shift whole chapters about as well as revise practically every passage with his nearly indecipherable scribblings. He would then call for fresh proofs. Sustained by innumerable cups of strong coffee, he would work through the night and devastate yet another set of proofs with a morass of further emendations. This extravagant process considerably reduced his earnings and added to his ever-present financial woes.

*Eugénie Grandet* is one of the "Scènes de la vie de province" within the series known collectively as the *Comédie humaine*. Balzac's ambitious sequence of ninety-one interconnected works populated by more than two thousand characters remains a cornerstone in the history of the European novel. Combining a scientist's concern for objectivity, a historian's interest in accuracy, and a great novelist's attentiveness to the creation of a believable fictional world, Balzac constructed his magnificent, elaborate narrative of French society. As in so much of the *Comédie humaine,* the plot of *Eugénie Grandet* is propelled by the centrality of money in personal and social relations. The novel stands apart, however, for its small number of characters, economy of incident, and unity of setting. No melodramatic events or philosophical digressions impede the progression of this bourgeois tragedy of avarice and betrayal in which once hopeful Eugénie, the daughter of the miser Grandet, is rejected by her greedy, ambitious lover and doomed to a passive existence of lonely piety.

Balzac presented this manuscript of one of his greatest and most popular novels to Mme Eveline de Hanska, a wealthy Polish countess whom he befriended and eventually married a few months before his death. In addition to Balzac, several other major French writers of the nineteenth century are represented in the Morgan Library. Autograph holdings include Anatole France's *Thaïs,* Zola's *Nana,* Maupassant's *Boule-de-suif, Fort comme la mort,* and *Bel-Ami,* as well as representations of Dumas père, Dumas fils, and Victor Hugo.

13 ❧

CHARLES DICKENS

*A Christmas Carol.* Autograph manuscript, 1843. MA 97. Purchased by Pierpont Morgan.

Dickens (1812-70) so artfully expressed the unique blend of nostalgia, joy, and hope which gives the Christmas season its special meaning that some would give him credit for inventing the holiday. Scrooge's regretful confrontation with the miserliness of his past, the Cratchits' modest Christmas dinner enriched by the family's good humor and love for one another, and Scrooge's reformation as the benefactor of the Cratchits continue to evoke great emotion in readers. From 1843 until 1847, Dickens delighted and touched his public annually with eagerly awaited Christmas stories, but the first, *A Christmas Carol,* has remained the most powerful of his seasonal creations. The tale is imbued with his own character and social attitudes. Like Bob Cratchit, he had known poverty and eked out a living as a clerk. Like Scrooge, he lived in great fear of financial ruin. His natural sympathy for the less fortunate inspired the benevolence which suffuses the work.

Dickens's note on title page of manuscript

From its inception, the work had particular significance for him. In 1843, he was concerned about his earnings. His family was growing and his most recent novel, *Martin Chuzzlewit,* did not sell well. Determined to achieve a monetary success, he planned a single volume work on a Christmas theme to be sold at a reasonable price and available in time for the holidays. Once he began writing in mid-October, he was consumed by the ghostly plot and extraordinary characters and completed the work in six weeks. By Christmas Eve, 6,000 copies had been sold. Though popular with holiday shoppers, the work earned Dickens far less than he had expected. The costs of producing an attractively bound and illustrated, yet affordable, volume cut deeply into profits. He did, however, capitalize on his readers' affection for

13 Page from Dickens's *A Christmas Carol*

the book by making it a centerpiece of the immensely successful public readings which he gave for the rest of his life.

The manuscript enables us to peer over the author's shoulder and observe him at work. The heavily corrected text, a morass of crossed-out and inserted words, reveals a scrupulous author who revised continuously. He presented the manuscript as a gift to his friend and solicitor Thomas Mitton. It passed through several hands before being acquired by Pierpont Morgan around the turn of the century. Besides *A Christmas Carol*, the Morgan Library has the manuscripts of two of Dickens's other Christmas books, *The Cricket on the Hearth* and *The Battle of Life*, as well as *Our Mutual Friend* and *No Thoroughfare*, which he wrote with Wilkie Collins for the 1867 Christmas issue of *All the Year Round*. There are also over 1,300 autograph letters.

14 ❧

WILLIAM MAKEPEACE THACKERAY

Autograph letter signed, 10 January 1841, to Edward FitzGerald. MA 4500. Bequest of Gordon N. Ray, 1987.

One of Thackeray's favorite correspondents was his friend Edward FitzGerald, renowned for his translation of *The Rubáiyát of Omar Khayyám*. FitzGerald burnt many of his letters from Thackeray (1811-63), but this particularly poignant one survived. Writing when he was first becoming known to the public for his humorous articles, the author confided his private anguish. His wife, Isabella, had suffered a mental breakdown. Thackeray had taken her to France to place her in the famed Maison de Santé of Dr. Esquirol, where patients were reputed to receive the most enlightened treatment

Caricature of Thackeray (left) and Dickens (right) by Alfred Bryan. Gift of Miss Caroline Newton, 1974.7

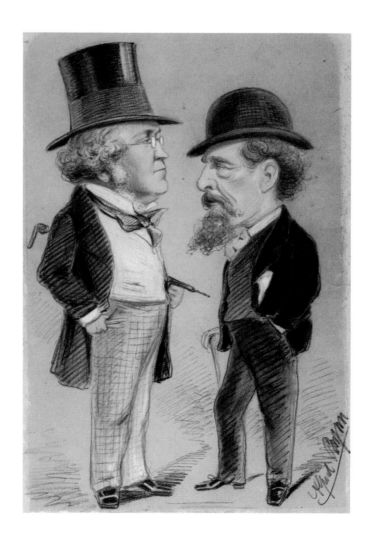

My dear old Edward. Your letter though it has not been
answered till now gave me a great pleasure — I think yours
are the only letters that were always welcome to me, for
they always contain something hearty w.h makes me happier
when I am happy, and consoles me when I am dull.
This blow that has come upon me has played the deuce
with me that is the fact, and I don't care to write to my
friends and pour out lamentations w.h are all the news I
have to tell. I saw my dear little woman yesterday for the
first time for six weeks, since w.h time she has been at
Esquirol's famous "maison de santé". Esquirol is dead since
she went there, & the place conducted by his nephew, who
is Lehuraine a famous name in his profession. He says
Elle doit guérir. and I think so too : at first she was in a fou
and violent, then she was indifferent, now she is melan
choly & silent and we are glad of it. She becomes her condition
and that is a great step to a cure, she knows every body
and recollects things but in a strange confused sort of way.
She kissed me at first very warmly and with tears in her
eyes, then she went away from me, as if she felt she was
unworthy of having such a God of a husband. God help her.
My father brother and cousin are all going off to Italy
in this dreadful weather, to meet a brother of the governor's

that medical science could then provide. Thackeray reported some improvement:

At first she was in a fever and violent, then she was indifferent, now she is melancholy & silent and we are glad of it. She bemoans her condition and that is a great step to cure. She kissed me at first very warmly and with tears in her eyes, then she went away from me, as if she felt she was unworthy of having such a God of a husband. God help her.

Isabella Thackeray was never cured, and her condition was a great sadness for the author. She eventually returned to England, where she died some thirty years after her husband.

Though one of the most famous of Victorian authors during his lifetime, Thackeray the person remained enigmatic until well into the twentieth century. He had no Boswell, and, indeed, expressed his hope to his daughter Anne that no biography would ever be written of him. When the first volume of Gordon Ray's monumental edition of the correspondence appeared in 1945, three-fifths of the some 1,600 surviving letters were unpublished. When completed, the four volumes revealed for the first time the full richness of Thackeray's personality. The edition also established Thackeray as one of the greatest English letter writers. Employing the correspondence as the "indispensable foundation of intimate biography," Gordon Ray went on to write the authoritative life of the author.

Among the several thousand autograph representations of English, French, and American authors and artists bequeathed to the Morgan Library by Gordon Ray are substantial groups of correspondence and manuscripts centering around Thackeray and his family. The Library's Thackeray holdings also include the manuscripts of *Denis Duval, Lovel the Widower, The Rose and the Ring, Vanity Fair,* and *The Virginians,* 185 autograph letters, and numerous drawings.

## 15 ❧

GEORGE ELIOT
PEN NAME OF MARIAN EVANS

*Scenes of Clerical Life.* Autograph manuscript, 1856-57. MA 722. Purchased by Pierpont Morgan, 1911.

George Henry Lewes submitted Marian Evans's (1819-80) first fictional effort to *Blackwood's Edinburgh Magazine* in 1856 as the initial story in a series by an anonymous friend. He assured the editor that the series "will consist of tales and sketches illustrative of the actual life of our country clergy about a quarter of a century ago; but solely in its *human* and *not at all* in its *theological* aspect." It does seem surprising that Evans—editor, translator, freethinker and non-believer—should have chosen as her first fictional subject the quiet lives of provincial clergy, making her entrée as novelist with a title as innocuous as *Scenes of Clerical Life.* But it was precisely that "human aspect" of her unlikely protagonists which Evans aimed to explore in her series of "sketches." Just a few days before beginning the clerical scenes, Evans completed an article entitled "Silly Novels by Lady Novelists," decrying the sentimentality and melodrama of popular Evangelical literature of the "White Neck-cloth School" with its backdrop of aristocratic gentility. When she tried her hand at fiction the following week, adopting the masculine pen name George Eliot, she proved that a realistic treatment of religious life among "commonplace people" can be far from silly.

At the start of Chapter 5 of "The Sad Fortunes of the Rev. Amos Barton," George Eliot wonders if "perhaps I am doing a bold thing to bespeak your sympathy on behalf of a man who was so very far from remarkable,—a man whose virtues were not heroic,…but was palpably and unmistakably commonplace." In the passage reproduced here, George Eliot steps in to offer an authorial apostrophe on behalf of her inarticulate heroes, with "their unspoken sorrows, and their sacred joys…Nay, is there not a pathos in their very insignificance—in our comparison of their dim and narrow existence with the glorious possibilities of that human nature which they share?" If her later novels were often told through vehicles more exceptional than Amos Barton's "dull grey eyes," George Eliot's social tragedy continued to derive from her characters' common humanity.

The manuscript of *Scenes of Clerical Life* is notably free of substantial emendation, for Eliot stood firm against the "cramping influence" of her editor John Blackwood. When he suggested that one character might be given a bit more "dignity," she refused to alter the manuscript: "My artistic bent is directed not at all to the presentation of eminently irreproachable characters, but to the presentation of mixed human beings in such a way as to call forth tolerant judgment, pity, and sympathy. And I cannot stir a step aside from what I *feel* to be *true* in character" (18 February 1857, National Library of Scotland).

*is more or less hard & disjointed. Yet these common place people — many of them — bear a conscience, & have felt the sublime prompting to do the painful right; they have their unspoken sorrows, & their sacred joys; their hearts have perhaps gone out towards their first-born, & they have mourned over the irreclaimable dead. Nay, is there not a pathos in their very insignificance, — in our comparison of their dim & narrow existence with the glorious possibilities of that human nature which they share?*

*Depend upon it, my dear lady, you would gain unspeakably if you would learn with me to see some of the poetry & the pathos, the tragedy & the comedy, lying in the experience of a human soul that looks out through dull grey eyes, & that speaks in a voice of quite ordinary tones. In these daily actions the recording angel probably enters into the celestial ledger chiefly by the word ditto. In that case, I should have no fear that you would not care to know what further befel the Rev. Amos, or that you would think the homely detail, I have to tell at all beneath your attention. As it is, you can, if you please, decline to pursue my story further, & you will easily find reading more to your taste, since I learn from the newspapers that many remarkable novels, full of striking situations, striking incidents, & eloquent writing, have appeared within the last season.*

*Meanwhile, readers who have begun to feel an interest in the Rev. Amos Barton & his wife, will be glad to learn that Mr. Oldinport lent the twenty pounds. But twenty*

15  Folio 60 of Eliot, *Scenes of Clerical Life*

JOHN RUSKIN

*The Stones of Venice*. Autograph manuscript
[1851-53]. MA 398-400. Purchased by
Pierpont Morgan, 1907.

When the adolescent Ruskin (1819-1900) and
his parents embarked on a continental trip in
1835, their final stop was the city which had
entranced the English since the Middle Ages.
To the pilgrims who passed through on their
way to the Holy Land, Venice was the embodi-
ment of luxury and power. By Ruskin's time,
the city had become a powerful symbol of
decay. The majesty and ornate beauty of her
churches and palaces, nevertheless, continued
to lure, enthrall, and inspire English visitors.
No exception, Ruskin drew on his six separate
journeys spread over seventeen years to record
his own multiple impressions in *The Stones of
Venice*. "To see clearly is poetry, prophecy, and
religion—all in one," he had written in *Modern
Painters*. Ruskin's magnificent study of Vene-
tian architecture, with plentiful evidence of his
sharp, critical eye and his deep sense of moral
purpose, explores the possibilities of that as-
sertion.

16  Page 1 of Ruskin, *The Stones of Venice*

Ruskin, *Self-portrait in Blue Neckcloth,*
watercolor. Gift of the Fellows, 1959.23

In the opening paragraphs, he sets forth his
argument in his characteristically rich, impres-
sionistic prose. The decline of Venice is linked
to the lost glory of ancient Tyre, and England is
admonished to heed the lesson of their tragic
falls. Whereas now vanished Tyre can only be
studied in the words of the Biblical prophets,
he notes, slowly deteriorating Venice remains
for our observation and edification:

Her successor, like her in perfection of beauty,
though less in endurance of dominion, is still left for
our beholding in the final period of her decline: a
ghost upon the sands of the sea, so weak—so quiet,—
so bereft of all but her loveliness, that we might well
doubt, as we watched her faint reflection in the
mirage of the lagoon, which was the City, and which
the Shadow.

I would endeavour to trace the lines of this image
before it be for ever lost, and to record, as far as I
may, the warning which seems to me to be uttered by
every one of the fast-gaining waves, that beat like
passing bells, against the STONES OF VENICE.

The Morgan Library owns a superb collec-
tion of Ruskin manuscripts, including *Modern
Painters* and the collections of Ruskin materials
formed by F. J. Sharp and Helen Gill Viljoen.
The holdings of Ruskin correspondence in-
clude almost six hundred of his letters to the
children's book author and illustrator Kate
Greenaway.

## 17 🙋

### WILLIAM MORRIS

*News from Nowhere: Being Some Chapters
from a Utopian Romance.* Autograph manu-
script [1889–90]. MA 4591. Purchased on the
Gordon N. Ray Fund, 1989.

"Society is to my mind wholly corrupt, & I can
take no deep-seated pleasure in anything it
turns out, except the materials for its own de-
struction in the shape of discontent and aspira-
tion for better things," wrote William Morris
(1834-96) in a letter to the printer and book-
binder T. J. Cobden-Sanderson. In his own life,
certainly, "aspiration to better things" had in-
formed the immensely diverse and remarkably
energetic Morris's accomplishments as writer,
designer, craftsman, printer, and political theo-
rist. In his final decade, he drew on his multiple
interests to create several visionary works
which allowed his idealism and literary imagi-
nation free rein. These extraordinary works
include the historical romances *The House of
the Wolfings, The Story of the Glittering Plain,*
and *The Well at the World's End,* as well as two
fantasies, *A Dream of John Ball* and *News
from Nowhere.*

*News from Nowhere* was Morris's direct re-
sponse to the Utopian romance *Looking Back-
ward* (1888) by the American novelist and po-
litical theorist Edward Bellamy. In Bellamy's
Utopia, social justice and culture thrive in an
industrial, urban setting. Morris envisions in-
stead a more pastoral society in which rural
and urban values are carefully balanced, tech-
nology operates harmoniously with nature,
and daily labor permits creativity. Social salva-
tion is possible when the patterns of art are
applied to everyday life. *News from Nowhere*
is presented as a dream of London and the
English countryside in the future. During his
reverie, the narrator is advised, "Go on living
while you may, striving with whatsoever pain
and labour needs must be to build up little by
little the new day of fellowship and rest and
happiness." When he awakes, he vows to share
the possibilities which he has glimpsed: "If
others can see it as I have seen it, then it may be
called a vision rather than a dream." Morris's
culminating work first appeared serially in
*Commonweal,* the organ of the Socialist

or lying down I could not tell × × × × ×

× × × ×

I lay in my bed in ~~Hamm~~ my dingy house at Hammersmith thinking about it all; and trying to think if I was overwhelmed with despair at finding I had been dreaming a dream.

Or indeed was it a dream? If so, why was I so conscious all along that I was really seeing all ~~that~~ new life from the outside, still wrapped up in the prejudices, the anxieties, the distress of this time of doubt and struggle?

All along, though those friends were so real to me, I had been feeling as t I had no business amongst them; as though the time would come when they would reject me, and say as Ellen's last mournful look seemed—

Say: "No, it will not do, you cannot be of us: you belong so entirely to the unhappiness of the past that our happiness even would weary you. Go back again now you have seen us, and your outwardness haue learned that in spite of all the infallible maxims of your day there is yet a time of rest in store for the world, when mastery has changed into fellowship — but not before — Go back again then, and while you live you will see all round you ~~the fitterry~~ people engaged in making others live lives which are not their own, while they themselves care nothing for their own real lives — men who hate life though they fear death. Go back and be the happier for having seen us, for having added a little hope to your struggle: so on ~~living~~ living while you may striving ~~little by little~~ with whatsoever pain and labour ~~needs~~ needs must be to build up little by little the new day of ~~fellowship~~, and rest and happiness."

Yes surely! and if others can see it as I have seen it then it may be called a vision rather than a dream.
                              The End.   William Morris

17 Folio 266 of Morris, *News from Nowhere*

the common, the vulgar, which are
the aims of the false ideal of our
days. Live! Live the wonderful life
that is in you! Let nothing be lost
upon you. Be always searching for new
sensations. Be afraid of nothing."

"A new Hedonism, that is what our
age wants. You might be its visible
symbol. With your personality there
is nothing you could not do. The
world belongs to you for a season."

["The moment I met you, I saw
that you were quite unconscious of
what you really are, of what might be. There
was so much about you that charmed
me that I felt I must tell you
something about yourself. I thought how
tragic it would be if you were wasted.
For, there is such a little time that
your youth will last, such a little
time."

"The common hill-flowers wither,
but they blossom again. The laburnum
will be as golden next June year, as it
is now. In a month there will be purple
stars on the clematis, and year after
year the green night of its leaves will
have its purple stars. But we never
get back our youth. The pulse of joy
that beats in us at twenty, becomes
sluggish. We degenerate into hideous puppets haunted
by the memory of the passions of which
we were afraid, and the exquisite temptations
that we did not dare to yield to. Youth!
Youth! There is absolutely nothing in the
world but youth!"

18  Folio 40 of Wilde, *The Picture of Dorian Gray*

League. The founding of a cooperative publishing and printing enterprise, the Kelmscott Press, quickly followed.

Some of the finest printed books and manuscripts from William Morris's own library were acquired by Pierpont Morgan in 1902. Among the autograph Morris manuscripts in the Library are *The House of the Wolfings* and *The Well at the World's End*.

18 ❧

OSCAR WILDE

*The Picture of Dorian Gray*. Autograph manuscript [1890]. MA 883. Purchased 1913.

The publication of this novel by Wilde (1854-1900) provoked one of literary history's most intense debates over art and morality. When the tale of a voluptuary who remains young while his portrait ages appeared in *Lippincott's Monthly Magazine*, controversy raged over Wilde's depiction of a life devoted to sensual gratification. Rarely had corruption been so powerfully conveyed in prose, and never before had homosexuality been so candidly presented in an English novel. One outraged critic condemned *Dorian Gray* as "a poisonous book, the atmosphere of which is heavy with the mephitic odors of moral and spiritual putrefaction." Wilde retorted that the book was "poisonous but perfect." In subsequent letters to newspapers, Wilde eloquently defended the principle that the artist's primary obligation is to aesthetic integrity rather than conventional morality.

In addition to revealing Wilde the writer as bold enough to explore previously forbidden themes, *Dorian Gray* offers much of Wilde the critic. A leading proponent of aestheticism, he incorporated many of the movement's doctrines in *Dorian Gray*. Several passages are paraphrases of John Ruskin, John Addington Symonds, and Walter Pater. On the page shown, Lord Henry rhapsodically invites Dorian Gray to seek and savor every experience, "Live! Live the wonderful life that is in you! Let nothing be lost upon you. Be always searching for new sensations." His words echo the conclusion of Pater's influential *Studies in the History of the Renaissance*, which was published seventeen years earlier. "Not the fruit of experience," Pater wrote, "but experience itself is the end." The novel is also one of Wilde's most personal works. He put something of himself into each of the main characters:

"Hallward is what I think I am; Lord Henry what the world thinks me; Dorian what I would like to be—in other ages perhaps."

The Morgan manuscript comprises the thirteen chapters that appeared in *Lippincott's* in 1890. Wilde was reputed to be a careless writer, who was interested foremost in completing a work as quickly as possible. His numerous revisions in the manuscript, however, reveal a meticulous craftsman. For the publication of *The Picture of Dorian Gray* as an individual volume a year later, Wilde added a preface and six chapters and reworked many passages. Almost sixty years after purchasing the manuscript in 1913, the Morgan Library acquired a portion of what became Chapter 5 in the printed edition. Also among the holdings is the only letter known to have survived from Wilde to his wife, Constance.

19 ❧

MARK TWAIN, PEN NAME OF
SAMUEL LANGHORNE CLEMENS

*Pudd'nhead Wilson*. Autograph manuscript, 1893. MA 881-82. Purchased by Pierpont Morgan from the author, 1909.

It took what Twain (1835-1910) called "a kind of literary Cæsarean operation" to divide this single manuscript into two distinct short novels, the farcical *Those Extraordinary Twins* and the ironic *Pudd'nhead Wilson*. What began as an extravagantly comic tale about Siamese twins was complicated by the intrusion (autonomous, Twain implies) of strangers like Pudd'nhead Wilson and Roxana, leaving Twain with "a most embarrassing circumstance…that it was not one story, but two stories tangled together; and they obstructed and interrupted each other at every turn and created no end of confusion and annoyance." Twain reports that he studied the manuscript during several trips across the Atlantic, and "pulled one of the stories out by the roots." The "operation" was a success.

The titular hero of the novel is a lawyer dubbed "Pudd'nhead" as a result of an unfortunate quip made upon his arrival in the small Missouri town of Dawson's Landing. His eccentric wisdom—not unlike Mark Twain's own droll insight—is reflected in chapter headings drawn from Pudd'nhead Wilson's calendar, ranging from the social ("Few things are harder to put up with than the annoyance of a good example") to the literary ("As to the Adjective:

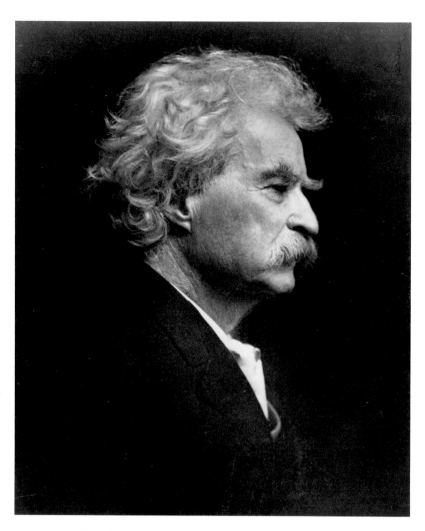

Photograph of Mark Twain, MA 1950, Harper collection

when in doubt, strike it out"). In a final court-room scene, Wilson lives down his nickname and solves a murder by employing the then unheard-of technique of fingerprinting.

The murderer is Tom Driscoll, a cowardly gambler raised as the son of a wealthy southern aristocrat but actually the son of a slave girl, Roxana, who switched her own baby with her master's to save him from the indignity of slavery. In a lengthy passage excised from the printed novel but reproduced here, Tom contemplates the debasing effect of slavery after learning of his own parentage:

Whence came that in him which was high, and whence that which was base? That which was high came from either blood, and was the monopoly of neither color; but that which was base was the *white* blood in him debased by the brutalizing effects of a long-drawn heredity of slave-owning, with the habit of abuse which the possession of irresponsible power always creates and perpetuates, by a law of human nature.

Twain, a friend of the family and a visitor to Morgan's library, wrote to Pierpont Morgan on the occasion of his purchase of the manuscript, "One of my highest ambitions is grati-fied—which was, to have something of mine placed elbow to elbow with that august company which you have gathered together to remain indestructible in a perishable world." Elbow to elbow with that august company are also the manuscripts of *Life on the Mississippi, The Man that Corrupted Hadleyburg, A Dou-ble-barrelled Detective Story,* several letters, and short pieces.

*241*

In his broodings in the solitudes,
he searched himself for the reasons
of certain things, & in toil & pain
he worked out the answers:

Why was he a coward? It was
the "nigger" in him. The nigger
blood? ~~Add to~~ Yes, the nigger blood
degraded from original courage
to cowardice by decades & gene-
rations of insult & outrage in-
flicted in circumstances which
forbade reprisals, & made mute
                        endurance
& meek ~~acceptance~~ the only refuge
& defence.

Whence came that in him which
was high, & whence that which was
base? That which was high came
from either blood, & was the mo-
nopoly of neither color; but that
which was base was the white
blood in him debased ~~& brutalized~~
by the brutalizing effects of a

19  Folio 241 of Twain, *Pudd'nhead Wilson*

ALBERT EINSTEIN

"Grundgedanken und Methoden der Relativitätstheorie, in ihrer Entwicklung dargestellt." Autograph manuscript, [ca. 1919-20]. Heineman MS 278. Dannie and Hettie Heineman Collection.

"[On January 7, 1907] there came to me the most fortunate thought of my life," wrote Albert Einstein (1879-1955) in this article intended for the British magazine *Nature*. Almost thirteen years later, he sought to recount for the public the process by which he had reached his theory of relativity. At thirty-five handwritten pages, however, the article proved too lengthy, and he decided not to publish it. The beginning of general awareness of Einstein's importance came soon thereafter, nevertheless, when headlines about the theory appeared in London and New York newspapers. His theory, a landmark of the creative imagination in science, became a central proposition of the twentieth century. Like his predecessor Sir Isaac Newton, Einstein altered human understanding of the nature of physical reality.

The manuscript of Einstein's article is one of the documents of scientific thought which came to the Library in 1977 from the Dannie and Hettie Heineman Foundation. Alongside important manuscripts of history, literature, music, and philosophy, four centuries of science are represented in the Heineman Collection. In one letter, Galileo announces his discovery of sunspots, with a postscript concerning observations made with the naked eye and "con telescopio." From Galileo's contemporary Johann Kepler, there are autograph mathematical calculations relating to astronomy. In several letters, Arnold Schopenhauer and a correspondent discuss geometry and theory of colors. And in a letter to a mentor, Charles Darwin describes plants from the Galapagos Archipelago and Tierra del Fuego, concluding, "I keep on steadily collecting every sort of fact, which may throw light on the origin of species."

The Heineman Collection greatly enriched the Library's small but fine foundation of manuscripts of scientists and inventors. Other examples are a letter from Galileo in which he laments the prohibition against reprinting his works, manuscripts of papers by Sir Isaac Newton on counterfeiting and coinage, and by Gug-

Einstein to E. M. Freundlich, September 21, 1911. The gift of Mr. Horace Wood Brock, Mr. John Biddle Brock, and Ms. Hope Brock Winthrop, in loving memory of their parents, Horace Brock and Hope Distler Brock, 1991

In diesen Gleichungen bedeutet $v$ den Vektor, $q$ die Grösse der
Geschwindigkeit, $\mathfrak{K}$ die auf den materiellen Punkt wirkende
Kraft. Solange die Geschwindigkeit gegen die Lichtgeschwindig-
keit klein ist, unterscheiden sich beide Gleichungen nicht
merklich. Bei Newton ist $m\,v$ der Ausdruck für den Impuls
(Schwung) der Masse, nach der Relativitätstheorie $\dfrac{m\,q}{\sqrt{1-\frac{q^2}{c^2}}}$. Die
letztere Grösse wird unendlich, wenn sich $q$ der Lichtgeschwin-
digkeit $c$ nähert, die erstere nicht. Damit hängt es zusammen,
dass es gemäss der Relativitätstheorie auch durch Aufwendung
noch so starker und noch so lang wirkender Kräfte nicht
möglich ist, die Geschwindigkeit des ~~Körpers~~ materiellen Punktes
bis zur Lichtgeschwindigkeit (oder darüber hinaus) zu steigern.
Die Lichtgeschwindigkeit spielt in der Theorie überhaupt die
Rolle einer physikalisch unendlich grossen, d. h. durch Projektile,
Signale (Wellen) etc. unübersteigbaren Geschwindigkeit. Dies lehrt
auch schon ein Blick auf die Lorentz - Transformation sowie
die oben aus derselben gezogenen Konsequenzen über bewegte
Massstäbe und Uhren.

Für die Energie eines bewegten Massenpunktes ergibt sich der Ausdruck

$$\mathfrak{E} = \frac{m c^2}{\sqrt{1-\frac{q^2}{c^2}}} \quad \dots (7)$$

oder – nach Potenzen von $q^2$ entwickelt

$$\mathfrak{E} = m c^2 + \tfrac{1}{2} m q^2 + \tfrac{3}{8} \frac{m}{c^2} q^4 \dots \quad \dots (7a)$$

Das zweite Glied dieser Entwicklung ist die als „kinetische Energie"
in der klassischen Mechanik. Das dritte, vierte etc. Glied verschwindet
gegen das zweite, wenn $\frac{q^2}{c^2}$ gegenüber der Einheit vernachlässigbar
ist. Besondere Beachtung verdient das erste Glied in (7a). Es muss
zwar daran erinnert werden, dass nicht die Energie des Massenpunktes
selbst, sondern nur deren Abhängigkeit von der Geschwindigkeit aus
den Bewegungsgleichungen folgt, sodass die Energie nur bis auf eine
additive Konstante definiert ist, welche wir in (7) weggelassen haben.
Hingegen ist das erste Glied $m c^2$ in (7a), auf welches sich der Ausdruck von $\mathfrak{E}$
im Falle $q = 0$ reduziert, so eng formal mit den folgenden verbunden
(wie ein Blick auf (7) zeigt), dass wir geneigt sein werden, ihm eine
physikalische Bedeutung beizumessen. Wir können $m c^2$ als die Energie
des Massenpunktes im Falle der Ruhe ($q = 0$) ansehen.

lielmo Marconi on wireless telegraphy, notes by Robert Fulton on the steamboat and proposals for methods of launching torpedoes, and a diagram and description by Samuel F. B. Morse of the original telegraph.

21 &

JOHN STEINBECK

*Travels with Charley.* Autograph manuscript, [ca. 1961]. MA 2199. Gift of the author, 1962.

Accepting the 1962 Nobel Prize for literature, John Steinbeck (1902-68) declared that literature was not "a game for the cloistered elect, the tinhorn mendicants of low calorie despair. It grew out of human need for it, and it has not changed except to become more needed." For almost forty years of professional writing, he exemplified this credo in a remarkable variety of forms—novel, short story, nonfiction, journalism, drama, and screenplay. Steinbeck shared the social concerns of many writers of his generation, but he roused the emotions of millions of American readers much more forcefully than did most of his contemporaries. His compassionate renderings of the plight of farmers and fruitpickers in works such as *The Grapes of Wrath* evoked great sympathy for all victims of the Dust Bowl and the Depression. Throughout his career, he condemned greed and exploitation, extolled loyalty and gallantry, and offered acute observations of the American land and its inhabitants in realistic, vigorous prose.

Shown here are the opening paragraphs of *Travels with Charley* (1962), including one which does not appear in the published volume. In initial sales *Travels with Charley* was more successful than any of Steinbeck's other books. In it, he recounts the rambling journey he made with Charley, his French poodle and inseparable companion, across the United States and back in a three-quarter-ton pickup truck named Rocinante. Throughout the book, the vivid descriptions of the terrain and its inhabitants reveal a writer long in love with the American landscape and uniquely attuned to the people's mores. There is exuberance in his portrayals of the uninhibited energy of Texans and the neighborliness of the people of Montana. Much of what he observes, though, invokes sad reflections on American restlessness and the waste and destruction wrought by progress in the twentieth century. In New Orleans, his characteristic outrage at social injustice comes to the fore, and he angrily depicts the taunting of a little black girl attempting to integrate a grammar school.

Steinbeck enjoyed a close association with the Morgan Library. He spent many hours consulting books and manuscripts at the Library when he was working on his rendering of *The Acts of King Arthur and His Noble Knights*. Many of the Library's Steinbeck manuscripts were given by him. In addition to *Travels with Charley*, the collection includes the manuscripts of his Nobel Prize address, *The Short Reign of Pippin IV, The Winter of Our Discontent, America and Americans*, the script of the film *Viva Zapata!*, as well as journals and correspondence.

1.

When I was very young and the urge to be some place else was on me, I was assured by mature people that maturity would cure this itch. Still having it when years described me as mature the prescribed remedy was middle age. In middle age I was assured that greater age would calm my fever and now at fifty eight perhaps senility will do the job. Nothing has worked. Four hoarse blasts of a ships' whistle still raises the hair on my neck and sets my feet to tapping. The sound of a jet, an engine warming up, even the clopping of shod hooves on pavement brings on the ancient shudder, the dry mouth and vacant eye, the hot palms and the churn of stomach high up under the rib cage. In other words, I don't improve, in further words, once a bum always a bum. I fear the disease is incurable. I set this matter down, not to instruct others but to inform myself.

In a long and wandery life, some verities have forced themselves on me. Perhaps those among my readers who have vagrant blood will find likeness of experience in a few generalities.

When the virus of restlessness begins to take possession of a wayward man, and the the road away from Here seems broad and straight and sweet, the victim must first find in himself a good and sufficient reason for going. This to the practical bum is not difficult. He has a built in garden of reasons to choose from. Next he must plan his trip in

# AIDA

OPERA IN QUATTRO ATTI

VERSI DI A. GHISLANZONI

MUSICA DI

# G. VERDI

DIRITTO DI TRADUZIONE RISERVATO

| CANTO E PIANOFORTE | PIANOFORTE SOLO |
|---|---|
| IN QUARTO = Franchi 50 | IN QUARTO = Franchi 40 |
| IN OTTAVO = Franchi 45 | IN OTTAVO = Franchi 30 |

PIANOFORTE A QUATTRO MANI = Franchi 45

EDIZIONI RICORDI

ROMA NAPOLI FIRENZE MILANO

PROPRIETÀ PER TUTTI I PAESI

DEPOSTO A NORMA DEI TRATTATI

GIULIO RICORDI

PARIGI — ESCUDIER

LITO. DOYEN TORINO

# VIII · MUSIC MANUSCRIPTS

Music manuscripts are many things to many people. They may be icons that are revered simply because (as one critic has observed) they were touched by the master's hand, looked upon by his eye. They have intrigued graphologists, who perceive in Beethoven's bewildering scrawl the turbulent evidence of romantic inspiration, or classical poise and balance in Mozart's tidy, elegant hand. But one must be wary of reading too much into the peculiarities of a person's handwriting; whether we write with calligraphic precision or in cacographic scribble is determined more by training than by emotional disposition or creative impulse. That is not to say that the study of a composer's handwriting is of no value; on the contrary, much can be learned by tracing the changes in Schubert's musical notation, for example, or by establishing the differences between Mozart's handwriting and that of his father, Leopold.

Music manuscripts are historical documents that may help scholars trace the evolution of a work, place it in the context of the composer's life, or, through watermark and allied paper studies, attach a more precise place and date to its composition. If we are fortunate, the composer will include that information on his manuscript and thus afford the researcher a verifiable date and location for the composition (or writing down) of the work in question. But even if the composer has not been so helpful, the paper itself may yield useful clues. The study of watermarks, for instance, has allowed scholars to date, localize, and authenticate many manuscripts. It must always be borne in mind that an autograph manuscript may be but one document among many used to establish an accurate reading of a work: there may be copyist's manuscripts that contain changes sanctioned by the composer; there may be printed proof copies that incorporate compositional changes; there may be printed copies used by the composer in which he entered later revisions and refinements. And, of course, there may be later editions that differ substantially from the original. The manuscript is often the first word in answering questions of textual accuracy, but it is not always the last.

Manuscripts offer only one point of departure for the scholar, student, or performer. In studying a given work, one must apply many other talents, for there is much that manuscripts do *not* tell us. If you look at the manuscript of a Bach cantata, for example, you will often find no written indication of either the tempo or dynamic level at which it should be played. The conductor who decides to perform the cantata thus cannot rely solely on the manuscript for guidance, but will bring to his performance a host of interpretive skills. (Of course, the same observation also holds true for, say, Mahler and Stravinsky, whose scores are filled with the most meticulous interpretive signs.)

The Morgan Library houses a collection of autograph music manuscripts that in diversity and quality, if not quantity, is unequaled in this country and surpassed by only a handful of archives in Europe. But unlike many other collections in the Library, the music manuscript collection goes back just thirty years. Pierpont Morgan is not on record as evincing any notable interest in music, although he did make two important purchases: the manuscript of Beethoven's Violin Sonata in G, op. 96; and two of the earliest surviving

letters of Mozart, written to his mother and sister in 1769 when he was thirteen years old.

An account of the Library as a major repository of music manuscripts begins in 1962, when the collection of books and manuscripts of the Heineman Foundation was placed on deposit. Between the two world wars Dannie Heineman and his wife, Hettie, built an outstanding collection of printed books and autograph letters and manuscripts of which the music section, although relatively small, was exceedingly well chosen. Among the notable manuscripts are the only extant portions of Bach's Cantata 197a (*Ehre sei Gott in der Höhe*), Mozart's Piano Concertos in C, K. 467, and D, K. 537 (*Coronation*), and his D-major piano rondo, K. 485, four early songs of Wagner, Chopin's Polonaise in A-flat, op. 53, Brahms's arrangement for piano four-hands of his String Sextet op. 18, and Mahler's *Klagende Lied*. In 1977 the collection was given to the Morgan Library, one of the most important and valuable gifts since the Library was founded.

The second major event in the history of the collection occurred in 1968, when the Trustees of the Mary Flagler Cary Charitable Trust donated Mrs. Cary's collection of music manuscripts, letters, and printed scores. One of the greatest collections of its kind, public or private, in the country, it was formed by Mrs. Melbert B. Cary, Jr., with the example and encouragement of her father, Harry Harkness Flagler. Mrs. Cary's collecting interests were firmly rooted in the Austro-Germanic traditions and in the nineteenth century. Fully three quarters of the manuscripts she acquired come from that period, and often from the pens of its luminaries. Her collection included Beethoven's *Geister* Trio, Schubert's *Schwanengesang* and String Quartet in D Minor (*Der Tod und das Mädchen*), Mendelssohn's *Meeresstille und glückliche Fahrt*, Chopin's Mazurkas op. 50, Bruch's Violin Concerto in G Minor, Brahms's First Symphony, and Richard Strauss's Songs op. 10 and *Don Juan*. Earlier autographs, although relatively few in number, were carefully selected, and included Bach's Cantata 112 (*Der Herr ist mein getreuer Hirt*), an early copyist's manuscript of Handel's *Messiah*, portions of Gluck's *Orfeo ed Euridice* and *Iphigenie auf Tauris*, Mozart's Violin Sonata in F, K. 376, and Haydn's Symphony no. 91.

One of the first large purchases the Library made after receiving the Cary Collection was an important group of Italian manuscripts, including works of Bellini, Cimarosa, Donizetti, Giordano, Mascagni, Pacini, Ponchielli, Puccini, Rossini, Spontini, and Verdi. Only a few of these composers were already represented, and none by a significant manuscript. The acquisition of these Italian manuscripts—in fact that of nearly every manuscript bought since 1968—was made possible through funds provided by the Mary Flagler Cary Charitable Trust. Notable among these are Brahms's Hungarian Dances for piano four-hands, Mahler's Fifth Symphony, Mozart's *Haffner* Symphony, K. 385, *Schauspieldirektor*, K. 486, and earliest known works, K. 1a-d, Pergolesi's Mass in F, Schoenberg's *Gurrelieder* and *Erwartung*, Schubert's *Winterreise* and eight Impromptus for piano, D. 899 and 935, Strauss's *Tod und Verklärung*, Stravinsky's *Perséphone*, Sullivan's *Trial By Jury*, and Weber's *Aufforderung zum Tanze*. It is in large part because of the continued growth of the Cary Collection that the Library has attracted so many other important gifts and collections on deposit.

Music scholars can also study manuscripts from one of the world's finest private collections of music manuscripts, the Robert Owen Lehman Collection, placed on deposit in the Morgan Library in 1972. Welcome not only for the singular distinction of its contents, this collection complements areas that are poorly represented in the Cary and

Heineman collections. The nucleus of the archive is a splendid group of manuscripts belonging to the eminent French pianist Alfred Cortot; it is especially strong in French music, notably Debussy, Ravel, Fauré, and Franck. To this core Mr. Lehman has added ten major Mozart autographs, several outstanding Mahler manuscripts, and a large number from the so-called second Viennese school of Schoenberg, Berg, and Webern. Mr. Lehman has, moreover, given the Library many manuscripts from his collection.

The Frederick R. Koch Foundation has purchased many important music manuscripts and letters, all of which are on deposit in the Library. Among the autograph manuscripts acquired by the foundation are the short score of Debussy's *Pelléas et Mélisande*, Berlioz's *Roi Lear* overture, Boccherini's Quintets for piano and strings op. 57, Mozart's Gavotte for orchestra, K. 300, large portions of Offenbach's *Contes d'Hoffmann*, a draft of Schubert's Fantasie in F Minor for piano four-hands, D. 940, the librettos of Verdi's *Ernani* and of Wagner's *Siegfried's Tod* (later *Götterdämmerung*) and *Lohengrin*, and over seventy William Walton manuscripts. The Frederick R. Koch Foundation deposit also includes large collections of letters by Offenbach, Poulenc, Puccini, Ravel, Saint-Saëns, Verdi, and Weber.

Music manuscripts are part of our musical heritage; each one is a unique record that transmits to us, however imperfectly, a written account of its author's passage through his compositional stages, from early sketch to final copy. It is argued that when new critical editions of works are published they diminish the need for these manuscripts and reduce their value; but even the most scrupulously prepared edition rarely, if ever, answers all the questions we may have about a work. To be sure, the manuscripts themselves leave us with uncertainties of meaning and ambiguities of interpretation, but without them an irreplaceable link in the documentary chain would be lost forever, and we would be the poorer for it.

---

1 &

JOHANN SEBASTIAN BACH

Cantata 112. *Der Herr ist mein getreuer Hirt*. Autograph manuscript, 1731. Mary Flagler Cary Music Collection.

Cantata 112 is one of three cantatas that Bach (1685-1750) composed for the second Sunday after Easter (*Misericordias Domini*). It was first performed, in Leipzig, on 8 April 1731; while it is probable that the entire manuscript was written around the same time, close study of it suggests that the first movement, notated in Bach's most elegant calligraphy, had been composed some time before, possibly as early as April 1725, and recopied into the 1731 manuscript. Bach frequently used previously composed music in his cantatas (and in other works), a reasonable economy given the large quantity of music he was required to produce and the often short amount of time he had to write it. The text of *Der Herr ist mein getreuer*

*Hirt* (The Lord is My Faithful Shepherd) is a version, by Wolfgang Meuslin, of the Twenty-third Psalm. Both the Epistle and the Gospel for *Misericordias Domini* have to do with sheep gone astray and with the Good Shepherd.

The Cantata opens with a festive chorus based on the chorale "Allein Gott in der Höh sei Ehr," a melody that appears in varied form in other movements as well. The second movement ("He leadeth me beside the still waters"), for alto and oboe d'amore, flows with a steady, reflective pace that conveys the calm assurance of the text. In the recitative for bass that follows ("Yea, though I walk through the valley of the shadow of death") the thematic interplay, heard now in the voice, now in the instrumental continuo, may suggest, as the noted Bach scholar Alfred Dürr observes, that the wanderer has not been abandoned. The fourth movement ("Thou preparest a table before me"), a duet for soprano and tenor, is a cheerful bourrée that celebrates God's care for man.

1 Page 1 from Johann Sebastian Bach, Cantata 112, 1731

*Creation*, engraving by Adriaen Collaert from a design
by Jan van der Staet, folio 3 of *Encomium Musices*, ca. 1590

The Cantata ends with the usual chorale, although here the second horn is given—atypically—an independent melodic line.

In addition to this Cantata, the Morgan Library houses the only extant portion of the autograph score of Cantata 197a, *Ehre sei Gott in der Höhe;* partly autograph orchestral parts for Cantata 9, *Es ist das Heil uns kommen her;* and, on deposit, the autograph manuscript of Cantata 171, *Gott, wie dein Name, so ist auch dein Ruhm.* For Bach's last surviving letter, see VIII, 2.

2 ❧

JOHANN SEBASTIAN BACH

Autograph letter signed, dated Leipzig,
2 November 1748, to Johann Elias Bach
in Schweinfurt. Mary Flagler Cary Music
Collection.

Of the fifty-seven letters Bach (1685-1750) is known to have written, only twenty-nine are in his hand. This letter to his cousin Johann Elias Bach, written from Leipzig on 2 November 1748, is one of only two Bach letters in this country, and is the last surviving letter in his hand. In it, he expresses regret that the distance between Schweinfurt and Leipzig will no doubt prevent his cousin from attending the marriage of Johann Sebastian's daughter Liessgen to Mr. Altnickol, the new organist in Naumburg.

Bach married twice: there were seven children from the first marriage, and thirteen from the second. Elisabeth Juliane Friederica, known as Liessgen ("Lizzy"), born in 1726 and died in 1781, was the fourth daughter from Bach's second marriage. Her wedding to Altnickol took place on 20 January 1749 in the Thomaskirche in Leipzig, where Bach held the position of Kantor. Bach was sixty-three years old and beginning to lose his eyesight when he wrote this letter.

2 Pages 2 and 3 from Johann Sebastian Bach to his cousin, 2 November 1748

While perfectly legible, it shows some signs of the stiff and cramped handwriting of his last years. Unlike most of his letters, which deal with professional and official duties, this one offers us a rare glimpse of his family life, and, as the following postscript shows, an example of his gentle sense of humor.

Bach thanks his cousin for his present of a cask of wine—which arrived nearly two-thirds empty—but, in a postscript, declines an offer for more of the liqueur "on account of the excessive expenses here. For since the carriage charges cost 16 groschen, the delivery man 2 groschen, the customs inspector 2 groschen, the inland duty 5 groschen, 3 pfennig, and the general duty 3 groschen, my honored cousin can judge for himself that each quart costs me almost five groschen, which for a present is really too expensive."

3 ❧

JOSEPH HAYDN

Symphony no. 91 in E-flat Major. Autograph manuscript, 1788. Mary Flagler Cary Music Collection.

Among the celebrated concert organizations active in Paris in the 1780s was the Concert de la Loge Olympique. One of its directors was the comte d'Ogny, a wealthy French aristocrat, who commissioned Haydn's famous Paris symphonies (nos. 82-87), composed in 1785 and 1786. A few years later, encouraged by the great success of the symphonies, d'Ogny commissioned three more (nos. 90-92). The Symphony no. 91 was composed in 1788, and is dedicated to d'Ogny. At about the same time a German patron, Prince Öttingen-Wallerstein,

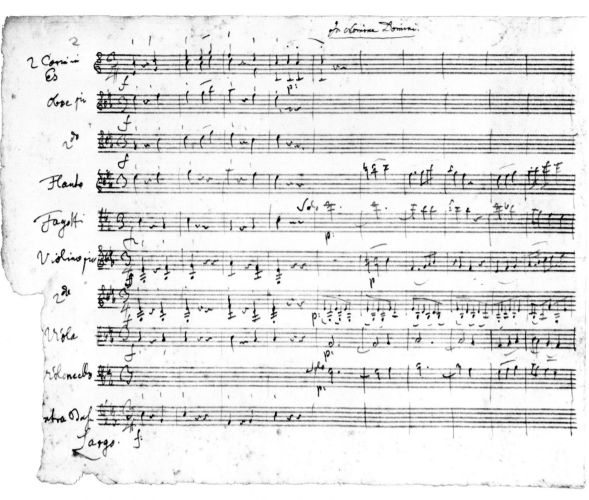

3  Page 1 from Haydn, Symphony no. 91 in E-flat Major, 1788

had also requested three new symphonies. Haydn (1732-1809), always the astute businessman, promptly complied by sending the same works to him. Haydn wrote over one hundred symphonies, a prodigious output spanning more than forty years.

By the 1770s, Haydn's music had become extremely popular in France. But because copyright laws as we know them did not exist, Haydn made no money from the many works of his published and performed in Paris. In fact, French publishers were so eager for his compositions that they simply passed off the works of countless minor composers as Haydn's own, at times simply erasing names from already engraved title pages and substituting Haydn's name. Between 1775 and 1780, more spurious than genuine works by Haydn were published in France. But many works

heard in the French capital *were* by Haydn, and were received with great acclaim. In September 1779, the *Mercure de France*, the leading French journal of its day, reported on a Concert Spirituel, the most famous and important concert series in Paris. It opened with a Haydn symphony that, according to the report,

was much applauded, and which deserved to be: noble and passionate, always graceful, always varied: the genius of this composer seems indeed inexhaustible. Among the large number of works he has published not one resembles another; each has its distinctive character; and yet as often as not one knows Haydn only by his minuets. He even seems to possess the secret of enlivening the musicians; the orchestra appears to delight in him and to identify itself with him; he is never more engaging than in the performance of his masterworks.

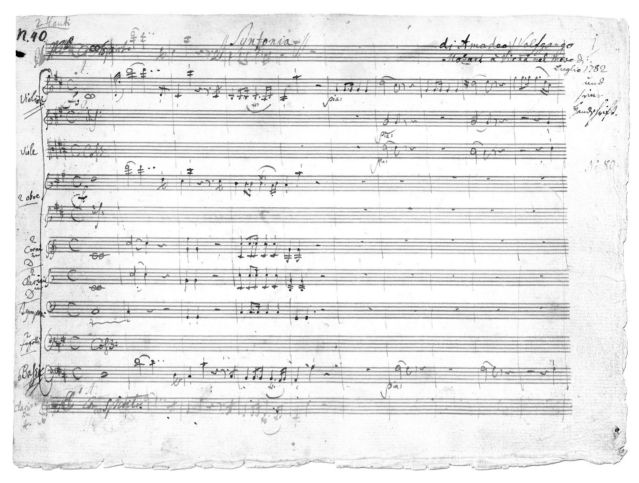

4  Page 1 from Mozart, Symphony in D Major, K. 385 *(Haffner)*, 1782

## 4 ??

### Wolfgang Amadeus Mozart

Symphony in D Major, K. 385 *(Haffner)*. Autograph manuscript, 1782. Mary Flagler Cary Music Collection.

The *Haffner* Symphony by Mozart (1756-91) is among the most famous symphonies of the eighteenth century and is one of the greatest musical treasures in the Morgan Library. The *Haffner* began as music written at the request of Mozart's father, in the summer of 1782, to accompany festivities in Salzburg at the ennoblement of Sigmund Haffner, a childhood friend of the composer's. In December 1782, finding himself in need of a new symphony, Mozart asked his father to return the manuscript of the Haffner music to him in Vienna. He discarded an introductory march and (pos-sibly) one of the two minuets and added flutes and clarinets to the first and last movements. The result, as he wrote to his father, was that "my new Haffner symphony has positively amazed me, for I had forgotten every single note of it. It must surely produce a good effect." The four-movement *Haffner* Symphony was performed at Mozart's first public concert in Vienna, on 23 March 1783, with Emperor Joseph II in attendance.

The manuscript of the *Haffner* Symphony remained in Mozart's possession until his death, in 1791, and was among those items sold by his widow, Constanze, to the music publisher Johann Anton André in 1799. After André's death, in 1842, it passed to his son Julius from whom, in 1864, it was purchased by Karl Mayer Rothschild, the Bavarian consul general in Frankfurt. In August 1865, Rothschild presented it to King Ludwig II of Bavaria on the

occasion of his twentieth birthday. When Ludwig died, in 1886, the manuscript passed to the Wittelsbach Trust, in Munich (Wittelsbach was the Bavarian royal house). It was purchased from the trust in the 1930s, smuggled out of Germany in 1936, and offered for sale in New York. Mary Flagler Cary bought the manuscript in 1940 and gave it to the National Orchestral Association, which she had founded ten years before. With funds generously provided by the Mary Flagler Cary Charitable Trust, the Morgan Library bought the manuscript from the National Orchestral Association in 1979.

The Morgan Library houses the finest collection of Mozart manuscripts in this country. In addition to the *Haffner* Symphony, there are autographs of the Piano Concerto in C Major, K. 467 (see VIII, 5); the Piano Concerto in D Major, K. 537 (*Coronation*); the concert aria *Misero! o sogno/Aura, che intorno spiri*, K. 431/425b; Cherubino's aria "Non so più cosa son" from *Le nozze di Figaro* in Mozart's arrangement for voice, violin, and piano; the Rondo for piano in D Major, K. 485; the comic opera *Der Schauspieldirektor* (The Impresario), K. 486; the Symphony in F Major, K. 112; and a manuscript, in Leopold's hand, of Mozart's earliest known compositions, K. 1a-d, four short keyboard works. On deposit are the autograph manuscripts of nine symphonies written in Salzburg in 1773 and 1774, the Piano Sonata in A Minor, K. 310, the Rondo for horn and orchestra in E-flat Major, K. 371, and the Fugue for two pianos, K. 426.

5 ❧

WOLFGANG AMADEUS MOZART

Piano Concerto in C Major, K. 467.
Autograph manuscript, 1785. Dannie and Hettie Heineman Collection.

Mozart (1756-91) wrote twenty-seven piano concertos. The early ones cannot, admittedly, be counted among his most distinguished works, although one can observe in them his artistic growth from a skillful adapter of other composers' compositions to a more mature and

*The Queen of the Night*, pen and watercolor design for Mozart's *The Magic Flute*, 1818, by Simon Quaglio. Gift of Mr. and Mrs. Donald M. Oenslager, 1982.75.524

technically assured artist. Beginning with the concerto in E-flat Major, K. 271 (*Jeune-homme*), he wrote a series of works that are among the sovereign masterpieces in the genre. As the noted pianist and writer Charles Rosen has observed, "Mozart's most signal triumphs took place where Haydn had failed: in the dramatic forms of the opera and the concerto, which pit the individual voice against the sonority of the mass."

Mozart apparently completed the great Piano Concerto in C Major, K. 467, in just four weeks. It was probably begun in mid-February 1785 and was finished by 9 March. For richness and diversity of melodic and motivic material, the first movement has few parallels among the concertos. In the outer movements the piano part makes formidable demands on the soloist's technique—the English writer C. M. Girdlestone calls one passage in the first movement "the thickest scrub of arpeggios and broken octaves that Mozart has ever set up before his executants"—but the virtuosity is always at the service of the music and never suggests self-indulgent display. Never, that is, so long as conductor and pianist choose a sensible tempo. The first movement is rare in Mozart's autographs in that it lacks a tempo direction. The first edition, published in 1800, prescribed "Allegro." For the true tempo marking we must go to the *Verzeichnüss aller meiner Werke*, the

catalogue Mozart kept of his works from 1784 until his death, where we find "Allegro maestoso." The sustained reverie of the second movement is justly famous, and has survived the myriad adaptations and transcriptions—including koto ensemble—to which it has latterly been subjected. It possesses the noble bearing of an aria from the later operas and of the late symphonic slow movement (the Andante cantabile of the *Jupiter* comes to mind).

6 &

Ludwig van Beethoven

Violin Sonata no. 10 in G Major, op. 96. Autograph manuscript, 1815. Purchased by Pierpont Morgan in 1907.

Beethoven (1770-1827) composed his first nine sonatas for violin and piano between 1797 and 1803. This is the autograph manuscript of the tenth, and last, of his violin sonatas, written in 1812, the year in which he completed the Seventh and Eighth symphonies. The sonata was written for Pierre Rode, the greatest French violinist of his day, and was first performed by Rode and Archduke Rudolph, to whom the work is dedicated. In late December 1812, a few days before the performance, Beethoven wrote to the archduke:

5  Page 1 from Mozart, Piano Concerto in C Major, K. 467, 1785

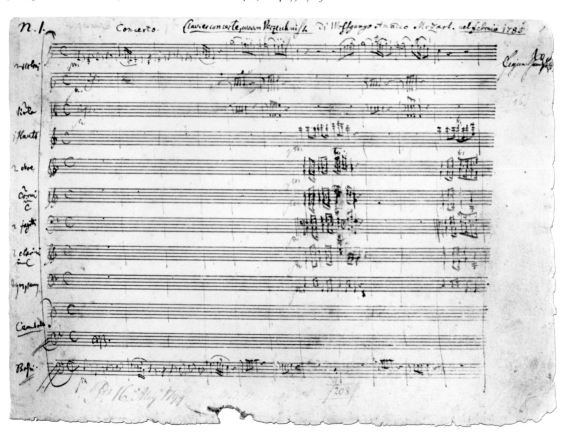

6 Page 1 from Beethoven, Violin Sonata no. 10 in G Major, op. 96, 1815

The copyist will be able to begin work on the last movement very early tomorrow morning. Since in the meantime I myself have been engaged on several other works, I have not hurried unduly to compose the last movement merely for the sake of being punctual, the more so as in view of Rode's playing I have had to give more thought to the composition of this movement. In our Finales we like to have fairly noisy passages, but R[ode] does not care for them—and so I have been rather hampered.

Despite Beethoven's having tailored the music to Rode's style, the violinist's skill had greatly deteriorated, and Beethoven expressed disappointment in the performance.

Although the sonata itself dates from 1812,

this manuscript was most likely written in early 1815 and transmits a revised version of the original work. When he made this copy Beethoven was unsure of when he had composed the sonata, and thus dated the manuscript "im Februar 1812 oder 13." The type of paper on which the sonata is written is very rarely found in Beethoven manuscripts; only thirty-three leaves are known, over half of them in the opus 96 autograph.

Pierpont Morgan bought this manuscript in Florence in 1907; it was the only major music manuscript he ever acquired and the first important Beethoven autograph to come to this country. In addition to this sonata, the Library owns the autograph manuscript of the Piano Trio op. 70, no. 1 (*Geister*), several of the *Schottische Lieder,* and sketches for the Piano Concerto no. 5 (*Emperor*), Piano Sonata op. 106 (*Hammerklavier*), String Quartet op. 95 (*Quartetto serioso*), and Piano Trio op. 97 (*Archduke*), as well as seven autograph letters and a manuscript leaf from Beethoven's kitchen account, with additions in his hand.

7 &

CARL MARIA VON WEBER

*Aufforderung zum Tanze.* Autograph manuscript, 1819. Mary Flagler Cary Music Collection.

Two entries in Weber's diary for 1819 record the composition of this piece. "July 23: Invitation to the Dance. D-flat Major. Draft completed." "July 28: Invitation to the Dance. Rondo for pianoforte. D-flat Major. Completed." In these brief entries Weber (1786-1826) noted the creation of his most famous composition for solo piano. It has been called an epoch-making work in the piano literature. Instantly successful, it has remained popular to the present day. Weber's series of exhilarating waltzes connected by more tranquil interludes, all in the form of a single-movement rondo, was without precedent. In this work, written in Weber's most brilliant pianistic idiom, can be traced the antecedents of Chopin's concert waltzes and of the waltz suites of Johann Strauss, Jr.

Weber dedicated *Invitation to the Dance* to his wife, the soprano Caroline Brandt. When Friedrich Wilhelm Jähns was compiling the first thematic catalogue of Weber's works, she told him that when Weber first played the work for her he provided a running commentary during the slow Introduction and Coda, describing the dancers' movements in almost balletic terms:

First approach of the dancer (bars 1-5) to whom the lady gives an evasive answer (5-9). His more pressing invitation (9-13: the grace note C and the long A flat are significant here); her actual acceptance of his request (13-16). They now converse in greater detail; he begins (17-19); she answers (19-21); he with heightened expression (21-23); she responds more warmly (23-25); now for the dance! His direct remarks concerning it (25-27); her answer (27-29); their coming together (29-31); their going forward; expectation of the beginning of the dance (31-35). The Dance. End: his thanks, her reply, and their parting. Silence.

Like many popular works, *Invitation to the Dance* has been arranged numerous times for other instruments, among them solo flute, zither, and two pianos, eight hands. It was orchestrated by Berlioz and performed as ballet music in his 1841 production of Weber's *Freischütz* in Paris. The work is probably best known today in this orchestral version. It is also familiar to the world of dance through *Le spectre de la rose,* the 1911 ballet by Diaghilev and Nijinsky.

The Library also has the autograph manuscript of an insert aria Weber wrote for the opera *Ines de Castro* (the composer has not yet been identified), and has on deposit the autograph of the Second Clarinet Concerto and sixty-two Weber letters.

8 &

FRANZ SCHUBERT

*Winterreise,* D. 911. Autograph manuscript of the song cycle, 1827. Mary Flagler Cary Music Collection.

In his "Reflections and Notes on My Friendship with Franz Schubert," published in 1858, Joseph Spaun wrote of his longtime friend Schubert (1797-1828):

For some time Schubert appeared very upset and melancholy. When I asked him what was troubling him, he would say only, "Soon you will hear and understand." One day he said to me, "Come over to Schober's today, and I will sing you a cycle of horrifying songs. I am anxious to know what you will say about them. They have cost me more effort than any of my other songs." So he sang the entire *Winterreise* through to us in a voice full of emotion. We were utterly dumbfounded by the mournful, gloomy tone of these songs, and Schober said that only one, "Der Lindenbaum," had appealed to him. To this Schubert

7  Page 1 from Weber, *Aufforderung zum Tanze,* 1819

replied, "I like these songs more than all the rest, and you will come to like them as well."

The twenty-four songs in *Winterreise,* settings of poems by Wilhelm Müller, form what many consider the greatest song cycle ever written. The songs did indeed cost Schubert considerable effort, evidence of which can be found in this manuscript, which actually consists of two separate documents. Part I, comprising the first twelve songs, is dated February 1827, and is a mixture of fair copies and heavily emended first versions. The twelve songs found in the second half of the *Winterreise* manuscript, the first of which is dated October 1827, are entirely in fair copy, and reveal none of the correc-

tions and revisions such as those found in the first half. Part I was published by Tobias Haslinger in January 1828; Part II, the proofs of which Schubert corrected on his deathbed, was announced for sale in December 1828, soon after the composer died, on 19 November.

In addition to *Winterreise,* the Morgan Library's Schubert collection includes his earliest known work, the Fantasie for piano four-hands, D. 1; *Erlkönig,* D. 328, and other songs; the String Quartet in D Minor, D. 810 (*Death and the Maiden*); the Rondo for violin and piano in B Minor, D. 895; the eight Impromptus for piano, D. 899 and 935; and *Schwanengesang,* D. 957.

8 Page 1 from Schubert, *Winterreise*, D. 911, folio 31, 1827

9 ॐ

HECTOR BERLIOZ

*Mémoires*. Part of the autograph manuscript of Chapter 26, 1830. The bequest of Sarah C. Fenderson.

Berlioz's memoirs, the main source for our knowledge of his life, are among the most moving, revealing, and without doubt most readable of any artist's. They were begun in 1848, largely completed by 1855, and first published (at his request) posthumously. They will consist, Berlioz (1803-69) wrote in the Preface, of "those things in my arduous and turbulent career which I believe may be of interest to lovers of art," and will "afford me the opportunity to give a clear idea of the difficulties confronting those who try to be composers at the present time, and to offer them a few useful hints." The *Mémoires* begin prosaically enough: "I was born on 11th December 1803 in La Côte Saint-André, a very small French town in the department of Isère between Vienne, Grenoble and Lyons." They end with a moving meditation on two motifs that sound in counterpoint throughout his book and his life: "Love or music—which power can uplift man to the sublimest heights? It is a large question; yet it seems to me that one should answer it in this way: Love cannot give an idea of music; music can give an idea of love. But why separate them? They are the two wings of the soul."

The page reproduced here describes the composition of the work by which Berlioz is probably still best known, the *Symphonie fantastique*:

Immediately after the composition of the *Faust* pieces [*Huit scènes de Faust*], and still under the influence of Goethe's poem, I wrote my Fantastic Symphony: very slowly and laboriously in some

Immédiatement après cette composition sur Faust et toujours sous l'influence du poëme de Goëthe, j'écrivis La Symphonie Fantastique, avec beaucoup de peine pour certaines parties, avec une facilité incroyable pour d'autres. Ainsi l'adagio (Scène aux champs) qui impressionne toujours si vivement le public et moi même, me fatigua pendant plus de trois semaines, je l'abandonnai et le repris deux ou trois fois ; la marche au supplice au contraire fut écrite en une nuit. J'ai néanmoins beaucoup retouché ces deux morceaux et tous les autres du même ouvrage pendant plusieurs années.

Le théâtre des Nouveautés s'étant mis depuis quelque temps à jouer des opéras comiques avait un assez bon orchestre dirigé par Bloc. Celui-ci m'engagea à proposer ma nouvelle œuvre aux directeurs de ce théâtre et à organiser avec eux un concert pour la faire entendre. Ils y consentirent, séduits uniquement par l'étrangeté du programme de la symphonie, qui leur parut devoir exciter la curiosité de la foule. Mais voulant obtenir une exécution grandiose j'invitai au dehors plus de quatre-vingt artistes qui, réunis à ceux de l'orchestre de Bloc, formaient un total de cent trente musiciens. Il n'y avait rien de préparé dans ce théâtre pour y disposer convenablement une pareille masse instrumentale ; ni la décoration nécessaire, ni les gradins, ni même les pupitres. Avec ce sangfroid des gens qui ne savent pas en quoi consistent les difficultés, les directeurs répondaient à toutes mes demandes à ce sujet : «Soyez tranquille, on arrangera cela, nous avons un machiniste intelligent.» Mais quand le jour de la répétition arriva, quand mes cent trente musiciens voulurent se ranger sur la scène, on ne sut où les mettre. J'eus recours à l'emplacement du petit orchestre d'en bas ; mais ce fut à peine si les violons seulement purent s'y caser. Un tumulte à rendre fou un auteur même beaucoup plus calme que moi éclata sur le théâtre. On demandait des pupitres ; les charpentiers cherchaient à confectionner précipitamment quelque chose qui pût en tenir lieu ; le machiniste jurait en cherchant ses fermes et ses portants ; on criait ici pour des

9  Page from chapter 26 of Berlioz, *Mémoires*, 1830

Caricature of Berlioz leading an orchestra in 1846 by Andreas Geiger, engraved by Cajetan. Bequest of Sarah C. Fenderson

parts, with extraordinary ease in others. The adagio (the Scene in the Country), which always affects the public and myself so keenly, cost me nearly a month's arduous toil; two or three times I gave it up. On the other hand, the March to the Scaffold was written in a night. But I continued to make considerable changes in both movements, and to the rest of the work, over the course of several years.

The Morgan Library owns nearly all of the surviving manuscript of the *Mémoires*–Chapters 12, 15-27, and 29, and parts of Chapters 28 and 30–and houses the largest collection of Berlioz letters outside France. Sarah C. Fenderson began collecting Berlioz's letters, books, and printed music in the 1940s. Although she always characterized her feelings for Berlioz as an interest, not a passion, she quietly and methodically built one of the most celebrated private collections of Berlioz letters in the world. Her collection was bequeathed to the Morgan Library in 1989.

10 ஐ

MIKHAIL GLINKA

[*Zhizn' za tsarya.*] First edition of the full score of *A Life for the Tsar*, 1881. Mary Flagler Cary Music Collection.

This rare first edition of the full score of *A Life for the Tsar* by Glinka (1804-57) was published only in 1881, forty-five years after the opera's première, in St. Petersburg, on 9 December 1836. There had been little need for a published full score, since before the 1880s the opera was heard almost exclusively in St. Petersburg and Moscow, where for many years it opened the opera seasons. (The first volume of the piano-vocal score was published in 1856.) On 9 December 1896, the sixtieth anniversary of the première, the opera received its 660th performance in St. Petersburg.

In 1834, having contemplated for several years the writing of a national opera, Glinka

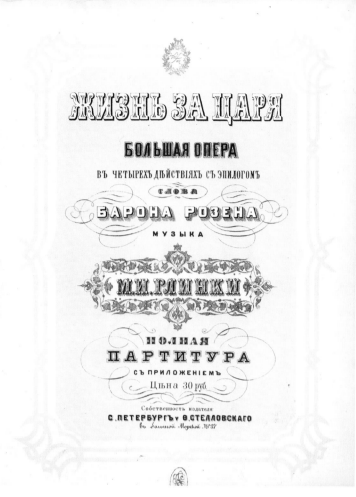

10 Title page from the first edition of Glinka, *A Life for the Tsar*, 1881

Signed photograph of Glinka, 1856
Gift of Mr. Janos Scholz

"came upon the idea for a Russian opera." He mentioned his plan to the poet Vasily Zhukovsky, who approved enthusiastically and suggested the subject of Ivan Susanin, the Russian peasant who, in 1612 or 1613, at the cost of his own life, had saved that of the first Romanov czar by diverting a group of Poles who were hunting him. Zhukovsky was but one of four persons who would eventually contribute to the libretto; most of the work fell to Baron Gregor Rosen, a writer of German extraction who was at that time secretary to the czarevitch (later Alexander II).

But Glinka's imagination "soon ran ahead of the industrious German; as if by an act of magic the plan of the whole opera was suddenly formed.... Many themes and even details of their workings flashed into my head at once. I began to work, but completely haphazardly—to wit, I began with the overture, with which others finish." Glinka had, in fact, completed most of the first two acts before Rosen was

11 Page 1 from Chopin, Polonaise in A-flat Major, op. 53, 1842

finally called upon to rewrite the libretto, fitting his text to music already composed. "Zhukovsky and others used to say jokingly that Rosen had lines already written and distributed among his pockets, and that all I had to do was to say what meter I needed, and how many lines, and he would take out as many of each sort as were required—each variety from a different pocket."

Rehearsals began in the spring of 1836 under the direction of Catterino Cavos, a Russianized Italian who, in 1815, had himself composed an opera, *Ivan Susanin*. Shortly before the première, Nicholas I attended a rehearsal and soon afterward granted Glinka permission to dedicate the work to him—requesting, at the same time, that the title be changed to *A Life for the Tsar*. (The historical czar of the opera was the founder of Nicholas's own dynasty.) After the 1917 Revolution the title reverted to *Ivan Susanin;* the libretto has since been completely rewritten.

11 ❧

FRÉDÉRIC CHOPIN

Polonaise in A-flat Major, op. 53. Autograph manuscript, 1842. Dannie and Hettie Heineman Collection.

The classic polonaise originated in Poland at the beginning of the nineteenth century. Many composers wrote polonaises—among them Beethoven, Schubert, Weber, Liszt, Mussorgsky, and Tchaikovsky—but Chopin's are by far the best known, and for many they define the genre. Chopin (1810-49) made the national dance a symbol of heroism and chivalry, and the A-flat Polonaise is the most overtly patriotic of his works. It was written in the summer of 1842 when the composer was living with the novelist George Sand at Nohant. Few pianists since have ventured to omit it from their repertory. We have Chopin's own words on how the work should *not* be performed (and how

Chopin himself played one of its more challenging passages). Sir Charles Hallé, the English pianist and conductor, wrote in his autobiography: "I remember how, on one occasion, in his gentle way he [Chopin] laid his hand upon my shoulder, saying how unhappy he felt, because he had heard his 'Grande Polonaise' in A flat *jouée vite!* [played fast], thereby destroying all the grandeur, the majesty, of this noble inspiration." And Adolf Gutmann, once described as Chopin's favorite pupil, if hardly his best, said that Chopin "could not thunder forth" the Polonaise "in the way we are accustomed to hear it. As for the famous octave passages which occur in it, he began them *pianissimo* and continued thus without much increase in loudness."

Chopin sent this manuscript to Breitkopf & Härtel in Leipzig in October 1843; the Polonaise was published by Breitkopf, and later that year, by Maurice Schlesinger in Paris. The manuscript shown here once belonged to the pianist and composer Clara Schumann, wife of Robert Schumann.

In addition to the Polonaise, the Library has, among other works, the autographs of the Etude in C Major, op. 10, no 7, the Mazurkas op. 50, the Mazurka op. 59 no. 3, and the Polonaises op. 26; manuscripts on deposit include the Etude in E Major, op. 10, no. 3, the Piano Sonata no. 1 in C Minor, the full score of his variations on "La cì darem la mano," op. 2, and a nearly complete draft of the Etude in F Minor, op. 10, no. 9.

12 ❧

GIUSEPPE VERDI

*Aida*. Milan: Ricordi, 1872. First edition of the libretto for the first performance in Italy, with Verdi's stage directions for the first three acts. Mary Flagler Cary Music Collection.

The première of *Aida* by Verdi (1813-1901) (which the composer did not attend) was on 24 December 1871 in Cairo. It was by all accounts a great success. The second performance took place on 8 February 1872 at La Scala, in Milan. Verdi, as usual, oversaw all aspects of the performance, including the *mise-en-scène*, or staging. He then went to Parma, where he supervised a production on 20 April. It was for this performance that Verdi annotated the libretto shown here, in which he has sketched

12 Pages 28 and 29 from Verdi, *Aida* libretto, 1872

out his staging for the first three acts, specifying in detail the singers' placement, movement, and even gestures. The Verdi scholar Julian Budden observes that "since most of the instructions are carried over word for word into the production book published by Ricordi" in 1873, it is "likely that they were first jotted down during rehearsals for the Italian première, and merely served the composer as an aide-memoire for the Parma performance."

Contrary to popular belief, *Aida* was not composed for the opening of the Suez Canal. The Khedive of Egypt planned to inaugurate a new opera house in Cairo as part of the celebrations surrounding the opening of the canal, on 17 November 1869, and asked Verdi to write an ode in honor of the occasion. Verdi declined (the opera house opened, on 1 November, with his *Rigoletto*), but the Khedive, largely through the celebrated Egyptologist Auguste Mariette, pursued his hopes for a work by Verdi. Mariette sent a synopsis of the Aida story to Camille Du Locle, co-librettist (with Joseph Méry) of Verdi's *Don Carlos;* Du Locle, encouraged by the Khedive's appeals, eventually persuaded Verdi to set the story. Du Locle wrote a prose libretto, in French, based on Mariette's draft. "Now we must think about the libretto, or, to be more precise, about writing the verses since verses are all that are required," Verdi wrote to the publisher Giulio Ricordi in June 1870. "Would Ghislanzoni be able or willing to do this job? It wouldn't be original work, make that quite clear to him; just a matter of writing the verses, which—let me tell you—will be very generously paid."

Antonio Ghislanzoni began work on the verses in mid-July; his collaboration with Verdi can be traced in an important series of letters from composer to librettist, nearly half of which are now in the Morgan Library. It is clear from the correspondence that Verdi took an active part in the final shaping of the libretto. Composition of the opera proceeded very quickly, for by November 1870 Verdi's wife, Giuseppina, reported that the work was complete. Verdi continued to revise the score for nearly a year.

Among the Verdi materials in the Library are several important music manuscripts, including an insert aria for Nicola Ivanoff to sing in *Ernani;* the autograph libretto of *Ernani* and over two hundred Verdi letters are on deposit.

## 13 ❧

### RICHARD WAGNER

*Die Meistersinger von Nürnberg.* Autograph manuscript of the 1862 version of the libretto. The gift of Arthur A. Houghton, Jr., in honor of the Fiftieth Anniversary of the Morgan Library.

In July 1845, while on a rest cure at the Bohemian town of Marienbad, Wagner (1813-83) wrote the first prose draft of what would become *Die Meistersinger von Nürnberg.* He did not return to the project for sixteen years. He wrote a second and third prose scenario in mid-November 1861; the poem itself was completed between 25 and 31 January 1862 in Paris. On 25 September, Wagner sent a fair copy of the libretto to the publisher Schott, and it is this state of the libretto that is preserved in the Morgan manuscript.

In October 1861 he had proposed to Schott the scheme for a popular comic opera of modest scale that, unlike *Tristan und Isolde* (completed in 1859), would not call for an outstanding tenor or for a great tragic soprano. As it turned out, however, *Die Meistersinger von Nürnberg* called for a tenor and soprano of the first order, included a bass-baritone role that is among the most taxing in the repertory, was the longest opera ever written, and, when published, the largest score yet printed. The opera was completed on 24 October 1867; in the twenty-two years since the Marienbad draft, Wagner had composed *Lohengrin, Das Rheingold, Die Walküre,* two-thirds of *Siegfried,* all of *Tristan und Isolde,* and had prepared the Paris version of *Tannhäuser.* The Morgan manuscript was once owned by Kaiser Wilhelm II, who, according to a long-standing story, showed it to Pierpont Morgan and George Clifford Thomas, a Philadelphia banker and philanthropist. Both men admired the document and Wilhelm (so the story goes) offered it as a gift to one of them—to be decided by the toss of a coin. Thomas won. Dr. A. S. W. Rosenbach, the noted Philadelphia bibliophile and dealer, acquired the libretto from the Thomas estate sometime after 1909, and in 1951 it was purchased from the Rosenbach firm by Arthur A. Houghton, Jr., who gave it to the Morgan Library in 1974.

The Library also has Wagner's own interleaved copy of the first printing of the libretto of *Der Ring des Nibelungen,* with extensive changes and corrections in his hand on the interleaved pages, and about one hundred let-

Ei, 's ist mir nur um den Lehrbuben leid:
der verliert mir allen Respect;
die Lene macht ihn schon nicht recht gescheit,
dass er Töpf' und Teller er leckt!
Wo Teufel er jetzt wieder steckt?
(Er stellt sich als wolle er nach David sehen.)

(Hält Sachs, und zieht ihn von Neuem an sich.)
O Sachs! Mein Freund! Du theurer Mann!
Wie ich der Edlen lohnen kann!—
Was ohne deine Liebe,
was wär' ich ohne dich,
ob je auch Kind ich bliebe,
erwecktest du nicht mich?
Durch dich gewann ich
was man preist,
durch dich ersann ich
was ein Geist!
Durch dich erwacht',
durch dich nur dacht'
ich edel, frei und kühn:
du ließest mich erblühn!—
O lieber Meister! schilt mich nur!
Ich war doch auf der rechten Spur:
denn, hatte ich die Wahl,
nur dich erwählt' ich mir:
du warest mein Gemahl,
den Preis nur reicht' ich dir!—
Doch nun hat's mich gewählet
zu nie gekannter Qual:
und werd' ich heut' vermählet,
so war's ohn' alle Wahl!
Das war ein Müssen, war ein Zwang!
Euch selbst, mein Meister, wurde bang.

Sachs.
Mein Kind:
von Tristan und Isolde
kenn' ich ein traurig Stück:
Hans Sachs war klug, und wollte
nichts von Herrn Marke's Glück.—
's war Zeit, dass ich den Rechten erkannt:
wär' sonst am End' doch hineingerannt.—
Aha! da streicht schon die Lene um's Haus.
Nun herein!—He, David! Kommst nicht heraus.

(Magdalene, in festlichem Staate, tritt durch die Laden-
thüre herein; aus der Kammer kommt zugleich David,
ebenfalls im Festkleid, mit Blumen und Bändern sehr
reich und zierlich ausgeputzt.)
Die Zeugen sind da, Gevatter zur Hand:
jetzt schnell zur Taufe! Nehmt euren Stand!
(Alle blicken ihn verwundert an.)
Ein Kind ward hier geboren:
jetzt sei ihm ein Nam' erkoren!
So ist's nach Meister Weis' und Art,
wenn eine Meisterweise geschaffen ward:
dass die einen guten Namen trag',
dran Jeder sie erkennen mag.

13  Page from the libretto of the 1862 version of Wagner, *Die Meistersinger von Nürnberg*

Siegfried and the Rhinemaidens, photograph of Josef Hoffmann's painting of
the set design for the first performance of Wagner's *Ring des Nibelungen*, 1876
Mary Flagler Cary Music Collection

14  Page 9 from the fourth movement of Brahms, Symphony no. 1 in C Minor, op. 68, 1876

ters. On deposit are the autograph manuscripts of two librettos: *Siegfried's Tod* (an early version of *Götterdämmerung*) and an early working draft of *Lohengrin*.

## 14 &

### JOHANNES BRAHMS

Symphony no. 1 in C Minor, op. 68.
Autograph manuscript of the full score
(first movement lacking), 1876.
Mary Flagler Cary Music Collection.

Brahms (1833-97) had a number of major orchestral works to his credit, including the First Piano Concerto, the two Serenades for orchestra, the Haydn variations, and the German Requiem, before he felt ready, at the age of forty-three, to release to the world his First Symphony. He began work on it in 1862—and possibly as early as 1855—but did not complete the composition until 1876. The pressure to produce a symphony—a genre held in the highest regard by adherents to the classical tradition—was daunting; in the early 1870s, Brahms wrote to his friend Hermann Levi, "I will never compose a symphony! You have no idea how much courage one must have when one hears marching behind him such a giant [as Beethoven]."

The symphony was first performed on 4 November in Karlsruhe, with Brahms's friend Otto Dessoff conducting from this manuscript. The Karlsruhe première was followed by performances in other German cities—reviews were mixed, on the whole more favorable than not—and, in 1877, by three performances in England. But the extensive program notes written by Sir George Macfarren for the performance in Cambridge in March 1877 quote several measures of music that would be unfamiliar to today's audiences. With the help of those program notes, and other, recently discovered sources, the original reading of the second movement can be partly reconstructed. Brahms continued to revise the symphony before submitting it to his publisher Simrock and at some point wrote out a clean copy of the new second movement.

The Morgan manuscript contains the full score of the second, third, and fourth movements; the autograph of the first movement does not survive.

The Morgan Library houses one of the two finest collections of Brahms manuscripts in this country; in addition to the First Symphony the Library has the manuscript of his arrangement for piano four-hands of his String Sextet no. 1 in B-flat Major, op. 18, the Sonata for 2 pianos in F Minor, op. 34b, the Hungarian Dances for piano four-hands, WoO 1, and several songs, including *Botschaft*, op. 47, no. 1, and *Dämmrung senkte sich von oben*, op. 59, no. 1. Among other works on deposit is the autograph manuscript of the Second Symphony.

Drypoint portrait of Gustav Mahler by Emil Orlik
Purchased as the gift of the Ann and Gordon
Getty Foundation

## 15 &

### GUSTAV MAHLER

Symphony no. 5. Autograph manuscript
of the full score, 1901-2. Mary Flagler Cary
Music Collection.

The Fifth Symphony by Gustav Mahler (1860-1911), composed in 1901 and 1902, was first performed on 18 October 1904 in Cologne. This symphony, observes Deryck Cooke, the English writer,

marks the beginning of Mahler's full maturity, being the first of a trilogy of "realistic," purely instrumen-

15 Page 43 of the first movement of Mahler, Symphony no. 5, 1901-2

tal symphonies—Nos. 5, 6, and 7—which occupied him during his middle period. The programmes, the voices, the songs, and the movements based on songs have gone; and the delicate or warm harmonic sonorities which formerly brought relief from pain have been largely replaced by a new type of naked contrapuntal texture, already foreshadowed in parts of the Fourth Symphony, but now given a hard edge by the starkest possible use of the woodwind and brass.

Writing to his wife, Alma, after the first rehearsal two days before, Mahler reports:

It all went off tolerably well. The Scherzo is the very devil of a movement. I see it is in for a peck of troubles! Conductors for the next fifty years will all take it too fast and make nonsense of it; and the public—Oh, heavens, what are they to make of this chaos of which new worlds are for ever being engendered, only to crumble in ruin the moment after? What are they to say to this primeval music, this foaming, roaring, raging sea of sound, to these dancing stars, to these breath-taking, iridescent and flashing breakers? . . . Oh that I might give my symphony its first performance fifty years after my death!

But Mahler was never satisfied with the orchestration of the Fifth, and revisions of the symphony occupied him for the rest of his life. On 8 February 1911, just over three months before his death, he wrote in one of his last letters: "I have finished my Fifth—it had to be

almost completely re-orchestrated. I simply can't understand why I still had to make such mistakes, like the merest beginner. (It is clear that all the experience I had gained in writing the first four symphonies completely let me down in this one—for a completely new style demanded a new technique.)"

The Morgan Library houses the most important collection of Mahler manuscripts.

16 ఎ

RICHARD STRAUSS

*Acht Lieder,* op. 10. Autograph manuscript of the songs, 1885. Mary Flagler Cary Music Collection.

Although Strauss (1864-1949) had written many songs before them, his eight songs, op.

16  Page of Richard Strauss, *Allerseelen* from *Acht Lieder,* op. 10, 1885

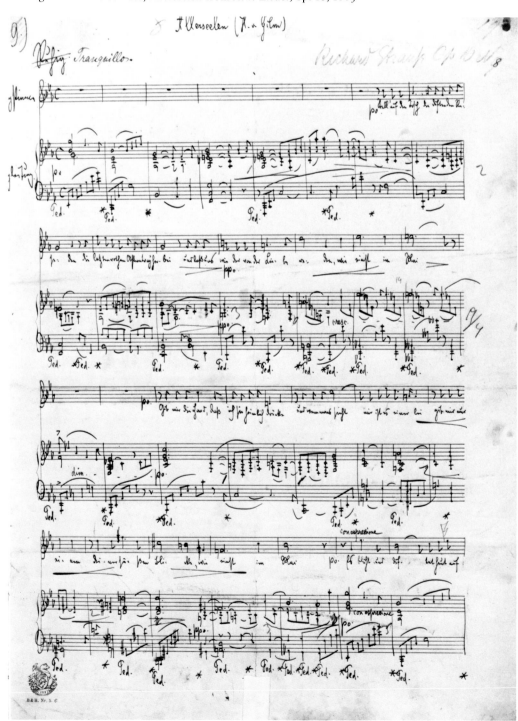

10, are generally regarded as the true beginning of his lieder-writing career. Composed between August and November 1885 to texts by the Tyrolean poet Hermann von Gilm, they were Strauss's first published songs. Three of them — *Zueignung* (Dedication), *Die Nacht* (Night), and *Allerseelen* (All Souls) — are world-famous. Strauss's father, Franz, asked him to dedicate the new songs to Johanna Pschorr, the composer's aunt, for whom most of his early lieder were written. But the opus 10 songs were written for tenor — although they are often sung by sopranos — and were dedicated instead to Heinrich Vogl, a tenor at the Munich Opera.

Although eight songs were published, there are nine in this manuscript; the sixth song, *Wer hat's gethan?* (Who has done it?) was rejected — whether by Strauss or by the publisher Joseph Aibl, and for what reason, is not known. There is no mention of the song in Strauss's correspondence with Aibl, and the composer never included it in later volumes of his songs. Perhaps Aibl was unhappy with nine songs (rather than, say, eight or ten) in one opus, and persuaded Strauss to omit one. And it has been conjectured that *Wer hat's gethan?* was dropped because unlike the other eight songs — and indeed unlike nearly all of Strauss's songs before the very late ones — it has an unusually long postlude for the piano that makes up nearly one-third of the song's length. Whatever the reason for excluding the song, it remained unknown for nearly a century, and was first published only in 1974.

In addition to these songs, the collection includes the autographs of *Don Juan* and *Tod und Verklärung*, two sketchbooks for *Die ägyptische Helena*, his arrangement for voice, harp, horns, and strings of *Morgen* (op. 27, no. 4), and over sixty letters. The manuscripts of *Aus Italien* and *Macbeth*, the Serenade for 13 winds, op. 7, the Lieder op. 27, and *Malven*, Strauss's last song, are on deposit.

17 ❧

ARNOLD SCHOENBERG

*Gurrelieder.* Autograph manuscript, 1911.
Mary Flagler Cary Music Collection.

*Gurrelieder,* his first great unqualified success, occupied Schoenberg (1874-1951) intermittently for over a decade. It was written between March 1900 and March 1901; the orchestration was begun in 1901, continued in 1902 and 1903, then put aside until 1910, and finally

Self-portrait of Schoenberg in black chalk
Gift of Mr. Robert Owen Lehman, 1969.21

completed in 1911. The first performance took place in Vienna on 23 February 1913. The vocal and instrumental requirements of the work are so large — six soloists, four choruses, and an orchestra of about 150 — that Schoenberg had to order special forty-eight-stave music paper for this manuscript. But despite such enormous forces, much of the score, like so many passages in Wagner's later operas (to which *Gurrelieder* is often indebted), is notable as much for its delicate, chamber-music textures as for its massed sonorities. The text of *Gurrelieder* (Songs of Gurre) is a cycle of poems by Jens Peter Jacobsen.

Five days after the première, Schoenberg's old friend David Josef Bach wrote in the *Arbeiter-Zeitung* that when the work ended

the audience's emotion erupted into an ovation lasting a quarter of an hour. This was genuine rejoicing, even if one or other member of the public may have introduced a jarring note of snobbery. What does it matter? Schoenberg has thirsted for recognition long enough; one may allow him to swallow a drop of harmless poison along with the honey of success.

And in the Berlin periodical *März*, Richard Specht reported that after the performance

a number of young people, complete strangers, came up to me, their cheeks glowing with shame, and confessed that they had brought along house-keys,

17  Page 74 from Schoenberg, *Gurrelieder*, 1911

in order to supplement Schoenberg's music by additions of a kind they had thought appropriate [whistling on keys was an established Viennese way of expressing public displeasure]; now they had been so completely converted to him that nothing could break their allegiance. Their shame and regret were the finest triumph that could have been desired by this artist who painfully wrestles, and who unflinchingly takes upon him all the sorrows of the conquistador.

The Library also possesses the autograph of the monodrama *Erwartung*, an early draft of Act I and part of Act II of the opera *Moses und Aron*, and forty-four Schoenberg letters. The manuscript of the Chamber Symphony op. 9 is on deposit.

18 ❦

IGOR STRAVINSKY

*Perséphone*. Autograph manuscript of the short score, 1936. Mary Flagler Cary Music Collection.

*Perséphone* was commissioned in 1933 by Ida Rubinstein, a dancer, actress, and wealthy patroness for whom Stravinsky (1882-1971) had written *Le baiser de la fée* in 1928. It was proposed that he make a musical setting of an early poem by André Gide based on the Homeric hymn to Demeter. (Demeter was the Greek goddess of fertility; her daughter, Persephone, was both queen of the underworld and goddess of the reviving crops.) The collaboration was not an entirely happy one. Stravinsky reports that when he first played the music to Gide at Mme Rubinstein's, Gide would only say "c'est curieux, c'est très curieux." He was displeased with Stravinsky's syllabic treatment of his text and felt that it violated his strongly held views on the nature of French prosody. According to Stravinsky, Gide "had expected the Perséphone text to be sung with exactly the same stress he would use to recite it. He believed my musical purpose should be to imitate or underline his verbal pattern: I would simply have to find the pitches

18  Page 1 from Stravinsky, *Perséphone*, 1936

Pencil sketch of Stravinsky made by Benedikt Fred Dolbin
during a rehearsal of *The Rake's Progress*, 1953. Gift of
Mrs. John H. Steiner, 1978.43

for his syllables, since he considered he had
already composed the rhythm. The tradition of
*poesia per musica* [poetry written for music]
meant nothing to him."

Stravinsky more than once expressed doubts
concerning what we might today call the multi-
media nature of *Perséphone*—the use of music
in context of other dramatic possibilities, such
as speech, solo and choral song, mime, and
dance. In particular it was the combination of
speech and music that he (and others) found
troublesome in the work. A year after the pre-
mière Stravinsky told an interviewer that he
preferred the work in concert rather than on
stage because the latter "involves too many
elements—scenographic, choreographic—that
dissipate the center of attention." (There is also
a problem of casting the title role, calling as it
does for a speaker-dancer—or, as the English

critic and musicologist Jeremy Noble puts it,
for "a diseuse who can dance or alternatively
a danseuse who can dise.") When asked many
years later how he felt about the use of music as
accompaniment to recitation, Stravinsky re-
plied, "Do not ask. Sins cannot be undone,
only forgiven."

In 1936, Stravinsky gave this short-score
manuscript of *Perséphone* to the Argentine au-
thor and editor Victoria Ocampo. He met her
that year, when she gave the French narration
of *Perséphone* at the Teatro Colón in Buenos
Aires. The manuscript is nearly complete; it
breaks off after the sixth measure of the last
number, "Ainsi vers l'ombre souterraine."

The Stravinsky collection at the Morgan Li-
brary is one of the two largest collections of the
composer's works in this country.

# IX THE GILBERT AND SULLIVAN COLLECTION

T HE FOURTEEN GILBERT AND SULLIVAN OPERAS, which were pro-
duced between 1871 and 1896, must be counted among the most characteristic and
enduring of Victorian institutions. Considering the enormous legacy the Victorian age has
left to following generations, it may seem surprising that the Savoy operas constitute
almost the totality of the living heritage of the British musical theater. But whereas the
fiction and poetry of the Victorian period can claim the works of Charles Dickens,
William Makepeace Thackeray, Anthony Trollope, George Eliot, Alfred Tennyson, and
countless others who are assured of places in posterity, the Victorian stage lives on, in a
popular sense, only in the plays of George Bernard Shaw and Oscar Wilde, and a few
works by such once-esteemed but now less well-known dramatists as Arthur Wing Pinero
and Henry Arthur Jones. And Victorian music and opera, notwithstanding their historical
interest, have paled beside the music of the Continental composers—Brahms, Wagner,
Verdi, Tchaikovsky, Dvořák, Bizet, and dozens of others whose music dominated nine-
teenth-century concert programs in Britain and North America. Only the Gilbert and
Sullivan operas can be compared happily with their European counterparts, the exuberant
and tuneful operettas of the likes of Strauss and Offenbach. In their melodic ingenuity,
vivacity, colorful settings, and cleverness of parody, the Savoy operas are as enchanting as
their Continental contemporaries; but in humor, cleverness with language, plot, strength
of characterization, dramatic consistency, musical sophistication, and integration of
music and words, the operas of Gilbert and Sullivan have had no equals.

The Library's Gilbert and Sullivan Collection is the most extensive archive of materials
relating to the lives and works of the dramatist William Schwenck Gilbert (1836-1911)
and the composer Arthur Seymour Sullivan (1842-1900). More than any other composer
and dramatist in Britain in their day, Gilbert and Sullivan were celebrities. Their well-
publicized lives fascinated contemporaries just as the subsequent documentation of their
lives continues to interest us. Sullivan, especially, enjoyed a privileged position in society
as well as the patronage and friendship of the royal family. He was active in every sphere
of music-making—conducting and performing as well as composing for the concert hall,
church, and theater alike. Gilbert, even before becoming Sullivan's librettist, was Britain's
most highly regarded dramatist. In his long career he came into contact with virtually
every important dramatist and theatrical performer of the time. The diversity of the two
men's activities in the pursuit of their professions, as well as in their private lives and wide
spheres of contact, is reflected in the depth and variety of the Library's holdings. Founded
by Reginald Allen, who brought his extraordinary collection to the Library in 1949 and
for many years served as its curator, the Gilbert and Sullivan collection has now grown to
several times its original size, through subsequent additions from Mr. Allen and other
donors, as well as purchases. Important items have also been given by Gilbert's adopted
daughter, the soprano Nancy McIntosh, and by Dame Bridget D'Oyly Carte, the grand-
daughter of Richard D'Oyly Carte, who produced nearly all of the Gilbert and Sullivan
operas and built London's Savoy Theatre expressly for their presentation.

Poster designed by Dudley Hardy for the revival
of *The Yeomen of the Guard*
by the D'Oyly Carte Opera Company, 1897

W. S. Gilbert                                          Arthur Sullivan

The Sullivan Archive, which was acquired in the early 1960s, consists of the composer's personal and business papers. It also contains many original literary, dramatic, and music manuscripts (including the autograph musical scores of three Gilbert and Sullivan operas, a fourth opera by Sullivan, and two operas by other composers for which Gilbert wrote the librettos); several thousand letters, mostly by and to Gilbert and Sullivan; thousands of early programs; an extensive collection of early printed editions of their works; and large numbers of original photographs, posters, playbills, ephemera, and memorabilia.

The collection is meant to serve not only as an archive, a repository for preserving all genres of original material relating to Gilbert and Sullivan, but as a center for the research and documentation of their personal and professional lives, especially of the bibliographic history of the printed editions of their works. Although, in its total of some seventy-five thousand individual items, nearly every possible connection is drawn to the Gilbert and Sullivan operas, the Library's collection concentrates on the productions and performances that took place under the direct supervision of the authors. In recent years the scope has been broadened to include manuscript and printed items relating to their closest and most important contemporaries.

The Gilbert and Sullivan collection is a valuable resource for conductors and stage directors, costume and set designers, and textual scholars and bibliographers. Owing, perhaps, to a heightened general awareness of and interest in Victorian music and theater, it is frequently consulted by writers and researchers, editors and publishers, and historians in diverse disciplines.

## H.M.S. PINAFORE SCORE

Arthur Sullivan. *H.M.S. Pinafore; or, The Lass That Loved a Sailor,* comic opera in two acts (1878). Libretto by W. S. Gilbert. Original autograph manuscript full score, [1878]. The gift of Arthur A. Houghton, Jr., 1987.

*H.M.S. Pinafore* was produced on Saturday, May 15, 1878, at the Opera Comique Theatre. Sullivan, who was as celebrated a conductor as a composer, led the first performance; thereafter the conductor's desk was occupied by the theater's musical director. More than any other opera, *H.M.S. Pinafore* was responsible for making Gilbert and Sullivan an English national institution. Their previous collaboration, *The Sorcerer,* had been popular enough to call for a successor, but it was considered such a novelty that it seemed to fall into no recognizable category. *H.M.S. Pinafore* solidified the genre that came to be known as Savoy opera (named for the theater built expressly for English comic opera) and its unprecedented popularity was such that the names of its creators, already known separately as the most popular and esteemed dramatist and composer then

1  *H. M. S. Pinafore,* full score autograph manuscript, 1878

alive in Britain, were seldom again to be thought of independently.

The illustration (page 128 of the manuscript) shows a portion of Sir Joseph Porter's famous self-introductory patter-song in Act I, "When I was a lad." Because the music was composed prior to late revisions in the libretto, the composer's manuscript reflects an early version of the words of the song: Sir Joseph (the "Ruler of the Queen's Navee"), who rose from humble beginnings, had originally apprenticed to a cotton broker, where "He took down the shutters and he swept the shop"; by the first night he had been "office boy to an attorney's firm," where "He polished up the handle of the big front door." Occasional markings in bold blue pencil bear witness to the use of this score in rehearsal and performance, and close examination reveals that it must have been used over many years and several productions. The manuscript includes an overture that was not present during the opera's long initial London run, but was added at the time of its official production in New York in 1879. Further, the score includes a version of the opera's conclusion that was performed only at its first revival, in 1887: amidst the patriotic fervor of Queen Victoria's jubilee year, the opera concluded with a chorus of "Rule, Britannia."

After Sullivan's death this score passed to his nephew, Herbert Thomas Sullivan. It remained in the family until 1966, when it was sold at an auction of many of Sullivan's manuscripts. The collection includes several other of Sullivan's important operatic scores, including the autographs of *Trial By Jury* (1875), *The Pirates of Penzance* (1879), and his first opera, *Cox and Box* (1866), as well as the original manuscripts of several dozens of his other works—together comprising the largest collection of manuscripts of the greatest of Victorian composers.

2 ❧

PIRATES OF PENZANCE LIBRETTO

William Schwenck Gilbert. *The Pirates of Penzance; or, The Slave of Duty*, comic opera in two acts (1879). Music by Arthur Sullivan. Autograph manuscript libretto, [1879]. Purchased as part of the Sullivan Archive, 1963.

*The Pirates of Penzance* stands alone among the Gilbert and Sullivan operas in that its first production took place in New York rather than in London. Late in 1879, Gilbert and Sullivan sailed to New York to produce a definitive

*H.M.S. Pinafore* in answer to innumerable unauthorized versions that had been presented to American audiences in more or less distorted form (and had returned none of the considerable profits to the authors). They also determined to produce a new opera first in America, and thereby forestall an otherwise inevitable repetition of these depredations.

*The Pirates of Penzance* was first performed at New York's Fifth Avenue Theatre on New Year's Eve, 1879. Sullivan conducted the first performance, and in the weeks that followed he and Gilbert prepared and launched several touring companies that took the opera to almost every city of any size in the United States and Canada. It was not until the opera had run its course in New York that it was first seen in London, at the Opera Comique Theatre on 3 April 1880. Although the opera has been dismissed as "Pinafore transferred to dry land," both Gilbert and Sullivan thought it superior to its nautical predecessor, and audiences over the years seem to have enjoyed the two operas equally. The illustration (page 27 of the manuscript) shows a portion of the finale of Act I, including the unaccompanied mock anthem "Hail, poetry," which gives an early intimation of the cultivated upbringing of the pirate clan, who, it is at last revealed, are "all noblemen who have gone wrong."

Of all of the Gilbert and Sullivan operas, the Library's archive is most comprehensive for *The Pirates of Penzance*: in addition to the autograph libretto, early programs, posters, photographs, and printed editions, it contains corrected proof copies of the libretto and vocal score, a rare pre-publication printed libretto, and a specially bound copy of the vocal score inscribed by Sullivan to Queen Victoria. There are three manuscript scores of the opera—Sullivan's original autograph and two copies, one in the hand of Alfred Cellier, Carte's musical director and Sullivan's close friend, the other in that of George Baird, a violist who for several decades was Carte's regular music copyist. These copies were probably made in New York and used by the early touring companies.

The presence of this manuscript libretto among Sullivan's papers suggests that this copy was used when he composed the score. The Sullivan Archive comprises one of the most comprehensive collections of the personal and professional papers of any composer. The bulk of the archive consists of Sullivan's correspondence—letters he received and file copies of his own letters. It also includes several volumes of his diaries, albums, family documents, his will,

27

**Gen.**

He is telling a terrible story,
But it doesn't diminish my glory,
For they would have taken my daughters
Over the billowy waters
If I hadn't, in elegant diction,
Indulged in an innocent fiction,
Which is not in the same category
As a regular terrible story.

**Ensemble.**

**Girls, aside**

He is telling a terrible story
Which will tend to diminish his glory.
Though they would have taken his daughters
Over the billowy waters
It's easy in elegant diction
To call it an innocent fiction.
But it comes in the same category
As a regular terrible story.

**Pirates, aside:**

If he's telling a terrible story
He shall die by a death that is gory
One of the cruellest slaughters
That ever were known in these waters.
And we'll finish his moral affliction
By a very complete malediction
As a compliment valedictory
If he's telling a terrible story!

**King**

Although our dark career
Sometimes involves the crime of stealing,
We rather think that we're
Not altogether void of feeling.
Although we live by strife,
We're always sorry to begin it,
And what, we ask, is life
Without a touch of poetry in it?

**All, kneeling**

Hail, poetry, thou heaven-born maid!
Thou gildest e'en the Pirate's trade
Hail, flowing fount of sentiment
All hail, divine emollient!

**King**

You may go, for you're at liberty, our pirate rules protect you,
And honorary members of our band we do elect you!
All    Hurrah!

2 *Pirates of Penzance*, autograph manuscript libretto, 1879

manuscripts of his speeches and lectures, and legal contracts and agreements with his various managers, collaborators, and music publishers.

## 3 ❧

### EARLY GILBERT OPERA SCORE

Thomas German Reed. *Our Island Home,* musical entertainment in one act (1870). Libretto by W. S. Gilbert. Autograph manuscript score, [1870]. The gift of Stainer & Bell, Limited, London, 1989.

Gilbert and Sullivan both owed a great deal to the earlier success of the composer-actor-manager Thomas German Reed (1817-88) and his wife, Priscilla, who in 1856 opened the small Royal Gallery of Illustration for programs of one-act musical pieces advertised as "entertainments." The Reeds afforded Gilbert important early opportunities to provide librettos for operatic entertainments, and they commissioned or produced Sullivan's earliest operas. It was also at the Gallery of Illustration that Gilbert and Sullivan were supposed to have been introduced by Frederic Clay, who had been Gilbert's collaborator and Sullivan's closest friend.

Among the most successful of the German Reed entertainments were Gilbert's *Ages Ago* (in collaboration with Clay) and Sullivan's *Cox and Box* (with lyrics by F. C. Burnand, based on the popular old farce by J. Maddison Morton), which appeared as a double bill in the fall of 1869. Commissioned from some of the most talented dramatists and composers, the Gallery of Illustration pieces were stylistic antecedents for the Savoy operas as well: it was Burnand, apparently, who quipped that the Gilbert and Sullivan operas had been "cradled among the Reeds." Indeed, one of the characters in this opera, a pirate called Captain Bang, bears a striking resemblance both to Captain Corcoran in *H.M.S. Pinafore* ("I never go below and I generally know / The weather from the 'lee' / And I'm never sick at sea") and the pirate apprentice Frederic in *The Pirates of Penzance.*

German Reed seems to have been the first impresario to suggest a Gilbert and Sullivan collaboration: in a letter dated 7 March 1870, he invited Sullivan to compose the music to a new piece by Gilbert. If Reed had been able to meet Sullivan's terms, *Our Island Home* would have been the first Gilbert and Sullivan opera; but in the end Reed himself composed the music. Although he was a prolific and respected composer, this is the only manuscript of any of his works that is known to survive. The illustra-

3  "Rise pretty one," from *Our Island Home* by Thomas German Reed and W. S. Gilbert, 1870

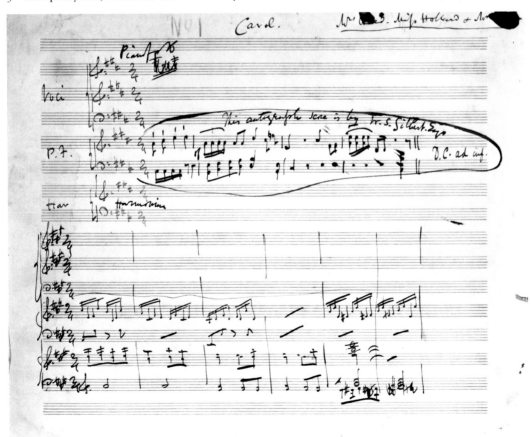

4  W. S. Gilbert letter with self-portrait sketch, 1904

tion shows the opening page of the first num-
ber, the quartet "Rise, pretty one." The circled
passage (within which Gilbert has written
"This autograph score is by W. S. Gilbert Esq.")
is the only known example of music written in
Gilbert's hand. Not surprisingly, it is non-
sense—Gilbert is supposed to have claimed to
be able to recognize only two tunes: one of
them was "God Save the Queen," and the other
one wasn't.

Alone among Gilbert's Gallery of Illustra-
tion pieces, neither the score nor the libretto of
*Our Island Home* was ever published. The Li-
brary's collection includes the complete manu-
script material for this chamber opera, includ-
ing the original score and instrumental and
vocal parts as well as the libretto. Manuscripts
and papers of other Victorian and Edwardian
composers are also found in the collection, in-
cluding, for example, the autograph score of
Edward German's last opera, *Fallen Fairies*
(1909), which was his only collaboration with
Gilbert.

## 4 ❧

### LETTER FROM GILBERT TO PINERO

W. S. Gilbert. Autograph letter to the dramatist
Arthur Wing Pinero, June 15, 1904, on Gil-
bert's writing paper, with a self-portrait sketch.

Arthur Wing Pinero (1855-1934), a generation
younger than Gilbert, rose from a mediocre
acting career (his Claudius, to Henry Irving's
Hamlet, was described by a Birmingham critic
as the worst ever seen in that city) to become
one of the most successful dramatists of the
nineteenth century. He is chiefly remembered
today for his most famous plays, *The Second
Mrs. Tanqueray* (1893) and *Trelawney of the
"Wells."* In 1889 his play *The Profligate*
was produced for the opening of Gilbert's new
Garrick Theatre, for which occasion Sullivan
contributed the music. Gilbert greatly admired
Pinero's talents and referred to him in one in-
terview as "a giant." The cordial spirit of this
brief letter, written late in Gilbert's life, reflects
their friendship as well. Gilbert has appended
to the letter a rare compliment, a humorous

and easily recognizable self-portrait sketch, showing the glowering persona that was—with some justification—his public image.

The Library's collection includes more than 5,000 letters, by Gilbert, by and to Sullivan, and from many musical and stage personalities, including performers in Gilbert and Sullivan productions, and a great many prominent figures in music, theater, literature, journalism, and society. It also includes nearly the whole of the correspondence between Gilbert and Sullivan: Gilbert's 175 original letters and Sullivan's drafts and autograph copies.

It was for his humorous verse and the cartoons and drawings that accompanied them that Gilbert achieved his first popularity (though popularity may be the wrong word for appearances in a magazine whose contributors always remained anonymous). For years Gilbert's "Bab" Ballads appeared week after week in the humor magazine *Fun*. Yet, he never considered himself other than an amateur illustrator. In the preface to the first edition of his collected ballads, he wrote, "I have ventured to publish the illustrations with them because, while they are certainly quite as bad as the Ballads, I suppose they are not much worse." Nevertheless, Gilbert also illustrated several books written by his father, William Gilbert, and when he published in 1890, at the time of a serious rift with D'Oyly Carte and Sullivan, a

collection of lyrics called *Songs of a Savoyard*, he accompanied them with newly executed illustrations. A number of Gilbert's pencil sketches are in the collection, as well as some of his finished pen-and-ink drawings, including some of the original "Bab" sketches as published in *Songs of a Savoyard* (1891), and a number of his letters include whimsical character sketches. There are also original drawings by other artists, including caricatures or cartoons by Max Beerbohm, Charles Dana Gibson, and the popular theatrical cartoonist Alfred Bryan.

5 ❧

EARLY DRAFTS OF IOLANTHE

William Schwenck Gilbert. *Iolanthe; or, The Peer and the Peri*, comic opera in two acts (1882). Music by Arthur Sullivan. Autograph manuscript plot sketchbook with pen-and-ink illustrations. The gift of Nancy McIntosh, 1949.

Gilbert was a methodical writer who carefully drafted, revised, and polished his works and entered these drafts in a series of notebooks. This manuscript contains the earliest versions of the opera *Iolanthe*, in the form of a stream of ideas and incidents and shreds of dialogue;

5 Sketches and outline by W. S. Gilbert for *Iolanthe*, 1882

many of these were incorporated in the final libretto, and many were abandoned. From the sketches with which Gilbert often accompanied the earliest drafts of his dramatic works it is clear that from the first Gilbert conceived them in visual and dramatic terms.

In the sketch on the page shown, the Lord Chancellor is followed by a train-bearer who matches his footwork step for step. The train-bearer does not appear in any libretto; yet it is clear that this humorous touch was not a rehearsal improvisation but a part of Gilbert's original conception. In other words, Gilbert was from the first thinking not only as librettist but also as stage director. Many anecdotes attest to his meticulous and perhaps dictatorial method of stage management. In contrast to the division of labor that typifies musical theater productions of this century, it may seem remarkable that Gilbert not only conceived the plot and composed the dialogue and lyrics, but also assumed the responsibilities of stage director, and often designed, or at least instructed the designers of, the sets and costumes. He was one of the first dramatists to insist on the presentation of his works according to his own conception, and a large share of the success of the operas on stage must be attributed to his talent as a stage director.

This manuscript was given to the Library by Nancy McIntosh, Gilbert's protégée who in 1893 sang the principal soprano role in *Utopia (Limited)*. From that time until Lady Gilbert's death in 1936, Nancy McIntosh lived as a member of the Gilbert family at Grim's Dyke. At the time of the formation of the Gilbert and Sullivan Collection, she presented several important manuscripts given to her by Gilbert. The collection includes a large number of Gilbert's manuscripts; in this respect, it is second in importance only to the archive of his papers in the British Library. Among the most important items are the plot sketchbook and final lyrics for *Utopia (Limited)*, the manuscript of Gilbert's unpublished stage adaptation of Dickens's novel *Great Expectations* (1871), the manuscripts of *The Pretty Druidess,* Gilbert's burlesque of Bellini's opera *Norma* (1869), and the scandalous burlesque *The Happy Land* (1873), individual lyrics from *The Yeomen of the Guard, The Mikado,* and *Utopia (Limited),* including several deleted numbers, and numerous examples of Gilbert's verse, drawings, and prose works.

6 Letter from Prime Minister Gladstone to Arthur Sullivan, 1883

6 ❧

A LETTER FROM THE PRIME MINISTER

William E. Gladstone to Arthur Sullivan, 3 May 1883. Purchased as a part of the Sullivan Archive, 1963.

Early in Sullivan's adult life he was to form friendships with the Prince of Wales and the duke of Edinburgh, and he also met the Prime Ministers Gladstone and Disraeli in professional circumstances. William E. Gladstone (1809-98) sang in performances that Sullivan conducted, and Sullivan set to music words by Disraeli. With a talent for attracting and cultivating the friendship of influential people, it is perhaps inevitable that Sullivan should have been showered with official honors through his career. In this letter Gladstone writes:

I have the pleasure to inform you that I am permitted by Her Majesty to propose that you should

receive the honour of Knighthood, in recognition of your distinguished talents as a composer and of the services which you have rendered to the promotion of the art of music generally in this country.

I hope it may be agreeable to you to accept the proposal.

Standing beside Sullivan at the investiture were his friend George Grove, compiler of the famous dictionary of music, and the composer George Macfarren. By the time he was knighted, at the age of forty-one, Sullivan had already been awarded honorary doctorates in music by both Oxford and Cambridge Universities and had been awarded the French Legion of Honor. Gilbert was eventually knighted as well, in 1907, at the age of seventy-one.

7 &

## IOLANTHE PROGRAM

*Iolanthe; or, The Peer and the Peri*, comic opera in two acts (1882). Program for first performance, at the Savoy Theatre, London, 25 November 1882.

*Iolanthe* was the first of the Gilbert and Sullivan operas that can be called a Savoy opera in the strictest sense, by virtue of the fact that it is the first opera to have had its first performance at the new Savoy Theatre. With his profits from the early Gilbert and Sullivan operas, D'Oyly Carte built the Savoy adjacent to his offices in the Strand, expressly for the production of comic opera. The theater was opened on 10 October 1882, at which time *Patience* was transferred from the Opera Comique to the new and larger theater.

This program bears the usual first-night announcement that "On this occasion the Opera will be conducted by the Composer." The bright gold color was not only symbolic of the splendor of the occasion but was in keeping with the comparative simplicity and restraint that distinguished the Savoy's decoration from the gingerbread interiors of most other theaters. The electric-light motif in the design referred to the theater's distinction as the first public building in London, and the first theater anywhere, to be lighted entirely by electricity. The program was designed by Alice Havers Morgan, who was to fashion many of the Savoy programs and souvenirs. Victorian theatrical programs were typically printed in four pages; new programs were printed every week, sometimes every night, and they recorded even temporary substitutions in the cast. For most of the productions at the Savoy Theatre two versions of the program were printed: a plain, typeset version on colored paper was given to occupants of the cheaper seats, and a smaller but more elaborate program, such as this one, printed in color on stiff card, was provided in the stalls, circles, and boxes.

Theatrical programs may provide information about the performance history and cast of a play or opera that is seldom found in other sources. The Library has more than five thousand programs for nineteenth-century performances of the operas of Gilbert and Sullivan (including first-night programs of each of them) as well as of their individual works.

7  Program from first performance of *Iolanthe*, 1882

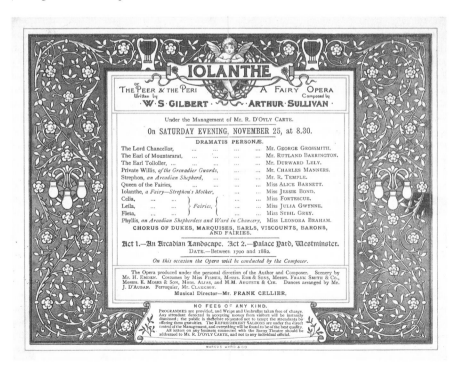

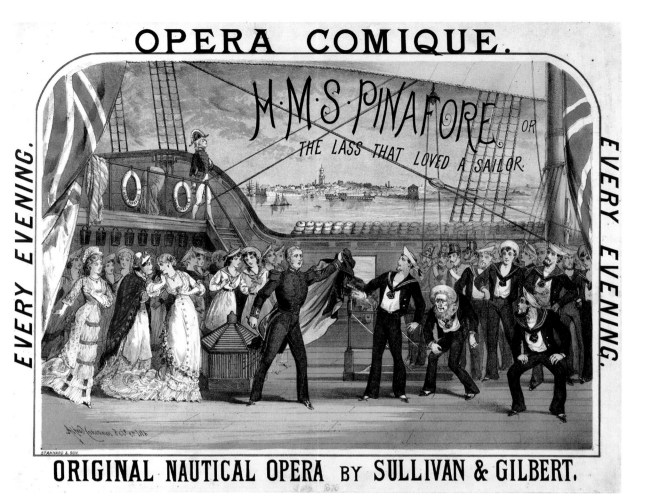

8  Poster from the first production of H. M. S. Pinafore, 1878

8 ❧

### H.M.S. PINAFORE POSTER

*H.M.S. Pinafore; or, The Lass That Loved a Sailor,* comic opera in two acts (1878). Color lithograph poster by Alfred Concanen, printed by Stannard and Son, London, [1878], 17¼ x 13 inches.

This poster was used for the first production of *H.M.S. Pinafore* at the Opera Comique Theatre, London, in 1878. It is believed to be the earliest surviving illustrated poster for any of the Gilbert and Sullivan operas. It depicts the climactic scene in Act II when Captain Corcoran surprises his daughter Josephine and the sailor Ralph Rackstraw as they are about to elope with the complicity of the ship's company.

Alfred Concanen (1835-86) was the best-known of the English artists who produced lithographic sheet music covers and theatrical posters. The exact technique used in printing the poster is not known; in some cases all of the colors were printed lithographically, but in other instances some of the colors were applied by hand. The oblong shape was shortly afterward superseded by the upright, twenty-by-thirty-inch "double-crown" poster.

The colorful images on early posters and sheet music are valuable as realistic representations of sets, costumes, and the arrangement of actors on the stage. (Photographs also survive of the original cast members in costume, but since the backgrounds usually consisted of stock scenes in the photographer's studio, they offer little idea of the original scenery.) The collection includes several hundred pictorial posters and typeset playbills dating from the earliest productions through the last pre-World War I revivals, including some productions of Gilbert's early stage works.

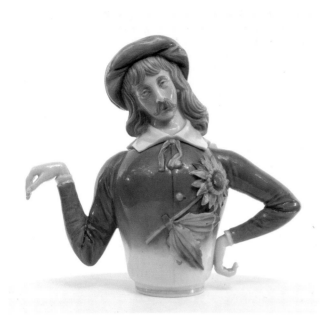

9  Aesthetic teapot

**9 ❧**

## AESTHETIC PATIENCE TEAPOT

"Aesthetic teapot," Worcester Royal Porcelain Co., Worcester, December 1881. 6 x 6¾ in.

The appearance in London on 23 April 1881 of the "aesthetic opera" *Patience* was announced with unprecedented publicity. Nor were audiences disappointed: with an engaging score, original and comic characters, brilliant dialogue, and splendid sets and costumes, the opera was immensely popular. Notwithstanding the topicality of its plot, which revolves around the rivalry of two pretentious poets for the attentions of a sensible milkmaid and the adoration of a chorus of "rapturous maidens," *Patience* has remained one of the most popular of the Savoy operas.

This decorative porcelain teapot was produced in an edition of only a few dozen pieces during the first run of the opera. The figures on the front and back of the teapot represent the poet Reginald Bunthorne and Patience, the milkmaid. On the bottom of the teapot are inscribed the words "Fearful consequences, through the laws of Natural Selection and Evolution, of living up to one's teapot." This inscription is no doubt founded on Oscar Wilde's remark, "I find it harder and harder every day to live up to my blue china," as it was rendered

by George Du Maurier, the merciless caricaturist of the aesthetic movement, in the pages of *Punch* magazine. Flamboyant and controversial, the precocious Oscar Wilde had made a strong impression upon London society, as had others identified with the aesthetic movement, such as James McNeill Whistler and Walter Crane. Wilde (who attended the first performance with characteristic flourish) was identified as a model for the preposterous aesthete and soon afterward served as an incarnate advertisement for the opera: D'Oyly Carte was to send Wilde on a lecture tour of the United States in 1882, partly to make clear to Americans the otherwise unfathomable phenomenon of the aesthetic movement in England.

The collection includes a large assortment of commercial ephemera related to the Savoy operas, including bisque and bronze figurines, china, pressed glass, buttons, toys and games, printed advertising cards, cigar and corset boxes, postcard and cigarette card series, and Currier and Ives lithographs. By far the majority of these items are of American origin. The hand-painted teapot is one of very few commercial objects related to the Gilbert and Sullivan operas that were produced in Britain, and it is of a higher level of craftsmanship than any of the American articles.

**10 ❧**

## GILBERT AND SULLIVAN SHEET MUSIC

*The Pirates of Penzance; or, The Slave of Duty,* comic opera in two acts (1879). Galop, arranged for piano solo by Charles D'Albert. Printed dance music based on tunes from the opera, with color lithograph cover illustration by Alfred Concanen, 1880.

*Trial By Jury,* dramatic cantata in one act (1875). Waltz, arranged for piano solo by Charles D'Albert. Printed dance music based on tunes from the opera, with color lithograph cover illustration [1875].

The music of *The Pirates of Penzance* remained in manuscript through the opera's first production in the United States in the first months of 1880, in order to prevent unauthorized American companies from exploiting the opera (as they had *H.M.S. Pinafore* in the previous year), and to insure that the work would secure copyright protection in Britain. It was only after the opera had opened in London on 3 April 1880—

10  Sheet music cover from *The Pirates of Penzance*, 1880

10  Sheet music cover from *Trial By Jury*, 1875

the date that Gilbert and Sullivan always regarded as the opera's official première—that the music and libretto were available for sale to the public.

The music to Victorian operas was published in an interesting variety of forms, including piano-vocal scores, piano-solo scores, individual songs, medleys and fantasias for piano and for other solo instruments, and selections for orchestras, ensembles, and military bands. In addition, it was usual for popular musical works—ballets, operas, and even works as unlikely as Rossini's *Petite Messe Solennelle*—to be attended by the appearance of medleys arranged in popular dance rhythms. Such arrangements nearly always appeared in four forms: the waltz, quadrilles, lancers, and either the polka or galop. Each of these was issued in versions for piano solo, piano duet (two players at one piano), septet or octet, full orchestra, and military band. Curiously, while these adaptations are based on tunes from the opera, the melodies are adapted to the stated dance meter and squared off to conform to the required phrase length, sometimes with little regard for felicity or fidelity.

A further curiosity is that of all of the printed manifestations of the music, only the piano solo dance arrangements were issued with illustrated covers. Every other publication bore a commonplace black-and-white typeset or engraved cover. No doubt these elaborate (and costly) covers were required because these arrangements were considered impulse purchases, for which a striking cover was an attraction. Most of these illustrations are realistic representations of scenes and characters in the original productions of the operas, and sometimes they are the only such illustrations in color. This illustration, by Alfred Concanen, shows the Pirate King in Act I, carrying the Jolly Roger.

*Trial By Jury*, produced at the Royalty Theatre in London in 1875, is the earliest of the Gilbert and Sullivan operas that has survived intact. (The music of *Thespis*, their first collaboration, has long been lost.) It was commissioned by Richard D'Oyly Carte as a short companion piece to accompany a production of Offenbach's *La Périchole*. Although *Trial By Jury* lasts little more than half an hour, and (uniquely among the Gilbert and Sullivan operas) it has no spoken dialogue, its success led directly, if not immediately, to the long-standing partnership of Carte, Sullivan, and Gilbert.

The illustration shows two scenes from *Trial By Jury*—the opera's closing tableau and the jurors' minstrel number. From this illustration, the original staging of both scenes can be discovered.

The Gilbert and Sullivan Collection contains a comprehensive collection of authorized editions of Sullivan's music published during his lifetime. In a letter to Sullivan after the success of *Patience* in 1881, the publisher Thomas Chappell proposed increasing Sullivan's royalty; in order to manage that he suggested simplifying the covers—not eliminating them altogether, because that would affect sales—and subsequent dance music covers were printed in two or three colors rather than six to ten as had been typical.

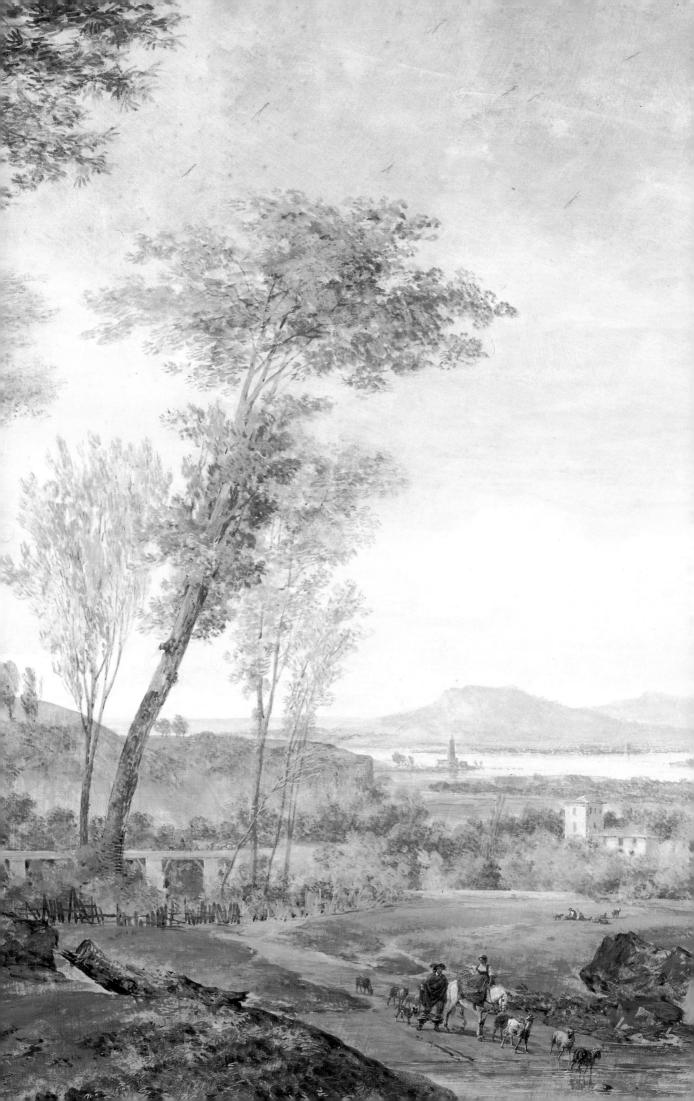

# X  DRAWINGS AND PRINTS

THE DRAWINGS REPRODUCED HERE are intended to give an indication of the scope and strengths of the Morgan Library's collection, which concentrates primarily on European art before 1825. Most of the major schools and periods within these limits are represented, the earliest being a rare example of trecento draughtsmanship attributed to Taddeo Gaddi, the latest being a study of a man by Degas. The selection also offers an opportunity to consider the different types of drawings and the ways in which they reveal an artist's working methods and creative processes. They range from preliminary sketches to final designs for a planned work. In some cases they may preserve discarded ideas and motifs; in others they may be the only surviving record of a lost work. Some drawings, such as the lovely Moreau landscape (x, 27 and detail at left), were clearly intended as independent works of art.

In 1910 Pierpont Morgan effectively established this collection in one stroke by purchasing 1500 old master drawings assembled by the English artist-collector Charles Fairfax Murray. Prior to this Morgan had acquired all of Theodore Irwin's Rembrandt etchings and then those collected by George Vanderbilt. Morgan had also purchased twenty-one William Blake watercolor illustrations to the Book of Job and a few individual drawings, such as the Gainsborough *Study of a Lady* (x, 20) and the Boucher *Cherubim*. Well chosen and comprehensive in its range, Fairfax Murray's collection is considered to be the first great European drawings collection to come to this country. Its special strengths remain unsurpassed in the United States. This is true of the Italian Renaissance and eighteenth-century schools, as it is of Netherlandish drawings of the sixteenth and seventeenth centuries. His collection was especially rich in the great seventeenth-century Dutch and Flemish masters. Fairfax Murray's extensive series of drawings by Rembrandt and his school admirably complemented the etchings Morgan already owned.

Not nearly so complete with respect to drawings of the French school, the Fairfax Murray collection nevertheless included some fine French drawings of the seventeenth and eighteenth centuries, among them a number of sheets by the great expatriate masters Claude Lorrain and Nicolas Poussin. The Fairfax Murray purchase also brought to this country an exceptional group of eighteenth-century English drawings with fine examples by Hogarth, Wilson, and above all, Gainsborough. Although there were a few drawings each by Dürer and Watteau, Pierpont Morgan made several important additional purchases of drawings by these artists before his death in 1913. His son, J. P. Morgan, Jr., continued to add to the Rembrandt etchings, but the Library did not actively collect drawings until the end of World War II, when its first curator of drawings, Felice Stampfle, was appointed. The formation of the Association of Fellows in 1949 provided the financial support needed to develop the collection, and many fine drawings have been purchased since that time. The extraordinary growth of the collection to its present size of around 9,000 sheets, however, is largely due to the private collections that have been presented to the Library. Notable among these was Mrs. J. P. Morgan's collection of more than 500 architectural and garden drawings, including the large series of drawings by Piranesi,

which was given in the 1960s by her sons, Henry S. and Junius P. Morgan. In 1973, the noted cellist and connoisseur Janos Scholz announced his gift of 1500 Italian old master drawings, thereby adding to the Library's already strong Italian holdings. This was especially significant, for it assured New York's position as the center for the study of Italian drawings in this country. The gift by Mrs. Donald M. Oenslager of her late husband's extensive collection of theater and stage designs also included a number of important Italian drawings, mainly of the eighteenth century. In his collecting, Mr. Oenslager, himself a theater designer and teacher, had endeavored to trace the evolution of stage design from the early Renaissance to recent times.

French drawings have become another major strength. Aside from some rare early drawings and the well-known group by Claude and Poussin, the Library is especially strong in its representation of French masters of the eighteenth century, particularly Watteau, Boucher, Fragonard, Robert, and Gabriel de Saint-Aubin. Only in recent years has the chronological limit of the collection been extended to the end of the nineteenth century, which is still only represented in outline. There are handsome examples, however, of drawings by Ingres and Delacroix as well as Degas and Cézanne. A promised gift of the collection formed by Eugene V. and Clare Thaw includes an especially fine range of nineteenth-century French drawings that someday will round out the Library's holdings in this period.

The chronological limits of works by English artists have also been extended well into the nineteenth century. The Library has been the recipient of many remarkable drawings of this school, including a number of Edward Lear and David Roberts watercolors. The potential for this growth always existed because illustrative drawings by Pre-Raphaelite artists were already well represented as were the illustrators of Dickens, whose books and manuscripts are so prominent elsewhere in the Library. The holdings of French drawings for book illustration are also strong and include examples by Cochin, Moreau le Jeune, Monsiau, Le Barbier, Isabey, and above all, Gravelot. In this connection the important artists' sketchbooks in the Library should also be mentioned since most of them are by artists of the French school.

The few examples of Spanish drawings in the collection are generally of high quality and include sheets by Ribera, Murillo, and Goya. A number of nineteenth-century German drawings by such artists as Friedrich, Kersting, and Menzel have been acquired in recent years. The Library has not actively collected American drawings. There is, however, a large group by the expatriate artist Benjamin West, who spent most of his career in England, where he was president of the Royal Academy. (There are also drawings by his son Raphael Lamar West.) John James Audubon's work is represented by some fine examples. The collection also includes many drawings by the American Renaissance muralist H. Siddons Mowbray, who was responsible for the decoration of the Library's Rotunda and East Room.

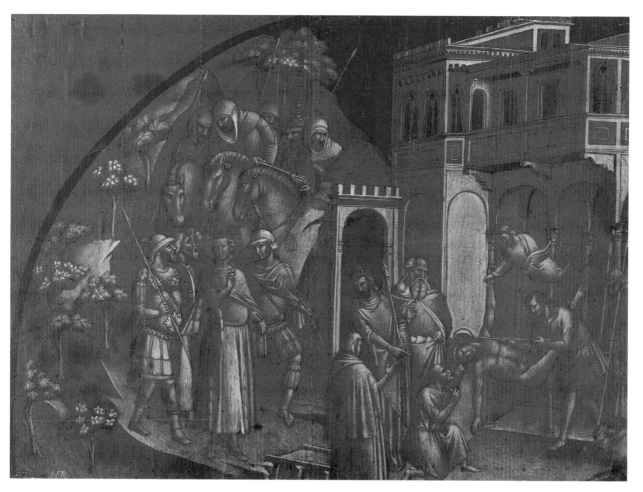

1 Attributed to Taddeo Gaddi, *Scenes from the Martyrdom of San Miniato*

1 &

ATTRIBUTED TO TADDEO GADDI

*Scenes from the Martyrdom of San Miniato.*
Pen and brown ink, brush and brown wash,
white bodycolor on a prepared brown ground,
purple wash for the lunette shape and sky;
traces of silverpoint on vellum. 11½ x 15⅝ in.
(292 x 397 mm). Purchased by Pierpont
Morgan, 1910. I, 1.

In extremely careful brushwork the artist has
depicted scenes from the martyrdom of Saint
Miniatus. The young martyr, who sometimes
in Florentine art is shown with a crown, as we
have here, was decapitated, probably at the
time of the persecution of Decius. The site of
the decapitation is thought to have been the
present Church of San Miniato al Monte,
which is on a hill overlooking the city of Flor-
ence. In the drawing we find at the left the saint
being led to his execution and on the right he is
seen undergoing his torture of having hot oil
poured in his ear. Further to the right, on the
missing part of the sheet we could expect to
have found the decapitation scene. A segment
of a circular framing line to the left indicates
that the original shape of the drawing was a
*lunetta*, a half circle which was the normal
form for a fresco on the upper part of a wall in
a vaulted room.

The sheet is one of the rare surviving exam-
ples of the trecento and remarkably well pre-
served. It had gone through attributions to
different masters of the Tuscan school before
its present attribution to Taddeo Gaddi was
advanced in 1985 by Luciano Bellosi. Taddeo
Gaddi was a pupil and assistant to Giotto. His
best-known work is the fresco cycle of the Ba-
roncelli Chapel in Santa Croce, Florence, be-
gun in 1327.

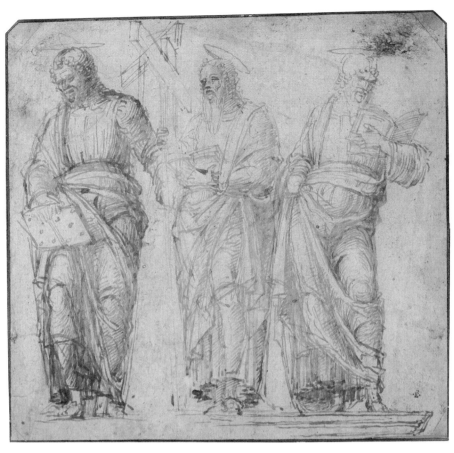

2 Andrea Mantegna, *Three Standing Apostles*

2 🐚

ANDREA MANTEGNA

*Three Standing Apostles*. Pen and brown ink
on paper tinted with red chalk. 7 x 7½ in.
(178 x 190 mm). Gift: Collection of Mr. and
Mrs. Eugene Victor Thaw. 1985.100.

Mantegna (1431-1506) was one of the most
outstanding painters and draughtsmen for
engraving in the early Renaissance in northern
Italy. Educated in Padua, he spent most of his
life at Mantua where he was court painter to
the ruling Gonzaga family from 1460 to his
death. His drawings are rare and sometimes
show close stylistic affinities with those of his
brother-in-law Giovanni Bellini, upon whose
early career he had an important influence.
This drawing belongs to a group formerly at-
tributed to Giovanni. There are only a few
drawings preparatory for Mantegna's paint-
ings on which other attributions can be based.

Among them is a drawing for the high altar of
Saint Zeno at Verona (1456-59) now in the
Getty Museum. The facial types and the ren-
dering of the hair compare especially well in
both drawings, while the way the drapery is
organized in the Morgan sheet—in long curv-
ing folds that allow the forms of the underlying
body to clearly show through the garments—is
parallel to forms he used throughout his later
career as a painter.

Our three saints are probably apostles, but
only one of them displays an attribute that may
suggest an identification, a cross alluding to
the martyrdom of Saint Philip or Saint Andrew,
though it is not of the X-shape usually used for
Saint Andrew's cross. Since the perspective is
from a very low point, it is probable that the
figures were prepared for placement above the
eye level of the spectator. A sheet in the Mu-
seum Boymans van Beuningen, Rotterdam,
may have served for the same commission. It
contains, alongside two smaller figures of Saint

John the Baptist, four standing apostles. Among them are Saints Peter and Paul and again a saint with a cross. They are stylistically identical to the Morgan figures but are seen from a slightly higher point. The drawing closest to the Morgan's is in the British Museum. Its size, the technique that was used, as well as the style and the low vantage point might indicate that it was a section of the Morgan sheet. The scale of the figure, however, is somewhat larger and the better condition of the drawing makes the connection less obvious. If the assumption is true, the drawing would originally have contained four apostles like the sheet in Rotterdam, though not the same ones. If we think of a painted arrangement of the eight apostles on the three sheets mentioned and four more apostles, for which we have no drawings, we could imagine a mural decoration consisting of three registers with four apostles each, one above the other.

3 ❧

LUCA SIGNORELLI

*Four Demons*. Black chalk. 13⅞ x 11⅛ in. (352 x 283 mm). Purchased as the gift of the Fellows. 1965.15.

Signorelli (1445/50-1525), who is said to have been a pupil of Piero della Francesca, developed a highly personal style that later, under the influence of Perugino, acquired some Umbrian features. He painted altarpieces, frescoes, and even portraits. In the beginning of the 1480s he was chosen to contribute to the mural decoration of the Sistine Chapel in the Vatican. His most famous paintings are probably his *Pan,* formerly in Berlin, and his frescoes in the Cappella di San Brizio in the cathedral of Orvieto, commissioned in 1499 and finished in 1504. There he depicted, among other subject matter, the Inferno and Orpheus in Hades. In

3  Luca Signorelli, *Four Demons*

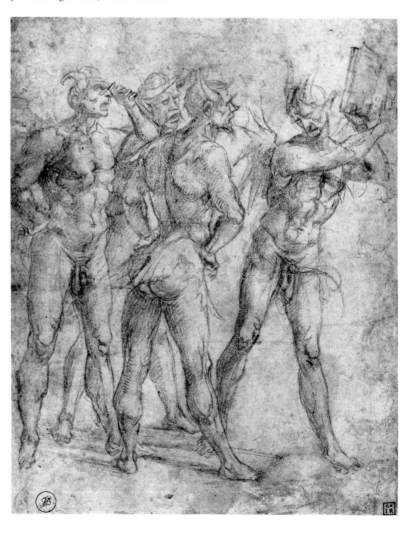

these representations occur demons not unlike those we see in this drawing. In fact the drawing has been considered preparatory for Orvieto, though its group of devils does not figure exactly in the frescoes.

The focus of the group's attention here seems to be a book held up by the demon on the right as the other three look on. The devil on the far left takes out a pair of spectacles to better examine the volume. The taut musculature and the stance of the demons are characteristic of Signorelli's figure types. He drew extensively, and his drawings form one of the earliest extant large groups of figure studies in black chalk. According to Bernard Berenson, Signorelli was the first painter in Italy to thoroughly exploit this medium, which was to play such an important role for the painters of the Italian Renaissance.

4 Del Sarto, *Youth Carrying a Sack on His Head*

## 4 🍂

ANDREA D'AGNOLO, CALLED DEL SARTO

*Youth Carrying a Sack on His Head*. Black chalk. Verso: Detail of the same figure in red and black chalk. 10⅜ x 5¼ in. (263 x 134 mm). Purchased by Pierpont Morgan, 1910. I, 30.

Andrea del Sarto (1486-1530) was one of the greatest painters and draughtsmen of the pure Florentine style of the High Renaissance. He was as accomplished in continuing the achievements of quattrocento narrative fresco cycles as he was in composing beautifully balanced and monumental altarpieces, typical of the High Renaissance. He was also a good portraitist.

As with most of Andrea's studies, this one demonstrates his unerring command of figure drawing. The manner in which the youth maintains his balance as he mounts the stairs, steadying the unwieldy sack on his head with one hand and holding a large basket against his hip with the other, is convincingly rendered. It is a fine example of the practice of making drawings from the live model in the studio. During the same session, Andrea turned the sheet over and made additional, more detailed studies in red and black chalk of the model's upraised left arm and head (not illustrated).

Both sides of this drawing are related to a figure at the right in *The Visitation*, one of the monochrome frescoes depicting the Life of John the Baptist in the cloister of the Confraternity of the Scalzo in Florence. Andrea's work on the frescoes may have begun about 1511 or 1512, but is only documented from 1515 until completion in 1526. *The Visitation* was completed in November 1524. Andrea, who died of the plague at the age of forty-four, was himself a member of the confraternity and is buried in the cloister.

## 5 🍂

ATTRIBUTED TO ANTONIO ALLEGRI, CALLED CORREGGIO

*Head of a Woman Crying Out*. Charcoal with traces of white chalk and brush and black oil pigment. 12⅝ x 8⅞ in. (332 x 224 mm). Purchased by Pierpont Morgan, 1910. IV, 30.

Antonio Correggio (1498-ca. 1534) was the leader of the Renaissance school of Parma. With his frescoes in the cupolas of San Giovanni Evangelista (1520-24) and the duomo of the

5   Correggio, *Head of a Woman Crying Out*

city (1526-30), he opened the way for illusionistic ceiling decorations, which made him a forerunner of the baroque style.

Among the earliest works attributed to Correggio are frescoes in the portico of the Church of Sant'Andrea at Mantua, one of them a circular depiction of Christ's Entombment. The drawing we see here is a fragment of the cartoon for this mural and shows the head of the woman crying out behind Christ's right shoulder. Being the last stage in the series of preparatory drawings for a painting, a cartoon must be the same size as the final design. To accomplish this here the artist was obliged to fasten several pieces of paper together (a seam is visible along the left side of the face).

While the connection with the fresco is undoubtedly correct, the authorship may be in question. The traditional attribution of the fresco to Correggio goes back to the early seventeenth century and should not be hastily discarded, but the stylistic difference between this presumably very early work—deeply influenced by the art of Andrea Mantegna—and those to follow is great.

6  Pontormo, *Standing Nude
and Two Seated Nudes*

6 ⮞

JACOPO CARUCCI, CALLED PONTORMO

*Standing Nude and Two Seated Nudes*. Red
chalk. 16 x 8⅞ in. (406 x 225 mm) Verso: Strid-
ing nude with upraised arms in black chalk,
with vestiges of white, over red chalk. Pur-
chased as the gift of the Fellows with the special
assistance of Mrs. Carl Stern and Mr. Janos
Scholz. 1954.4.

Pontormo (1494-1557) is one of the greatest
figures among the Italian mannerists. He came

to Florence in 1506, entered Andrea del Sarto's
workshop in 1512, and spent his entire life in
and around Florence. Though deeply influ-
enced by Leonardo, Michelangelo, Dürer, and
Lucas van Leyden, he developed a very per-
sonal style of painting and drawing which
was of the greatest importance to the next
generation of Florentine painters, notably
Bronzino.

This drawing, in red and white chalk, depicts
a group of male nudes. On the back is a single
male figure in black, red, and white chalk, who
is possibly an executioner or one of the tormen-

tors in a Flagellation of Christ (not illustrated). None of these figures has been found in extant Pontormo paintings. The bending movement and the proportions of the figures as well as the facial types with large, hollow eye sockets and upraised brows are typical of Pontormo. Similar figural and facial characteristics can be found in his altarpiece of 1518 in San Michele Visdomini, Florence, and other works of his early maturity. The rather angular line still betrays an affinity to Andrea del Sarto, while the heavy influence of Michelangelo's style, which Pontormo would later emulate so strongly, is not yet visible. A dating of around 1520 seems, therefore, the most convincing.

7 🐚

FRANCESCO MAZZOLA
CALLED PARMIGIANINO

*Three Putti.* Pen and brown ink, brown wash, over red chalk, some squaring for transfer in lead, black ink ruled border. Verso: Black chalk sketch of Diana and Actaeon. 6³/₁₆ x 6¹/₈ in. (157 x 156 mm). Purchased by Pierpont Morgan, 1910. I, 49.

A follower of Correggio, Parmigianino (1503-40) is the outstanding master of mannerism in Parma. His drawings are well represented at the Library. The sheet with three putti in triangular spandrels on the recto and Diana and Actaeon on the verso (not illustrated) was done in preparation for his first monumental assignment—the decoration of the ceiling and upper walls in the Camera della Stufetta in the Castle of Fontanellato near Parma.

The decorative scheme with its overgrown trelliswork is dependent upon that of Correggio's Camera della Badessa Giovanna Piacenza in the Convent of St. Paul in Parma. The figural types, faces, and mannerist elegance of the pose are, however, already typical of Parmigianino, as is every other feature of the drawing. The putto on the left, which has been squared for transfer, appears in the painting between the stag-headed Actaeon and the splashing Diana.

7  Parmigianino, *Three Putti*

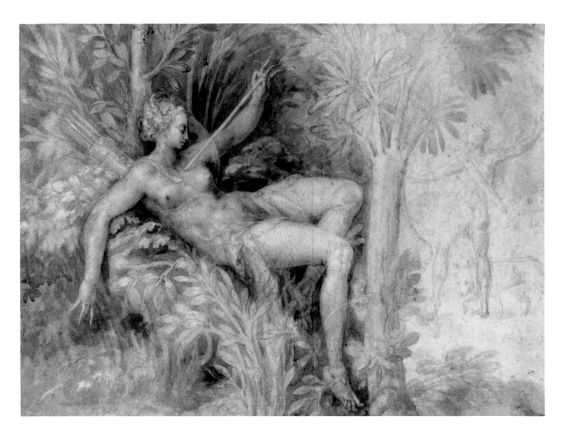

8  Maître de Flore, *Procris and Cephalus*

8 ⍦

MAÎTRE DE FLORE

*Procris and Cephalus*. Brush and brown wash, some pen and brown ink, heightened with white, over preliminary indications in black chalk. 8⅝ x 12⅛ in. (219 x 308 mm). Purchased as the gift of the Fellows with the special assistance of Miss Alice Tully, Miss Julia Wightman, and the Thorne Foundation, 1978. 1978.34.

Beginning in the mid 1500s, the royal residence of François I at Fontainebleau became an important center for the development of a new and highly influential style derived from the late Italian *maniera*. This drawing of Cephalus and Procris is typical of the school of Fontainebleau, which delighted in complex iconography and the antique. It is one of only two known drawings by an anonymous French artist who was working at Fontainebleau in the second half of the sixteenth century; he has been called Maître de Flore by the art historian Charles Sterling. The name comes from two paintings ascribed to the artist, both of which have Flora as the subject. Here, the artist has illustrated a tale from Ovid's *Metamorphoses*. The reclining nude figure is Procris, fatally wounded by a spear thrown by her husband Cephalus. According to the story, Procris, wrongly suspecting Cephalus of being unfaithful, concealed herself in the forest to spy on him. Hearing a noise in the thicket, Cephalus hurled his magic spear which never missed its mark, killing her. In the picture, the dying Procris is seen gracefully disposed among the leafy foliage, removing the spear from her breast with her long tapering fingers. In the background, his hunting dog at his side, Cephalus is still unaware of the tragedy that has occurred.

The purpose for which the drawing was done is not known. It may have been made in preparation for a painting or a tapestry. The rendering of Procris has a sculptural solidity in contrast to the more painterly background of the forest and shrubbery, suggesting that it could have been intended for a mixed stucco and painted decoration of the sort popular at Fontainebleau.

JACQUES BELLANGE

*The Hunter Orion Carrying Diana on His Shoulders.* Pen and brown ink, brown wash; extraneous spots of red chalk and green paint. 13¾ x 7⅞ in. (350 x 200 mm). Inscribed in pen and brown ink at lower right corner, *Belange.* Purchased as the gift of the Fellows, 1971. 1971.8.

The highly personal style of the French mannerist Bellange (active 1602-16) is strikingly exemplified in this drawing of Orion carrying Diana on his shoulders. The subject is depicted in a self-consciously elegant, almost choreographic pose. Orion, the mythical giant, mighty hunter, and favorite of Diana, is arrayed in fanciful armor decorated with grotesque masks. Astride his shoulders sits the lithe and slender goddess of the hunt, armed with bow and quiver.

Bellange was popular in his time as a painter and decorator at the court of Lorraine at Nancy. Not much is known about him. In 1606 he was at work on a series of hunting scenes for a gallery of the ducal palace at Nancy, and in 1611 he was decorating another gallery there with subjects from Ovid. He was highly regarded as an etcher, and this study was made in preparation for an undated print. His work is sometimes based on Italian models. The subject of this drawing is similarly depicted in a Giorgio Ghisi print of 1553 after Luca Penni.

9  Bellange, *The Hunter Orion Carrying Diana on His Shoulders*

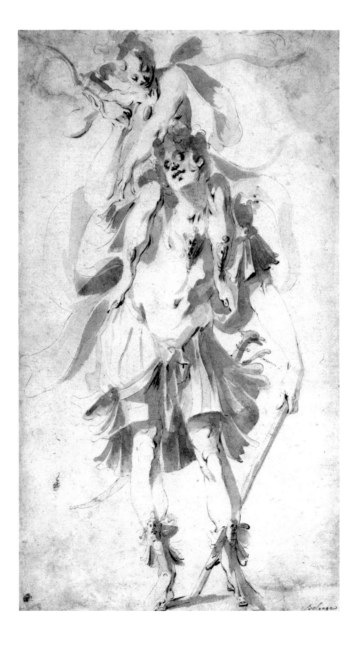

PIETRO BERRETTINI
CALLED PIETRO DA CORTONA

*Woman Holding a Tiara.* Black and red chalk. 8¹¹⁄₁₆ x 10⅞ in. (220 x 277 mm). Purchased as the gift of the Fellows with the special assistance of Mr. and Mrs. Carl Stern. 1965.16.

Pietro da Cortona (1596-1669) was a painter and architect. Born and educated in Tuscany, he went to Rome early in his life and became the most prominent decorator of the huge interiors of the Italian high baroque. He worked mainly in Rome but also in Florence where he decorated the rooms of Palazzo Pitti for the Medici. In Rome, from 1633 to 1639 he painted the enormous ceiling fresco of the salone of the Palazzo Barberini which represents the glory of the Barberini family and the virtues of the pontiff. The coat of arms of the Barberini is crowned by two hovering women who hold the keys of Saint Peter and the papal tiara. The drawing is done in preparation for the figure with the papal crown. It is one of Cortona's most impressive and beautiful studies. The arms and face are modeled with black and red chalks while the garment and the crown are only roughly indicated in black.

ALBRECHT DÜRER

*Adam and Eve.* Pen and brown ink, brown wash, corrections in white. 9⁹⁄₁₆ x 7⅞ in. (243 x 200 mm). Purchased by Pierpont Morgan, 1910. I, 257d.

The great German artist Albrecht Dürer (1471-1527) was surely one of the universally gifted masters of the Renaissance. His woodcuts and intaglio engravings were well known throughout Europe and deeply influenced art for more than a century. *Adam and Eve* is one of his most beautiful drawings. Dürer pieced together two single studies in order to obtain the basic composition of his print of 1504, *The Fall of Man*. In the final print, the human ancestors are shown before a wood populated with animals. Other drawings for Dürer's *Adam and Eve* show the individual figures and Adam's arms and hands. Large watercolors depicting the elk and the parrot in the engraving were done earlier and only reused in the course of the print's preparation.

10  Pietro da Cortona, *Woman Holding a Tiara*

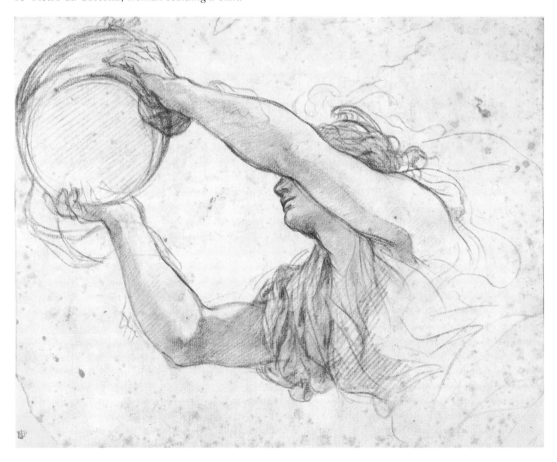

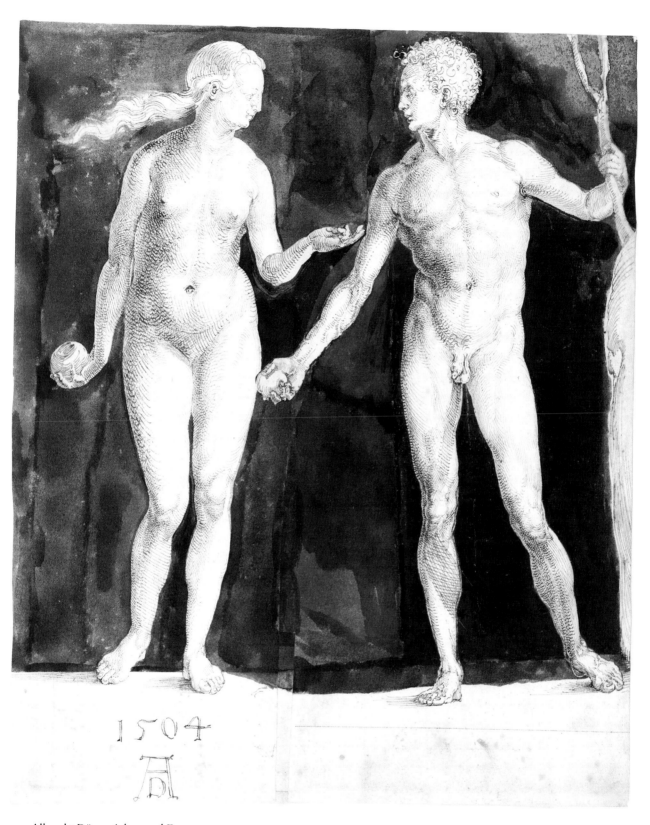

11  Albrecht Dürer, *Adam and Eve*

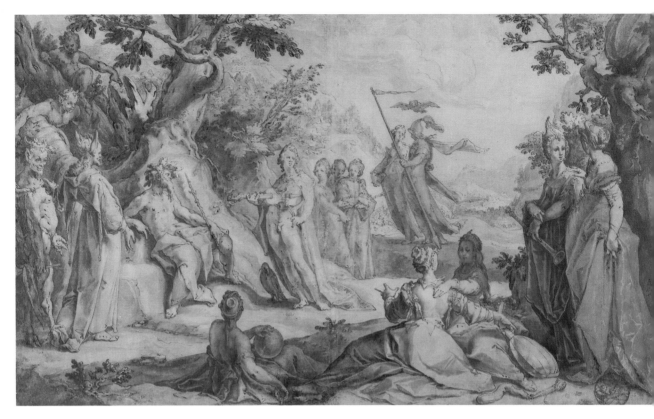

12 Hendrick Goltzius, *The Judgment of Midas*

12 ❧

HENDRICK GOLTZIUS

*The Judgment of Midas*. Pen and brown ink, red-violet, brown, and gray watercolor, green tempera, heightened in white tempera; traced with a stylus. Signed and dated 1590. 15¾ x 26¹³/₁₆ in. (400 x 681 mm). Purchased by Pierpont Morgan, 1910. I, 228.

Hendrick Goltzius (1558-1617), who was born in Germany but worked mainly in Haarlem, was one of the greatest engravers of the sixteenth and early seventeenth centuries. Through widespread engravings after his inventions and by his own hand, he was of outstanding importance to the dissemination of northern mannerist forms.

This is the final preparatory drawing for his print *The Judgment of Midas*. The sheet has been indented with a colorless stylus used in transferring the composition onto the copper plate. In the center is the victorious Apollo playing a viol. On his rock-hewn seat is Tmolus, king of the mountain, whose judgment of the musical contest in favor of Apollo was accepted by all except King Midas. Standing to the left are Midas, identified by the ass's ears bestowed upon him because of his dissension, and Pan or Marsyas. Toward the right of the scene are the nine muses and Athena, one of whose attributes, an owl, hovers above her. Apollo's musical contest is described in both Ovid's *Metamorphoses* and *Fasti*. It is possible that Goltzius used both these sources for his composition.

It was normal practice at that time and in Goltzius's circle not to indicate the graphic pattern of the future print in the drawing but to depict light and shade with washes. Here, in addition to the washes, green bodycolor is used for the dress of Urania in the right foreground.

13 &

PETER PAUL RUBENS

*Seated Nude Youth*. Black chalk heightened
with white tempera on light gray paper. 19$^{11}$/$_{16}$
x 11¾ in. (500 x 299 mm). Purchased by
Pierpont Morgan, 1910. I, 232.

Peter Paul Rubens (1577-1640), the outstand-
ing painter of the Flemish baroque, was one of
the most accomplished draughtsmen of his day.
This beautiful study was done in preparation
for the main figure in his painting *Daniel in the
Lion's Den*, 1614-15 (National Gallery of Art,
Washington). It is a work of his early maturity.
In a letter of 1618, he refers to "Daniel in the
midst of many lions" as being "entirely by my
hand."

The pose of the youth is derived from a draw-
ing by the Italian mannerist Girolamo Muzia-
no, which depicts an old man, St. Jerome.
Rubens adopted it for the youthful Daniel, af-
ter carefully studying the modulation of the
body with light and shade from the model.

A drawing of one of the lions in the picture,
sometimes attributed to Rubens, is also in the
collection.

13  Peter Paul Rubens, *Seated Nude Youth*

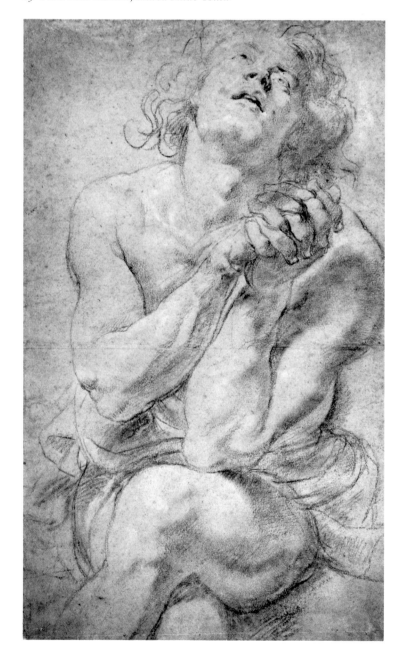

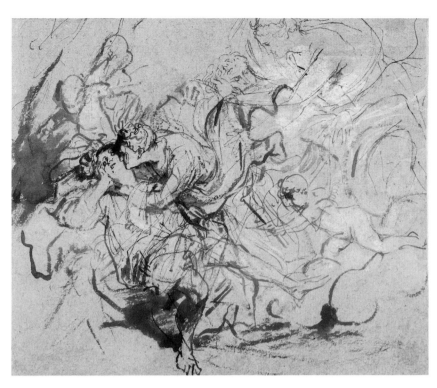

14  Anthony van Dyck, *Diana and Endymion*

14 ⟨⟨

ANTHONY VAN DYCK

*Diana and Endymion.* Pen and point of brush, brown ink and brown wash, heightened with white tempera on gray-blue paper. 7½ x 9 in. (190 x 228 mm). Purchased by Pierpont Morgan, 1910. I, 240.

Anthony van Dyck (Flemish, 1599-1641) was Rubens's greatest pupil. He studied in Antwerp and was later deeply impressed by Titian, whose works he knew intimately from a period of time spent in Italy. He painted religious as well as secular objects and was one of the most outstanding portraitists. The last decade of his life he spent in England as court painter to Charles I.

This drawing is a sketch, a very early stage in the preparation of a painting. The group, comprising the goddess Diana (identified by the crescent on her forehead) and the shepherd Endymion, whom she visited during his sleep, was first sketched on the lower left and then repeated on the upper right with slight alterations. There is no knowledge of a painting of this subject by Van Dyck. He does, however, seem to have used this sketch for his *Rinaldo*

*and Armida,* purchased by Charles I in 1629 and now in the Baltimore Museum of Art. The general disposition of the figures is similar and the way Armida's mantle billows up into the air is particularly close to that in this drawing.

15 ⟨⟨

REMBRANDT HARMENSZ VAN RIJN

*Woman Carrying a Child Downstairs.* Pen and brown ink, brown wash. 7⅜ x 5³⁄₁₆ in. (187 x 132 mm). Purchased by Pierpont Morgan, 1910. I, 191.

This marvelous drawing by Holland's greatest painter, Rembrandt (1606-69), shows his ability in observing everyday life and recording it on paper. He depicts a young woman descending a staircase with a heavy child in her arms. The air of tender family intimacy and personal engagement with the subject once led scholars to believe that the drawing depicted Rembrandt's first wife, Saskia, carrying her son Rumbartus. Archival evidence about Rumbartus's dates of birth and death, however, does not support this identification. The drawing is generally dated to 1636 on stylistic grounds.

In energetic pen strokes Rembrandt indicated the essentials of figure and setting. He used broad, bold strokes and layers of brown washes to give variety and depth of tone. Like so many of his drawings, this sketch is not related to any known print or painting by him. It may have come from a portfolio of 135 Rembrandt drawings entitled "The Life of Women and Children."

16 ⁊⁊

REMBRANDT HARMENSZ VAN RIJN

*Christ Presented to the People ("Ecce Homo").*
Drypoint, printed on Japanese paper (B. 76-I).
Purchased by Pierpont Morgan, 1905.

This is one of the rare impressions of the first state of *Ecce Homo* (1655) by Rembrandt (1606-69). It shows Pilate presenting Christ to the people gathered before his palace. Rembrandt took the idea of showing the event in a stage-like setting, with spectators massed in front, from a print of the same subject by Lucas van Leyden. He framed and silhouetted the two principal figures against the palace door-

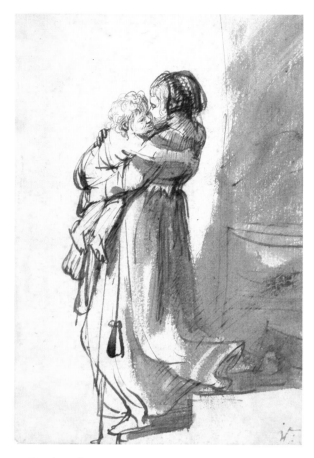

15  Rembrandt, *Woman Carrying a Child Downstairs*

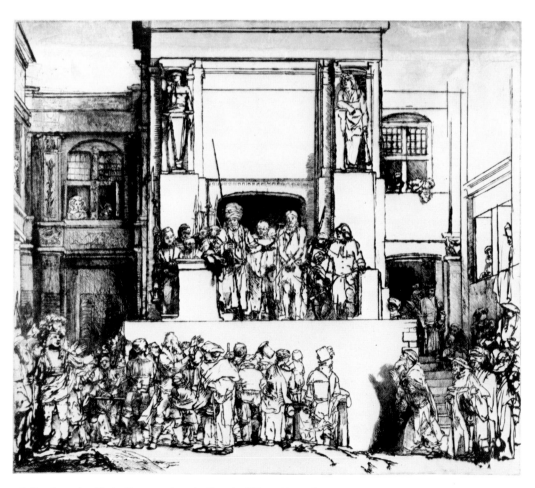

16  Rembrandt, *Christ Presented to the People ("Ecce Homo")*

17  Nicolas Poussin, *The Death of Hippolytus*

way. On the left stands Pilate, wearing a turban and elaborate robes. Christ, bareheaded and with his hands bound in front of him, appears before the people. Later Rembrandt reworked much of the plate, scraping out the entire group in front of the central terrace and adding two sustaining arches instead. He worked with the needle directly on the surface of the copper plate. This technique caused the metal along the furrows of the engraved lines to raise up in burrs that kept much of the ink in early proofs, such as the present one, and is responsible for the soft, dark, velvety effect we can observe over the entire print. The soft yellowish tone of the paper adds another note of warm tonality to the proof. Rembrandt printed on all different kinds of material, using vellum, normal white European paper, oatmill paper, and oriental (among them Japanese) papers. Prints on the latter are rare. In this case, he had to join a small strip to the top in order to get a large enough sheet for the image.

The Morgan Library's collection of Rembrandt's printed *oeuvre* is said to be the best in the country. Morgan acquired his prints from two outstanding American collectors: in 1900 he purchased 272 prints belonging to Theodore Irwin and five years later purchased 112 from George W. Vanderbilt. Under Morgan's son, J. P. Morgan, Jr., the Rembrandt collection con-

tinued to grow, the finest additions coming from the Gerstenberg collection in Berlin.

## 17 ❧

### NICOLAS POUSSIN

*The Death of Hippolytus.* Pen and brown ink, brown wash, over faint indications in black chalk. Verso: Asclepius Restoring Hippolytus to Life, in pen and brown ink over black chalk. 8⅞ x 13¹/₁₆ in. (224 x 332 mm). Purchased by Pierpont Morgan, 1910. I, 267.

This drawing has been described as "one of the freest and most dramatic" the French artist Nicolas Poussin (1594-1665) ever produced. Even in such a dramatic scene as *The Death of Hippolytus*, his style, clarity, and precision of expression is evident. Characteristically for Poussin, the subject is drawn from the antique, in this case Ovid's *Metamorphoses*. Wrongly accused of seducing his stepmother, Hippolytus has incurred the wrath of his father, Theseus, who calls on the sea god Poseidon to destroy him. Illustrated here is the moment after Hippolytus's chariot crashes into a rock, his horses having been frightened by a bull that Poseidon sent from the sea. The two witnesses in the center of the composition rush

to quiet the terrified animals, while on the far right a man pulls Hippolytus's lifeless body from beneath the overturned chariot.

No painting by Poussin is known of this unusual subject. The drawing has been dated between the late 1630s and early 1640s on the basis of stylistic features characteristic of the artist's drawings in both decades. In the thirties, his method was to work first in line to achieve movement and liveliness and then apply broad areas of wash for modeling and dramatic lighting effects. While line is preserved here along with an especially brilliant use of wash throughout the drawing, Poussin—in the manner of his work of the forties—modeled the foreground figures with careful applications of wash and the point of the brush. On the verso of this sheet, sketched only in pen, the narrative continues with the subject of Asclepius restoring Hippolytus to life.

Some of the most remarkable works of seventeenth-century French art were produced not in Paris but in Rome; it was here that Poussin and his fellow expatriate artist Claude spent almost the whole of their careers. Poussin was the leading exponent of French classicism, which was to become the standard for artists to imitate or reject for the next two hundred years.

18 ❧

CLAUDE GELLÉE
CALLED CLAUDE LORRAIN

*Landscape with Shepherd and Flock at the Edge of a Wood.* Pen, brush and brown ink, over graphite. 8$^7$/₁₆ x 13 in. (217 x 330 mm). Signed and dated in pen and brown ink on verso, *Claudio Gellée / fecit et inventor / Roma 1645.* Purchased by Pierpont Morgan, 1910. III, 82.

Like his contemporary Poussin, Claude (1600-82) left France when a very young man and spent most of his active life in Rome.

During his early years in Italy, Claude roamed the Campagna painting and sketching from dawn to dusk. He was particularly attuned to the transforming effects of light at various times of day. The present drawing is not, however, based on direct observation from nature but belongs to a large category of "ideal" landscapes that were composed in the studio. Elements which he invented are arranged to create a mood of idyllic tranquility, underlined here by the solitary shepherd tending his flock. Particularly noteworthy is Claude's subtle use of wash to render the effects of sunlight on massed foliage. With marked contrasts of light and shade, he evokes the long

18   Claude Lorrain, *Landscape with Shepherd and Flock at the Edge of a Wood*

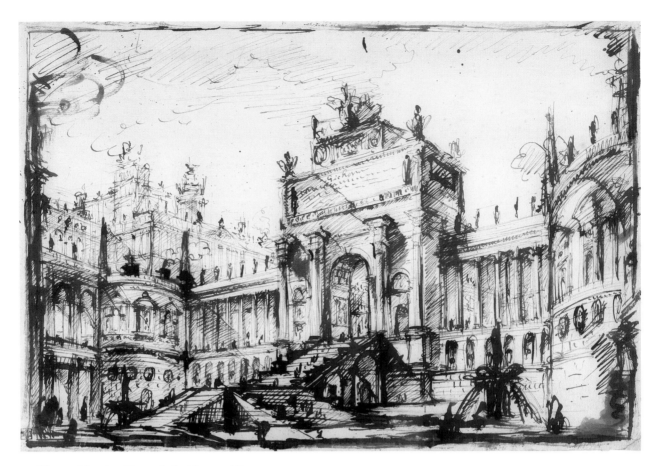

19  Giovanni Battista Piranesi, *Architectural Fantasy*

shadows of late afternoon and the fading prospect of distant hills. His romantic orientation to the Italian landscape is basically northern in temperament, recalling the work of such other northern artists in Rome as Elsheimer and Bril.

Claude had a profound effect on generations of subsequent artists, particularly in England. Turner, to mention but one example, aspired to be as great as Claude. English collectors as well were drawn to his work. They not only purchased his paintings and drawings, but some even redesigned their country parks to conform to the Virgilian rustic ideal of his landscapes. It became fashionable to carry a Claude glass, a blackened convex mirror which converted any landscape to Claudian harmony.

19 ɷ

GIOVANNI BATTISTA PIRANESI

*Architectural Fantasy.* Pen and brown ink, brown wash. 13 x 19⁵/₁₆ in. (330 x 491 mm). Gift of Janos Scholz, 1974. 1974.27.

Piranesi (1720-78), received his early training in Venice but worked mainly in Rome. Though a trained architect, he executed only one architectural project, the redecoration of Santa Maria del Priorato in Rome. He was famous in his time, and remains so today, as an engraver of the beauties of Rome, its contemporary buildings as well as archeological sites and excavations. In addition his designs for furniture deeply influenced the development of the European taste for neoclassicism.

This drawing represents an imaginary neoclassical building. A monumental flight of stairs, flanked by two fountains, leads up to a central opening. Piranesi played with similar ideas in his first important series of engravings, *La prima parte di architettura*, published in the early 1740s, and continued to do so into the 1750s. The Library has one of the major collections of Piranesi's works, including over one hundred of his drawings.

20 🕭

GIOVANNI BATTISTA TIEPOLO

*The Figure of Time Holding a Putto*. Pen and brown ink, brown wash, over black chalk. 10⁹/₁₆ x 12⁷/₁₆ in. (268 x 315 mm). Purchased by Pierpont Morgan, 1910. IV, 125.

The baroque decoration of huge interiors with illusionistic paintings developed in the seventeenth century and reached its peak in the eighteenth. Giovanni Battista Tiepolo (1696-1770), a Venetian painter who excelled also in easel painting and monumental altarpieces, was its chief representative. He worked extensively in northern Italy. From 1750 to 1753, he created his masterwork, the frescoes in the Kaisersaal and the staircase in the Würzburg Residenz. The end of his life, from 1762 on, he spent in Madrid.

In 1740, before leaving for Germany, Tiepolo painted one of his most monumental secular ceiling decorations, that of the gallery shaped *salone* of the Palazzo Clerici in Milan. There his work reached full maturity. He depicted the course of the sun amidst the continents and mythological personages, representing Time ravishing Beauty in the guise of Saturn abducting Venus. The Library's drawing is connected with the south portion of the fresco. The winged figure seated on a cloud is identified by the scythe and hourglass as Time or Saturn.

It was the custom of Tiepolo and his son to mount their drawings systematically into albums; the present sheet is one of a group of more than one hundred drawings from such an album that later passed intact to the English collector Edward Cheney, then to Charles Fairfax Murray, and from him to Pierpont Morgan in 1910.

21 🕭

THOMAS GAINSBOROUGH

*Study of a Lady*. Black and white chalk, some stumping, on buff prepared paper. 19½ x 12¼ in. (495 x 311 mm). Purchased by Pierpont Morgan, 1910. III,63b.

This vibrant drawing in black and white chalks is one of more than twenty sheets in the Library's collection by the brilliant eighteenth-century English portraitist Thomas Gainsborough (1727-88). He seldom chose to portray his sitters in the generalized, classical costumes that Reynolds employed in his paint-

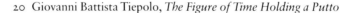

20  Giovanni Battista Tiepolo, *The Figure of Time Holding a Putto*

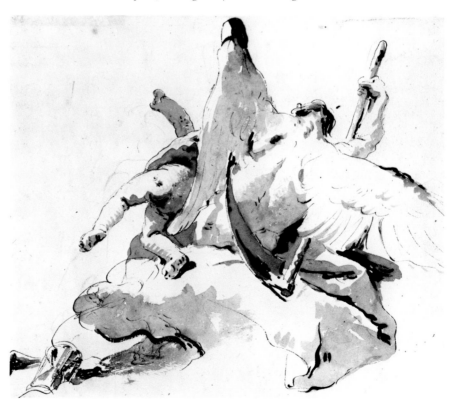

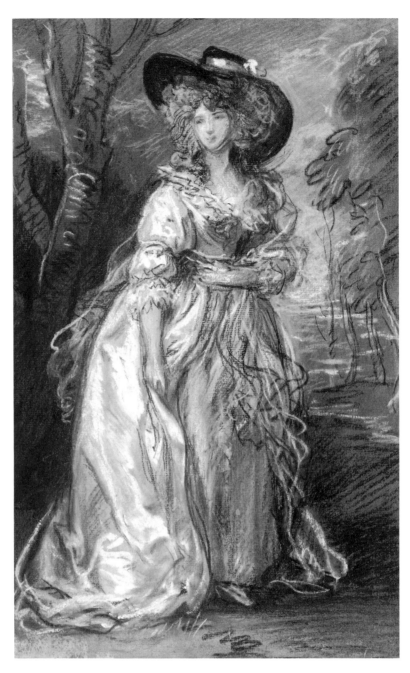

21 Thomas Gainsborough, *Study of a Lady*

ings. Rather, Gainsborough preferred to carefully record the fashions of his time: here, for instance, his close attention to such details as the broad-brimmed picture hat and loose flowing curls helps to date this drawing to about 1785.

It has been argued that the drawing is one of a group of studies of well-dressed ladies that were preparatory for a painting to be called *The Richmond Water-Walk,* or *Windsor.* The

project, which apparently was never carried out, was reportedly commissioned by George III in about 1785 and intended as a companion piece to *The Mall* (now in the Frick Collection, New York). According to Gainsborough's close friend William Pearce, the artist spent one morning in St. James's Park sketching "high-dressed and fashionable" ladies in preparation for the work. The Morgan sketch does indeed appear to have been executed rapidly and on

site. Gainsborough's lively chalk lines integrate the figure and landscape and give an extraordinary sense of movement and vitality. He refrains, however, from any searching study of either the inner life or the anatomical structure of the figure.

For many years the subject was mistakenly thought to be Georgiana, duchess of Devonshire. In 1901 Pierpont Morgan had gone to great lengths to buy Gainsborough's very famous oil portrait of the duchess (now in a private collection). When he bought this drawing in 1904, it was still considered a study for his much-loved painting.

22 ❧

HENRY FUSELI

*The Portrait of Martha Hess*. Black chalk, some stumping, heightened with white, on light brown paper. 20⅜ x 13⅞ in. (518 x 356 mm).

Purchased as the gift of Mrs. W. Murray Crane, 1954. 1954.1.

Martha Hess, described by contemporaries as "ethereal" and "inclined to religious fanaticism," was dying of consumption when Fuseli (1741-1825) drew this portrait of her in late 1778 or 1779. It was one of several portraits that he made of her and her sister Magdalena during a trip to his native Zurich. His great skill as a draughtsman can be seen in the controlled short strokes and very fine cross-hatchings of chalk from which Martha Hess's face fully emerges, framed by a cloud of dark hair. Except for eight years in Rome, the Swiss-born painter spent nearly all of his career in London, where he was an influential figure among English romantic artists and intellectuals.

In the portrait of Martha Hess, Fuseli has used formal precision and clarity of execution to express an emotional state that is mysterious, irrational, and slightly disturbing.

22  Henry Fuseli, *The Portrait of Martha Hess*

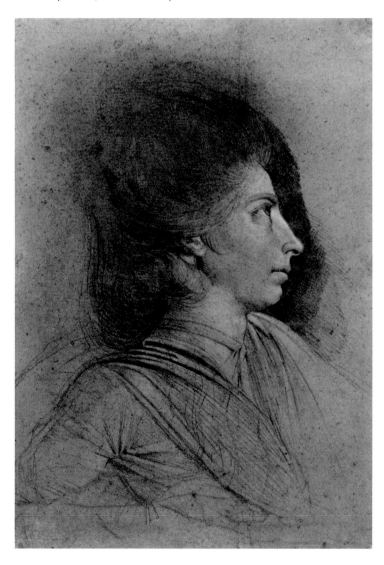

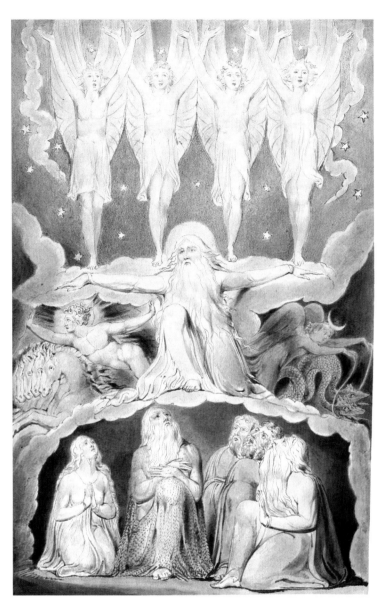

23  William Blake, *"When the Morning Stars Sang Together"*

Martha Hess was a niece of his close friend the theologian and mystic Johann Kaspar Lavater. Some of the drawings Fuseli made of Martha and her sister Magdalena were engraved for Lavater's famous book on physiognomy, the *Physiognomische Fragmente*. An edition illustrated by Fuseli brought the artist widespread European recognition.

23 &

William Blake

*"When the Morning Stars Sang Together."* Pen and brush, black and gray inks and wash, wa-

tercolor, over preliminary indications in graphite. 11 x 7¹/₁₆ in. (280 x 179 mm). Book of Job, No. 14. Purchased by Pierpont Morgan, 1903.

The series of twenty-one watercolor illustrations by William Blake (1757-1827) for the Book of Job are recognized as one of the supreme achievements of that visionary poet and artist. Shown here is the fourteenth in the series, in which God re-enacts the creation of the world while Job and his wife kneel below. The scene follows upon the moment in the story in which Job challenges God to appear and explain why he has deserved the succession of evils that has devastated his life. According to

the biblical text: "Then the Lord answered Job out of the whirlwind…Where wast thou when I laid the foundations of the earth?… When the morning stars sang together, and all the sons of God shouted for joy?" God continues to pose a series of rhetorical questions which concludes, "Shall he that contendeth with the Almighty instruct him?" Humbled, Job acknowledges God's supreme wisdom and power.

The design for this illustration is divided into three horizontal regions. In the lowest register are Job, his wife, and the "false friends" who have assured Job of their knowledge of God's motivations. They are separated from God by a layer of clouds that encase them in a cave-like dwelling. In the central area, God stretches his arms over Helios, the sun god, and Selene, the moon goddess, in a re-enactment of the Creation. In the starry firmament above, angels ("the morning stars") raise their arms in joyful praise.

Blake produced the Job series in about 1805 for Thomas Butts, a minor civil servant who commissioned many works from Blake between 1799 and 1810. The theme of Job was important to Blake, and he returned to it throughout his career. He made a second set of illustrations to the Book of Job in 1821. These he traced and copied for the artist John Linnell, who later commissioned the engravings. In order to produce the engravings, a third series of drawings was created (now in the Fitzwilliam Museum, Cambridge) in which the designs are reduced and have indications for borders. In March 1823 an agreement was made to publish the engravings, and they appeared early in 1826, the year before Blake's death. The Library's Blake collection is extensive and includes his twelve illustrations for Milton's *L'Allegro* and *Il Penseroso*, both of which were also once part of the Butts collection.

For Blake, the spiritual alone was real, and he felt himself completely isolated from the material universe. Even as a child, he had visions. Beginning with the publication of *Songs of Innocence* in 1789 (see IV, 25), he claimed a distinctive mystic vision. Despite the enthusiasm of a circle of devoted friends, neither Blake's poetry nor art found a wide audience, and, after a lifetime of continuous hard work, he spent his last years in obscurity.

24 🙠

FRANCISCO GOYA Y LUCIENTES

*Pesadilla* or *Nightmare*. Point of brush, gray and black washes. 10⅜ x 6¾ in. (264 x 171 mm). Gift of Mr. and Mrs. Richard J. Bernhard, 1959. 1959.13.

Goya (1746-1828) was one of the most remarkable artists of all time. He was an eminent painter of frescoes, altarpieces, and easel paintings, an inventive designer of tapestries, a brilliant portraitist, a prominent etcher and lithographer. Most of his drawings come from eight albums and date from the middle of the nineties to the end of his life. They were clearly intended as independent works of art.

The first outlines of this drawing were made with the point of the brush in a very pale gray ink. Then different shades were applied in many layers, both with the point of the brush and the broad brush, to complete the image.

The drawing is one of a group that comes from the so-called Black Border Album. These drawings have been dated to the period of about 1814 to 1817 on the grounds of politi-

24 Francisco Goya, *Pesadilla* or *Nightmare*

cal allusions to events occurring after the return of Fernando VI from France and the subsequent abrogation of the constitution.

While a woman on a bull generally personifies Europe, here she seems to represent fear and horror. Goya entitled the work *Pesadilla*, meaning "nightmare."

25 🙞

JEAN-ANTOINE WATTEAU

*Seated Young Woman.* Black, red, and white chalk. 10 x 6¾ in. (254 x 171 mm). Purchased by Pierpont Morgan, 1911. I, 278a.

Watteau (1684-1721) may be regarded as the greatest French artist of his century. He was one of the principal creators of the rococo style. Combining real and imaginary elements in his paintings, he enveloped them in a poetic atmosphere—an atmosphere also present in his drawings. In this study of a casually posed young woman, Watteau's gift for suggesting the bloom and luminosity of flesh is superbly realized in a few crisp but subtle strokes. Using a combination of red, black, and white chalks he deftly produces shimmering, coloristic effects. His adoption of the so-called *trois crayons* technique may well be a result of his study of Rubens's drawings in the collection of his wealthy friend and patron Pierre Crozat. So complete was Watteau's mastery of this technique that it is often associated with him.

Watteau drew incessantly from life, often with no immediate purpose in mind. These figure studies were kept in a book and used and reused when he composed his paintings. The pretty blonde model seen here appears to have sat for him often. She may be the same woman who posed for the nude study of Flora in the Louvre, which was preparatory for a series of paintings of the seasons that Watteau was commissioned to do for Crozat's dining room. Although this drawing of a seated woman does not appear in any surviving paintings by the artist, it was etched by Boucher in the *Figures de différents caractères*, a compendium of 103 prints after Watteau's drawings published as a tribute to the artist soon after his death from consumption at the age of thirty-seven.

25  Jean-Antoine Watteau, *Seated Young Woman*

26 🙞

JEAN-HONORÉ FRAGONARD

*Young Woman Seated in a Garden.* Red chalk over a few slight indications in graphite. 8¾ x 11¹/₁₆ in. (222 x 281 mm). Purchased by Pierpont Morgan, 1910. I, 289a.

The art of Fragonard (1732-1806), who was one of the supreme exponents of the French rococo style, is filled with scenes of dalliance and youthful merrymaking in luxurious garden settings. A prolific painter, he was also one of the greatest draughtsmen of his time, able to draw almost effortlessly and with equal ease in brush, wash, and chalk. This sheet is one of a series of drawings of fashionable young women, several of which were engraved. Most are sketched in red chalk, a medium especially favored by French artists of the eighteenth century. The Library's drawing begins with a slight sketch in graphite and is generally more fully composed than the others. The garden, however, is suggested in a few rapid strokes. The charming sitter may be a member of the artist's family, possibly his daughter Rosalie. In any event, the small oval face, with its delicate features, is characteristic of his ideal of feminine beauty.

This sheet was acquired by Pierpont Morgan

26 Jean-Honoré Fragonard, *Young Woman Seated in a Garden*

in 1910 as part of the Charles Fairfax Murray collection. Morgan also owned Fragonard's famous Progress of Love series, painted for the comtesse du Barry, mistress of Louis XV, now in the Frick Collection. Fragonard's career was long and covered the extremes of the eighteenth century. He was successively a pupil of Chardin, Boucher, and Van Loo, and also studied in Rome at the French Academy. Much later, after his patronage was swept away by the Revolution, Fragonard ended his career as a member of the commission that established the Louvre Museum.

27 ঌ

LOUIS GABRIEL MOREAU
CALLED L'AÎNÉ

*"La Vallée": Pastoral River Landscape with Traveler Accompanying Shepherdess on Horseback with Flock of Sheep and Goats about to Ford a Stream.* Gouache over preliminary indications in graphite. 22⅞ x 33⁵⁄₁₆ in. (593 x 844 mm). Signed with initials in pen and black ink, *L M.* Purchased on the von Bulow Fund, 1981. 1981.11.

The eighteenth-century French landscape artist Louis Gabriel Moreau (1740-1806) was called l'Aîné to distinguish him from his brother, the book illustrator Jean Michel Moreau le Jeune. He often worked in gouache, a difficult medium which gives the look of painting without having its flexibility. Like watercolor, it is water based and dries quickly, but the pigments are opaque rather than transparent. For this large, and wonderfully airy panoramic river view, the artist chose a relatively thin oriental paper, first preparing it with a layer of blue gouache. He then painted in the general outlines of the composition, brushing most of the surface with a broad soft brush to achieve atmospheric effects before the surface dried. Later, once the surface was dry, he added accents in color where needed, including the group of peasants with their sheep and goats in the foreground.

Because of the difficulty of working in gouache, the scenes were probably composed in the studio. Since Moreau apparently never left the Ile-de-France, most of his landscapes must be based on views around Paris. Nevertheless, this large landscape evokes the look and feel of an Italian scene and may reflect knowledge of the work of Marco Ricci, the

seventeenth-century Venetian landscapist who also worked in gouache. Moreau's silvery tones and naturalism look ahead to the landscapes of Corot and the Barbizon painters of the nineteenth century.

Louis Gabriel Moreau devoted himself to landscape painting at a time when the genre was still held in some disdain within the hierarchy of subject matter established by the French academicians. It was not until 1817, eleven years after his death, that landscape painting was officially acknowledged by the academy with the inauguration of a Prix de Rome in the field of historic landscape. Moreau's full recognition as a major artist in this field has only come about in this century.

## 28 &

### PIERRE-PAUL PRUD'HON

*Female Nude.* Black, white, and pale pink chalk, some stumping, on blue paper. 23 3/16 x 12 7/16 in. (589 x 316 mm). Gift of Mr. and Mrs. Eugene Victor Thaw, 1974. 1974.71.

Although Prud'hon (1758-1823) was ten years younger than the French neoclassicist Jacques-

Louis David, his work in many respects is more easily connected with the elegance and refinement of eighteenth-century rococo. Prud'hon excelled in the depiction of sensuous forms, often employing broad painterly brushstrokes combined with a soft chiaroscuro. It is a style which owes much to the art of Correggio and ultimately to the *sfumato* of Leonardo.

This highly finished nude is one of at least eleven preparatory studies for the figure of Innocence in Prud'hon's *Love Seducing Innocence.* There are four known paintings as well as two oil sketches of the subject. It is clear that when he made this drawing, Prud'hon already knew the pose he intended for the figure in the painted version. There Innocence, her eyes demurely downcast, slips her arm around Love, who resembles an Apollo-like youth. Here, the combination of black, white, and pale pink, almost flesh-colored, chalks creates a soft chiaroscuro effect, which is intensified by the blue paper on which Prud'hon liked to draw.

During his lifetime Prud'hon achieved considerable success not only as a painter but as a book illustrator. He was a favorite of the Empress Josephine, and the Library's group of Prud'hon drawings includes a sketch for the portrait of her in the Louvre. While many of his

27 Louis Gabriel Moreau, *"La Vallée"*

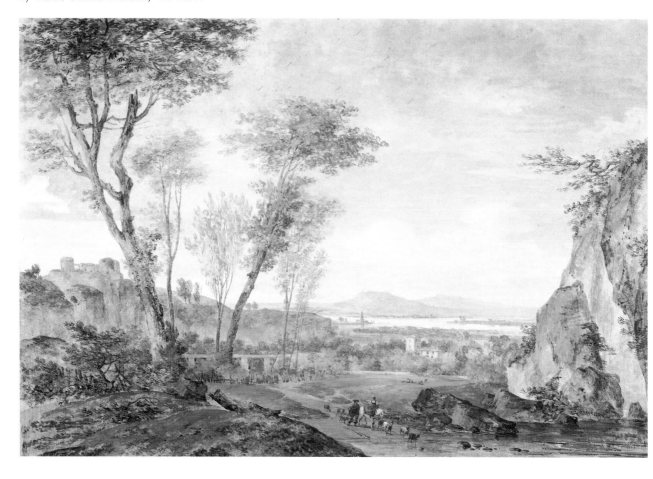

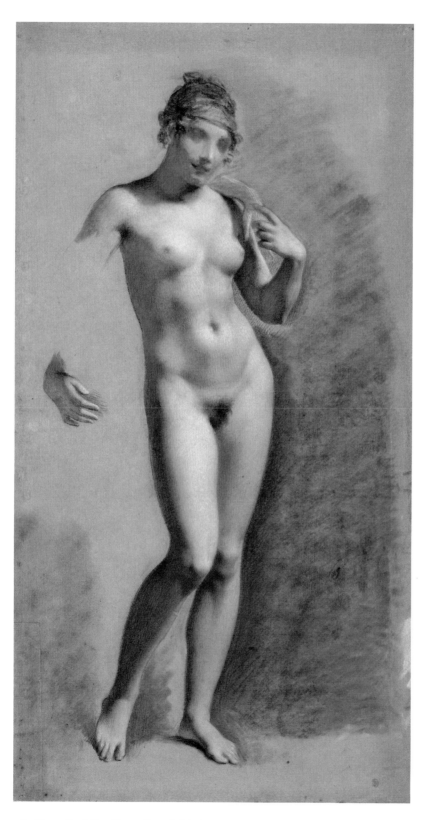

28  Pierre-Paul Prud'hon, *Female Nude*

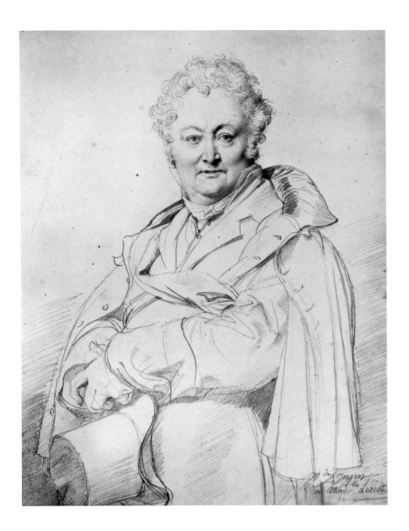

canvases have lost definition, his drawings, particularly his studies of female nudes, continue to entrance with their beautiful subtlety and refinement.

## 29 ❧

### JEAN-AUGUSTE-DOMINIQUE INGRES

*Portrait of Guillaume Guillon Lethière (1760-1832).* Pencil on wove paper. 11 x 8¾ in. (280 x 221 mm). Bequest of Therese Kuhn Straus in memory of her husband, Herbert N. Straus, 1977. 1977.56.

In this 1815 portrait of the French neoclassical painter Guillaume Guillon Lethière, Ingres (1780-1867) used a combination of soft and hard pencils to suggest a variety of tonal effects. A tautly stretched paper tablet provided a fine resilient surface, on which he could draw with absolute control. Few artists have employed the pencil with more precision or with greater

sensitivity to its possibilities than Ingres.

The sitter, as is often the case in Ingres's portraits of this period, was a friend and associate. Like Ingres, he had been a pupil of Jacques-Louis David, and by this time he was the director of the French Academy in Rome. Ingres, having received the coveted Prix de Rome, arrived in the city in 1806. His stipend entitled him to only two years' study at the academy, and he financed his continued stay in Italy with pencil portraits such as this one, which he sold at a rate of about forty francs each. Ingres's virtuoso drawing depicts Lethière's facial features precisely and reveals him as an imposing and intelligent man. The bravura handling of the cloak and upturned collar captures some of the dash that was associated with him as well. The drawing is inscribed to Hortense Lescot (later Mme Haudebourt-Lescot), a pupil and friend of the sitter.

Ingres's portraiture, like the whole of his art, was profoundly influenced by his study of Raphael. At a time when Delacroix was revolu-

tionizing French art with his painterly, romantic style, Ingres was the leader of the opposing "classicist" camp. His insistence on the primacy of drawing was legendary; he once gave Degas the now-famous advice, "draw lines, young man, many lines."

30 🐚

HILARE-GERMAIN-EDGAR DEGAS

*Standing Man with a Bowler Hat.* Essence on brown oiled paper; pentimenti. 12¾ x 7⅞ in. (323 x 201 mm). Bequest of John S. Thacher, 1985. 1985.39.

Degas (1834-1917) is ranked among the finest draughtsmen and painters of the French Impressionists. His work is particularly noted for the subtleties of pose, gesture, and expression that reveal psychological and emotional states. While his pictures frequently suggest a spontaneous or accidental quality, they were in reality carefully planned compositions.

There is some reason to believe that this drawing of a man standing is related to one of his early masterpieces, an enigmatic painting called *Interior (The Rape)* (Philadelphia Museum of Art). The canvas, dated about 1868-69, shows a simple bedroom, illuminated by a single gaslamp. In one corner a half-

30 Hilaire-Germain-Edgar Degas,
*Standing Man with a Bowler Hat*

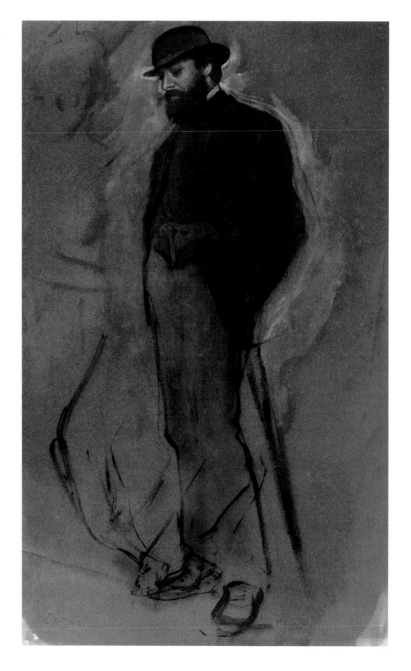

dressed woman crouches in a chair and turns her face to the wall. In the opposite corner a man with his hands in his pockets leans up against the door. Although Degas apparently never named the painting "The Rape," it is easy to see how the title soon became attached to the work. The connection of the Library's drawing with the painting is intriguing, particularly because the attitude of the standing figure evokes the same moody ambivalence as the painting. There are, however, obvious differences between the man in the painting and the man in the Morgan drawing. In the former, he rests his back against the wall, his hands in his pockets and his legs spread; his jacket is off and his hat lies on a bureau. In the drawing, he is standing upright, dressed as if he were ready to go out, with bowler hat and umbrella; in his left hand is a cigar. Pentimenti in the drawing clearly show that Degas's first idea was to have the man leaning back slightly with his legs crossed. Perhaps the most convincing connec-tion with the painting, however, comes in an old inscription found on the back of the frame of the drawing which reads "première idée pour le Viol..." (first idea for the Rape). The Library also owns a study of a seated woman, similar both in style and technique, that is preparatory for the Philadelphia picture.

Throughout his life, Degas experimented with traditional media to create new and inno-vative effects. The drawing is executed in a substance of his own invention, which he called "peinture à l'essence." By removing the oil from the oil paint and mixing the residue with tur-pentine, he was able to achieve a dry chalky effect. As Degas's eyesight began to fail, he gradually abandoned oil painting, preferring to work in pastel.

The drawing is one of a group of eight by Degas that came to the Library in 1985 as part of the John S. Thacher bequest. These were the first drawings by Degas to enter the Library's collection.

# INDEX OF ILLUSTRATIONS

*Compiled by Elizabeth O'Keefe*

IN AUGUST COMPANY was designed by Klaus Gemming, New Haven, Connecticut. The text was set by Finn Typographic Service, Stamford, Connecticut, in Sabon-Antiqua, designed by Jan Tschichold in 1967. It is a modern rendering of fonts engraved by Garamond and Granjon and named for another typefounder of the sixteenth century, Jacques Sabon.

The illustrations were reproduced in fine-line screen and printed in offset lithography in four-color process and duotone by Van Dyck/Columbia Printing, North Haven, Connecticut, on 80 lb. dull-coated Quintessence paper, made by Potlatch Corporation.

The book was bound by the Acme Bookbinding Company, Charlestown, Massachusetts, part of the edition in paper and part in natural-finish Imperial cloth. Both editions include Rainbow Colonial endsheets made by Ecological Fibers. The slipcase for a special edition was made by the Taylor Box Company, Warren, Rhode Island.

The decorations stamped on the cloth binding were taken from the back cover of the Lindau Gospels (VI, 2), page 175.

The emblem of the Morgan Library on the title page, showing a monk dictating to a scribe, was adapted by the noted illustrator Fritz Kredel from the thirteenth-century French Moralized Bible (III, 15), page 89.